# INTERNET
# CULTURE

*edited by* DAVID PORTER

ROUTLEDGE
New York and London

Published in 1997 by

Routledge
29 West 35th Street
New York, NY 10001

Published in Great Britain by

Routledge
11 New Fetter Lane
London EC4P 4EE

Library of Congress Cataloging-in-Publication Data

Internet culture / edited by David Porter.
     p.      cm.
     ISBN 0-415-91683-6 (hardbound)
     ISBN 0-415-91664-4 (pbk.)
     1. Internet (Computer network) -- Social Aspects.
I. Porter, David, 1965—   .
ZA4201.I56   1996             96-36557
303.48'33--dc20              CIP

To the Memory of
Sara Prather Armfield Hill
Loving Teacher and Friend

# CONTENTS

## ACKNOWLEDGMENTS

I would like to express my thanks to the many friends, teachers, and colleagues who contributed to making this collection possible. Helen Tartar, Wanda Corn, and Charles Junkerman offered advice and encouragement in the early stages of the project. Jeffrey Schnapp, Janice Pang, and Pericles Lewis commented on portions of the manuscript, and Scott Mackey helped with technical glitches. Lengthy discussions with Robert Gordon, Nancy Schniedewind, and Marcel Lieberman were especially valuable in sharpening my sense of the complexity of the central issues in the book.

I am grateful to the directors, staff, and fellows of the Stanford Humanities Center for the research support and warm collegiality I enjoyed during the fellowship year I spent there working on this project, as well as to my advisors Herbert Lindenberger and John Bender for their continuing guidance. A special thanks, finally, to my parents, for just about everything else, and to Lani Wang for enduring my netsurfing phase and for offering frequent and welcome reminders that email does not always suffice.

*INTRODUCTION*

David Porter

If the Internet can be uderstood as the site of any culture at all, it is not, presumably, culture in the sense either of an elitist enclave or of a homogeneous social sphere. The culture that the Net embodies, rather, is a product of the peculiar conditions of virtual acquaintance that prevail online, a collective adaptation to the high frequency of anonymous, experimental, and even fleeting encounters familiar to anyone who has ventured into a newsgroup debate. The majority of one's correspondents in cyberspace, after all, have no bodies, no faces, no histories beyond what they may choose to reveal. There are no vocal inflections, no signatures, no gestures or embraces. There are words, but they often seem words stripped of context, words desperately burdened by the lack of the other familiar markers of identity in this strange, ethereal realm. It is no wonder that these digitalized words, flung about among strangers and strained beyond the limits of what written language in other contexts is called upon to do, are given to frequent misreading, or that they erupt as often as they do into antagonistic "flames." In a medium of disembodied voices and decontextualized points of view, a medum, furthermore, beholden to the

fetishization of speed, the experience of ambiguity and mis-reading is bound to be less an exception than the norm.

It is the collective response to this experience of ambiguity, the gradual process of adaptation to the semiotic universe of free-floating electronic alibis that constitutes the unique culture of the Internet. Recent media hype about the World Wide Web and Information Superhighway notwithstanding, what continues most powerfully to draw people to the Internet is its power and novelty as a medium of person-to-person communication. People log on to newsgroups, listservers, and the interactive role-playing sites known as MUDs and MOOs for the same reason they might hang out at a bar or on a street corner or at the coffee machine at work: they've either got something to say or else an ear to lend to those who do. There is an expectation here of exchange, of sociability, even of empathy in conversations that may involve personal concerns, playful banter or philosophical debate. Whether what comes out of all this virtual talk can be properly termed "community" is a complicated question that a number of the following essays address at length. There is no doubt, however, that such interactions, when sustained, can give rise to a unique and intriguing form of social space, and one that will continue to provoke reassessments of the fundamental nature of "community" itself.

It is when the motivating expectation of sociability in cyberspace confronts the essential ambiguity and facelessness of the Internet medium that the resulting interactions begin to take on a distinctive shape, bringing the cultural contours of this space into view. As participants adjust to the prevailing conditions of anonymity and to the potentially disconcerting experience of being reduced to a detached voice floating in an amorphous electronic void, they become adept as well at reconstituting the faceless words around them into bodies, histories, lives: an imaginative engagement by which they become fully vested co-producers of the virtual worlds that they inhabit, and the boundaries distinguishing "real" from "virtual" experience begin to fade. Acts of creative reading, in other words, can and do stand in for physical presence in these online encounters. The question, then, is whether this substitution renders the experience itself "unreal," or somehow less than fully authentic.

The acts of interpretation that color and enliven the virtual universe are neither fortuitous nor random. If the allure of the Internet is the possibility of interaction with other people, this desire for human contact, in turn, insists on the appear-

ance of humanity at the other end of the wire. Where only electronic fragments are to be had, a more substantial being must be fleshed out in a reader's mind with all the familiar markers by which he or she might be "known." In a medium that presents such boundless opportunities for experimenting with one's public personae, the "accuracy" of these imaginary projections would seem a matter of little concern. Far more important is the fact that they arise consistently and even necessarily as a very condition of the medium's appeal. The defining interaction of Internet culture lies not in the interface between the user and the computer, but rather in that between the user and the collective imagination of the vast virtual audience to whom one submits an endless succession of enticing, exasperating, evocative figments of one's being.

Viewed collectively over a period of time, such interactions come to take on these discernible features and to reveal those characteristic "ways of being" in a virtual world that an anthropologist might regard as together constituting the culture of such a place. One can find on the Internet established conventions of self-presentation and argument, widely shared systems of value and belief, complete lexicons of gestural symbols to convey nuances of personal style, and modified standards of social decorum that facilitate easy interactions with strangers. The entire spectrum of interpersonal dynamics has adapted to the peculiar conditions of online connectivity: there are uniquely Net-based tokens of respect, affection, and group bonding alongside equally Net-specific forms of harassment, hostility, and violence. Education, public debate, sexuality, and even game-playing have given rise, in their Internet incarnations, to distinct modes of writing and interpretation that exploit the possibilities of instantaneous one-to-many communication while making the best of its limitations, often in surprising ways.

The essays collected in this anthology set out to examine as cultural phenomena the characteristic ways of being and interacting that have taken shape in the public spaces of the Internet. The following questions, which were provided to all the contributors at an early stage, define a common conceptual framework for the collection as a whole.

1  What are the distinctive, defining characteristics of the Internet as a cultural sphere? What, precisely, in other words, is Internet culture, if such a thing can be allowed to exist?

2 How does the Internet affect our understanding and experience of community? What is the sociology of so-called virtual communities and the precise nature of the communality they claim to embody?

3 What can be said about the psychology of virtual personhood? What are the implications of anonymity and role-playing online—are identity, agency, and subjectivity reconfigured in their cyberial incarnations?

4 What does communication become in this new cultural dimension? What effects does the Internet have on our practice or conception of reading and writing, and how does it color social interactions between individuals and within groups?

5 Finally, what are the political dimensions of Internet culture? Whose interests does it serve and how, and what are the directions and broader implications of the "progress" it represents? Are there other modes of public discourse, contemporary or historical, that might provide a useful basis for comparison?

The essays are grouped into four sections corresponding roughly to the last four questions and the four primary sites of cultural production and adaptation on the Internet that they represent:: virtual communities; virtual bodies; language, writing, and rhetoric; and politics and the public sphere.

Part One explores the virtual spaces that have been established by the citizens of the Internet, spaces where the impulse to create a sense of place, belonging, and even of collectivity is often nearly as tangible as the basic desire for social interaction that brings people there in the first place. Shawn Wilbur, a cultural historian who also hosts one of the Internet's most renowned real-time discussion sites, the Postmodern Culture MOO, offers in the opening essay a critical interrogation of the very concept of "virtual community." Beginning with an excavation of the cultural and etymological roots of the phrase itself, Wilbur sets out to explore the full range of its modern connotations by delving into the ruins of two very different virtual communities that have come and gone within the last five years. Sociologist Derek Foster considers the realignment of personal and collective identities brought about by the public presentation of

private selves so characteristic of online discussion forums, and asks whether the electronic mediation of personal interactions is compatible with the social and psychological underpinnings of sustained community engagement. Turning next to a specific and deeply revealing instance of community formation on the Internet, Michele Tepper describes the humor-based discursive conventions that have evolved on one newsgroup as a means of defining and controlling group membership. Dave Healy closes Part One with an essay that situates the peculiar dynamics of social formations on the Internet within an American literary tradition of profound ambivalence towards the promise of community and corresponding fascination with the elusive topos of the frontier.

Even an electronic frontier, as Howard Rheingold amply demonstrates, will have its homesteaders; the virtual bodies that inhabit the open spaces of the Internet provide the focus of Part Two. What are the desires—either for pleasure or transcendence—that animate these bodies, and on what basis do we distinguish the experiences of their electronic and corporeal incarnations? Shannon McRae brings her perspective as the host of a virtual world to the question of eroticism and sexuality in an online medium that offers seemingly unlimited possibilities for experimentation in the (re)construction of gender identities. Taking a closer look at the implications of virtual "embodiment" in the often fictional characters of MUDs, or multi-user dungeons, anthropologist Mizuko Ito focuses on the fragile and even collapsing boundaries between the physical and the non-physical, real and virtual, machine and organism so characteristic of these intensely consuming environments. A compelling theological precedent for the modern experience of virtual transcendence on the Internet informs medievalist Jeffrey Fisher's essay, which, through parallel readings of Dante and cyberpunk literature, mystical visions and MUD reincarnations, proposes a richly historicized revision of the idea of the body and of memory in an age whose technology would often seem to leave them behind.

Although the latest generation of Internet software has stressed multimedia applications, the public conversations and personal encounters that characterize the non-commercial culture of the Internet remain almost exclusively text-based. It is to this specifically textual and rhetorical basis of computer-mediated communication that we turn in Part Three. Cultural

critic Charles Stivale first examines the widespread phenomenon of "spam"—aggressive or harassing verbal behavior—in public discussion and role-playing sites on the Internet by way of comparison with other forms of parodic and oppositional language. A related—and equally common—rhetorical gesture is the "flame," an inflammatory, aggressively satirical response to another person's posting. William Millard, the editor of *21st Century* magazine, offers an analysis of the culture of flaming on the Internet through a consideration both of literary and historical precedents and of his own involvement in a prolonged and intensely self-reflective flame-war on an American Studies discussion list.

An historical context for such practices is provided by Brian Connery, an English professor and the founding editor of the journal *Writing on the Edge*. In his overview of the coffeehouse culture of seventeenth- and eighteenth-century England, Connery portrays an institution which in its centrality both as a social space and as a clearinghouse for public "news" and information played a crucial role in the evolution of an anti-authoritarian—and ultimately democratic—public discourse in England, and which might usefully be regarded as an antecedent for the predominant rhetorical practices of Internet newsgroups and discussion lists. In the closing essay of this section, media historian James Knapp locates one of the most familiar forms of Internet writing—reflective and often polemical commentary on a potentially controversial topic— within another kind of literary and historical context—that of the essay genre—and considers the plausibility of viewing the public newsgroups that host the most lively exchanges of these "essayistic messages" in the light of a Habermasian notion of the public sphere.

Knapp's essay serves as a segue as well into the final part of the anthology, which takes on the broader cultural impact of the Internet with respect to politics and the idea of a democratic public sphere. In this section, our working conception of Internet culture as a set of structural norms and possibilities that have arisen exclusively within the sequestered worlds of the Net must expand to accommodate the effects its extraordinary growth on the lives even of those not immediately involved with it. Just as the culture of television or of Hollywood in the United States leaves a profound mark on the daily experience of viewers and non-viewers alike, so the shared practices and expectations of Internet users—with regard, for example, to sociability or participa-

tion in the political process—may come to have a subtle ripple effect on a broader national culture as a whole.

Mark Poster, a professor of history and critical theory, opens Part Four with a consideration of the long-term political impact of the Internet regarded not just as an extension of existing institutions but as a profoundly transformative technological structure in its own right. Pointing to its radical decentralization and the possibility it offers for the instantaneous dissemination of endlessly reproducible artifacts, Poster argues that the Internet medium may well give rise to entirely new social functions, subject positions, and conceptions of individual agency. Taking a somewhat more skeptical view, Joseph Lockard presents a scathing critique of the automatic association of Internet access and democratic enlightenment he finds in many quarters. Addressing issues of accessibility, community, race, and class as they inform the social ideology of the Net, he warns against the uncritical embrace of machine-mediated communication as a source of emancipatory change in human relations.

Turning next to the question of pedagogical applications of these technologies, English professor Joseph Tabbi weighs the benefits of the Internet as a "cultural laboratory... for experiments in communicative action" against the new forms of anxiety that such experiments entail, and proposes ways this very tension might be put to productive use in the intellectual "contact zone" of the college classroom. Jon Stratton, a professor of cultural studies, closes the collection by addressing the increasing globalization of cyberspace in the context of the modern history of capitalism, mass communication, and the formation of nation-states, and suggests how the Internet's increasing commercialization and saturation in the mythology of the American small town may complicate the often heralded emergence of a truly transnational public sphere.

The Internet has grown in recent years from a fringe cultural phenomenon to a significant site of cultural transformation and production in its own right. The fifteen essays in this volume set out to map the contours of this new domain of language, politics, and identity with reference to historical contexts, lived experience, and theoretical models. The collective aim of the contributors is to interrogate both the sustaining myths and rituals of existing virtual worlds and the implications of the on-going mass migration onto the electronic frontier, and perhaps also, finally, to provoke freshly informed

reconsiderations of the more familiar landscapes being left behind. Virtuality has infused the reality of millions; the hybrid culture which they now inhabit is the subject of this book.

*ONE*

# *VIRTUAL*
# *COMMUNITIES*

# AN ARCHAEOLOGY OF CYBERSPACES
## VIRTUALITY, COMMUNITY, IDENTITY

Shawn P. Wilbur

*Internet Culture? Virtual Community?*
"Virtual community" is certainly among the most used, and perhaps abused, phrases in the literature on computer-mediated communication (CMC). This should come as no surprise. An increasing number of people are finding their lives touched by collectivities which have nothing to do with physical proximity. A space has opened up for something like community on computer networks, at a time when so many forms of "real life" community seem under attack, perhaps even by the same techno-cultural forces that make Internet culture possible. We need to be particularly critical as we approach the tools we use to explore Internet culture, even the words we choose to employ. Consider the notion of "virtual community." It reveals something about our presuppositions about both (unmodified, presumably "real") community and (primarily computer) technology that this phrase even makes sense. It is more revealing that we might think of "virtual community" as a new arrival on the cultural scene.

What follows is an attempt to come to grips with at least some of the questions raised by the notion of "virtual community," and particularly by its apparent acceptance as a phrase of choice among Internet users, CMC researchers and journalists alike. It is an "archeological" study in two rather different ways. The first section, which is an exploration—or perhaps excavation—of some of the possible cultural and etymological roots of the phrase "virtual community," aims at unearthing a range of interpretive possibilities and spreading them out so we can begin the speculative (re)construction of concepts that we can use for rigorous research in CMC. The second section involves the exploration of slightly more literal ruins, as I examine what remains of two "virtual communities" that have already come and gone—a section of a text-base virtual reality system housed at MIT's Media Lab, and a voice-based "virtual village" created by Harlequin Romance in conjunction with one of its book series. Throughout, the work is driven by my sense that Internet users and CMC researchers have been hasty in their adoption of tools and terminology, but also by a feeling that the choices we have made in haste may prove to be surprisingly powerful, assuming we learn to use them with eyes wide open.

It is probably worth noting that my investments in these subjects are complex and multiple. Researchers on the Internet seem to show a high tendency toward "going native," and I fear I am no exception. Although I have attempted to write what follows in the voice of a CMC researcher and academic, I wear numerous other hats on the Internet— nonprofessional user, electronic publisher, MOO "wizard," and owner of several electronic mailing lists, among others. I suspect some of those other voices will have their say before we are through. Of course, reference to the personal—and the resulting scholarly discomfort—seems to be characteristic of much of the emerging literature on Internet culture. This may simply be a logical result of the strangely solitary work that many CMC researchers are engaged in, sitting alone at their computers, but surrounded by a global multitude.

### The Right Tools for the Job

We use words as tools, as individuals and as scholars. On the Internet we use little else. Whatever else Internet culture might be, it is still largely a text-based affair. Words are not simply tools which we can use in any way we see fit. They come to us framed by specific histories of use and meaning, and are products of particular ideological struggles. Richard Dawkins'

notion of the "meme" may help us here. The meme is the cultural equivalent of a gene, a basic "unit of imitation." As genes act as replicators for biological structures, memes replicate cultures.[1] If we think of terms like virtual community or computer-mediated communication as the result of memetic (re)combinations, then perhaps we are more likely to be concerned about their particular inheritances, but we are also encouraged to consider the hardiness of our concepts. We ought to be on the lookout for recessive memes, and for the circumstances where elements of our memetic heritage might recombine in ways which do not enhance our possibilities for cultural survival.

The current benchmark for any study of virtual community is Howard Rheingold's *The Virtual Community: Homesteading on the Electronic Frontier*. Rheingold's earlier *Virtual Reality* established him as both a sharp-eyed observer and talented popularizer of "new edge" technologies.[2] According to Rheingold,

> Virtual communities are social aggregations that emerge from the Net when enough people carry on those public discussions long enough, with sufficient human feeling, to form webs of personal relationships in cyberspace.[3]

"Sufficient human feeling" is a rather imprecise measure, full of assumptions about the "human" and about what emotions will count as "feeling." And we are left to wonder about the ends to which this "human feeling" will be "sufficient." We are left very much in the dark about the process of community development—perhaps "generation" or "genesis" would be as appropriate—but we know that the key ingredients are communication and feeling. To his credit, Rheingold is not inclined to claim any great definitional rigor, although he provides plenty of indications about his own feelings. Judging from the examples which he uses, Rheingold is most prepared to see "community" in those groups that move from CMC to face-to-face interaction, as well as in those who share specific, or useful, details of "real life" (RL).[4] It seems that for Rheingold, despite his immersion in certain virtual communities and his guarded enthusiasm for the uses of CMC, the best virtual community is an extension of "real community"—though not, I think, in Marshall McLuhan's sense of transformative extension and amputation.

Another aspect of Rheingold's study that we ought to note,

AN ARCHAEOLOGY OF CYBERSPACES

at least in passing, is his invocation of the "electronic frontier" metaphor, particularly in his use of the term "homesteading" to describe "pioneers" in virtual community-building. Because of organizations like the Electronic Frontier Foundation (EFF), which have played an important role in addressing new issues of civil liberty and privacy relating to CMC, the notion of an electronic frontier has gained considerable currency online, even among computer users who might otherwise have reservations about a metaphor so steeped in traditions of imperialism, rough justice and the sometimes violent opposition of any number of others.[5] In the complex social and legal spaces of Internet culture, groups like EFF seem to be wearing the white hats, but we may want to consider the memetic heritage they carry with them. In any event, we should take note of the connection made between community and the near-primitive conditions of a frontier.

*Community*

From here, we must proceed carefully. A little bit of etymological spadework only serves to show how complicated the issues are.[6] Community seems to refer primarily to relations of commonality between persons and objects, and only rather imprecisely to the site of such community. What is important is a holding-in-common of qualities, properties, identities or ideas. The roots of community are sunk deep into rather abstract terrain. For example, community has achieved a remarkable flexibility in its career as a political term. It can be used to mean a quite literal holding-in-common of goods, as in a communist society, or it can refer much more broadly to the state and its citizens. In common usage, it can also refer to the location within which a community is gathered. Under the influence of bureaucracy and cartographic standards, this more common usage reduces the holding-in-common of the community to a matter of proximity. Community becomes shorthand for community-of-location, although we hardly presume anything like joint ownership.

A personal example will clarify what is at stake here. My earliest recollections of the word "community" are of seeing it on road maps, back-seat driving as my father steered the family car through the rather desolate expanses of the southern San Joaquin Valley. I would track our route from town to town— except that most of the towns in that part of the world were little more than crossroads with perhaps a gas station and a few trailers nearby. The maps designated these tiny towns, with a

population under some magic number which I have long since forgotten, as communities. As a child, then, I imagined that a community was an empty, or nearly nonexistent, town.

This lowest common denominator for community is certainly far from Rheingold's "sufficient human feeling." Yet these tiny rural sites resonate with a discourse of homesteading and frontiers, if only to draw a clear line between those communities that grew to become larger dots on the map, merging into one another as they spread, and those that remain isolated. Here is one place to begin to ask questions about the ends of the homesteading process—about issues of ownership and enterprise, the division of labor and the establishment of law and order. For the most part, Rheingold leaves these questions open. Are his "homesteaders" the relatively well-to-do patrons of high-priced services like the WELL (Whole Earth 'Lectronic Link)?[7] If so, then what role are the less "civilized" or less affluent denizens of the Internet destined to play? For the moment, the white hats at EFF and elsewhere seem inclined to defend outlaws and "savages," but it may be that their role is somewhat obscured by the relative absence of real law on the Internet thus far.

*The Virtual*

In everyday speech, the "virtual" seems most often to refer to that which appears to be (but is not) real, authentic or proper—although it may have the same effects. Even in this colloquial form it attests to the possibility that seeming and being might be confused, and that the confusion might not matter in the end. But this sense of the virtual arises from a complex history of relations between reality, appearance and goodness. The roots of "virtuality" are in "virtue", and therefore in both power and morality. In an archaic form, the virtual and the virtuous were synonymous. Another sense of the virtual— which we might think is unconnected—refers to optics, where the virtual image is, for example, that which appears in the mirror. But it may be that all of these etymological threads finally wind together.

The deepest roots of virtuality seem to reach back into a religious world view where power and moral goodness are united in virtue. And the characteristic of the virtual is that it is able to produce effects, or to produce itself as an effect even in the absence of the "real effect." The air of the miraculous that clings to virtue helps to obscure the distinction between real effects of power and/or goodness and effects that are as good as

real. The two uses of the term seem to have been concurrent. Perhaps this is an almost necessary effect of the highly metaphorical world of a Christian church that can conjure the (virtual) body of Christ anyplace "where two or three are gathered together in [Jesus'] name" (Matthew 18:20), or that at one time invested authority for an entire religion in an elite council or "virtual church."

A more secular understanding of virtue begins by assigning it to more physical powers, so that virtue is equated with health, strength and sexual purity. These are, of course, still closely tied to notions of morality. Between this physical virtue and the virtuality of appearances there may in fact be some sort of discontinuity. We can draw on what we know of the history of Protestantism to suggest at least one possible bridge between the two. Think of "visible saints," caught between an unknown but predestined fate and the demands of a culture that demanded "proofs" of salvation.[8] You can perhaps see how a good (apparently moral) appearance can come to be as good as a good heart. Following Max Weber, you can see how the preoccupation with the former came to largely replace concern for the latter.

The optical definition of the virtual undoubtedly shares some elements of the miraculous, but refers specifically to the realm of appearances. Optical technologies deceive us in potentially useful ways, by bringing that which can't be seen into view—via reflection, refraction, magnification, remote viewing or simulation. We need only turn on the television to see how powerful these technologies can be. It is no wonder that the promise of immersive virtual reality has caused so much controversy. And perhaps it should be no surprise that this extreme form of optical virtuality has given rise to a fresh outburst of moral concern, such as the media's titillated fascination with "cybersex" and "teledildonics." Behind the rather tiresome, but by no means novel, interest in "dirty tech" there is a more intense and interesting concern about the blurring of the boundaries between fact and fantasy. Paul Virilio has suggested that technologies of the virtual are destined to not only simulate the real, as Jean Baudrillard has suggested, but to replace it.[9]

*The I in Cyberspace*

Before returning to the question of the virtual community, it may be worth exploring one more use of the virtual that relates to issues of individual identity. The computer—and particularly

the computer as Internet terminal—is an odd sort of vision machine. It involves the user, primarily through vision, in forms of telepresence which may mimic any and all of the senses. It is likely that those who become most immersed in Internet culture develop a sort of synesthesia which allows them to exercise all of the senses through their eyes and fingers. Perhaps this is something like the extension and amputation of the central nervous system that Marshall McLuhan suggested was the effect of the computer, but many computer users seem to experience the movement "into" cyberspace as an unshackling from real life constraints—transcendence rather than prosthesis. At the limit, the (emancipatory) discourse of cyberspace suggests the possibility of stepping beyond and remaining one's self in some lasting way through virtual identity-play.

I suspect that there is some truth to the suggestion that the experience of dislocation in time and space—an effect of immersion in Internet culture—can help individuals to see their own identities in a different perspective. But the more extravagant claims seem to rely on some aura of the miraculous that still clings to technologies of the virtual. I am reminded of the privileged place of the mirror in Jacques Lacan's psychoanalysis. In his seminar of 1953–54, Lacan used an elaborate diagram to explain the dynamics of ego formation. Through a combination of curved and plane mirrors, an imagined subject is made to see two distinct objects, a vase and a bouquet, as if the vase contained the bouquet. This trick done with mirrors, Lacan says, is the necessary mechanism of misrecognition by which human subjects are able to imagine that they possess a coherent (phallic) identity. In Lacan's diagram, the virtual space 'behind' the plane mirror is where the subject imagines (through misrecognition) that its self exists as a unity (rather than some disorganized collection of identifications.) This virtual space also contains the reflection of the subject's eye—the place of the virtual subject—which might, Lacan seems to suggest, look back at the jumble and see it as such.[10] This seems to be a space for the analyst, but it also seems to be an impossible space—a fantasy of analysis, which may finally be little more than a kind of joint projection— which would have to be constructed through misrecognition of some sort, just as much as the subject's assumption of the position of whole bouquet-in-vase identity. However, it seems like the virtual is where all the action is, despite its impossible status. The work of analysis takes place between an analysand that imagines that it is—or at least ought to be—whole and an

AN ARCHAEOLOGY OF CYBERSPACES

analyst that has some investment in clearly discerning the analysand's fragmentation. Both are operating in spaces which are finally dark and uninhabitable.

When we return to the question of free identity play on the Internet we may be seeing the invocation of something very much like the Lacanian analytic situation. A great deal of the discussion of the liberatory potential of the Internet relies on the assumption that one could assume something very much like the position of the virtual subject. There is some sort of attempt at self-therapy work going on "behind" the plane of the computer screen. But we are as torn as Lacan seems to be between the dynamics of the mirror and those of the screen, dynamics which seem to be quite different. In particular, there seems to be some confusion about whether or not one can occupy the place behind the screen. It is not an impossible space in the same sense, in part because there is no necessity that the virtual image have any particularly "truthful" or even "real" relation to the subject. The persona that appears in cyberspace is potentially more fluid than those we assume in other aspects of our lives, in part because we can consciously shape it. And that consciousness may allow us to engage with ourselves in what appear to be novel ways. However, we should take care to consider the extent to which this heightened self-consciousness is attributable to the novelty of CMC rather than any particular power of the medium. There remains around many of our dreams about Internet culture more than a whiff of pixie dust, incense and brimstone.

No doubt, the debates will continue. And perhaps I too am guilty of closing the door prematurely. What is clear at this stage of the game is that an engagement with virtual community in any adequate, rigorous way will involve us in the painstaking negotiation of a complex field of meanings and associations—one where the possibility of choosing between the real and the as-good-as-real will constitute only one more question among many.

In this terrain, one must remain aware of the effects of speed. The desert communities of my youth were not all deserted, but my passage through them—in the rudimentary cyberspace of an automobile traveling at highway speeds—was far too rapid. My fleeting presence was out of sync with the rhythms of life in those spaces. In writing about Internet culture, I have tried to remain in sync with my experience of life online. It is a difficult work—one more reason to use great care

in constructing a work which must be a representation as-good-as some aspect of that culture.

*(Re)Combinations*

So what is virtual community? Too quickly—or at "net.speed," we might suggest:

1 It is the experience of sharing with unseen others a space of communication. It is other contributors to electronic mailings lists, like Future Culture or Cybermind, that flood my email inbox with hundreds of messages every hour of the day. It is the crowd that gathers in the text-based virtual reality of Postmodern Culture MOO, where I am one of the "wizards," and where virtual hot-tub parties compete with art exhibits and discussion groups for attention and system resources. It is the result of a semi-compulsive practice of checking in occasionally with others who are checking in occasionally in all sorts of online forums. It is the synergistic sum of all the semi-compulsive individuals who have come to think of themselves as something like citizens in someplace we refer to with words like "cyberspace" or "the Net," collaborators in the mass conjuring trick which produces what we might want to call "Internet culture."

2 For me it is the work of a few hours a day, carved up into minutes and carried on from before dawn until long after dark. I venture out onto the Net when I wake in the night, while coffee water boils, or bath water runs, between manuscript sections or student appointments. Or I keep a network connection open in the background while I do other work. Once or twice a day, I log on for longer periods of time, mostly to engage in more demanding realtime communication, but I find that is not enough. My friends and colleagues express similar needs for frequent connection, either in conversation or through the covetous looks they cast at occupied terminals in the office. Virtual community is this work, this immersion, and also the connections it represents. Sometimes it is realtime communication. More often it is asynchronous and mostly solitary, a sort of textual flirtation that only occasionally aims at any direct confronta-

tion of voices or bodies. But then the phone rings at midnight and a strange voice speaks your name, or a letter arrives in the mail, or you find yourself with an airline ticket to spend the week in a distant city, crashing on the couch of someone you have shared text with for a year but have never—that is, never "truly," as your friends will remind you—met.

3 Virtual community is the illusion of a community where there are no real people and no real communication. It is a term used by idealistic technophiles who fail to understand that the authentic cannot be engendered through technological means. Virtual community flies in the face of a "human nature" that is essentially, it seems, depraved.

4 Virtual community has no necessary link to computers or to glossy high technologies. There is a virtual community of mail artists—individuals who subvert the world's postal systems to their own ideological and aesthetic ends. There are old fashioned party lines and pen-pal networks. Perhaps all of these collectivities, however mediated, warrant the term "community."

5 Virtual community is the simulation of community, preferably with a large dose of tradition and very little mess. Colonial Williamsburg, Disneyland and the KOA camp down the road all share some of this flavor. Please pay at the gate.

6 Virtual community is people all over the world gathered around television sets to watch the Super Bowl or a World Cup match.

7 Virtual community is the new middle landscape, the garden in the machine, where democratic values can thrive in a sort of cyber-Jeffersonian renaissance. Driven into a new sort of wilderness, beyond an electronic frontier, we will learn once again to be self-reliant, but also to respect one another. We will reconcile expansion with intimacy, and the values of capitalism with "family values."

We could undoubtedly go on and on. Each of these definitions responds some of the memetic material carried by the notion of virtual community. None of them addresses the entire lineage, across time and cultures. We hardly expect that it could or would. Some of these definitions push the limits of intelligibility, bound up as tightly as they are in the contradictions and confusions which inform notions of community and the virtual.

Perhaps multiple, contradictory definitions look considerably less useful than, for example, Rheingold's fairly elegant, singular attempt. However, the point of all of this memetic dissection is not to better fit the words "virtual community" to some known social reality. Instead, we are at a point in our researches into Internet culture where it is particularly important not to force old conceptions—such as that of the mythical frontier, for example—on the new phenomenon of decentralized networks of multi-tasking, time-sharing machines and human-machine interfaces. We do not know very much about Internet culture, so perhaps the best definitions are multi-bladed, critical Swiss army knives. Precisely because of the richness of its memetic lineage, "virtual community" will serve us remarkably well.

I will conclude this exploration with two brief case studies which will demonstrate the utility of virtual community as a guiding concept for CMC research, and to once again emphasize the openness of the field by comparing an element of Internet culture with a telephone-based system of a rather different sort. These are not representative cases in any ideal sense. Instead they represent extremes which may function as a foil for work, like Rheingold's, that has thus far looked within a fairly narrow range for its examples of virtual community.

*The Voicemail Village*

The remains of my time in the virtual village of Tyler, Wisconsin consist of a stack of twelve paperback romances, three copies of the same recipe, the records of four toll calls and an academic paper that came out of my experience there. That, and a few memories, is all that is left of twelve months spent involved in the lives and loves—particularly the loves—of the people of Tyler, unless we count my increased and increasingly grudging respect for the business savvy of Harlequin Enterprises as an artifact of the period. And yet, for a year, I was involved with the characters that moved through the twelve-book Tyler romance series.

         AN ARCHAEOLOGY OF CYBERSPACES

I came to Tyler at a time when my scholarly focus was still print media. My exit, which was also in some sense an expulsion, coincided, not entirely coincidentally, with my entrance into the world of Internet culture. Harlequin launched the Tyler series in March 1992, in the midst of one of its periodic product facelifts. This time, the new face was decidedly high-tech, with photographic, or nearly photographic cover art and a smooth, polished look that might well have been designed in a wind tunnel. At first glance, Tyler may have appeared to be a departure from this approach, with its homely, bumpy, quilt-motif covers and small town setting. However, Tyler was perhaps as elaborately constructed as any mass market book series to date, and it was not without its own technological innovations. Along with the usual Harlequin promotions, Tyler featured a 1-900 number line (1-900-78-TYLER) which allowed you to listen to the voices of various characters as they told you the daily town gossip, gave you previews of forthcoming novels, or shared recipes. In this elaborate voicemail system, you could navigate from one section of Tyler to another by the usual "if you want X, press Y" commands. You could also leave messages at various points, mostly to order books or have a copy of the recipe of the month mailed to you.

Perhaps it is too much to liken this to a sort of virtual reality, although it involves the negotiation of a fairly explicit landscape using commands similar to those you might use in a MUD on the Internet. But even if we were to acknowledge that 1-900-TYLER connected us to a bizarre, rudimentary voice-based virtual reality, should we think of Tyler as a virtual community? By Rheingold's definition we would have to say no, I think. The requirement of explicit person-to-person communication means that no matter how many individuals shared the experience of the virtual Tyler, they did not constitute a community. No doubt, some outpourings of human feeling were orchestrated by the combination of written and aural texts. If you, the anonymous reader, read the books and called the number then you and I would have something in common. But what does this sort of sharing mean? Can we acknowledge that there is something like virtual community that comes from those cultures of compatible or shared consumption that shape so much of our multi-mediated daily lives? Are we certain that we know the difference between talking to one another and talking to the television?

Tyler raises a number of interesting questions about community. Some of them were clear to me when I first began to

analyze the series. For example, we suspect that there is something like a community of readers who share particular tastes and concerns that will lead them to a series like Tyler, or to romances in general. Sometimes this potential community shows itself as something more solid, in the form of magazines like *Romantic Times* which chronicle its existence, or at conferences for romance readers and writers. I also suspect that there is considerable overlap between those who read and those who write romance novels, and that successful women writers may be more important heroines for their readers than the rather less dynamic leading ladies who populate the novels. The case has been made for romance writing and reading alike as strategies of resistance to patriarchal demands. In this context, the question about the potential community of romance readers is a political one, and the choice to not acknowledge the (no doubt highly mediated) communication that might be taking place is one we make at some risk. In particular, we might be inclined to look for solidarity in a series focused on a literal community, especially since the Tyler series is finally itself an extended prescription for the reunification of urban and rural elements to rekindle supposed core values of American life. We might wonder how well this quasi-populist rhetoric serves the ends of a multinational corporation like the one that owns Harlequin. We should be particularly wary of the role it proposes for itself—a mediator at several levels of a new community now rather fully integrated into an economy that thrives on homework and decentralized production, and that relies on input from consumers to direct ever more accurate marketing back to them.

Tyler is, perhaps, the simulacrum of a community. It is a virtual community both because it is contained in print and voice media and because it is a replacement for the kind of person-to-person interaction that it portrays so appealingly. Its subsequent disappearance—the 1-900 numbers have long since been disconnected—marks it as primarily an artifact of marketing. But before we smugly dismiss Tyler as a mere historical curiosity, let's consider how different the interactions are on the average moderated electronic mailing list, or Usenet news group. To what extent, in other words, does the Internet actually function as an effective many-to-many communication system, and to what extent does the highly segmented and self-selecting nature of so much of the Internet foster many-to-one conversations between enthusiasts and their subject matter? I have argued elsewhere that one of the reasons that flame

AN ARCHAEOLOGY OF CYBERSPACES

wars can be so easily started or prolonged is that in many forums the subject matter, and the user's relation to it, is more important to the user than the relations between partici-pants.[11] Perhaps great portions of the Net are composed of these cultures of compatible, though not always convivial, consumption.

*Follow the Bouncing Donuts*

The rise and fall of the FutureCulture (FC) experiment on MIT's MediaMOO was a rather different sort of affair. The FC's Main Hall is mostly quiet now, but once it was the site of some of the most interesting and fruitful online interactions that I have experienced. FC is an electronic mailing list with several hundred subscribers from around the world. Its nominal focus is new technology and its effect on global culture, but the actu-al discussions range broadly—from questions about the future of monogamy to discussions of constitutional issues. On FC, the future is now, and much of what goes on appears to be an attempt to learn to live in a world that appears to be constantly new, endlessly shifting. The people on the list drive the discus-sion with their particular interests. There is no clearly defined subject matter to mediate between individuals, and things can become quite personal. For those who doubt the possibility of online intimacy, I can only speak of births and deaths that have shaken the list in a variety of ways—of hours sitting at my key-board with tears streaming down my face, or convulsed with laughter. Communication on electronic mailing lists is asyn-chronous, which has some advantages over a realtime forum like Internet Relay Chat (IRC) for creating connections between individuals. It is rare, for instance, for me to log in without finding some new mail from members of FC, which is always there when I have the time to read it. Realtime forums cannot accommodate nearly as many different community members, since they rely on immediate responses and hence require the coordination of physical presences across increasingly far-flung time zones.

However, the immediacy of realtime communication has a definite appeal, and it is common for groups based in asynchronous forums to experiment with realtime interac-tions. At the time of FC's entrance into MediaMOO, there was also a great deal of interest in IRC as a means of expanding list-members' contact with one another. In fact, the MOO and IRC users engaged in a rather heated feud on the list, and in both realtime environments, for several months. What was at

stake was the shape of the FC community, and more specifically its speed. The IRC crowd was arguing in favor of a sort of relatively transparent presence, and against what they saw as the "clutter" of text-based virtual reality. One of the most interesting conflicts revolved around the use of props in MOO. Why, for example, should one spend time programming an elaborate and realistic coffee pot in cyberspace? Must online community depend on the creation of a comfortable, familiar real life environment? Or should we be looking for alternative settings more conducive to other sorts of interaction, and perhaps other sorts of community?

The debate was never settled and the site is now deserted, but the artifacts of a brief period of playful experimentation still litter the empty rooms. Exits are traversed with commands like "flip" (and "backflip" to return). The FC rec-room features a ping pong table, a pente board, grandstand seating and a number of virtual refreshments—including a box of donuts that can be eaten, replenished with a "bake" command, squashed or thrown. The "throw" command sets off a series of messages that describe the donut ricocheting from wall to wall before finally coming to rest. I helped a much younger friend write the code that made the donuts bounce, and I have seen university professors take great glee in filling the "air" of FCRec with flying donuts. Often, these outbursts would come within minutes of serious discussions of philosophy or music, or debates about the impact of new technologies or laws. The participants varied substantially in age, education and occupation, but a well-coded food fight can be wonderfully leveling.

So where are they now? Were those early interactions in fact too frivolous to sustain interest, or was the environment that was built not sufficiently lifelike, or perhaps too slavish in its adherence to the "real"? These are the questions we would ask if we interpreted the silence and emptiness of the FC/MediaMOO complex as sign of a failure. But if we track down the participants in this short-lived community, we find signs of another sort. For example, the decline of FC/MediaMOO was matched by the birth of BayMOO, a San Francisco-based MOO run almost entirely in its first few months by members of FC, or individuals who were connected through contacts made at MediaMOO. People still talk about FC using words like "home," which is startling. The shell of FC/MediaMOO is perhaps just that, a shell which the FC community broke out of at some moment that none of us can quite recall, and to which it would be difficult to return. It is possible

AN ARCHAEOLOGY OF CYBERSPACES

that FC itself might be constraining at some point in the community's life, and perhaps there will come a time when we will look back fondly at the list from wherever it is that the transformed community now gathers. There were communities before FC which represent part of its lineage. Some of them still survive in the environment the list provides.

*Shapes of Community*

It is too easy to log into an online chat system and imagine that it is just like wandering into a local bar. It is too easy to login and imagine that it is all make-believe. It is altogether too easy to enter a virtual world and imagine that this allows us to understand the "real" one. Any study of virtual community will involve us in the difficult job of picking a path across a shifting terrain, where issues of presence, reality, illusion, morality, power, feeling, trust, love, and much more, set up roadblocks at every turn. The hazards are doubled for any traveler who hopes to report what s/he has seen, since every description takes us into the realm of the virtual, the as-good-as. However, faced with the challenge, we should not be too dismayed. As we can see, the tools that we have selected seem remarkably flexible. One step on the road to increasing our flexibility as CMC researchers is to understand these tools.

We should be prepared to find community under a wide variety of circumstances, in a broad range of environments, and intermingled with any number of elements that seem to work against the development of "sufficient human feeling." With their eyes wide open and using the tools we have inherited—with some respect for the memetic inheritances that they carry—CMC researchers may be able to carry forward the study of community in directions which we had not previously even imagined. We can imagine the next set of hurdles, which will, I suspect, have to be taken both all at once and at a run. Community, virtuality, mediation, commerce: how are these elements articulated within "Internet culture"? Can we tell the difference, for example, between a community and a market segment, or a culture of compatible consumption? What are the relations between the real and the virtual, between being and seeming, between "real life" and "net.life"? Are the structures and marks of class, race, gender and the like more or less deeply inscribed in these virtual spaces? Can these clearly mediated spaces provide a place for contesting "real world" powers? Or are many of these questions badly posed, as they assume a certain authenticity and lack of mediation in our

everyday lives which is perhaps illusory? Is the screen a mirror, or something else? These are only a few of the pressing questions, and they are pressing more urgently every day.

NOTES

1  Richard Dawkins, *The Selfish Gene* (New York: Oxford University Press, 1989).

2  See also Bruce Sterling, *The Hacker Crackdown* (New York: Bantam, 1992); Clifford Stoll, *The Cuckoo's Egg* (New York: Doubleday, 1989); and Stewart Brand, *II Cybernetic Frontiers* (New York: Random House, 1974).

3  Howard Rheingold, *The Virtual Community: Homesteading on the Electronic Frontier* (Reading, MA: Addison-Wesley, 1993), 5.

4  A common usage on the Internet refers to online activites as VR, for "virtual reality," and offline activites as RL, for "real life." There is, however, a strong element of irony that informs much of this attribution of online activity to the realm of the non-real.

5  See Rheingold's chapter on the Electronic Frontier Foundation and similar organizations (Rheingold, 241–275).

6  In what follows, I have relied on the entries for "community" and "virtual" in *The Oxford English Dictionary, Second Edition* (Oxford: Oxford University Press, 1989) for etymological guidance.

7  The WELL, or Whole Earth 'Lectronic Link, is a computer conferencing system based in the San Francisco area, which charges a combination of monthly membership and hourly usage fees. It is the focus of Rheingold's introductory, definitional chapters. However, many inhabitants of communities on the open Internet see communities such as the WELL much as inhabitants of the central parts of a city might look on walled, well-policed suburbs. Rheingold is careful to look at other environments, but it is not clear that "sufficient human feeling" represents an adequate measure for community on Internet Relay Chat or within a Usenet newsgroup, nor is it clear how we would measure it.

8  The standard treatment of this theological problem is Edmund

Sears Morgan, *Visible Saints* (New York: New York University Press, 1963).

9  Louise Wilson, "Cyberwar, God, and Television: Interview with Paul Virilio," *CTHEORY* (electronic edition), Article 20, December 1994. Virilio himself draws the comparison between himself and Baudrillard, claiming that he has surpassed Baudrillard in predicting the replacement of the real by the virtual. However, this sounds very much like Baudrillard's explanation of simulation as "more real than the real."

10  Jacques Lacan, *Freud's Papers on Techniques* (The Seminar of Jacques Lacan, Book I), (New York: Norton, 1991), 139–142.

11  See my "Running Down the Meme: Cyberpunk, alt.cyberpunk, and the Panic of '93" (ftp://ftp.netcom.com /pub/sw/swilbur/Running_Meme.txt), originally presented to the American Culture Association National Conference, 1994.

# COMMUNITY AND IDENTITY IN
# THE ELECTRONIC VILLAGE

Derek Foster

The Internet is clearly the foremost among new information technologies that promise to significantly impact the day to day circumstances of all social relations. The Internet is a real example of a broadband, wide-area computer network that allows each individual user an equal voice, or at the least an equal opportunity to speak. Increasing numbers of people, upon discovering the Internet, are enamored by the technology's ability to publicly legitimate their self-expression and by the freedom it provides from traditional space and time barriers. A central question is whether, as is often claimed, this empowerment and the ability to connect with increasing ease to ever-growing numbers of like-minded people encourage a sense of community.

Obviously, communication and community have a common lineage. "The term communication comes from the Latin *communis* (common) or *communicare* (to establish a

community or a commonness)" (Merill & Lowenstein 1979, 5). But though communication serves as the basis of community, it must not be equated with it. One can communicate with another individual without considering that person to be a member of one's own community. This then, touches upon the real concern of this paper; to what degree can one say that the Internet facilitates "community"?

The Internet, for our purposes, provides a technological infrastructure for computer-mediated communication (CMC) across both time and space. The conceptual space in which this communication occurs is referred to as cyberspace, an environment in which face-to-face communication is impossible. A form of virtual co-presence, however, is established as a result of individuals' electronic interactions not being restricted by traditional boundaries of time and space: this is the basis of what is commonly refered to as "virtual community."

Howard Rheingold defines these virtual communities as "the social aggregations that emerge from the Net when enough people carry on those public discussions long enough, with sufficient human feeling, to form webs of personal relationships in cyberspace" (Rheingold 1993, 5). It is this vision of the Internet which I propose to interrogate in this chapter. Any sense of community found on the Internet must, I contend, necessarily be virtual, but may not be sufficiently communal. Rheingold ascribes social meaning to cyberspatial gatherings, and presents us with a dialectic of the personal flowing unproblematically from the public. But I question the degree to which the traditional idea of community is an fact present in "virtual communities." As more people gravitate to this new means of communication, concomitant changes in the conception of both community and identity will inevitably emerge.

The "virtual" nature of virtual communities should preclude any simple characterization of their existence. Observers of CMC typically associate the term with the containers of the communicative acts themselves. Thus, one frequently hears of a particular form of community that is associated with MUDs (multi-user dungeons) or even Usenet newsgroups. Others have chosen a different approach; Kumiko Aoki divided the study of virtual communities into three separate groupings: 1) those which totally overlap with physical communities; 2) those that overlap with these "real-life" communities to some degree; and 3) ones that are totally separated from physical communities (Aoki 1994). Each of these approaches has its merits. For our purposes, however, virtual communities are not

deemed to be the products of a particular means of structuring communication, nor those explicitly organized in relation to physical space. Rather, these "bodies," these "occupants" of conceptual space should be recognized as the ideal constructs that they are.

Benedict Anderson's *Imagined Communities* is insightful on this point: "All communities larger than primordial villages of face-to-face contact (and perhaps even these) are imagined. Communities are to be distinguished, not by their falsity or genuineness, but by the style in which they are imagined" (Anderson 1983, 6). The context of CMC necessarily emphasizes the act of imagination that is required to summon the image of communion with others who are often faceless, transient, or anonymous. In this regard, asking questions of the social-psychological aspects of CMC are fundamentally useful. Such questions allow us to place Rheingold's earlier "social aggregations" in perspective, and ask to what extent these can be seen as public or private expressions.

The term "community" is broadly used to refer to an ideal type of social relations known as *Gemeinschaft*, the embryo of which is found in the relations of kindred individuals (Toennies 1957, 37). Succinctly stated, the term embodies a set of voluntary, social, and reciprocal relations that are bound together by an immutable "we-feeling." This is typically contrasted with its polar opposite, *Gesellschaft*, or impersonal association. *Gesellshaft* is often cited as the utilitarian sentiment that underpins modern, industrial, urban life. Community assumes a solidarity among all those who comprise it. It is an entity that is seen as "emerging from the mutual commitment, mutual involvement, mutual responsibility, and mutual respect between a society and its individual members" (Walls 1993, 156).

Community, then, is built by a sufficient flow of "we-relevant" information. The "we" or the collective identity that results is structured around others who are seen as similar to the "me." In this sense, community, like any form of communication, is not fully realized without a conception of self. Essentially, this entails that "what goes to make up the organized self is the organization of the attitudes which are common to the group. A person is a personality because he belongs to a community" (Mead 1993, 158). This perspective is reflective of the tradition of Augustinian inwardness which states that "one's deepest identity is the one which binds one to one's fellow humans; there is something common to all men

COMMUNITY AND IDENTITY

and getting in touch with this common element is getting in touch with one's real self" (Rorty 1991, 196).

Obviously then, just as self-definition underlies our relations with others, so too does it structure our communities: the organization of the self is the foundation of the communicative effort. The question then, of how CMC affects the organization of the self is very pertinent. Are virtual communities most appropriately viewed as being structured around personal identity or communal identity? One would like to presume that it is the latter—that in the creation of solidarity, that which we ascribe to *Gemeinschaft*, we are made more sensitive to the situation of the other. This searching for community makes it more difficult to marginalize people who are different from ourselves. On the other hand, CMC can free individuals from the yoke of traditional restraints upon information retrieval; individual pursuits and specific fields of interest can be easily pursued through increasingly narrow fields of vision. In this respect, the self is pursued, but not entirely in blissful ignorance of the other. It is merely that the other has been relegated to a sub-strata of the self. "The striving subject enters into conversation in order to build itself up through the search for truth. Thus the person who converses relates to herself/himself even when s/he seems to be relating to others" (Taylor 1991, 17).

This, then, is a particular danger of CMC. Solipsism, or the extreme preoccupation with and indulgence of one's own inclinations is potentially engendered in the technology. The reification of private space occurs as one's own idiosyncratic world view acts as a protective enclosure against the onslaught of a brave new world of information. This notion of protection still assumes that the other exists. The importance of our relations to others for the assertion of one's own self-identity never wavers, such that "self-consciousness presupposes the re-cognition of self in other" (Taylor 1991, 18). However, as the private becomes more all-encompassing and the image of one's own world view becomes more convincing, one can lose sight of the other altogether.

Even the human/computer interface itself obscures the stage that individuals place themselves upon: "The 'content' of a medium is like the juicy piece of meat carried by the burglar to distract the watchdog of the mind" (McLuhan 1964, 32). In this respect, the connectivity that CMC virtual communities confer upon us blinds the observer to the real character of the technology—all of its users exist as individuals extending their

selves through the computer network, but isolated by the necessary mediation of the cathode ray tube and the keyboard. This should not be taken to mean that virtual communities are havens for antisocial behavior. Nor should one infer that virtual communities attract the alienated person, or encourage a general state of anomie. The latter situation is said to exist under conditions in which "most people no longer feel that they are 'getting anywhere' with reference to what they desire" (Clinard 1964, 5). The very fact that individuals are seeking to communicate their vision of self in public obviates this. The self is not all that exists, but egoistic self-absorption, such as CMC may encourage, embodies a situation in which "the other is not really other, but is actually a moment in my own self-becoming" (Taylor 1991, 17). In such a situation, one might term the computer-mediated subject a conscious one, but one without self-consciousness.

Evidently then, CMC has the potential to reify both personal and communal identity. In this regard, it may even be making the distinction between the two redundant. In a pioneering work in the psychoanalytic theory of communication, it was observed that communication always involves a dialectic between unconscious centrifugal and centripetal tendencies in self-expression(Spitz, 1957). CMC magnifies this ability simultaneously to express both the self and the other, the individual and the community.

Framed from another perspective, this dialectic entails a "continual oscillation between relative openness and closedness—resilient adjustment to intakes of information/entropy" (Klapp 1978, 17). Good forms of openness embody the tenets of liberal solidarity; expressive, well-informed individuals leading to the cross-fertilization of knowledge. Just as there are bad forms of openness—the communicative act undertaken indiscriminately and without direction—so too are there good forms of closure. These entail ability on the part of the "net.denizen" to exert self-control, and to be discriminating and selective in the face of so much information. On the other hand, there is also the possibility of bad closure, the individual who becomes insular, narrow-minded, and isolated.

Baudrillard has a unique outlook on this form of closed mind when he states that "every individual sees himself promoted to the controls of a hypothetical machine, isolated in a position of perfect sovereignty" (Baudrillard 1988, 15). CMC, in fact, offers a form of this ecstacy of communication. The newfound ability to communicate with vast numbers of like-

minded others, regardless of barriers of time and space, obscures the "electronic encephelization" (Baudrillard 1988, 17) of our selves at the expense of the other.

In the foregoing discussion, I have tried to illuminate some of the conflict between the concepts of community and individuality and to dissuade the reader from making any facile assumptions about which of the two necessarily follows from the public presentation of our private selves. If any tentative conclusions are in order, however, they are likely to deal with the artificial sense of "we-feeling" that is typically an outgrowth of CMC under the conditions of non-presence. It is altogether too easy to ignore difference, and to attribute one's image of self to the other instead of defining one's self in reference to the other. When one's image of the communal self is thus distorted, any hopes of true *Gemeinschaft*-style relations are very faint indeed.

It is here, then, that we examine in greater depth the social ramifications of CMC, rather than the individuated psychological effects which have had more emphasis placed on them so far. We take from the psychological the stress on the privatization of the public, and now seek to comment on this as a social phenomenon, rather than a personal one. As Baudrillard said, "the body as a stage, the landscape as a stage, and time as a stage are slowly disappearing. The same holds true for the public space" (Baudrillard 1988, 19).

What happens, then, to the public space when it is confronted with an enormous, ephemeral connecting space? To these ends, it is to Habermas' notion of the public sphere that we now turn:

> By "the public sphere" we mean first of all a realm of our social life in which something approaching public opinion can be formed. Access is guaranteed to all citizens. A portion of the public sphere comes into being in every conversation in which private individuals assemble to form a public body. (Habermas 1989, 136).

Habermas elevates his definition of public opinion to the level of informed discussion and reasoned argument. In doing so, he assumes that members of the public sphere are able to rationally think for themselves, to organize their own relations and to develop independent, critical opinions. The public sphere therefore, is impoverished by the removal of public discourse. The elevation of the private occurs at the expense of the

public and the ability to arrive at public opinion. This curtails the possibility of *Gemeinschaft*-style relations, if we recognize these as flowing out of an open discourse among self-conscious members of a community.

Guaranteed access to all is an important aspect of the public sphere. If we view the public as a communally shared life-form, the ideal of this sharing can only be obtained through communicative action—the ability of individuals to engage in substantive public discourse. The public sphere can then be seen as an ideal speech community, one which is not obtainable if individuals are excluded from involvement in the public discourse. In trying to ascertain the significance of CMC, Garth Graham (1995) has stated that universal access includes the freedom to communicate. The interactivity, of CMC is about human connections. It is about talking. It serves individuals and communities, not mass audiences.

Graham's insight is useful in that his notion of community is more than the simple access to the means to communicate. His vision also includes the assertion of public opinion, the elimination of privileges, and the discussion, and acting upon, of general norms and mores. Graham's vision of electronic community is both egalitarian and decentralized. One must not let the former obscure the latter such that once something approximating universal access is obtained, we have fooled ourselves into thinking that we have obtained public opinion or the *Geist* of *Gemeinschaft*.

This spirit of community is essential to the vitality of virtual communities. That which holds a virtual community intact is the subjective criterion of togetherness, a feeling of connectedness that confers a sense of belonging. Virtual communities require much more than the mere act of connection itself. "It seems that the key to a virtual community is the human interaction that computers, and the computer space allotted to the group, foster" (Lapachet, 1995a). The quality of this interaction must be questioned, especially in light of the preceding arguments about the intrusiveness of the private upon the public that is facilitated by CMC's transformation of social space.

A brief example of a pioneering attempt at a form of virtual community will help to illustrate. Santa Monica's Public Electronic Network (PEN) was an attempt at establishing a community online, but one whose feeling of community was arguably never so acute as to be termed an online community. The objectives of PEN embodied what we hope to find in

virtual communities—a new kind of public meeting ground in which all voices are equal, anyone can speak at any time, and no one can be silenced. Designed to serve the local needs of a geographic community, interactive communications and public information systems were provided through a computer network. In this respect, PEN represented "a community computing network [which] must be integrated into the real world community that it serves" (Cisler, 1993).

PEN certainly provided access to the means to communicate. While only 64 people could use the system at once, there were over 20 public terminals that were located in libraries, community centers, elderly housing and city buildings (Varley 1991, 44). The dream was that a "dialogue between citizens, between citizens and politicians, between citizens and public servants [could] be realized with the use of such networks with less dependence on time and space" (Alexander 1991, 5). Such a system was originally believed by many to be a sufficient step towards a reinvigoration of *Gemeinschaft*: "If only citizens could communicate more, discussion would eventually lead to consensus" (Dutton & Guthrie, quoted in Alexander 1991, 7). However, as should be obvious by now, communication alone does not constitute a community.

In fact, there is little, if any, evidence to indicate that anything approaching consensus was reached through PEN. After two years of operation, only two percent of Santa Monicans were using the system (Alexander 1991, 10). This led some to claim that it is "nothing more than a high-tech toy kept alive by a few computer enthusiasts with nothing better to do" (Varley 1991, 44). PEN was also plagued by the lack of involvement of elected officials. These comprised a fundamental part of the other for whom PEN was intended. Indeed, "PEN itself was subject to the competing objectives of a variety of players including interest groups, councillors, citizens, and city hall staff. Each of the players pursued different objectives" (Alexander 1991, 10).

In this sense, the dialogue that was meant to occur between the different players typically reverted to a monologue. Here then, we can see how the public plurality of private spaces that CMC facilitates is evident even in a grounded communal cyberspace. The different games which each group of players brought to PEN encouraged the construction of "multiple cyberspaces," even within the city-space of Santa Monica. Viewed through the lens of a "social presence" model of CMC (Short et al. 1976, 65), we can see this plurality of

spaces existing wherever CMC occurs, not merely at the ethere-al level of the global village:

> These cyberspaces will not all be the same, and they will not all be open to the general public. [Any] network is a connected platform for the collection of diverse communities, but only a loose heterogeneous community itself (Progress & Freedom Foundation, 1994).

*Gemeinschaft*, or community, obviously makes any network more attractive than one which merely provides access to unlimited information. This aspect of a network implies that conversation with others can shape both the culture and the sociology of the conceptual space that its electronic interlocutors inhabit. As PEN demonstrates, however, "virtual communities are not electronic villages...often many virtual communities can help make up an electronic village, but virtual communities are more communication and people oriented, while electronic villages are hardware and connection oriented" (Lapachet, 1995b).

Peculiar forms of community exist even in these electronic villages. Observing these, one must ask whether the problem lies in technology or the uses to which individuals put that technology. Technology could be considered the root of the problem if one considers virtual communities a postmodern form of the spectacle—driving people indoors and making them think that virtual communities are real communities. This belief, however, obscures that fact that all reality is essentially a matter of perception. This includes the degree to which we associate aspects of our daily life with a sense of community. But it is also not entirely appropriate to vilify the individual. After all, virtual communities offer a means by which individuals can seek a new form of community, rather than shun a currently useful one. This tack is taken by Baudrillard, who "sees electronic communication as part of the whole web of hyper-realistic illusion we've turned to, in our technologically stimulated flight from the breakdown of human communities" (Rheingold 1993, 225).

Virtual communities fit into the hyper-real if one concedes that they offer the semblance of community but lack its fundamental characteristics. Indeed, voices bemoaning of the loss of traditional forms of community are frequently heard in the discourse of virtual communities. A most popular lament is that "there is no place left where people can discuss the realities

which concern them, because they can never lastingly free themselves from the crushing presence of media discourse and the various forces organized to relay it" (Debord in Rheingold 1993, 298). Much of this rhetoric hearkens back to *The Great Good Place* by Ray Oldenburg, a work concerned with the loss of place and the fragmentation of the social fabric in modern American life. "The structure of shared experience beyond that offered by family, jobs, and passive consumerism is small and dwindling," Oldenburg writes. "The essential group experience is being replaced by the exaggerated self-consciousness of individuals"(Rheingold 1991, 25).

Those who trumpet the transformative power of virtual communities see them as loci for a reinvigorated informal public life. But if one places any merit in the social-psychological interrogation of virtual communities that we have conducted, one will not come such a conclusion quite so blissfully. The factors that make CMC so attractive, its ability to play with identity, anonymity, and the distanciation of time and space, are those that preclude the necessary ascendancy of *Gemeinschaft* over *Gesellschaft* in these conceptual spaces. CMC mediates our interactions in such a way that our social cyberspatial selves are far more likely an extension of our conscious selves than a representation of self-conscious being. To be properly self-conscious one must take account of the other, and there is no reason to believe that this is any easier in an environment of ostensibly "many-to-many" communication than it was under previous conditions. People "do want to be able to explore the social space of their surroundings on their own" (Debord 1977, 24), but this is too easily conducted under conditions of egoistic introspection. In such a case, any informal conviviality that is present will do nothing to further the vision of community. In fact, the mediated, necessarily non-presence nature of CMC may further the solipsistic state of consciousness that Oldenburg was lamenting.

Such a perspective treats the idea that when individuals go to new places they learn new things about themselves with some skepticism. Garth Graham (1995) claims that this is what occurs in the strange spaces of cyberspace—one opts in and out of many communities, with many different norms and values. Occupying each of these requires that the individual make personal adjustments. Instead of simply assuming that beneficent acculturation occurs, one might rather see the individual gravitating towards spaces that do not seem so strange, and engaging in a process of self-legitimation. In

order to reduce cognitive dissonance, individuals engage in selective exposure as they embark upon their potential learning experience.

Selective exposure is probably the most common heuristic device, or mental shortcut, that individuals use to simplify their information processing. It is typically used to create an environment of supporting information as individuals pursue an orientation that is consistent with their currently held world view. There is no reason to believe that people would act any differently than usual when confronting information in cyber-space. In fact, the nature of this information, often appearing as it does devoid of context, may make the process of creating cognitive balance easier. To create this balance, one typically either ignores information that is contradictory to what is already known, or somehow adapts the incoming information to that body of knowledge.

Somewhat surprisingly, after his earlier characterization of online communities, Graham (1995) makes reference to this characteristic of CMC: "Choices, perhaps unconsciously, are made about the shape of the group. In other words, even how it feels, its physicality, is, to a certain degree, self-selected". The diagram presented below is partially grounded in this belief; it is an adaptation of the model which Graham presents of how a CMC structured community might appear:

PROCESS AXIS
(sustaining inclusiveness via attention to emotional needs)

| self-conscious action (community affiliation) | questions the validity of continuing community affiliation |
|---|---|
| **CONTEXT AXIS** local issues | global issues |
| self-centered action | questions community |

(sustaining inclusiveness by actions related to tasks)

For our purposes, we can take the process axis to deal with social dynamics, or the extent to which either *Gemeinschaft* or *Gesellschaft* are realized. The context axis deals with the struc-

COMMUNITY AND IDENTITY

turing of interest. We can take this to summarize the dialectic between self and other, or private and public. The center point of equilibrium is the utopian goal, the point at which the individual is fully realized within the community. Graham (1995) notes that at a basic level, such a model describes any informal discussion. But its location within cyberspace reveals that "computer mediated conversations are self-referential...[CMC exposes] the dynamic nature of the structure of a self-organizing community."

As any attempt at mapping must admit to being, the above model can only be as accurate as our understanding of the conceptual space with which we engage. Obviously, the descriptions of the four sectors are not fixed, as any intersection of two different points will conjure up a different impression of the nature of community that is involved. Therefore, we should not be content with a rudimentary representation of social aggregations; we should coordinate this with a representation of how we aggregate these social units. "Society not only continues to exist by transmission, by communication, but it may fairly be said to exist in transmission, in communication" (Dewey 1916, 5). We can say that the same holds true for community. In this perspective then, the culture of virtual communities is formally ascertained by relating the communicative act to the broader environment in which it occurs.

Relating community to the symbolic act of communicating is useful in that the contingency of community is linked to the contingency of identity, and identity, as has already been demonstrated, is dependent upon the means by which we communicate it. Habermas assists us in that his treatment of effective communication is divided into four domains also:

EXTERNAL WORLD OF NATURE
|
truth
|
LANGUAGE—comprehensibility—SPEECH ACT—
truthfulness—SPEAKER
|
legitimacy
|
SOCIAL NORMS
(Wuthrow et al. 1984, 208)

We must, with CMC, take with doubled seriousness the

internal world of the person communicating, the realm of subjectivity. This is especially true when one acknowledges the illusory status of self-conscious actors who exercise their "information sovereignty." In such a situation, the inner thoughts, feelings, and perceptions of culture-producing actors is very important. Yet one cannot simply reduce virtual communities to a dialectic between subjectively and objectively observed socio-cultural reality. Unlike "real" physical communities, the "truthfulness" of virtual communities is problematic; the "virtual" in the term entails that one must internalize the definition of community; it cannot be externalized into a specific, objective product.

So upon what, then, is the contingency of virtual communities most properly structured? While language and social norms certainly contribute towards a conception of the term, neither fully encapsulates it. Without fail, the realm of external nature is vitiated of any practical usefulness, and yet to ground the term "virtual community" entirely within the realm of the subjective actor is also ill-advised; this leaves one open to unfailing critiques of the absolute relativity of truth. Perhaps then, the fullest understanding of the term is gained by grounding it in the communicative act itself. If, as we have repeatedly seen, the nature of computer-mediated communication is such that it affects the social relationships of its participants, perhaps one might actually say that the "medium is the message."

This paper has attempted to map some largely uncharted territory. The unique infrastructure of CMC and the new forms of social relations it has brought about raise pressing issues of communication and community that need to be critically interrogated. This should be done, however, in a manner that leaves room for negotiation with the technology, and which does not outwardly ascribe the highest form of consciousness to either of the blissful states of communal connectivity or isolated individualism. Rather, virtual communities should be seen as being co-determined by the simultaneous forces of *Gemeinschaft* and *Gesellschaft*. It is this aspect which makes them crucial sites for the redefinition of both the public and the private self and other, and for further investigation of the ever-expanding possibilities of human interaction.

Alexander, Cynthia. "Circuits, Wizardry, and Wisdom: Democratic Processes and the New Information Technologies." Paper presented at the 1991 Annual Meeting of the Canadian Communication Association. 1991.

Anderson, Benedict. *Imagined Communities.* London: Verso, 1983.

Aoki, Kumiko. *Virtual Communities in Japan.* (ftp://ftp.sunsite.udc.edu/academic/comms/papers). November, 1994.

Baudrillard, Jean. *The Ecstasy of Communication.* New York: Autonomedia, 1988.

Cisler, Steve. *Community Computer Networks.* ftp.apple.com. 1993.

Clinard, Marshall B, ed. *Anomie and Deviant Behavior.* New York: Free Press, 1964.

Debord, Guy. *Society of the Spectacle.* Detroit: Black and Red, 1977.

Dewey, John. *Democracy and Education.* New York: Macmillan, 1916.

Freedman, Norbert, and Stanley, Grand, eds. *Communicative Structures and Psychic Structures.* New York: Plenum Press, 1977.

Graham, Paul. *Freenets and the Politics of Community in Electronic Networks.* (http://www.usask.ca/library/gic/v1n1/graham/graham.html/abstract). February, 1995.

Habermas Jurgen. "The Public Sphere: An Encyclopedia Article," in Stephen Brunner and Douglas Kellner, eds. *Critical Theory and Society.* New York: Routledge, 1989.

Klapp, Orin. *Opening and Closing.* Cambridge: Cambridge University Press, 1978.

Lapachet, Jaye. *Virtual Communities in Education.* (http://bliss.berkeley.edu/impact/students/papers.html). February, 1995.

——*Virtual Communities: The 90's Mind-Altering Drug or Facilitator of Human Interaction.* (http://bliss.berkeley.edu/impact/students/jaye). February, 1995b.

McLuhan, Marshall. *Understanding Media*. New York: Penguin, 1964.

Mead, George Herbert. "The Emergent Self," in James Farganis, ed. *Readings in Social Theory*. New York: McGraw-Hill, 1993.

Merill, John C., and Ralph L. Lowenstein. *Media, Messages, and Men*. New York: Longman, 1979.

The Progress and Freedom Foundation. *Cyberspace and the American Dream*. Available via email from pff@aol.com. January, 1995.

Rheingold, Howard. *The Virtual Community*. Reading, Mass: Addison-Wesley, 1993.

Rorty, Richard. *Essays on Heidegger and Others*. Cambridge: University Press, 1991.

Short, J. et al. *The Social Psychology of Telecommunications*. New York: Wiley, 1976.

Spitz, Rene. *No and Yes*. New York: International University Press, 1957.

Taylor, Mark. "Paralectics," in Robert Scharlemann, ed. *On the Other*. Maryland: University Press of America, 1991.

Toennies, Ferdinand. *Community and Society*. New York: Michigan University Press, 1957.

Varley, Pamela. "Electronic Democracy," in *Technology Review*. November/ December, 1991.

Walls, John. "Global Networking for Local Development," in Linda Harasim, ed. *Global Networks*. Cambridge, Mass: The MIT Press, 1993.

Wuthrow, Robert, et al. *Cultural Analysis*. London: Routledge & Kegan Paul, 1984.

# USENET COMMUNITIES AND THE
# CULTURAL POLITICS OF INFORMATION

Michele Tepper

Imagine yourself reading the Usenet newsgroup alt.folklore.urban (known as AFU to its regular readers). There is a discussion, cross-posted also to all the groups in the rec.arts.startrek hierarchy, about the technical errors in the various *Star Trek* shows. A contributor (or "poster") to AFU who goes by the pseudonym "snopes" follows up this thread by pointing out a blooper that he has noticed: when a shuttle leaves the *Enterprise*, the special-effects designers show it casting a shadow on the larger ship's hull. "Hello?" he asks disdainfully, "Are there any technical advisors working on this show? Do they really think that objects cast shadows in a vacuum? I know zip about physics, but even I could spot that one."[1]

How do you respond to his mistake? If you hit "n" to move on, or send polite email pointing out that light, and therefore shadows, can exist in a vacuum, then you have successfully avoided the trap that snopes has laid for you. If, on the other

hand, you post a follow-up with an irate correction, or personal insults on the lines of "Dude. . . you are a ridiculously abusive moron," you have been "trolled."[2]

In July of 1994, you would not have been alone. Over one hundred people responded to snopes's post within the first three days, and the thread continued to attract new trollees for several weeks as snopes and others who got the joke continued to elaborate on the original post. At one point, the message was being circulated with an attached summary reading, "This is a joke posting, filled with intentional mistakes. Only follow up if you don't get the joke"; even these posts were followed up by trollees.[3] The incident has become notorious in AFU history, and there are still jokes in the group about the propagation of photons in vacuums, or even vacuum cleaners.

What is that makes trolling attractive to its practitioners and apparently irresistible to many of its targets? The answer, I suggest, is twofold. Trolling is accepted and reinforced within the alt.folklore.urban subculture because it serves the dual purpose of enforcing community standards and of increasing community cohesion by providing a game that all those who know the rules can play against those who do not. It works both as a game and as a method of subcultural boundary demarcation because the playing pieces in this game are not plastic markers or toy money but pieces of information. Trolling may be able to trace its lineage back through the deadpan humor of Andy Kaufman, Mark Twain, and even Jonathan Swift, but it is this dual role—along with the centrality in the game of informational and cultural capital—that makes its Usenet incarnation a revealing case study for Internet community formation.

Trolling, of course, is named after the fishing technique in which one lets a boat drift while dangling a line with a baited hook attached and waits to see what bites. In trolling's Usenet incarnation, the hook is baited with misinformation of a specific kind: if it is at first glance incorrect, and at second or third glance comically incorrect, in a deliberately comic way, it's probably a good troll. Only those who take the bait will post a follow-up response; those in the know will perhaps read it over a second time, chuckle to themselves, and go on.[4] Posting a message, in other words, to a classical music newsgroup claiming that the true lyrical beauty of the tuba has not yet been fully appreciated might be comic but would not be a troll; claiming that Seiji Ozawa is best known as the greatest tuba player of his generation would be. Similarly, posting "Rangers suck!" to

rec.sport.hockey would be "flamebait," an attempt to move people to an angry response. Posting that the ice was of unacceptably poor quality for the hockey games played at the 1992 Summer Olympics would be a troll. Trolling requires a certain amount of verbal dexterity—"Trolls, like puns, are most despised by those unable to make them"—and like puns are also most successful if delivered deadpan: "Al Capone, who played the heavy in many Abbott and Costello movies, died decades ago, so I doubt he's on *The Untouchables*."[5]

The hoped for response to a troll is an indignant correction. It is through such a correction that the complicated play of cultural capital that constitutes trolling begins. The corrector, being outside of the community in which trolling is practiced, believes that he is proving his superiority to the troller by catching the troller's error, but he is in fact proving his inferior command of the codes of the local subculture in which trolling is practiced. This ignorance is highlighted within AFU by the group custom of noting in the message header that the post is a troll; acceptable notations include "troll," "llort," and, as an AFU in-joke, any variation on the phrase "Phil Gustafson scooped up from lake, scuba gear and all, dropped on forest fire." This rule is meant to "prevent inexperienced braggarts from posting something obtuse, then following up the ripostes with the claim that 'it was all a troll,' but it also exacerbates trolling's reputation as an "anti-newbie sport" because it enhances the comic effect (for those within the newsgroup community) of the trollee's misrecognition of himself as more knowledgeable than the troller.[6] Although, as noted above, a good troll will be comic in its own right, its humor is not complete without someone following up to "set the record straight." A frequent refrain among these trollees, or "catches" as they are often known, is "Maybe I'm missing something here." They are indeed, and the fishing-derived terminology that surrounds trolling only serves to further obfuscate matters for those who do not know the local ways. It is often considered particularly astonishing when catches, in order to correct the original troller's error, follow up to posts saying "nice troll," but it should not be; to someone who does not know the slang, a post praising the troller's technique with a rod and reel would be only meaningless gibberish.

Once this initial response is received, other posters from within the subculture can add another layer of confusion to the discussion by correcting the corrector:

>You remember incorrectly. Jamie Lee Curtis was

USENET COMMUNITIES

>NOT in Star Wars.

That was Carrie Fisher. Ridiculous. Carrie Fisher
is much too small and slight to carry that heavy
hairy suit around all day on the set.[7]

This may lead to a further correction and another troll, or
it can lead to another insider following up and adding yet
another layer of complexity in a game of one-upmanship that
continues until the regulars tire of it or someone "bites the
hook." Conversely, the game can be ended by a successful
troller's proclamation to the catch that "YHBT. YHL. HAND," a
cryptic announcement of triumph (the acronyms expand to
read "You Have Been Trolled. You Have Lost. Have A Nice
Day.") that in its very unintelligibility mocks the catch's out-
sider status. In AFU, in fact, the acronymic troll announcement
has been called a "WAFU, YN" acronym: literally, "We're
alt.folklore.urban, you're not."[8]

That AFU, a group dedicated to debunking misinforma-
tion, should be a hotbed of trolling would seem at first only to
complicate the matter, but in fact trolling is a creative response
to issues of group management in the "cooperative anarchy"
that constitutes the AFU community, and one particularly well
suited to the community's participants as well.[9] The group is
primarily dedicated to the discussion, tracking, and debunking
of myth, supposition, and the contemporary folktales that Jan
Harold Brunvand has popularized under the label of "urban
legends."[10] The discussion on AFU covers a vast range of pop-
ular culture; as the introduction to the Frequently Asked
Questions list, or FAQ, puts it:

The group has broadened its god-given mandate
from a place for discussing urban legends (ULs)
to a place for confirming or disproving beliefs and
facts of all kinds.... In other words, it's a great
place to get a reality check on anything that "a
friend" told you, or to compare notes about odd
things.[11]

Given such a mandate, AFU has to maintain a certain openness
to new posters, since new stories and new versions of old sto-
ries are always needed. J.C. Herz's mass-market guide to surfing
the Internet goes so far as to claim that "this group is one of the
few places on the Net where newbies are warmly welcomed."[12]
Herz's assertion, however, needs some qualification: AFU wel-

comes newcomers, but only those newcomers who are willing to play by the rules of AFU's native subculture. As a group, it is decidedly unfriendly to those who are not willing to put the time in to learning its ways.

> Actually, tell you what scares the shit out of me on the net. AFU (alt.folklore.urban). Now there's a newsgroup to dread. Posting as a newbie there should be one of those (often fatal) moves grouped under the same heading as accidentally shooting yourself through the private parts, [or] putting your arm in a Moulinex device and turning it on (just more painful).[13]

Ray Depew, an "Old Hat"—that is, a member of an invitation-only mailing list for long-time regulars on AFU—summed up the tensions inherent in welcoming new people in to the group in a 1993 post: "We love newbies here. The thing is, we like some of the newbies as friends, and we like others with ketchup."[14]

Trolling as a method of enforcing subcultural standards works with this tension, making it clear who among the newcomers are unduly credulous for a group intellectually predicated on skepticism and anxious to prove the extent of their cultural capital. It is worth remembering in this context the other resonance of the word "troll": it is not only a fishing technique but also the name of a legendary figure who guards a bridge and only allows those who can answer its questions correctly to pass.

The gate being guarded in AFU trolling is the entrance to membership in the AFU subculture. Any newbie who bites on trolls frequently enough to win the "Trout of the Month" award handed out by AFU's Game Warden, a poster known as Articulate Mandible, is not likely ever to reach the insider status of being named an Old Hat. For this reason, trolls in AFU are supposed to be posted only to AFU and not crossposted to other groups. The FAQ explicitly states the "if you must troll, bear in mind that trolling outside of AFU is pretty weak";[15] cross-posting trolls to other groups may gain one personal notoriety, but crossposting works to define the AFU community far less efficiently and comprehensively in terms of the external rather than the internal other. As such, it is a discouraged and controversial practice: even when the AFU Game Warden attempted to defend the crossposting of trolls by expert trollers, his post referred to the readers of other newsgroups as "the filthy masses" and "foreigners."[16]

The cultural anxieties implicit in labelling the denizens of other groups, however ironically, as "foreigners," should serve as a reminder that all national and community identities are relational. They are identities whose meaning depends on their place in a system of differences. However, as Andrew Parker et al. make clear, "the very fact that such identities depend constitutively on difference means that nations are forever haunted by their various definitional others."[17] AFU's self-definition in contrast to the "filthy masses" of the rest of Usenet means that its identity needs to be maintained in the face of those masses and of the fear that the group will be overwhelmed by them. These fears are part of the reason why the group frowns on the crossposting of trolls. A spectacularly successful crossposted troll like the "shadows in a vacuum" example with which I began can precipitate an invasion of the external other as indignant replies roll in, overwhelming the volume of posts by the regular readers. In alt.religion.kibology, a humor group in which trolls are always crossposted, the ideal response seems to be a befuddled aggressiveness that can be used to mock the entirety of the crossposted-to group over the course of several days. The ever-fluctuating readership of alt.religion.kibology has far less invested in the creation of long-term community than the more stable Old Hat core readership of AFU does, and so does not need to regulate the practice of trolling to protect its own group culture in the same way.

Usenet is not a particularly propitious space in which to form any long-term community in the first place, and this may be part of the reason why research on virtual communities has instead focused on sites for realtime interaction such as MUDs/MOOs and IRC channels.[18] However, any user of LISTSERV mailing lists, bulletin boards, and Usenet newsgroups can tell you that virtual communities arise in these non-realtime arenas as well. Although a discussion composed of discrete postings lacks the immediacy that many find so alluring about realtime sites, it has an advantage over these latter in that the membership of the community is not constrained by the logistics of who can log on when. Time lags in the conversation allow for the formation of email back channels between group regulars that help promote conversational intimacy among the regulars.[19]

Established online communities of this kind, however, such as the parenting conference on the WELL that Rheingold celebrates in *The Virtual Community*, share one major difference from Usenet: they have "hosts," or moderators, who are

responsible for keeping the group running smoothly and for ejecting any seriously disruptive posters from the discussion.[20] Usenet, on the other hand, is a distributed international conferencing system that lacks any centralized government except that which the system operators and users agree to accept. The vast majority of Usenet groups in which discussion occurs have no immediate control mechanism: they are "unmoderated," which means that anyone with access to Usenet can both read and post messages to them. System administrators can revoke their users' access entirely if they violate site regulations, but given the extremity of such a measure and the generally libertarian politics of computing culture, access is seldom revoked except as a last resort. Even then, given the tremendous proliferation of commercial Internet access providers over the last few years, there is no guarantee that the offending poster will not return in a different guise from another account.[21] Furthermore, while only an estimated quarter of those with email accounts have any access to MUDs and IRC, anyone who has a valid email address and knows how to use a mail-to-news gateway can post to Usenet, thus making Usenet's readership a far less self-selecting and potentially more diverse group than users of realtime sites.[22]

In spite of or rather because of these difficulties in finding an implicit common ground, communities with explicit standards of behavior and self-definitions continue to form on Usenet. Different newsgroups attract different sorts of readers, or at least different styles of posting, and subcultures are formed within the large and heterogeneous Usenet culture. These subcultures require maintenance: posters must recognize and adhere to the group's standards, and new readers must be trained in the group's ways. Furthermore, if no one can be prevented from reading or writing to the group, there must be some way of distinguishing between those posters to the group who are actually "in" the group and those who are still "outside" it, and all this must be accomplished through asynchronous textual production, with none of the verbal or visual cues that are so crucial to traditional notions of subcultural formation.

One of the ways in which group membership is signaled in such a medium is through participation in the stories the group tells about itself. For instance, the regular readers of rec.pets.dogs.misc maintain the fiction that their dogs gather in Champaign, Illinois, from all over the world on every major holiday. Another way group membership is signaled is through textual tics that take the place of fashion as a membership-sig-

naler in traditional subcultures. In AFU, due to typos in previous postings, "newsgroup" is written "newsfroup," "veracity" is spelled "voracity," and "co-worker" has become "cow orker." Telling an AFU poster that she has misspelled "veracity" is not unlike telling a hippie to cut his hair: you have proven that you do not "get it." The results can be a cause for chagrin on the corrector's part:

> I fell for such a troll myself—once—by attempting to correct the curiously persistent misspelling of "veracity" (as "voracity") in the alt.folklore.urban newsgroup. Curiously persistent my foot—it turned out that the regulars in this group always spell it "voracity," hoping to hook a clueless newbie like me.[23]

As should be clear from the preceding pages, what Evan Morris here interprets as a troll was not intended as a troll by the AFU regulars he corrected. The "curiously persistent misspelling" refers back to an incident that is part of the group's collective memory and does not constitute an active attempt to exclude others, but to mark one's own inclusion. Newbies who correct such "errors" are referred to as having "jumped in the boat"— they have exposed themselves as outsiders without anyone needing to put any effort in to excluding them.

The roots of trolling lie with newbies who jumped in the boat because they did not understand group markers or group culture. New posters who wish to become part of the AFU culture are always advised to read the FAQ (frequently asked questions) file, which along with some guidelines about group culture contains a long list of legends and information about their truth or falsehood. There are always those who do not do so and post questions about things that the group has hashed out interminably in the past. Since the group has a stable core membership who can remember discussing a topic the previous year, not to mention the previous month, a certain level of "boredom, silliness, and a feeling of superiority" can be occasioned by the five-hundredth post insisting that "posh" began as an acronym for "port out, starboard home." Originally, according to one member of the group, trolling "was a meta-comment—'Gee, if you think that question is stupid here is a more stupid one!'—not calling for an answer. Then people began answering it, and the whole thing escalated."[24] The moment of trolling, in other words, acts as an announcement and a definition of community. As Homi

Bhabha has pointed out, a community's ways of proclaiming who they are performatively creates their identity.[25] The question then becomes one of what sort of community is constituted, and why trolling has flourished within AFU while it is unknown in some groups and disdained in others.

To begin with the most obvious point, it is easy to see what the appeal of humor as part of an initiation and exclusion process might be in a group in which the "oldest of the Old Hats," Peter van der Linden, is the author of two books on practical jokes as well as one on computer programming.[26] The group's sense of humor is one of the first things regulars cite when discussing what they find appealing about AFU: "the discussion level is of high quality, and the humor usually leaves rec.humor.funny gasping."[27] However, trolls are not just any type of joke; they are very specifically jokes made about, and with, information. The humor is predicated on the error: the joke in the "shadows in a vacuum" troll is not funny if you do not have enough basic knowledge of science to recognize that light travels—and can be blocked—in the vacuum of outer space.

Such information is, finally, at the heart of the AFU community. No matter why people choose to stay in the group, they are drawn there at first by the folklore and trivia that are the group's mainstay. If, as Benedict Anderson claims, "communities are to be distinguished, not by their falsity/genuineness, but by the style in which they are imagined," then we can distinguish the AFU community as one that imagines itself as predicated on the production and transmission of information.[28] Furthermore, if trolling is read as being akin to Bhabha's performative strain of national identity formation, then the detailed research that is posted to debunk or verify various urban legends would be the pedagogical, the related but not necessarily complementary strain that "founds its narrative authority in a tradition of the people."[29] That is, it not only teaches about the specific legends, but about the way things are supposed to be done within the AFU community. The ability to locate, evaluate, and report on information is a necessary skill for membership in the AFU community on the pedagogical level. A critical perspective is also necessary, and AFU is full of intelligent grassroots cultural criticism that takes on the questions of why particular legends have staying power and what the morality plays that frequently underlie urban legends suggest about our society.[30] Trolling takes this mastery to a meta-level, demonstrating one's ability to play with information, to

feel so confident of one's mastery of a body of information and of the intellectual skills necessary for managing it that one can pretend not to have mastery while still managing to signal that one's show of ignorance is a joke.

In this light, it should not be surprising that the two most notorious trollers in AFU, Ted Frank and snopes, are also two of the most consistent posters of serious research. It should also not be surprising that they are, respectively, a lawyer and a historian, professions in which one's ability to manage information is crucial to one's possibilities for advancement. Ethologists and psychologists have long known that childhood play is a preparation for the rigors of adulthood, where skills that will be necessary in later life can be practiced in a safer environment. Similarly, many forms of adult play serve not only to increase group cohesion among the players but to sharpen their skills and strengths. Trolling, in this light, can be read as a game in which the skills necessary for success in the professional-managerial class are practiced and honed.

If trolling is read as being a game played by a community of information managers to patrol the boundaries of their group, it becomes less surprising that it is indigenous to Usenet. As Andrew Ross notes:

> The history of the development of information-processing systems is intimate with the rise of the professional-managerial class in this century. Among other things, both information technology and the professional-managerial class are institutional formations for stabilizing and controlling the predictive and planning functions of Gramsci's broad category of "intellectuals"— all those who use words, statistics, or knowledge skills to organize and shape human activity.[31]

The skills and access that are necessary to use the resources available on Usenet and the Internet have, for the most part, only been available through the educational system, which selects and reproduces the bourgeois version of the Gramscian intellectual: the professional and the manager. This access has then allowed members and would-be members of the professional-managerial class to meet and form communities that are at least partially detached from geographic boundaries: new imagined communities in the suburbia of cyberspace for the hyped Information Age.

Commercial access providers and public-access Freenets

are diminishing the proportion of users that come out of the primarily white and male hacker subculture whose assumptions underlie Usenet's technological structure and social discourses. Commercial access providers pose socio-economic barriers as well: it is still expensive to purchase a computer and a modem, not to mention the monthly fees for service. These barriers shape online communities in ways that their participants may not even recognize. Neil deMause tells the story of his own experience with New York's ECHO bulletin-board service:

> It took me a while to get hooked, but soon enough it had me—instant camaraderie with a bunch of total strangers isn't something to be taken lightly these days. But the seeming openness of our virtual community masked the fact that the edges were well-defined: it wasn't so much a matter of who was there, but who wasn't. What finally drove it home for me was when a bunch of people started a group rant about how New York City cabbies don't speak English well enough, and I abruptly realized that the chances of a multilingual cabbie showing up to give them their comeuppance was damn near zero.[32]

Trolling also assumes the absence of this multilingual (and presumably lower class) cabbie, and if the cabbie were to show up in AFU, trolling would probably not work on him or her. The reader that the troller is fishing for shares not only his assumption of the importance of knowledge and information capital, but his cultural referents as well. The most common trolls take their bait from the realm of the cultural, either by using such AFU-specific sources as the folk etymology of "posh" in an AFU troll or by making outrageous errors on the level of Usenet's common culture, which is for the most part American mass culture: "No, [the actress who played Peter Pan] was Mary Matalin. Marlie Matlin is the daughter of Larry Hagman (from Bewitched)."[33]

The shadows-in-a-vacuum troll with which I began is not a strictly cultural troll. However, science, together with a 60s-era faith in the benevolent power of the scientific, is part of the broader *Star Trek* culture, which is, I believe, one of the reasons why this particular troll worked. Even if a reader of the rec.arts.startrek hierarchy began reading the groups with little or no knowledge of science, these groups' detailed discussions of the plausibility of *Star Trek* "science" would educate him or

her relatively quickly. These detailed discussions are as much part of the rec.arts.startrek culture as "voracity" is of the AFU one. Therefore, one way to try to prove one's membership in the rec.arts.startrek community might be to correct a basic error such as the shadows-in-a-vacuum troll. The rush to make one's mark might well mean that the trollee would not pause to reflect on whether the post might be a joke, or even to read the post past the obvious error. The cruel comedy of trolling is that the very gesture by which trollees lay claim to insider status is precisely that by which they brand themselves as outsiders.

For the last six years, the Internet has been growing exponentially. There are as many new people with Internet access as there were people on the Internet the year before.[34] As with all cases of exponential growth, the true impact of this rapid increase was not felt immediately, but as the promise of the Information Superhighway continues to gain in popularity, more people with little previous background in computing are thrown in to a preexisting culture whose rules they may not understand. As Usenet continues to change, trolling will probably become less and less effective as a community-formation technique. If communities do "depend constitutively on difference," then the ability to construct those who are outside the AFU culture as other depends on their recognizing the difference of AFU from other places on the net as well. That is, trolling as a community practice needs the users who consider uninformed posting to AFU the equivalent of sticking a limb in a Moulinex. However, many of these newer users either do not see or do not choose to recognize the ways in which AFU constitutes itself as different. As one veteran complained, "Fact is traffic here has increased enormously and most of the new stuff is, plain and simple, shit."[35] These new users may well also have a different approach to the cultural politics of information than the average AFU regular: rather than mastering information, they may be working not to be mastered by it. But even if all the users on Usenet were of the same class fragment, the subcultures that make groups distinct have grown up locally on Usenet, not in the broader culture, and with new users coming in at such a rapid pace it becomes harder and harder to teach them the norms of a particular newsgroup unless they make a real effort to learn them.

Trolling's continued effectiveness is also hampered by its previous successes. New users are learning about trolls long before they come into contact with them, and are becoming somewhat more suspicious. The most notable change over the

course of the writing of this paper has been a rise in the follow-ups to trolls that say only "nice troll" or some variant of "I know this is a troll, but I'm going to correct you anyway." The former has led one person to declare a "Moratorium on Troll-Pointing Out": "Trolling isn't so bad, in and of itself. But what is with these fucking people that feel an irresistible compulsion to point out every troll they come across? 'Nice troll' has become the 'me too' of 1995. And it's getting worse with each passing day."[36] The remedy: such posters are now called "bafoons," after another memorable misspelling, and are considered as "caught" as any other gullible corrector. In both cases, the posters are displaying precisely the sorts of insecurities that trolling is designed to point up, but not in the desired manner, and the rules of the game will almost certainly have to change to keep its status as an insiders' game intact.

The sites of AFU's community may shift as well. Within the last two years, two invitation-only auxiliary mailing lists—Old Hats and Young Hats—have been established alongside the "public space" of the AFU newsgroup to facilitate conversation about what was going on in the newsgroup among AFU regulars. As the number of people posting to AFU continues to increase and the public spaces of Usenet become more anarchic and less communal, it may well be that in the future these very successful semi-private lists will serve as the center rather than the margins of the AFU community. While there are many who are concerned with what will happen to the interactions among the group if "we move the signal out of AFU into our super-secret mailing lists,"[37] these lists—like the new walled communities in the suburbs—could serve as a physical boundary when, and if, the participants feel that cultural boundaries have completely failed. If this occurs, it will mark the end of trolling as currently practiced on AFU, because if everyone knows from the beginning who the members of the community are, the cultural boundary mechanisms cease to be necessary. Trolling is, in the end, a game to be played in public to maintain a semi-private community, and an entirely private community would need a new game to play.

NOTES

1  snopes, post to rec.arts.startrek.current, July 27, 1994.

2  Adam Nash, post to rec.arts.startrek.current, August 3, 1994.

3 Clay Shirky, post to alt.folklore.urban, October 21, 1994.

4 David DeLaney, post to alt.culture.usenet, January 10, 1995.

5 Dave Hatunen, post to alt.folklore.urban, January 28, 1995; Ted Frank, post to soc.college, December 23, 1994.

6 Peter van der Linden, post to alt.folklore.urban, October 10, 1994; Stephen Zatman, post to alt.folklore.urban, October 6, 1994.

7 Cindy Kandolf, post to alt.folklore.urban, January 10, 1995.

8 Sean Willard, post to alt.folklore.urban, November 29, 1994.

9 "Cooperative anarchy" is the term Derek Tearne used to describe AFU's governance over the course of an email conversation in August 1994.

10 Jan Harold Brunvand's books for a general readership are *The Vanishing Hitchhiker, The Mexican Pet, The Choking Doberman, Curses! Broiled Again!,* and *The Baby Train* (New York: W.W. Norton, 1981, 1984, 1986, 1989, and 1993, respectively).

11 Terry Chan, "Alt.Folklore.Urban Frequently Asked Questions [Part 1 of 4]" (http://www.urbanlegends.com).

12 J.C. Herz, *Surfing on the Internet* (Boston: Little, Brown, 1995), 34.

13 From a post to alt.fan.pratchett, quoted by Steve Caskey in a post to alt.folklore.urban, September 24, 1994.

14 Ray Depew, post to alt.folklore.urban, December 13, 1993 (http://www.urbanlegends.com/afu/snide/1993/newbies/depew).

15 Terry Chan, "Alt.Folklore.Urban Frequently Asked Questions [Part 2 of 4]" (http://www.urbanlegends.com/AFUFAQ.html).

16 Articulate Mandible, post to alt.folklore.urban, February 25, 1995.

17 Andrew Parker, Mary Russo, Doris Sommer, and Patricia Yaeger, "Introduction," in *Nationalisms and Sexualities* (New York and London: Routledge, 1992), 5.

18 See the PARC Xerox archives of papers on MOOs in general,

and PARC's own LambdaMOO in particular, at ftp://parcftp. xerox.com/pub/MOO/papers/. Howard Rheingold maintains a WWW page at http://www.well.com/www/hlr/vircom/ index. html on virtual communities and virtual reality.

19  In my own experience, AFU is a virtual community of this kind, and one that has resulted in physical gatherings of its members as well as lasting, "real life" friendships.

20  Rheingold discusses the Parenting Conference on the WELL in chapter 1 of *The Virtual Community: Homesteading on the Electronic Frontier* (New York: HarperCollins, 1993).

21  This is not limited to Usenet, of course: Julian Dibbell notes in "A Rape In Cyberspace," *Village Voice* (December 21, 1993); also available at ftp://parcftp.xerox.com/pub/MOO/papers/ VillageVoice.txt that the "virtual rapist" of LambdaMOO returned under a new name after being banished.

22  Matrix Information and Directory Services (MIDS), "New Data on the Size of the Internet and the Matrix," Press Release (October 1994), available at http://www.tic.com/mids/ pressbig.html.

23  Evan Morris, "Computers in the '90s: Internet Lingo for a 'Newbie,'" *Newsday* (February 21, 1995).

24  Peter van der Linden, personal email to author, April 3, 1995.

25  Homi K. Bhabha, "DissemiNation," *Nation and Narration* (New York and London: Routledge, 1990).

26  Peter van der Linden, *The Official Handbook of Practical Jokes* and *The Second Official Handbook of Practical Jokes* (New York: Signet, 1989 and 1991); *Expert C Programming: Deep C Secrets* (New York: Prentice-Hall, 1994); both are recognized parts of AFU culture.

27  Harry M.F. Teasley, post to alt.folklore.urban, March 1, 1995.

28  Benedict Anderson, *Imagined Communities: Reflections on the Origins and Spread of Nationalism* (New York and London: Verso, 1991), 6.

29  Bhabha, 299.

30  On the morality-play aspect of legends, see especially Brunvand,
    *The Vanishing Hitchhiker.*

31  Andrew Ross, "The New Smartness," in Gretchen Bender and
    Timothy Druckrey, eds., *Culture on the Brink: Ideologies of
    Technology*, Dia Center for the Arts Discussions in Contemporary
    Culture, no. 9 (Seattle, WA: The Bay Press, 1994), 331.

32  Neil deMause, "They Paved Paradise and Put Up an Information
    Superhighway," *Processed World* (forthcoming).

33  Ted Frank, post to alt.religion.kibology, December 18, 1994.

34  MIDS Press Release, op. cit.

35  Len Berlind, post to alt.folklore.urban, January 29, 1995, available
    at http://www.urbanlegends.com/afu/guides/posting.berlind.

36  Paul Phillips, post to alt.culture.internet, July 15, 1995.

37  Ray Depew, post to Old Hats & Young Hats mailing lists,
    April 6, 1995.

## CYBERSPACE AND PLACE

### THE INTERNET AS MIDDLE LANDSCAPE ON THE ELECTRONIC FRONTIER

Dave Healy

> *Lo, soul, seest thou not God's purpose from the first?*
> *The earth to be spann'd, connected by network,*
> *The races, neighbors, to marry and be given in marriage,*
> *The oceans to be cross'd, the distant brought near,*
> *The lands to be welded together.*
> —Walt Whitman, "A Passage to India"

Since the publication of Frederick Jackson Turner's 1893 essay"The Significance of the Frontier in American History," it has been impossible to ignore the profound sense in which the American psyche has been shaped by the idea of a frontier, that hypothetical border-land between civilization and the wilderness. "American social development has been continually beginning over again on the frontier. This perennial rebirth, this fluidity of American life, this expansion westward with its new opportunities, its continuous touch with the simplicity of

primitive society, furnish the forces dominating American character."[1] Turner's essay announced the closing of the geographical frontier and mused about the implications of that reality for a people whose city upon a hill had hitherto always been seen as an outpost, a temporary stopping place on the relentless march westward. What would Americans do, Turner wondered, without the safety-valve of a physical frontier? How would the expansionist mindset engendered by what historian Henry Nash Smith would later call the "virgin land" find outlets now that the continent had been explored and the wilderness cultivated? How would a nation that coalesced around a collective "errand into the wilderness" respond once that errand had been completed?[2] Turner presented no detailed forecast, only his conviction that the frontier spirit would continue to animate and shape the American experiment:

> He would be a rash prophet who should assert that the expansive character of American life has now entirely ceased. Movement has been its dominant fact, and, unless this training has no effect upon a people, the American energy will continually demand a wider field for its exercise.[3]

Though Turner's frontier hypothesis has been widely debated by historians and cultural critics, there is no denying its pervasive influence on cultural interpretation. As Smith observed, it "revolutionized American historiography and eventually made itself felt in economics and sociology, in literary criticism, and even in politics."[4] In the area of art and literature, Leo Marx has shown how eighteenth and nineteenth-century American art and literature dramatized the frontier dynamic by valorizing a "middle landscape" between nature and civilization, between the country and the city. Geographer Yi-Fu Tuan complicates the frontier hypothesis by observing that, historically, large-scale migration has occurred in two directions: cooped-up Europeans escaping to the uncrowded New World, and later, disenchanted rural-dwellers "escaping" to the city. "We tend to forget," says Tuan, "that rural-urban migration, like the earlier movement across the ocean and into the New World, could also be motivated by the impulse to escape crowding." The small town could be considered "crowded in the economic sense because it did not provide enough jobs, and in a psychological sense because it imposed too many social constraints on behavior." The tensions between city and country are for Tuan a manifestation of a larger

tension, which he characterizes as place versus space: "Place is security, space is freedom: we are attached to the one and long for the other."[5]

The movement from space to place is the drama of American history. But, as Turner foretold, that drama did not end with the closing of the physical frontier and the domestication of the virgin land. The search for new wilderness has continued unabated, from global colonization to the now clichéd "final frontier" of outer space. But of course no frontier is final—only new for awhile, then destablized and contested, eventually transcended and absorbed into our collective pioneer spirit, our eternal restlessness, our longing for space and our attachment to place. The most recent chapter in this drama is the Internet, a story still being written. The metaphorical space of the Internet may be seen as representing a new kind of frontier, but one where some of the same tensions that characterized American settlement continue to be played out.

The American literary hero—from James Fenimore Cooper's Natty Bumpo to Mark Twain's Huck Finn to Ken Kesey's Randle Patrick McMurphy—has typically been an outsider, bordering on an outlaw. The computer hacker is a spiritual descendant of these literary predecessors. Like Huck Finn, the prototypical hacker is a young male who finds salvation in his escape from the "civilizing" influence of authority figures. His raft is his computer terminal, with which he charts a course into new and sometimes dangerous realms. But the classic American hero, though he might be a loner at heart, rarely operates alone. Natty Bumpo has his Chingachgook, Huck his Jim, McMurphy his Big Chief, and their stories document journeys into complex social realms. So, too, the Internet, as the name suggests, is not about an escape into isolation, but rather an ongoing and outgoing exercise in connectedness. Through many forms of computer-mediated communication (CMC)—bulletin boards, newsgroups, Internet Relay Chat (IRC), MUDs and MOOs—Internet navigators encounter fellow travelers. What kind of connectedness do they experience? What sort of a place is cyberspace, and what makes it an appealing frontier for a new generation of Americans? Precisely because computer culture is associated with modernity or postmodernity, we tend not to see its connections to earlier history. It would behove us, though, to remove our historical blinders. Examining American historical antecedents will shed significant light on a contemporary cultural phenomenon as profound and consequential as any in our history.

Our long-standing cultural ambivalence toward technology is nicely captured in Leo Marx's title: *The Machine in the Garden: Technology and the Pastoral Ideal in America.* Of particular interest to Marx in tracing that ambivalence are the American transcendentalists Emerson, Whitman, and Thoreau. All three evidence profound misgivings about the machine and its anticipated effects on the social and spiritual health of the nation, yet none is the simplistic primitivist that we sometimes naively associate with the American pastoral tradition. In their complex and sometimes contradictory vision of the dawning of the Machine Age, these writers prefigure much of what is troubling and exciting and complicating about computer culture at the end of the twentieth century.

If for us the computer represents the apotheosis of technological development, with all its potential and its threats, for the mid-nineteenth-century transcendentalist those contradictions were captured in the image of the railroad. Emerson, Whitman, and Thoreau all invoke that symbol to suggest both the menace and the promise of technology. In 1842 Emerson wrote in his journal: "I hear the whistle of the locomotive in the woods. Wherever that music comes it has its sequel. It is the voice of the civility of the Nineteenth Century saying, 'Here I am.' It is interrogative: it is prophetic: and this Cassandra is believed."[6]

Whitman's "Passage to India" is notable for the way it envisions the railroad, along with the Suez Canal and the transatlantic cable, as part of a vast network linking not only cities but, by extension, even continents:

> Lo, soul, seest thou not God's purpose from the first?
> The earth to be spann'd, connected by network,
> The races, neighbors, to marry and be given in marriage,
> The oceans to be cross'd, the distant brought near,
> The lands to be welded together.[7]

The most complex and sustained evocation of the railroad's import is Thoreau's. At times the locomotive is depicted as a sinister beast, a "devilish Iron Horse," a "bloated pest" corrupting and polluting the pristine wilderness. Elsewhere, though, Thoreau's description is more benign: "I watch the passage of the morning cars with the same feeling that I do the rising of the sun, which is hardly more regular." Furthermore, the railroad represents more than a mechanical intrusion into the garden, for it serves as Thoreau's walkway and connection to society: "The Fitchburg Railroad touches the pond about a hundred

rods south of where I dwell. I usually go to the village along its causeway, and am, as it were, related to society by this link."[8]

For Thoreau the railroad is a symbol of a fundamental tension deep within human nature: an urge to withdraw into an undisturbed private world, along side a desire for connectedness and relatedness. It was, of course, the impulse to withdraw that led Thoreau to Walden Pond in the first place. He shows himself an heir of the elbow-room-loving Daniel Boone by building his house "a mile from any neighbor." But, as Stanley Cavell has observed, that location "was just far enough to be seen clearly. However closely Thoreau's own 'literary withdrawal' resembles those of the Romantics, in its need for solitude and for nature, the withdrawal he depicts in Walden creates a version of what the Puritan Congregationalists called a member of the church's congregation: a visible saint."[9] Although the popular caricature of Thoreau portrays him as hermit, he was anything but: "As for men, they will hardly fail one any where. I had more visitors while I live in the woods than at any period of my life. . . . Every day or two I strolled to the village to hear some of the gossip which is incessantly going on there."[10] Thoreau is far enough away so that his company is "winnowed," and his life uncrowded, but close enough to civilization to maintain social relations. Walden Pond, then, becomes a "middle landscape" between civilization and the wilderness.

The contemporary linguist Deborah Tannen has written extensively on the complex ways we use language to negotiate this middle distance and to satisfy our contradictory desires for "involvement" and "independence." Like Schopenhauer's porcupines trying to get through the winter, "[w]e need to get close to each other to have a sense of community, to feel we're not alone in the world. But we need to keep our distance from each other to preserve our independence, so others don't impose on or engulf us." What linguistists refer to as *politeness* "accounts for the way we serve these needs and react to the double bind."[11]

That double bind has been described in sociological terms by Robert Bellah and his colleagues in their important examination of the American psyche, *Habits of the Heart: Individualism and Commitment in American Life.* The dominance of what they call "ontological individualism" has created a "culture of separation" that renders individuals passive and isolated in the face of larger social needs: "When the world comes to us in pieces, in fragments, lacking any overall patterns, it is hard to see how it might be transformed."[12]

Although the culture of separation is pervasive and powerful, there is another reality as well—the "culture of coherence"—that reminds individuals of their relatedness and connectedness. While *Habits of the Heart* was written before the Internet emerged as a widespread cultural phenomenon, the Internet dramatizes in forceful and revealing ways the clash of cultures that Bellah et al. foreshadowed.

To the extent that the Internet represents a culture of coherence, it serves as a corrective to the dangers of individualism. Those dangers were revealingly chronicled by the French social philosopher Alexis de Tocqueville after his visits to America in the 1830s. "Individualism," wrote de Tocqueville, "is a calm and considered feeling which disposes each citizen to isolate himself from the mass of his fellows and withdraw into the circle of family and friends; with this little society formed to his taste, he gladly leaves the greater society to look after itself."[13] According to de Tocqueville, the best antidote to this isolationist tendency was involvement in public affairs; thus, he was impressed by the vigorous associational life of early nineteenth-century American religious and civic institutions.

From one perspective, the Internet represents, for community-minded citizens, an almost limitless potential for an associational life. No longer limited by geographical happenstance to the interactions that might develop in a town or neighborhood or workplace, individuals can free themselves from the accidents of physical location to create their own virtual places. The right of assembly, which has always been a legal guarantee, becomes more consequential as the constraints of localization give way to the unfettered opportunities of virtual association. As de Tocqueville observed, individualism breeds isolation: "Each man is forever thrown back on himself alone, and there is danger that he may be shut up in the solitude of his own heart."[14] The networked citizen, though, is never alone. Synchronously or asynchronously, the sun never sets on the virtual community. But although the Internet has expanded opportunities for association, the Net's culture of coherence is compromised at the same time by limits both imposed and chosen, that tend to perpetuate a culture of separation in the very midst of what appears to be an unprecedented opportunity for community building.

The most obvious limitation to the realization of virtual community is access. Despite the demonstrable growth of the Internet and optimistic predictions about the inevitable ubiquity of computers, the fact remains that Internet access is still

available to only a minority of citizens. Even in the educational realm, where we might expect a cutting-edge atmosphere to prevail, technological capabilities are widely disparate, and many students and teachers remain outside the Net. Of the approximately 10,000 people who indicated an initial interest in the recently-formed Alliance for Computers in Writing, only about 1500 have email addresses. Particularly in K–12 public schools, subject to shrinking resources, Internet access is often perceived as a luxury that even well-intentioned districts cannot afford. As public school teachers well know, even affordable technology may not be available: witness the small percentage of teachers who in 1995 have a phone in their classroom.

Virtual community as an antidote to the more pernicious effects of individualism is further constrained by its voluntary nature. In many ways Internet culture is a logical and predictable outgrowth of what Bellah et al. call "the American search for spontaneous community with the like-minded." Community is "spontaneous" in the sense that it emerges in the immediate and ever-changing circumstances in which mobile Americans increasingly find themselves. The successful professional cannot be tied to a particular location. "'Leaving home' for the professional middle class is not something one does once and for all—it is an ever-present possibility."[15] Community is also spontaneous by virtue of being created rather than imposed. As Peter Drucker has observed, "The old communities—family, village, parish, and so on—have all but disappeared in the knowledge society. Their place has largely been taken by the new unit of social organization, the organization. Where community was fate, organization is voluntary membership."[16] One consequence of their voluntary nature is that these associations tend to be more homogenous than heterogeneous. For that reason, Bellah et al. prefer to call them "lifestyle enclaves" rather than communities. "Lifestyle," in their scheme, is more closely linked to leisure and consumption than to work: "It brings together those who are socially, economically, or culturally similar, and one of its chief aims is the enjoyment of being with those who 'share one's lifestyle.'" The lifestyle enclave, then, is a debased form of community: "Whereas a community attempts to be an inclusive whole, celebrating the interdependence of public and private life and of the different callings of all, lifestyle is fundamentally segmental and celebrates the narcissism of similarity."[17]

The most comprehensive and sustained discussion of community in cyberspace is Howard Rheingold's *The Virtual*

*Community*. For Rheingold, virtual community is chosen rather than given and, like the lifestyle enclave, reflects the voluntary association of like-minded individuals. He quotes with approval J.C.R. Licklider's 1968 prediction that "life will be happier for the on-line individual because the people with whom one interacts most strongly will be selected more by commonality of interests and goals than by accidents of proximity."[18] The phrase "accidents of proximity" was no doubt supposed to have a negative ring, but proximity is not necessarily an accident waiting to happen. Indeed, it is sometimes in the very givenness of "accidental" location that people grow the most, as they find themselves forced to rub shoulders with others who are different. The history of desegregation efforts in this country affirms the value of diversity, to the point of manipulating the enrollment of public schools, if necessary, to achieve it.

The Internet, however, promotes uniformity more than diversity, homogeneity more than heterogeneity. Email discussion lists, bulletin boards, newsgroups, MUDs and MOOs, even many IRC channels, have announced topics and themes—with social sanctions often brought to bear on individuals who depart from the topic. Although it has become a commonplace to tout the way the Net masks such social markers as race and gender, virtual anonymity does not necessarily lead to relational diversity. At my university, for example, the IRC addicts are just as segregated as the occupants of my son's high school lunch room. In our computer lab the Vietnamese students hang out on Vietnamese channels, just as at Ben's school they all sit at their own tables at lunch. The difference between IRC and the cafeteria, though, is that even if Asians and Anglos sit at different tables for lunch, they are likely, at the very least, to overhear each other; and the possibility for more substantial interaction exists—precisely because of physical proximity. On the Net, however, talk tends not to get "overheard"; the boundaries separating virtual conversants are less substantial, but their effect is more dramatic. Two virtual places may be "separated" by only a keystroke, but their inhabitants will never meet.

Virtual encounters, as a result of their potentially anonymous, fleeting nature, do not oblige their participants to deal with diversity. If one doesn't like the way a conversation is developing, a thousand alternatives are just keystrokes away. The only way that Rheingold can suggest any kind of relational imperative in the virtual community is by appropriating the language of addiction. Describing the acrimony that developed

at one point on his wide-area network, the WELL, Rheingold says, "People who had to live with each other, because they were all veteran addicts of the same social space, found themselves disliking one another."[19]

Cultural coherence is threatened, not only by the homogenous and voluntary nature of online community, but also by its impermanence. The "Net-surfing" metaphor is a revealing one, implying as it does recreationality and transience. One floats in and out of conversations, borne primarily by curiosity and a desire to be carried along on a conversational wave. If the surf dies down, one simply moves on up the beach looking for another wave. The distinguishing feature of online conversations is that people come and go; even weighty topics are threatened by an incipient trivializing created and exacerbated by intermittent participation.

Finally, true community on the Internet is threatened by non-instrumentality. For de Tocqueville, associations constitute a corrective to individualism to the extent that they result in collective action. Interactions on the Internet, however, rarely lead to action. Their primary purpose is informational or social, not political. Occasionally, political action can be roused—for example, by perceived threats to the Internet's accessibility, autonomy, or safety (such as the overstated danger posed by the much-discussed Clipper chip, or when the Electronic Frontier Foundation mobilized to defend the electronic fort from nefarious system crackers)—but for the most part Net culture does not produce collective real-world behaviors. Rheingold describes several exceptions to this tendency, including an overseas health crisis that mobilized the Internet's resources to help intervene in a life-threatening situation, and the efforts of online community activists to encourage participation in city politics or to combat the isolation of rural schools with the help of CMC technology.[20] But given the explosive growth of the Internet, such examples are fairly rare. The situations Rheingold refers to as electronic "barn-raising" probably had much to do with the fact that his own group (the WELL) was in part a face-to-face as well as a virtual community. For the most part, the Internet has not counteracted a trend in American civic life toward less activism. Since the 1960s, participation in such organizations as the PTA, political parties, labor unions, and fraternal organizations has declined markedly.[21] Bellah et al. attribute this trend to a "therapeutic" mindset that personalizes and privatizes meaning:

One's "growth" is a purely private matter. It may

CYBERSPACE AND PLACE

involve maneuvering within the structure of bureaucratic rules and roles, changing jobs, maybe even changing spouses if necessary. But what is missing is any collective context in which one might act as a participant to change the institutional structures that frustrate and limit. Therapy's "democratic side" lacks any public forum. Its freedom is closer to the free choice of a market economy than to the shared argument and action of free citizens in a republic.[22]

But I do not want to appear too cynical about the idea of virtual community. Although the Net has not done as much yet as it could to increase political activism, it almost certainly has ameliorated some of the effects of individualism, particularly that most American of virtues: self-reliance. It was Emerson, of course, in his essay of that title, who publicly valorized an attribute that Americans had always affirmed and benefited from: "To believe your own thought, to believe that what is true for you in your private heart is true for all men—that is genius....Trust thyself: every heart vibrates to that iron string."[23] Whitman, too, as the chief exponent of what Bellah et al. call "expressive individualism," was a lyrical spokesman for the virtues of autonomy, self-sufficiency, and personal force. His famous poem "Song of Myself" locates the self-reliant individual at the center of the cosmos. And Thoreau, of course, shows his allegiance to the doctrine of self-reliance on nearly every page of *Walden*.

Bellah and his colleagues have documented the endurance of self-reliance as preached by the American transcendentalists, among their middle-class interviewees. Increasingly, though, self-reliance seems like an old-fashioned virtue—not old-fashioned in the sense of representing a fundamental part of our heritage that we need to recapture, but rather an old-fashionedness that we have outgrown and need to leave behind. Earlier generations of Americans could afford to be self-reliant because the world they lived in could by and large be negotiated by self-sufficient generalists. Today, however, no one can know enough to get by. The increasing sophistication and complexity of our technology is emblematic of the increasing complexity of modern life, a complexity that has brought about an unprecedented degree of interdependence.

The Internet is a testimony to that interdependence and a perpetual reminder that our lives are intrinsically and inescapably social. In the face of increasing geographic and

occupational mobility, we need ways to maintain connections and connectedness, and the Net provides almost limitless possibilities. But the Net is also an apt medium for contemporary Americans because it doesn't *demand* anything. Though it has grown to be an international phenomenon, the Internet is characteristically American in its forging of a "middle landscape" between isolation and connectedness. "CMC is a way to meet people, whether or not you feel the need to affiliate with them on a community level. It's a way of both making contact with and maintaining a distance from others."[24]

"Place," says Tuan, "is security, space is freedom: we are attached to the one and long for the other." The freedom represented by physical space is not peculiar to Americans, but it does have special resonance for a nation that began with an errand into the wilderness. Our frontier mentality makes us particularly receptive to what the contemporary naturalist Paul Gruchow calls "the necessity of empty places," or to the words of Gruchow's spiritual ancestor Henry David Thoreau: "We need the tonic of wildness."[25] But wild(er)ness is only a tonic, not a steady diet. We need settled places as well. In the words of Howard Rheingold's subtitle, we are homesteaders on the electronic frontier. Some of us prefer the more settled environment of a moderated bulletin board or email list, where sysops and group norms serve to maintain boundaries and limits, some sense of insiders and outsiders; or the more hierarchical world of MUDs and MOOs with their wizards and gods, where one can construct one's own virtual space. Others prefer the fluidity of IRC or the anarchy of Usenet, where limits on expression are almost nonexistent and unfettered individualism flourishes.

In this regard, the Internet is more accurately described as a loose collection or "ecosystem" of subcultures rather than a monolithic culture.[26] While an individual discussion list or bulletin board may evidence considerable homogeneity, collectively the networks that make up the Internet represent an astonishing—indeed, bewildering—diversity. Just as it is difficult to speak of "American culture" without resorting to reductionism, so too "Internet culture" is a construct that may mask the variety of life in cyberspace. But while virtual space reflects real space in providing a range of options for would-be homesteaders, those options reflect differing possibilities and limitations.

Perhaps the most obvious difference between the two realms, for my purposes in this chapter, is the fact that no latter-day Frederick Jackson Turner is ever likely to stand before his colleagues to announce the closing of the electronic

frontier. Unlike the geographical continent, cyberspace has no inherent limitations. An overloaded mainframe may represent a temporary roadblock on the information superhighway, but the possibilities for expansion are (virtually) limitless. Cyberspace also differs from the landscape in the freedom from economic constraints it provides for electronic homesteaders. As Tuan observes, "Working-class and poor people do not live in houses or neighborhoods of their own design. They move either into residences that have been abandoned by the well-to-do, or into new subsidized housing. . . . In contrast, the affluent are able to occupy an environment of their own design."[27] The Internet presents some limitations to mobility as well. For example, "building permits" in many MOOs are granted by wizards only to "qualified" applicants, and moderated discussion lists may exclude some kinds of participation. But these constraints are social, not economic; thus, the Internet provides a more achievable level of democracy than many citizens experience elsewhere.

I have suggested that the Internet represents a kind of "middle landscape" that allows individuals to exercise their impulses for both separation and connectedness. We are still latter-day Huck Finns and Daniel Boones, lighting out for the territories in an endless quest for elbow room, and the infinite reaches of cyberspace beckon enticingly, just a few magic keystrokes away. But we long for place as well as space. We are heirs not only of the primitivist philosopher Daniel Boone, who "fled into the wilderness before the advance of settlement," but also the empire-building Boone, the "standard-bearer of civilization."[28] We long for that amorphous and elusive realm inhabited by Cooper's Natty Bumpo: "Although Natty represents a central value in American life, he is not the product of American society nor does he live within it. Rather he inhabits a middle ground between the settlements and the wilds."[29]

But that middle ground is not only elusive, it is also fragile. The virtual community that many of us find attractive is threatened, as Bellah et al. remind us, by our individualism and self-interest, and by the Internet's sheer complexity. "Perhaps," muses Howard Rheingold,

> cyberspace is one of the informal places where people can rebuild the aspects of community that were lost when the malt shop became a mall. Or perhaps cyberspace is precisely the *wrong* place to look for the rebirth of community, offering not a

tool for conviviality but a life-denying simulacrum of real passion and true commitment to one another. In either case, we need to find out soon.[30]

NOTES

1 Frederick Jackson Turner, *The Frontier in American History* (Malabar, Florida: Krieger, 1985), 2–3.

2 The phrase "errand into the wilderness" came originally from the title of a 1670 sermon by the second-generation Puritan Samuel Danforth: "A Brief Recognition of New England's Errand into the Wilderness." See also Perry Miller, *Errand Into the Wilderness* (New York: Harper & Row, 1964).

3 Turner, 37.

4 Henry Nash Smith, *Virgin Land: The American West as Symbol and Myth* (Cambridge: Harvard University Press, 1950), 250. For a survey of challenges to Turner, see Smith, 295–296.

5 Yi-Fu Tuan, *Space and Place: The Perspective of Experience* (Minneapolis: University of Minnesota Press, 1977), 60, 3.

6 Quoted in Leo Marx, *The Machine in the Garden: Technology and the Pastoral Ideal in America* (New York: Oxford, 1964), 17.

7 Walt Whitman, *Complete Poetry and Selected Prose*, ed. James E. Miller, Jr. (Boston: Houghton Mifflin, 1959), 288, lines 16–20.

8 Henry David Thoreau, *The Illustrated Walden*, ed. J. Lyndon Shanley (Princeton: Princeton University Press, 1973), 115–116.

9 Stanley Cavell, *The Senses of Walden* (New York: Viking, 1972), 11.

10 Thoreau, 143–144, 167.

11 Deborah Tannen, *That's Not What I Meant! How Conversational Style Makes or Breaks Relationships* (New York: Ballentine, 1987), 17.

12 Robert N. Bellah et al., *Habits of the Heart: Individualism and Commitment in American Life* (Berkeley: University of California Press, 1985), 277.

CYBERSPACE AND PLACE

13 Alexis de Tocqueville, *Democracy in America*, trans. George Lawrence, ed. J. P. Mayer (New York: Doubleday/Anchor, 1969), 506.

14 Tocqueville, 508.

15 Bellah et al., 251, 197.

16 Peter F. Drucker, "The Age of Social Transformation," *The Atlantic Monthly*, Nov. 1994, 53–80.

17 Bellah et al., 72.

18 Howard Rheingold, *The Virtual Community: Homesteading on the Electronic Frontier* (New York: HarperCollins, 1993), 24.

19 Rheingold, 37.

20 Rheingold, 28–32, 241–51.

21 Robert Putnam, "Bowling Alone: America's Declining Social Capital," *Journal of Democracy* 6: 1 (1995), 65–78.

22 Bellah et al., 127.

23 Ralph Waldo Emerson, "Self-Reliance," *The American Tradition in Literature*, ed. Sculley Bradley et al., 4th ed., vol. 1 (New York: Grosset & Dunlap, 1974), 1108.

24 Rheingold, 26.

25 Paul Gruchow, *The Necessity of Empty Places* (New York: St. Martins, 1988).

26 Rheingold, 3.

27 Tuan, 171.

28 Smith, 55.

29 Larzer Ziff, *Literary Democracy: The Declaration of Cultural Independence in America* (New York: Penguin, 1981), 266.

30 Rheingold, 26.

*TWO*

# VIRTUAL BODIES

# FLESH MADE WORD

## SEX, TEXT AND THE VIRTUAL BODY

Shannon McRae

In the decade since William Gibson coined the term "cyberspace," the "consensual hallucination" he envisioned has become a significant reality.[1] Like the national highway system to which they have been all too frequently compared, computer networks have reconfigured the cultural landscape. Gibson's paranoiac vision of a world rendered nearly uninhabitable by warring multinational corporations whose hegemony is enabled by means of a vast, interlinked information network mirrors current reality with considerable accuracy. Late capitalism is character- ized by the growth of multinationals that render political and cultural boundaries obsolete, and whose nexus of control is as intangible as it is total: an electronic network that encompasses the entire world.

Cyberspace has become an increasingly populated universe, a rapidly evolving civilization with its own history, politics, heroes, villains, legends and lore. It is not so much a parallel to the "real world" as an increasingly significant dimen-

sion within it. This is largely due to the proliferation of the technology that makes the space accessible. In Gibson's novels, the technology of cyberspace is available only to an elite: the corporations that buy, sell and jealously guard information, and the highly skilled "net cowboys," hackers who make a game and an art of stealing it. In reality, the technology with which cyberspace is accessed and constructed, although not yet universally available—and to some downright incomprehensible—has become over the past few years an increasingly familiar if not completely colonized territory. Neither the remote, parallel, universe of Gibson's fiction nor the scary, computer-generated universe of films such as *Lawnmower Man*, virtual reality has come to be not so much a fiction as a condition, an alternate way of relating with the world and with other human beings. Virtual existence has become so immediate that what constitutes "the real" is called into question.

"By the late twentieth century," Donna Haraway writes, "our time, a mythic time, we are all chimeras, theorized and fabricated hybrids of machine and organism. In short, we are cyborgs."[2] The cyborg is no longer "a fiction mapping our social and bodily reality," but the lived experience of millions of people who spend most of their time working and playing in digital space. Gleeful cyborgs, "the illegitimate offspring of militarism and patriarchal capitalism," fulfilling one of childhood's most avid and most forbidden wishes, are out playing on the highway that their fathers built.[3] And in any variety of makeshift, sprawling encampments alongside the highway, they discover other shape-shifters, gaze into other eyes, glowing, opaque and shining phosphor-bright. An entire, hybrid generation has redefined the concept of "doing it in the road."

Virtual sex, including phone sex, erotic email exchanges and encounters on chatlines, BBSs and virtual communities, enables erotic interaction between individuals whose bodies may never touch, who may never even see each others' faces or exchange real names. Popular discussion of virtual sex (or, less appealingly, "teledildonics") has tended to classify it with the type of fleeting, anonymous erotic experience that can be obtained in sex clubs, pick-up bars or by calling professional phone-sex lines. This type of discussion tends to analyze the phenomenon as the result of technologically mediated alienation, motivated by fear—of AIDS, of strangers, or of the fact that the body is rapidly becoming redundant in an age of progressive denaturation. Certainly remote sexual interaction has come to the fore at the same point in history that various

practices that drastically refigure the human body have become popular—bodybuilding, dieting, working out, piercing, tattooing, plastic surgery. All of these can be read as efforts to exert control over the one medium individuals feel they still can control.

There is, however, a more positive way to regard virtual sex. Demonstrating an adaptability admirably in keeping with the seemingly endless evolutionary permutations of capitalism, human beings have turned the machinery of power into sources of pleasure, countering "the grips of power with the claims of bodies, pleasures and knowledges, in their multiplicity and their possibility of resistance."[4]

This is not to say that everyone engaged in virtual socialization are interested in sexual interaction. And of those who are, most might not even regard it as an experience any more interesting or personally transformative than any other kind of semi-anonymous erotic encounter. A casual survey taken amongst individuals who have engaged in some form of virtual sex might suggest that the consensus is that it's no more immersive than, as one person put it, "an interactive Penthouse Forum." While some may well find technologically facilitated eroticism to be a disembodied, alienating and ultimately meaningless experience, others, however, have discovered that it can be as involving, intense and transformative as the best kinds of embodied erotic encounters, and that furthermore, its virtuality enhances rather than detracts from the experience.

Virtual sex allows for a certain freedom of expression, of physical presentation and of experimentation beyond one's own real-life limits. At its best, it not only complicates but drastically unsettles the division between mind, body and self that has become a comfortable truism in Western metaphysics. When projected into virtuality, "mind," "body" and "self" all become consciously manufactured constructs through which individuals interact with each other.

Before continuing with a discussion of virtual sex, it might be useful to clarify what "virtual reality" actually is. One commonly understood definition is that summarized by Elizabeth Reid. Virtual reality involves:

> systems that offer users visual, auditory and tactile information about an environment which exists as data in a computer system rather than as physical objects and locations. This is the virtual reality depicted in *The Lawnmower Man* and approximated by the *Virtuality* arcade games marketed by Horizon Entertainment.[5]

The term also describes some of the technology that was used in the Gulf War and certain systems currently under development by such institutions as the Human Interface Technology Lab. Another type exists, however, that is not dependent upon complex and expensive gadgetry nor prepackaged experience, but is easily accessible and created primarily by its users. Although the various telephone and online chatlines, bulletin board systems, newsgroups and any of a number of commercial service providers that have proliferated in the past several years fall roughly under this type of virtual reality, perhaps the richest, complex and most comprehensively elaborate environments are MUDs (Multi-User Dimensions or Dungeons). These are "networked, multi-participant, user extensible systems which are commonly found on the Internet."[6]

MUDs are text-based virtual worlds, interactive databases from which it is possible to craft highly complex, extremely vivid environments in which the user experiences a feeling of actual presence. Their users, many of whom have been participating for years, regard MUDs as communities, imaginary environments that allow for very real emotional and social interactions.[7] The type of interactions depends upon the particular MUD. Some are used primarily for Dungeons and Dragons style gaming, others, such as LambdaMOO and the other satellite MOOs that have sprung up within the past two or three years are reserved for academic research, professional interactions and experiments in community organization or collective programming.[8]

MUDs are unique among other voice-based or text-based environments in that users can move about within a described space, handle and create objects and interact with other players with bodies that they construct. The feeling of being embodied in actual space is often sufficiently "real" that the senses are engaged in a complex interchange of experience between a physical and a prosthetic body. Players similarly engage with each other in meaningful, complex and frequently intense ways, in the absence of the conventions of nuance, gesture and tone that facilitate human interaction.

> Despite the absence of the familiar channels of interpersonal meaning, players do not fail to make sense of each other. On the contrary, MUD environments are extremely culturally rich, and communication between MUD players is often highly emotionally charged. Although they cannot see, hear or touch one another, MUD players

have developed ways to convey shades of
expression that would usually be transmitted
through these senses. . . On MUDs, text replaces
gesture,and even becomes gestural itself.[9]

Players create context in two ways: self-presentation, and
modes of speech whose nuances come to be collectively under-
stood. When a player first arrives on a MUD, her first act is usu-
ally to describe herself and to choose a gender. Once assumed,
both can be changed at will. Players can "morph" (change from
one description and/or gender to another) with a single com-
mand, or simply rewrite themselves at any time. They look at
each other, their environment and the objects around them
with another command. Communication with other players is
enabled with a few simple keystrokes. Two modes of communi-
cations exist: the "say," in which a player makes a statement, and
the "emote," in which she gestures, makes a facial expression or
strikes a pose. If Galatea wanted to say something to anyone
else in the room, she would type:
    say Hello everyone.
Everyone in the room would see:
    Galatea says: "Hello everyone."
If Galatea wished to emote rather than say something, she
might type:
    :looks skeptical and taps a foot impatiently.
Everyone in the room would then see:
    Galatea looks skeptical and taps a foot impatiently.

Emoting allows for a richness and variety of communica-
tive nuances not easily conveyable in other electronically medi-
ated environments. For this reason, sexual engagement takes
on a dimension quite different from other virtual encounters
such as phone sex, email or bulletin board systems.

The lack of physical presence combined with the infinite
malleability of bodies on MUDs complicates sexual interaction
in interesting ways. While many individuals engage in the fairly
limited standard rituals of singles cruising, both gay and
straight, others seek out erotic experiences that would be
painful, difficult or simply impossible in real life. The residents
of one highly popular MUCK (a special type of MUD) describe
themselves as anthropomorphized animals. While newcomers
to this world usually get an impression of cloying cuteness,
those with patience to seek out the large and active sexual sub-
culture soon discover a number of unique sexual practices
invented by and specific to players on that particular MUCK.

According to Kanu, a regular player there, one of the clas-

FLESH MADE WORD

sic forms of animal sex is predator/prey S & M, "where the submissive partner is eaten at climax. I haven't tried that, but I'm told it is interesting." Species are apparently chosen according to a highly complex social code. "Bears and wolves are usually dominant. Foxes are sorta generally lecherous. Elves are sexless and annoyingly clever. Small animals are often very submissive." Kanu, who plays a young, human male character—"low tech, simple, friendly"—finds that while some other players find him quite attractive, others "are quite zoophilic and don't like having sex with a human."

Kanu related to me some of his experiences:

> I met a bear in a bar once, and followed him home. That lead to an S & M scene where he was dominant. . . .He bit me and threatened me with his teeth and claws. . . .Some players sort of invent new kinds of sex organs. For example, there was a centaur that had a really HUGE cock. But he was submissive, and what he liked was for people to fuck his cock. It was like a vagina on the end of a giant penis.

When I asked how animal forms might particularly enhance role-play, Kanu suggested that they might allow for more primal experimentation, including the sensual and psychic effects of "predation, claws, teeth, size and strength parameters." Also, animal players enjoy playing with various sizes:

> Some players are small. Like an ermine who likes me always wants to be taken home and used like a sex toy. The ermine would climb up my pants leg, etc. I didn't really get into it. Too silly for me.

On another, similar world:

> There is a region that is devoted to giants. Giant animals mostly. Its almost all homosexual domination scene there. . . .I got caught by a giant Lion there once. A very long scene followed. Lots of threatening, running around trying to pleasure him, getting stuck in his mouth and up his ass. Probably the kinkiest thing I've done there. . . .He was like ten times bigger than me. . . .The Lion really wanted me to be a permanent slave. Took me around and showed me skeletons of players who weren't loyal enough.[10]

Besides the freedom and potential for experimentation allowed by the occupation of an animal body, one of the more frequently discussed occurrences in virtual environments is the tendency of individuals to assume a gender other than that with which they identify in real life. When the choice of gender is an option rather than a strictly reified social construct, the potential exists for gender as a primary marker of identity to be subverted. Reflecting the demographics of the Internet as a whole, most MUD players are young, heterosexual males between the ages of nineteen and twenty-five. A surprising number of these young men take the opportunity to experience social interaction in a female body. This is not to say that all or even most of these young men are consciously engaging in gender subversion. Stephen Shaviro, who has spent some time on various MOOs, sees very little inventiveness in the behavior that he has observed:

> But let's not get carried away with utopian fantasies. Most straight men are assholes, and the mere opportunity for expanded gender play on the Net doesn't do anything to change that. A successful drag performance is harder to pull off than you think. Straight guys often pretend to be girls on the Net—I've done it often myself—thinking that the disguise will make it easier to score with "actual" girls. But what goes around comes around: the girls these guys meet usually turn out to be other guys in virtual disguise. Face it, the information of which most straight men are composed is monotonously self-referential: it just turns round and round forever in the self-same loop.[11]

What actually occurs, however, is not necessarily that simple. While the primary motivation for straight men on the Internet to pass as female may be to meet girls, the girls attracted to another "woman's" attention are likely to be lesbians. If the girls are actually other boys, then what occurs is not a heterosexual experience at all, but either an enactment of a lesbian experience or two boys making love while one or both are assuming female bodies.

If boys can be girls and straights can be queers and dykes can be fags and two lesbian lovers can turn out to both be men in real life, then "straight" or "queer," "male" or "female" become unreliable as markers of identity. It is not so much that gender roles or sexual preferences actually change as that cross-

gender role play troubles the link between gender and desire, from which we, usually unquestioningly, construct our identities as sexual beings. Gender becomes a verb, not a noun, a position to occupy rather than a fixed role. In many cases, gender becomes the effect that one individual can have upon another.

The extent to which individuals actually care whether or not they are engaged in play that potentially poses serious c hallenges to identity issues varies. The seriousness of sexual interaction varies as much on the Internet as in "real life." Some are cruising, looking for adventure and novel sensation, others for emotional bonding. Some consider gender-bending to be part of the game and do not care if the people with whom they are flirting are what they say they are or not. For others, the discovery of a deceit can precipitate an emotional crisis of surprising intensity.

A professor I interviewed, whom I'll call Shade, saw virtual sex as a way to explore aspects of her sexuality that she had never experienced in "real life": sex with men, and playing out S & M fantasies in a milieu she regarded as somewhat safer.

Rather than being a pleasurable, liberating experience, however, her first experiment, which occurred on LambdaMOO, was traumatic. When the boy with whom she was playing began to play more roughly than she felt comfortable with, she found herself far more deeply upset by the scene than she had anticipated. She abruptly left for her own room, but remained connected on the MOO. A woman who had also been involved in the scene became concerned, paged her (paging is a means of players who are not in the same room to communicate with each other), and offered to ask a girlfriend of hers, another lesbian, over to comfort Shade.

The girlfriend, Trina, was extremely gentle, very understanding, and after a fairly short time, Shade became intimately involved with her. Their involvement included S & M role-playing, which she felt was much safer with a woman. When, after several weeks of intense sexual encounters, Trina confessed to being male in real life, Shade was furious. Feeling duped, betrayed and multiply set up, it was several weeks before she felt she could trust anybody she met virtually again.

According to Shade, Trina's rationale for passing as lesbian was, apparently, to "help women," and keep them safe from other men who might hurt them.[12] What his actual intentions were is impossible to determine. The incident happened several years ago, and Trina has since either left LambdaMOO or, as some-

times occurs when someone becomes visibly unpopular, assumed another identity. Possibly a group of boys playing at the various roles the freedom of the Internet allowed them found themselves caught up in human emotions they never imagined could come into play in a faceless, pseudonymous space.

Shade's story is by no means, however, the only incident of genuine emotional pain incurred in what newcomers naively believe to be an environment in which role-playing becomes divorced from emotional reality. Another woman I spoke to, who in real life is married and considers herself to be in a monogamous relationship, also found herself befriending and becoming emotionally involved with someone she thought was another woman. Although they maintained their friendship when he revealed his true gender, she felt that the quality of their interaction had changed. As she put it: "I guess, sadly then, when it was a woman, it was 'help the sister' and she'll help you. When it was a man, it was the old, boring game of 'batter your head senselessly against a titanium shell.' Anyway, he changed my life."[13]

One of the more curious gender-bending practices that occurs is that a surprising number of men, both gay and straight, masquerade as women in order to seduce other men. Some try it on a dare, perhaps as a characteristically 1990s form of macho bravado, simply to see if they can pass, to see if they can be better women than women. A familiar rite of passage on LambdaMOO involves young men inciting other young men to assume a female description and successfully seduce a player who is notorious for his seductive behavior towards women. For many, "passing" is a game, something to be gotten away with. Others, however, are motivated by a sense of self-exploration, to see, like Tiresias, whether sexual pleasure is more intense from the point of view of a woman.

It can easily be argued that the free experimentation with gender roles that virtual reality allows accomplishes nothing but reinforcement of those roles, and to a certain extent this claim is true. In order to enact "female" and hope to attract partners, one must not only assume the pronouns, but craft a description that falls within the realm of what is considered attractive. Most people do not stretch their imaginations much beyond the usual categorizations. Voluptuous breasts, slim waists, flowing hair, etc. proliferate as quickly in virtual reality as in any Barbie Doll factory.

Some individuals, however, come to find themselves occupying the opposite gender with such intensity that they discov-

er aspects of themselves that they may not otherwise have encountered. Elaine, who in real life is male, identifies as straight and has never had a male lover in reality, has found playing female to be intensely transformative. For her, being female "has something to do with wanting to inhabit something—elan, humor, emotional presence, communication, words—that I felt so utterly close to but just had no male model for."[14]

In another conversation, she expressed how intense it was for her to experience herself as female while engaged in sex with a male-presenting player:

> When you're getting fucked by a man there's this amazing thing. . . you realize you're being given all this energy and power. . . it courses through you and you can channel it, throw it back, turn up the voltage, make it explode, shoot it out your fingertips. . . .Or just surf it like a wave. . . only it's both inside and outside you, dissolving. . . .God only knows what weird stuff I'm saying about femaleness and. . . [maleness] and myself and who knows what, but I feel it. . . strongly.[15]

Besides all the permutations and combinations possible to enact with female and male, some MUDs offer alternative gender choices. The "Spivak" gender available on LambdaMOO, with its unique pronouns (e, em, eir, eirs, eirself) has allowed some individuals to sidestep the restrictions of human anatomy as well as customary gender roles.[16] Because the pronouns assigned to "em" efface gender distinctions, a Spivak can have any morphological form and genital structure "e" devises for "emself." Twin describes her experience of a Spivak body with an imaginative richness and sensuality that pale the erotic potential offered by unexamined enactments of female or maleness:

> For me, spivak is able to transform very quickly . . . well maybe gradually. . . say, grow a penis in a few minutes. . . ? And two spivaks means that one could shape the other, as well. . . if the other allows the suggestions. . . and for me there's also these little extensions. . . like very fine root hairs on a tree root. . . anyway. . . these little hairs form lots and lots of connections. . . .They are very sensitive. . . and as love-making progresses. . . they stroke,

> penetrate, and even fuse. Also, spivak sex, for me,
> involved musical tones from deep inside the chest,
> much like cat's purring. . . and little chiming
> sounds from those tentacles.[17]

The conventions of virtual sex involve a mutual exchange in which someone emotes actions in the third person that she is performing upon her partner, who is addressed in the second person. Because such an exchange requires a constant phasing between the virtual and the actual, a simultaneous awareness not only of the corporeal body at the keyboard, the emoting, speaking self on the screen, but also the existence of another individual, real and projected, who is similarly engaged—mind/body awareness is not split, but doubled, magnified, intermingled.

To say that virtual sex involves highly self-conscious role-play does not mean that the roles enacted are in any way necessarily false. As is also true in drama, ritual, liturgy and certain sexual practices, a role within the context of a given scene can be enacted with such focus and intensity of purpose that the "I" becomes meaningless, standing outside the self in a state of ekstasis, quite literally a being put out of its place, enraptured, seized by force, bursting, smitten. When intense erotic union is accomplished in a void, in which bodies are simultaneously acutely imagined, vividly felt and utterly absent, the resultant sense of seizure, of scattering, of self-loss can be experienced as a violent mingling of pleasure and pain.

In "The Ego and the Id," Freud states that "pain seems to play a part in the process. . . by which in general we arrive at the idea of our own body. . . .The ego is first and foremost a bodily ego; it is not merely a surface entity, but is itself the projection of a surface."[18] In suggesting that our sense of our own embodiment is linked to pain, Freud also suggests that the experience of pain is inextricably linked to erotic experience.[19] Moreover, the intensity of certain types of erotic pleasure is derived not from satisfaction, but from increasing and maintaining tension to such a high degree that pain and pleasure are simultaneously experienced.

According to Leo Bersani, "the pleasurable-unpleasurable tension of sexuality—the pain of a self-shattering excitement—aims at being maintained, replicated, and even increased." Continuing Freud's discussion, Bersani argues that the "human subject is originally shattered into sexuality," and suggests that human sexual pleasure may well be inextricably linked with masochism.[20]

FLESH MADE WORD

Bersani's discussion of masochism might be one useful model to account for the kind of intensity that some individuals experience during virtual sex. In order to fully engage in virtual sex, an individual must construct an imaginary body, transfer her sense-awareness into it as well as onto the body of the imagined other who is similarly focused, and simultaneously double and displace her embodied sense of self. The intensity of pleasure results from precisely this kind of sustained self-shattering.

Another, perhaps slightly less perverse model is the tradition of Courtly Love. Like the courtly lover, the virtual sex partner imagines love scenes between herself and her beloved that take on an intensity and a reality of their own precisely because actual, physical bodies may never meet. Another similarity is that nearly all of the exchange is enacted in the exchange of words: poetry, music or conversation. In order to exist in virtual reality, and to sustain erotic pleasure, the individual must maintain her powers of language at a moment when the power of coherent verbal expression is customarily abandoned. The speaking and experiencing parts of the embodied self are necessarily split by the requirement of maintaining language within sensation. Rather than a sensory void, however, this split can perhaps be described as a highly charged space—the delirious, lacerating edge between the apprehension of language and the implicit, the imminent death of language (of the speaking "I") that Roland Barthes describes in *The Pleasure of the Text*.[21]

Paradoxically, the more intensely individuals experienced in virtual sex feel pleasure, the better able they are to evoke bodily intensities in words, leaping onto the gap between utterance and experience, simultaneously enacting the rush of bodily sensation and the writer's ecstasy at producing text, being-in-text and being-in-body.

Continually subjecting oneself to a condition in which bodily experience and emotion are constantly expressed in words is problematic. Our culture has frequently found the enormous range of emotions and experiences that are simply not expressible in language to be therefore unworthy of attention, to the detriment of real emotional health. Real, living bodies are already devalued in an age where the passive reception of selected information has come to replace lived experience as reality.

Nevertheless, sex, love and pleasure in any form may well afford some measure of resistance against social and technological forces that would divide us from each other and prevent

us from naming and shaping our own experience. Eroticizing our technology does not mean giving up the ghost, but rather giving in to the pleasures of corporeality that renders meaningless the arbitrary divisions of animal, spirit and machine.

NOTES

*Another version of this paper appeared in* Wired Women: Gender and New Realities in Cyberspace, *Lynn Cherny and Elizabeth Reba Weise, eds. (Seattle: Seal Press, 1996), 125–146.*

1 William Gibson, *Neuromancer* (New York: Ace, 1984), 51.

2 Donna Haraway, "A Cyborg Manifesto: Science, Technology, and Socialist Feminism in the Late Twentieth Century," in *Simians, Cyborgs, and Women: The Reinvention of Nature* (New York: Routledge, Chapman & Hall, Inc., 1991), 151.

3 Haraway, 150.

4 Michel Foucault, *The History of Sexuality, an Introduction*, trans. Robert Hurley (New York: Random House, 1978), vol. 1, 157.

5 Elizabeth Reid, *Cultural Formations in Text-Based Virtual Realities,* unpublished thesis, University of Melbourne, 1994, 3.

6 Reid, 4.

7 Reid, 3–4.

8 MOOs are Object-Oriented Muds, so called because their particular interface allows for the construction and manipulation of programmed objects, which can be made to interact with each other and which can act as a basis on which to construct other, more complex objects.

9 Reid, 17.

10 Interview with Kanu, DhalgrenMOO, March 29, 1995.

11 Steven Shaviro, "Doom Patrols" (ftp://ftp.u.washington.edu/public/shaviro/doom.html).

12  Interview with Shade, DhalgrenMOO, December 5th, 1994.

13  Interview with existence, LambdaMOO, March 31, 1995.

14  Interview with Elaine, DhalgrenMOO, October 24th, 1994.

15  Elaine, October 30th, 1994.

16  This gender category was originally employed by Michael Spivak
     in *The Joy of TEX: a Gourmet Guide to Typesetting with the AMS-
     TEX Macro Package* (Providence: American Mathematical
     Society, 1990).

17  Interview with Twine, DhalgrenMOO, December 10, 1994.

18  Sigmund Freud, "The Ego and the Id," *The Standard Edition of the
     Complete Psychological Works of Sigmund Freud,* vol. 18, 25–26.

19  Sigmund Freud, *Three Essays on the Theory of Sexuality,* trans.
     James Strachey (HarperCollins, 1962), 25.

20  Leo Bersani, *The Culture of Redemption* (Cambridge: Harvard
     University Press, 1990), 36.

21  Roland Barthes, *The Pleasure of the Text,* trans. Richard Miller
     (New York: Hill and Wang, 1975).

# VIRTUALLY EMBODIED

## THE REALITY OF FANTASY IN
## A MULTI-USER DUNGEON

Mizuko Ito

In her influential 1985 essay, "A Cyborg Manifesto," Donna Haraway suggests the image of the cyborg, "a hybrid of machine and organism" (Haraway 1985, 129) as a metaphor to describe the late twentieth century's imploding boundaries between human and animal, organism and machine, and the physical and non-physical. Communications technologies appear in this story, together with biotechnologies, as "crucial tools for recrafting our bodies," key players in a move toward "the translation of the world into a problem of coding" (Haraway 1985, 164). From our vantage point in the mid-1990s, Haraway seems to offer a prescient glimpse into current informatic webs of meaning and materiality that constitute the burgeoning Internet, a galvanizing foray into the analytic problematics and postmodern politics that crisscross this new terrain. This essay focuses ethnographic attention on the third of Haraway's collapsing boundaries, that between the physical and non-physical, taking as a departure point the interpenetra-

tion of machine and organism that constitutes Internet culture.

Examining virtual worlds as an implosion of the physical and non-physical poses an analytic conundrum to social and cultural theory because of the difficulty in untangling the chains of associations that link mind, fantasy, and information, in opposition to body, reality, and materiality. Much of the social commentary around virtual worlds implicitly reinscribes a split between information (virtuality) and materials (reality), describing ways in which online spaces provide a space of "pure" information that is both amputated from, and inconsequential for, real world physicality. To sample eclectically from a number of incommensurable conversations, some expressions of related sentiments about online worlds include: "it is just an open world where your mind is the only limitation" (Jaron Lanier in Woolley 1992, 14); "*Such sites are the essence of postindustrial society*—pure information *duplicated in metasocial form*" (Tomas 1992, 35; [emphasis in original]); "This apparently boundless universe of data breaks all the rules of physical reality" (Rushkoff 1994, 2); "Cyberspace is like Oz—it is, we get there, but it has no location" (Stenger 1992, 53). These sound bites are not meant to be encompassing or emblematic of the perspectives of those quoted, but rather as a selective identification of an often implicit pattern of discourse.

What they do have in common is a descriptive tendency to equate online or virtual worlds with a dematerialized realm of pure information, unfettered by the constraints of real life. While I agree with the sentiment that online spaces provide opportunities for strikingly new social formations, I am wary of the tendency to view the virtual as a radically disjunctive and purely imaginary space that lacks consequentiality, location, or materiality. The very success of interfaces that couple ever more intimately with their users tends to obfuscate the technological apparatuses that undergird the net. Much as language becomes transparent with mastery, Net travel and communication becomes increasingly effortless as users become more savvy, relying automatically on a whole new series of semiotic technologies. And like film, whose subjective impact is based on a systematic erasure of the technological apparatuses that produce its effects, interfaces for virtual worlds are becoming both more accessible and more technologically opaque.[1] While recognizing the increasingly immersive capabilities of networked virtual worlds, I would like to resist the desire for seamlessness and transcendence by keeping in view both the real subjective consequences and investments of online interaction,

and the concrete local and material conditions that enable Internet travel.[2] My approach, in short, is to look at Internet culture as contingent on and located in both semiotic and material technologies.

My aim in this deliberately inhibited vision is to take into account the costs and investments entailed in online interaction. By drawing on anthropological, feminist, and social and cultural studies approaches to technoscience, I hope to call attention to particular and embodied circumstances of Internet use. Anthropological impulses compel me to insist on cyberspace as a legitimate, lively, and uniquely embodied field site.[3] Feminist politics draw my attention as much to online absence as to presence, as well as issues in access and control, the erasures of agencies, and the invisible and (usually) faithful technologies that produce the magic of online travel.[4] Finally, social and cultural studies of science and technology focus on the immense social, material, and semiotic apparatuses that undergird the reality of science and technology.[5]

My field sites, for the past few years, have been combat-based multi-user dungeons (MUDs), virtual worlds that are among the most imaginative and fantastic social spaces on the net. After providing a sketch of the kinds of MUDs that I study, I will explore virtual embodiment and the reality of these fantasy worlds in three cases studies that explore: MUD romance, issues of accountability and consequentiality in online crime, and, finally, the perils of machine embodiment through a case of virtual diaspora. The two analytic moves I make are to insist on Internet texts as real social facts, and, secondly, to examine how they are embodied and located through technological apparatuses.

*Multi-User Dungeons*

MUDs are text-based virtual worlds in which Internet users can create characters in a shared, interactive space. The first MUDs were built in the early 1980s around fantasy role playing themes reminiscent of Dungeons and Dragons games, concretizing heroic fantasy stories into an interactive, social, distributed form. Currently, there are a proliferation of different types of MUDs with different themes, purposes, and operating systems. The MUDs that I study are LPMUDs, which are "traditional" and "mainstream" MUDs in the sense that they are combat and role-playing game oriented, and tend to use medieval images.[6] These combat-oriented MUDs stand in contrast to non-gaming "talker" MUDs or educational or

professional MUDs. There are currently hundreds of MUDs running worldwide with tens of thousands of users.

As a player on an LPMUD, what you see on your computer monitor is text that describes the environment and other characters in the environment, as well as the actions that you and others perform. Travel through the environment is accomplished with simple commands such as "North," "South," "East," "West," "Up," "Down," "Open Door," etc. Typing the "who" command gives you a list of other participants, and their titles. You can talk to other players in private, or use public chat channels by typing in the desired conversational text. "Soul" commands enable your character to express activity such as smiling, frowning, waving, pouting, blushing, etc.[7]

When first creating a permanent character,[8] you are asked to choose a character name, a gender (usually male or female), and a race (such as elf, dwarf, human, etc.), and begin playing as a first level player. Your character has certain attributes and assets that improve as you accumulate more treasure and kill monsters and other players, and solve quests on the MUD.[9] Gaining experience points, loot and levels, as well as social recognizability and connections is an extremely time-consuming process, so commitment to a particular character and MUD is solidified as one's character develops. While the first two or three levels might be gained in the first few days of playing, achieving the higher ranks of levels fifteen and above, out of a usual twenty to thirty levels, can take months of very active engagement. A sense of presence and location in the virtual world is strengthened through a progressive customization of social position and material accumulation. Higher-level players construct elaborate residences, costumes, and social cliques. As in any community, in other words, a sense of belonging, identity, and social status requires substantial commitment on the part of its members.

Above players in the MUD hierarchy are wizards, who have gained the highest levels and accomplished all the quests, and are responsible for actually building the MUD environment and administering the MUD. LPMUDs are unabashedly hierarchical. Highest level wizards are often called Gods and, as the name implies, have near absolute power to implement decisions on their MUDs. It is often the idiosyncratic visions of particular wizards that become coded into the MUD environment as concrete, structuring resources. While wizards fully participate in the same social conviviality as the players, their pleasures revolve around authorship and management rather

than combat and play. Compared to the gaming structures that govern players, formal parameters for wizard conduct are fewer, being generally limited to some from of peer review and management hierarchy.

While I have not conducted any systematic demographic study of the user base of these worlds,[10] access requires either affiliation with a university; governmental institution; or high-tech corporation or private ownership of a computer with a modem, an Internet account, and a personal phone line. The ability to touch-type is generally a necessity, and if one is to contribute to the actual construction of these worlds, some expertise in computer languages is required. Thus, while the user base of the Internet at large may be increasingly diverse, the *production* of MUD worlds is overwhelmingly dominated by the technologically elite. Running a MUD server will usually require special access to a university or corporate computer system. Thus the fantasy of the mud environment is a complex interaction between a network of various "real world" material technologies as well as the cultural capital of its users and designers.

MUDder subjectivity is both technologically empowered and highly contingent on local and material conditions. Here, I would like to borrow from Donna Haraway's image of the cyborg that is never whole (Haraway 1991), "compounds of the organic, technical, mythic, textual and political" (Haraway 1992, 42), or what Marilyn Strathern might call circuits of partial connections (Strathern 1991). This cyborg is a techno-organic machine within which the division between the symbolic and the material are blurred in a fluid dance of partially determinate relationality. In what follows, I have attempted some preliminary steps toward such a description of cyborg subjectivity.

*Fantasy and Reality*

In the revised introduction to *Reading the Romance*, Janice Radway describes her focus on the actual readers of romance novels as a response to the dominant analytic tendency for purely text-based studies of literature. In her book, she pursues a reader-based account, based on interviews and questionnaires, of the practices of reading romance novels alongside a textual analysis of their content. In her conclusion, she describes an analytic tension between the textual analysis, which sees the structures of a conservative patriarchy reinscribed in the novels, and the reader-oriented approach, which sees the act of reading as located resistance against oppressive structures of the patriarchal family. Rather than privileging one

perspective as more encompassing or correct, she suggests that, by juxtaposing both viewpoints, one can achieve a richer analysis. In Radway's words:

> Had I looked solely at the act of reading as it is understood by the women themselves or, alternately, at the covert significance of the romance's narrative structure, I might have been able to provide one clear-cut, sharp-focus image. In the first case, the image would suggest that the act of romance reading is oppositional because it allows the women to refuse momentarily their self-abnegating social role. In the second, the image would imply that the romance's narrative structure embodies a simple recapitulation and recommendation of patriarchy and its constituent social practices and ideologies. However, by looking at the romance-reading behavior of real women through several lenses, . . . this study has consciously chosen to juxtapose multiple views of the complex social interaction between people and texts known as reading (Radway 1991, 210).

Radway takes pains to emphasize the act of romance reading as located opposition, but she also describes a certain ambivalence, suggesting that "when viewed from the vantage point of a feminism that would like to see the women's oppositional impulse lead to real social change, romance reading can also be seen as an activity that could potentially disarm that impulse" (Radway 1991, 213). The analytic tension that Radway describes between the fantasy world of the texts and "real" social contexts is precisely the analytic conundrum that I am attempting to address, and thus provides a prime starting point for my analysis of MUD practices. Like Radway, I have struggled to reconcile the symbolic content of MUDs with the located processes and material conditions of engagement with these worlds, and I find her juxtaposition of fantasy content and readerly practice suggestive. In particular, her attempts to read across the split between text and society, trying to incorporate both in to her analysis, are pointers to an analysis that takes both textual and material realities into account. What I find wanting in Radway's treatment, however, is a way of describing the textual worlds of the romance readers as themselves constitutive of "real" social relations, and participation in fantasy as itself a social event to be analyzed in terms not ultimately reducible to a social reality outside of the text. While

certainly the act of reading involves an isolated person engaged with a text, I am left wondering if these novels, artifacts that migrated translocally, can be seen as comprising an intertextual virtual community. I wonder if one can conceptualize romance reading as a participatory and profoundly social engagement with the broader community, not predicated on physical co-presence. The complex social and economic maneuverings that enable these women to carve out their own time and space to read, and their intense and immersive engagement with these novels, points, for me, to metaphors of travel, extension, and participation rather than merely isolation and escapism.

The MUDs that I study also participate in an analytically perplexing text/society relation in that they involve inert and physically isolated bodies interacting with vividly immersive fantasy texts. The sorts of tropes around violence, conquest, and colonization operating in many of these worlds, as well as in the discourse around the Internet more generally, are rich material for content analyses.[11] But MUDs differ from novels in that they foreground interactivity and travel to alternative domains through an explicitly networked sociality. So instead of focusing on how textual artifacts constructed on the Net circulate through "real" social contexts at large, I would like to examine the inter- and intra-textuality of the Net as itself a social and political context where history, politics. and discourse are being constituted. By insisting on the reality of the virtual I do not intend to reduce social practice to language games, but rather to foreground the inseparability of semiotic and material technologies. In Appadurai's words, I would like to insist on the role of "the imagination as a social practice" (Appadurai 1990, 5), rather than as merely a commentary on, or a reflection of, "real" social relations whose ultimate ground is a singular subjectivity localized by the biological body.

Within MUDs, the tension between textuality and "real" sociality is similar to the relation between the native categories of "real life" and "just a game." Often MUD users (or MUDders, as they call themselves) use the category of "real life" as a denaturalized category, to refer to existence that is not computationally contingent. In other words, as MUDder Howard Hsieh defines it in his MUD dictionary, real life is "the stuff that interrupts your mudding" (Hsieh 1994). The statement, "It's just a game," followed by the injunction, "Get a life," is a claim made occasionally by MUDders in order to chastise somebody who is overly invested in a MUD, or to diffuse the wrath of a colleague

who finds their MUD activity reprehensible. So while these categories of "real life" versus "the game" are ubiquitous oppositional categories within MUD conversation, what counts as the real is hotly contested. Both "the game" and "real life" are partial realities that matter (Turkle 1994).

Immersion in the MUD context, whether for purely social or gaming purposes, requires partial bracketing of "real life"— a stilling of the physical body, and a turning one's attention to the text on the screen. While all MUDders that I have spoken to point to this sensation of immersion, or bracketing, the degree to which and the ways in which the virtual world is considered a reality that matters and that has consequentiality in their real lives varies widely. The flavor of the controversy surrounding the reality or real life consequences of MUDs is captured in the following statement in the document of MUD "Frequently Asked Questions," written by Jennifer Smith, and published periodically in the newsgroup rec.games.mud.misc. Question 13 reads,

> Is MUDding a game, or an extension of real life with gamelike qualities? It's up to you. Some jaded cynics like to laugh at idealists who think it's partially for real, but we personally think they're not playing it right. Certainly the hack-'n-slash stuff is only a game, but the social aspects may well be less so (Smith, J. 1994).

So while a vague sentiment exists among MUDders that there are certainly elements of MUDs that are fantastic, silly, trivial, and just for fun, other aspects, most notably the social, have a reality to them that is not easily denied. "Reality," or visible and salient relationships, is a located inflection of consequentiality, not reducible to commonsensical distinctions between fantasy and reality. The case of MUD marriage and romance may furnish some material for illuminating this dynamic.

*Living the Romance*
Different MUDs institutionalize marriage in different ways, but in the LPMUDs that I study, predictable norms of monogamous heterosexuality are playfully reproduced. One can generally find a chapel, a priest, and heterosexual newlyweds, provided with familiar props such as rings, wedding dresses, and bouquets. Couples might subsequently pool bank accounts, or talk on a special private channel enabled by their wedding rings. They sometimes even adopt other players as

their children. It is rare to have things such as sex and pregnancy coded into the MUD system, but Farside, the primary MUD that I play, does have a simple but bizarre concretization of sexuality. To be sexually active, one must first purchase genitalia, after which it will be noted in your character description that you are sexually mature. A simple command will enable you to have sex with another character of the opposite gender, providing that they too are sexually mature, and frequent sexual acts may eventually lead to pregnancy of the female character. After a period of time she will have a child, described by the system as a slave with its mother's attributes and pre-programmed to obey and follow her around.[12]

These gaming components of marriage and kinship are relatively simple, and are used by MUDders as resources to structure social interaction. While it is possible to "read" this text—this concretization of social relations in virtual environments—as a simple reinscription of hegemonic notions of gender, kinship, and sexuality, to *end* there would be to miss the peculiarities of MUD materiality, reducing MUDs to merely a commentary on or reflection of real life, rather than as an alternative space with its own unique networks of accountability. To read a MUD as a text *about* real life ignores the travel that takes place through the prostheses of networking technologies and the profoundly embodied nature of experience in virtual worlds. One is not "in" real life reading the MUD, one is, as Stone might say, elsewhere (Stone 1991). The elements that I have described are merely the structural elements of the gaming system; the reality, so to speak, of MUDsex and MUDmarriage is a bit more complex.

For example, my partner in real life often eyes me suspiciously as I sit in front of my terminal—"You're not MUDmarried are you?" "Are you having netsex?" We both laugh, and yet I scrupulously avoid MUD romance because of a sort of uncomfortable guilty twinge; clearly a result of his only partially serious questions. My bracketing of the two worlds is apparently incomplete.

By contrast, one of my MUD friends, despite protestations from her jealous real-life mate, is married to a number of different MUDders on different MUDs. Though her real-life mate is also a MUDder, Tenar, or Melissa in real life, refuses to MUDmarry him, or even to have virtual sex with him. She is a powerful and well-liked figure on a number of different MUDs, and no doubt has little trouble in maintaining numerous romantic Internet liaisons. She describes virtual sex as akin to

VIRTUALLY EMBODIED

an interactive romance novel. The metaphor is crucial. The fantasy "text" is paramount, the real bodies nonexistent. She explains: "It is how you describe yourself and how you act (on the Internet) that makes up the 'real you'. . . . real-life persons' looks mean so little to me. . . ." She explains to me, additionally, that the real-life gender of her MUDspouse would be of little concern to her. "You see," she explains to me, patiently, "to me there is no real body." What is at stake here is not the immediacy or reality, if you will, of experience on a MUD. Both my friend and I are equally embedded within the MUD environment; we are both effective travelers. What is at stake, rather, is the visibility of certain relationships from our respective points of view. For her, the appeal of the virtual world lies in the relative invisibility of real life consequences and relationships. "Too much reality in virtual reality kills it all."

This is not to say that the virtual body lacks substance. Tenar is a unique, well-developed, and profoundly real partial reembodiment of Melissa. She describes herself as constructing an online description of herself that recalls her svelte eighteen-year-old body. And she tells me, with disarming honesty, "I don't bring Melissa into the game, but I bring Tenar back with me." In other words, Melissa is invisible from the point of view of Tenar, but Melissa sees Tenar as a more positive self image that animates her real life.

Both Melissa and I fully participate in an online social reality that is not reducible to experiences localized by our biological bodies, despite the fact that we have differing senses of accountability in our participation in these partially disjunctive worlds. Farside, for both of us, is a reality that matters. We are each able to occupy unique subject positions within the MUD universe that are related in partial and shifting ways to identities localized by biological bodies.[13]

*Crime, Discipline, and Accountability*
In considering the complex couplings and decouplings of MUDders from and between fantasy worlds, virtual identities emerge as extensible and malleable, but also particular, contingent, and embodied through the prosthetic technologies of computers and computer networks. These virtual characters can be seen as alternative reembodiments in a partially disjunctive world, with complex mechanisms for handling connection and accountability that are absolutely contingent on the technosocial apparatuses that produce their effects.

One of the arenas where consequentiality and accountabil-

ity are hotly contested on combat MUDs is around the social practice of killing other player characters (pking). Pking is a social practice toward which many MUDders experience a degree of ambivalence. For example, Scott Frank, an anthropologist and a MUDder, sees it as morally reprehensible, and yet, significantly, Frank is a co-founder of a vigilante group on Farside that hunts and kills players that have killed defenseless players, or that have MUD-raped somebody.[14] Other players will use pking only if provoked. For example, they might kill somebody that has stolen some of their loot. Other players enjoy pking "for the thrill of it," and higher level players will often engage in extensive pking battles, as part of the game. Generally, though, it is considered sociopathic behavior for higher level characters to prey on newbies, and many MUDs have rules in place prohibiting this kind of practice.

In a face-to-face interview that I had with Frank, he elucidated the ambivalence around killing and violence, and the complex play between the categories of the virtual ("abstract") and the real.

MIZUKO ITO: Do you ever have moral positions about violence on MUDs?

SCOTT FRANK: [shakes his head] A MUD is very far removed. Gosh, I sound kind of hypocritical. On the one hand, I'm saying stuff like social skills transfer. But then I'm saying that I don't think violence does. Violence is very, very abstract on a MUD. When you're talking with somebody, and utilizing social skills, you're *really* doing it. When you're fighting a monster, you're not *actually* going out and hitting anything. There are different layers of reality. You're really talking to people. You're not *really* fighting something.

MI: How about pking?

SF: Pking... [shakes head] See, I don't get pking. It's never, ever appealed to me. The thought of ending somebody's... I mean, somebody who's *real*, somebody who has their own thoughts. Of ending that person's extension on a MUD. It's just... It's almost like killing to me I guess. I just don't get it.

MI: So that feels very different to you from killing monsters.

SF: A monster is nothing. A monster is an extension of the game. It's not *real*. A person's *real*.

The "reality" of violence on MUDs is carefully qualified; violent fantasy is neither the same as "real life" violence nor reducible to "just a game." While the non-computational is elided within the category of the real, some of the terms of "real" consequentiality are located squarely within the gaming context. Virtual death only has structural consequences of virtual bodies, and yet it is "real" or more consequential than monster killing because of an identification with biologically based subjectivity. The "reality" of the fantasy character, the extension of MUDder subjectivity, is a result of both intratextual and extratextual connections. It can not be reduced to either. The explicit and implicit rules of MUD practice are based an acknowledgment of both kinds of relationships.

In terms of machine connectivity, access to the MUD server is enabled by the Internet, and for Farside, as in most combat MUDs, access is open for anyone who has telnet capabilities on the Net and the semiotic technologies necessary for discursive engagement with these worlds. With the right kind of Internet access, one can open multiple connections either to the same MUD or to a number of different MUDs at the same time. There is generally little restriction on the number of characters that one can create or the number of MUDs that one can be logged on to concurrently. What is restricted, however, is the number of characters that one can run concurrently on a particular combat MUD. Otherwise, a number of virtual characters connected with a particular biological body could collectively gain unfair advantage, ganging together to attack a monster or another player. Dispensable adjunct characters could die sacrificial deaths in order to consolidate experience points and treasure in a single primary character, creating a monstrous collective organism that defies socially acceptable subject boundaries. In other words, most combat MUDs require multiple characters of a single physically located self to be either spatially or temporally distanced from each other.

While most players abide by this rule, in the case of the occasional rule transgression, virtual bodies are difficult to discipline. The technical capability for multiple self-proliferation sits in uneasy tension with the social more of one body per person. Pakka, the sheriff of Farside, explained to me the difficulties he has had in disciplining characters on MUDs:

Multiple characters are extremely hard to catch.

> Something has to set off in your mind—this person, these two are always on together. They call in from the same location. They always run together. You've got to notice that.

Once Pakka catches somebody breaking the rules, punishment is also difficult to enforce. He can banish and delete a particular character on a MUD, but nothing prevents the repeated creation of newbie (new) characters that can hurl a continuous barrage of abuse at the sheriff. For repeated offenders, the entire site has to be banned, which means anyone logging in from that site can no longer get on. This slows but does not stop a "criminal" who has access to multiple computers at a computer lab. In other words, the freedom of travel enabled by multiple concurrent connections makes it extremely difficult to fix a singular subject position to a particular virtual body. The sheriff can strip a character of all possessions and physical strength, but the voice of an adept cybernaut inhabiting an anonymous, unmarked body proves nearly impossible to stifle.

The rule on multiple synchronous characters on a single MUD does not, however, prohibit a range of other intriguing possibilities around multiple virtual identities. Different MUDs provide different pleasures, fantasies, capabilities, and features, and different social positions within MUDs provide opportunities for experiencing different social locations. Some MUDders have confided in me the pleasures and difficulties of gender swapping, and occasionally a story circulates about a chagrined MUDder's discovery of the unexpected biological gender of a MUD intimate. Wizards, who have to act as responsible administrators or coders on their home MUDs, often create player characters on other MUDs to revisit the pleasures of combat and play. Sometimes they will log onto their home MUD just to check out the environment and social scene from the point of view of a low-level player. Generic newbie or guest characters also provide opportunities for anonymous lurking and freedom from a socially marked, recognizable character. Anonymity is one of many possible subject positions on MUDs, and is usually the exception rather than the rule.

MUDder subjectivity, then, is both enabled and policed by sociotechnical structures of extension and control that are distributed through global computer networks. They are neither disconnected from nor reducible to subjectivity localized by the biological body in a fixed locale, but are concretely re-embodied through computational prostheses.

In his discussion of computers and digitality, Brian Cantwell Smith argues for a deconstruction of the conceptual boundary between the formal realm of "pure symbols" and the messy world of objects and referents:

> Inside is the pure, clear realm of symbols, abstract, classified, discretely categorized, mathematically modeled. The "semantic" realm, on the contrary, is assumed to be outside—out in the messy "real world."

Instead, Smith insists that:

> [C]omputers participate in their subject matters: they muck around in, create and destroy, change, and constitute, to say nothing of represent and reason and store information about, a hundred realms—new realms, some of them, that owe their existence to the very computers that interact with them.

A good example is when you scratch a CD: "a fingernail can leave a wake of devastation hundreds of bits wide," triggering complex recovery schemes to prop up the "digital abstraction" (Smith 1994). The questions that I have been asking in this paper parallel Smith's inquiry in some crucial ways. Where Smith questions whether computer functions are merely symbolic, I question whether online worlds are merely virtual. Or more specifically, I might suggest an understanding of the virtual as the computationally embodied, rather than as the dematerialized.

The question of machine bodies, and their participation in the construction of online worlds, returns us to the issue of the boundary between the physical and the non-physical in computers and computer networks. From the point of view of the human user, online worlds provide opportunities for creative bodily forgetting, where the user is plunged into a sort of magical realm of the digital. The machine, in this scenario, is a faithful extension of user agency, its bodily processes rendered invisible to maintain an ideally seamless fantasy abstraction. In the discourses around the Internet, machine bodies are similarly rendered homogeneous and invisible, silent and faithful enactors of a global web of seamless information. What this picture leaves out, and what social and cultural studies of science and technology draw attention to, are heterogeneities, the

concreteness, and the local particularities—in short, the materiality—of information.

One of the consequences of online ethnography is that these heterogeneous materialities and localities are excruciatingly difficult to see, since the technically naive ethnographer participates in the same systems of erasure; the guts of my own computer, and the computers that I bounce across to get to Farside, not to mention the physical bodies of other Farsidians, are systematically unavailable to me. And beyond these absences lie the many agents and agencies implicated in the production and maintenance of computers and computer networks—multinational corporations, microelectronics factory workers, and military funding agencies, to name a few. My attempt, here, is to take a few steps toward making some of these absences at least partially visible from the point of view of, and in the terms of, the actual online worlds. This is not to say that these systems of erasure are not powerful and enabling; they are the very basis of our successful couplings with prosthetic devices. What I am suggesting, however, is that while we participate in these empowering worlds, we should also be in some way accountable, or at the very least, appreciative, of the webs of invisible agencies that enable our extensions (Suchman 1994).

Returning to Haraway and Strathern's circuits of partial connections, the figure of the cyborg suggests translocal networks and relations that are never disembodied or deterritorialized into a homogenized global imagination. Thus, for example, unified communities are not imagined through particular mass media texts, but rather lived through negotiating particular locations and relationships within texts that migrate through particular sociotechnical apparatuses. So the seeming immutability and imaginary homogeneity of a particular text is constantly being subverted by the selective positionings of heterogeneous agents that co-construct meaning with the structuring resources of the text. Close attention to technological contingencies will help to counteract the tendency to see global informational networks as an unimpeded free flow of information and cultural capital in a purely symbolic realm.

In closing, I would like to underscore the very local computational contingencies that qualify the freedom of MUDder travel with a sad epilogue to my story of Farside. During the period of my engagement with Farside it has shifted locations to a number of different machines around the world. The files that contain all the information about the MUD operating system, the world, and every character reside in the server unless

there are backups on other machines. In August, 1994, the machine that Farside was living in experienced a system failure, and all player files and interface elements were lost. There were no backups, and shortly thereafter the university banned MUDs. Farsidians immigrated en masse to, among other MUDs, Kerovnia, a MUD that many Farsidians also had characters on. Marius, the administrator of Farside, would post occasional notes on Kerovnia as to his efforts at reconstructing files, or trying to find a new site. Farsidians waited in helpless distress for some good news. I pined at the loss of my fieldsite, not to mention the character that, for me, was quite an accomplished ninth level. I created a newbie character on Kerovnia, and began conducting interviews with former Farsidians there, happy to see old friends using the same names on a MUD that had many shared elements with Farside.

A few months thereafter, I received a letter from Marius, forwarded through many email boxes around the world, that he had tried his best, but had to conclude that all was lost for Farside. I have not had a chance to discuss with many fellow Farsidians about the loss, so I can only speculate as to their reactions. I do recall, however, a number of years ago, when I was a newbie on Farside, there was a MUD called Sushi that was often used as an alternate by Farsidians. Some months later, Sushi, for reasons unknown to me, was shut down. There was a sudden influx of new characters on Farside with the tag "Sushiite" appended to their titles. For a few months, they comprised a highly visible enclave within the Farside social and political scene, a displaced but proud sub-community.

Perhaps Farsidians will similarly rally around an imagined community in a displaced locale, or perhaps they will quietly disperse and assimilate to other worlds, virtual or otherwise. Or perhaps they will reconstruct their world out of fragmentary code and collective memory. Regardless of the outcome, it is clear that Farsidian identity is located not only in the fantasy text, but in the machine architectures and social relations that animated that text. Just as mass media artifacts operate as material structures that enable the articulation of certain subject positions, global networks are concrete sedimentations of particular machines and machine sociality.

Certainly, bits of code mobilized by silicon chips and transported through fiber optics and telephone lines do not have the same materiality as flesh and blood, hunger, and organic pain. And my parallels between diasporic identity politics and Farsidian displacement are not meant as a trivialization of the

more weighty consequentiality of organically embodied experience. And yet, as I sit, tightly coupled to my computer keyboard, embedded in semiotic meanderings through my computer monitor, I question any clean separation between human and machine, the social and the technological, the real and the textual. Current trends in technology development and international politics suggest that, increasingly, machine bodies will be the zones of contestation for transnational power brokering. It is hardly the moment to ignore either the materiality or consequentiality of the virtual imagination.

NOTES

Thanks to the many people who have commented on, inspired, and guided this paper through numerous permutations: Debbora Battaglia, Carol Delaney, Ray McDermott, Joan Fujimura, Donna Haraway, Sylvia Yanagisako, Purnima Mankekar, Julian Bleecker, Stefan Helmreich, Brian Cantwell Smith, Scott Fisher, Joichi Ito, Momoko Ito, Timothy Leary, David Porter, Pavel Curtis, Mike Dixon, Scott Frank, Cliff Li, Benjamin Stickney, Melissa Delaney, Andrew Blythe, Matt Messier, Craig Zieman, Paul Victor Smith, and Daniel Kerr.

*Portions of this paper were presented at the 1994 meetings of the Society for the Social Studies of Science in New Orleans, under the title, "Cyborg Couplings in a Multi-User Dungeon," and the American Anthropological Association in Atlanta under the title, "Cyborg Fantasies: Extensions of Selfhood in a Multi-User Dungeon."*

1 See Fisher 1994 for a discussion of the invisible resources needed to engage with cyberspace.

2 Here, while I am implicated in these discourses through my use of spatial metaphors and metaphors of travel, I am attempting, at the same time, to deconstruct the closure of "artificial worlds" as bounded, non-physical, and culturally universal entities. Stefan Helmreich discusses the culturally specific ways in which people discuss computers as specifically bounded "worlds" (Helmreich 1995).

3 Here I find myself allied with anthropologists in the fields of

communications studies who are examining the local and embodied contexts of mass media reception (for example: Bobo 1993; Gupta forthcoming; Mankekar 1993) as well as cyborg anthropologists (Downey et al. 1995) and ethnographers of technology use; for reviews see Escobar 1994, Hess 1992, and Traweek 1993.

4  Here, feminist studies of science and technology inform my work—for example, a form of "situated knowledges" articulated by Haraway (1986), Lucy Suchman's "located accountability" (1994) and Joan Fujimura's questioning of "Where Do We Stand?" (1991).

5  See, for example, Bijker et al. 1987, Bijker and Law 1992, Clarke and Fujimura 1992, Jasanoff et al. 1995, Lynch and Woolgar 1990, and Pickering 1992.

6  "LP" are the initials of the developer of this particular mud operating system.

7  A typical mud environment and encounter might appear as follows:

> You are near the center of the little village of Dambarsham. To the north, along Kite Row, you can hear laughter and merry-making. East the road continues into the center of Dambarsham. A street named Wildman's Walk is south, from which you can hear a loud "clanking" noise. You quickly come to the conclusion that this is not a quiet little country village. The only peace is to the west, where the road starts to make its way out of Dambarsham. There are four obvious exits: west, north, south, and east.
> -Duke Adinar appears.
> -Duke Adinar waves
> >wave
> -You wave
> >say hi Ad
> -You say "hi Ad"
> -Duke Adinar grins mischievously

8  I am using the term "character" here to describe what has elsewhere been called an "avatar" or an "online persona." I use it as on ironic play on mass media and fantasy characters. I will be using "biological" body in a similarly ironic way to describe the non-computational side of MUDder identifications.

9  By typing "score" or "inventory" you can see your current attributes and possessions. For example:

>score

You are Mimi the lowrank ranger (nice).

You have 5276 experience points, 3405 gold coins,

74 hit points(74).

66 spell points.

Wimpy mode.

Age: 13 hours 32 minutes 52 seconds.

Dexterity: 3    Strength: 4    Constitution: 4

Intelligence: 3    Power: 4    Agility: 4.

As of now you are level 3.

>inventory

You are carrying:

Cola bottle.

Cloak.

A Hawk (perched on shoulder).

A hawk's quicktyper.

A White Sash (worn).

The Hitch-hikers Guide to the Galaxy.

Mimi's house key.

Permanent invitation to visit Joichi's house.

10  In his 1993 book, Howard Rheingold cites two estimates of the MUD user base in 1992: Richard Bartle, designer of the first MUD, estimates 100,000 users past and present. Pavel Curtis, MUD developer at Xerox PARC, estimates 20,000 active MUDders (Rheingold 1993: 146).

11  See Grey and Driscoll 1992, Stone 1990.

12  Male characters have been known to have sex changes in order to acquire their own slaves.

13  For a discussion of further cases of "constructions and reconstructions of the self" in MUDs, see Turkle 1994.

14  On Farside the command "fuck [character name]" results in an online description of sexual engagement with the person in question. MUDrape in this context refers to an unwanted sexual liaison of this sort, or to a range of more idiosyncratic unsolicited sexual advances.

Appadurai, Arjun
  1990  Disjuncture and Difference in the Global Cultural
        Economy. *Public Culture* 2(2): 1–24.

Bambara, Toni Cade
  1993  Reading the Signs, Empowering the Eye: *Daughters of the
        Dust* and the Black Independent Cinema Movement. In
        *Black American Cinema*. Manthia Diawara ed.
        118–144. New York: Routledge.

Bijker, Wiebe E., and John Law eds.
  1994  *Shaping Technology/Building Society: Studies in
        Sociotechnical Change.*

Bijker, Wiebe E., Thomas P. Hughes, and Trevor Pinch eds.
  1987  *The Social Construction of Technological Systems: New
        Directions in the Sociology and History of Technology.*
        Cambridge: MIT Press.

Bobo, Jacqueline
  1993  Reading Through the Text: The Black Woman as
        Audience. In *Black American Cinema*. Manthia Diawara
        ed. 272–287. New York: Routledge.

Clarke, Adele and Joan Fujimura eds.
  1992  *The Right Tools for the Job: At Work in Twentieth-Century
        Life Sciences*. Princeton: Princeton University Press.

Downey, Gary Lee, Joseph Dumit and Sarah Williams
  1996  Granting Membership to the Cyborg Image. In *The Cyborg
        Handbook*. Chris Hables Gray, Heidi Figueroa-Sarriera,
        and Steven Mentor, eds. New York: Routledge.

Escobar, Arturo
  1994  Welcome to Cyberia: Notes on the Anthropology of
        Cyberculture. *Current Anthropology* 35(3): 211–232.

Fisher, Scott
  1994  Telepresence: Context and Sense-ability in Digital Worlds.
        In *TechnoCulture Matrix*. Toshiharu Ito ed. 86–87.
        Tokyo: NTT Publishing Co.

Fujimura, Joan

    1991  On Methods, Ontologies, and Representation in the Sociology of Science: Where Do We Stand? In *Social Organization and Social Process: Essays in Honor of Anselm Strauss.* David Maines ed. 207–248. New York: Aldine de Gruyter.

Grey, Chris and Mark Driscoll

    1992  What's Real About Virtual Reality? *Visual Anthropology Review* 8 (fall 1992): 39–49.

Gupta, Akhil

    1995  Blurred Boundaries: The Discourse of Corruption, the Culture of Politics, and the Imagined State. *American Ethnologist* 22(2): 375–402.

Haraway, Donna

    1991 [1985]  A Cyborg Manifesto: Science, Technology, and Socialist-Feminism in the Late Twentieth Century. In *Simians, Cyborgs, and Women.* New York: Routledge. 127–148.

    1991 [1986]  Situated Knowledges: The Science Question in Feminism and the Privilege of Partial Perspective. In *Simians, Cyborgs, and Women.* New York: Routledge. 183–202.

Hayles, Katherine

    1992  The Materiality of Informatics. *Configurations* 1: 147–170.

Helmreich, Stefan

    1995  Anthropology Inside and Outside the Looking-Glass Worlds of Artificial Life. Presented at the workshop Biology, Computers, and Society: At the Intersection of the "Real" and the "Virtual," Stanford University, June 2–4.

Hess, David

    1992  Introduction: The New Ethnography and the Anthropology of Science and Technology. *Knowledge and Society* 9: 1–26.

Hsieh, Howard

    1994  Mudders Dictionary. Posted to rec.games.mud.misc, September 18.

Jasanoff, Shelia, Gerald E. Markle, James C. Petersen, and Trevor Pinch eds.
    1995  *Handbook of Science and Technology Studies.* Thousand Oaks: Sage.

Lynch, Michael and Steve Woolgar eds.
    1988  *Representation in Scientific Practice.* Cambridge: MIT Press.

Mankekar, Purnima
    1993  National Texts and Gendered Lives: An Ethnography of Television Viewers In a North Indian City. *American Ethnologist* 10(3): 543–563.

Pickering, Andrew ed.
    1992  *Science as Practice and Culture.* Chicago: University of Chicago Press.

Radway, Janice A.
    1991 [1984]  *Reading the Romance: Women, Patriarchy, and Popular Literature.* Chapel Hill: University of North Carolina Press.

Rheingold, Howard
    1993  *The Virtual Community: Homesteading on the Electronic Frontier.* New York: Addison-Wesley.

Rushkoff, Douglas
    1994  *Cyberia: Life in the Trenches of Hyperspace.* San Francisco: Harper San Francisco.

Smith, Brian Cantwell
    1994  Coming Apart at the Seams: The Role of Computation in a Successor Metaphysics. Presented at the workshop Biology, Computers, and Society: At the Intersection of the "Real" and the "Virtual," Stanford University, June 2–4.

Smith, Jennifer
    1994  MUD Frequently Asked Questions. Posted to rec.games.mud.misc., June 1.

Stone, Allucquere Rosanne
    1991  Will the Real Body Please Stand Up?: Boundary Stories about Virtual Cultures. In *Cyberspace: The First Steps.* Michael Benedikt ed. 81–118. Cambridge: MIT Press.

Stenger, Nicole
    1992   Mind Is a Leaking Rainbow. In *Cyberspace: The First Steps*.
           Michael Benedikt ed. 49–58. Cambridge: MIT Press.

Strathern, Marilyn
    1991   *Partial Connections*. Savage, Maryland: Rowman and
           Littlefield.

Suchman, Lucy
    1994   Working Relations of Technology Production and Use.
           *Computer Supported Cooperative Work* 2: 21–39.

Tomas, David
    1992   Old Rituals for New Space: *Rites de Passage* and William
           Gibson's Cultural Model of Cyberspace. In *Cyberspace:
           The First Steps*. Michael Benedikt ed. 31–48. Cambridge:
           MIT Press.

Traweek, Sharon
    1993   An Introduction to Cultural and Social Studies of Sciences
           and Technologies. *Culture, Medicine, and Psychiatry* 17: 3–25.

Turkle, Sherry
    1994   Constructions and Reconstructions of Self in Virtual
           Reality: Playing in the MUDs. *Mind, Culture, and Activity*
           1(3): 158–167.

Woolley, Benjamin
    1992   *Virtual Worlds: A Journey in Hype and Hyperreality*.
           Cambridge: Blackwell.

# THE POSTMODERN PARADISO
## DANTE, CYBERPUNK, AND THE
## TECHNOSOPHY OF CYBERSPACE

Jeffrey Fisher

> *Since the universe is actually composed of information,*
> *then it can be said that information will save us.*
> —Philip K. Dick

The Middle Ages seem to crop up a lot these postmodern days. Frequently they appear in the guise of the Dark Ages, signaling a past collective self that we have transcended through the progress of history and science.[1] A common example of this generally modernist mythography contrasts the modern invention of the individual with the relative lack of individual identity or definition in pre-modern Europe. Certainly modern and medieval understandings of individuality and identity are different, but these accounts generally do not go very far towards discovering the ways in which that might be true. The concern is not a historical one, strictly speaking, but mythological—the construction of an "other" past by which we define ourselves, and to which we are superior, however "fascinating"

that past might be. Not every invocation of the Middle Ages in modernist and postmodern discourse is so negative, however, even when it generalizes. Jean Baudrillard has recently discussed the Biosphere 2 project in terms of the medieval concern for immortality and the resurrection of the body.[2] While he invokes medieval culture as a critique of Biosphere 2, he adopts a less condescending attitude than one might expect, insofar as his argument is premised on an important continuity between the medieval and the postmodern.

Within the trajectory, then, of a growing tradition of postmodern allusion to medieval thought, Katherine Hayles, in a recent essay on cyberspace, makes the following observation: "Perhaps not since the Middle Ages has the fantasy of leaving the body behind been so widely dispersed through the population, and never has it been so strongly linked with existing technologies."[3] This desire for disembodiment informs much cyberpunk literature, and consequently forms the subject matter of much criticism. Hayles here gestures, in an off-hand way, toward the (presumed) universal medieval yearning for the next life, and thereby links the postmodern daydream of disembodiment with the religious aspirations of the Middle Ages.

Arthur Kroker calls the socioeconomic manifestation of this fantasy the "will to virtuality." He connects it with memory, or, more properly, overcoming memory in virtual databanks:

> Archivalism is power: The power to download the body into data, to screen the body electronic, to file, delete and recombine the body in its virtual form as a relational data base into new configurations. Archivalists are Nietzsche's body and conscience vivisectionists, vampiring organic flesh, and draining its fluids into cold streams of telemetry. . . .Medievalism might have been characterized by "bleeding" through the application of leeches to the skin as a medical practice, but recombinant history [i.e. history as dead information] gives us virtual bleeding.[4]

The archival instinct is the drive to tame memory, to contain it by institutionalizing it. But this rendering memory permanent is in fact the death of memory because memory itself is transcended by an excess of remembering—memory and history become dead information. Thus the medieval reference in Kroker's analysis serves a dual function. It connects the attempt to purify digitally with a resultant evil—that is, bleeding as

well-intentioned but wrong-headed. More interestingly, in connecting body and memory, it sets up a medieval mirror for the will to virtuality; whereas bleeding as a medical practice is an attempt to remove illness and discard it, leaving the body purified, virtual bleeding aims to extract pure personality and discard the body. Kroker's point seems to be that the archive of disembodied telemetries, in the service of a virtual elite, is not memory at all but dead information. It transcends memory both insofar as it is a simulacrum (in the Baudrillardian sense of a copy without an original) of memory and insofar as it creates an excess of memory. What is interesting for the present essay is the way in which Kroker's observation ties in with Hayles's, that is, the link between disembodiment and memory. Transcendence is immediately of memory, but by extension of the body and things bodily. The transcendence of memory in cyberspace is thus the transcendence of history.

In the following chapter I explore the relationship between memory, body, and transcendence by examining the shared ambivalence of the Middle Ages and postmodernity toward the body, and the fundamental role in both periods of memory and amnesia in overcoming the limitations of corporeality. Medieval attitudes toward the body are more complicated than a stereotyped dualism. Conversely, while we in the modern world chastise our medieval counterparts for their otherworldly neglect of the body, we also strive to dominate our bodies on the road to success by practicing a peculiar form of asceticism. And, more importantly for our present concerns, we yearn for the hypercorporeality of cyberspace, where we can leave behind the physical and mental limitations of our bodies. We could go more places, know more—be more—if we could only get beyond this mortal coil.

The first part of this chapter presents a medieval view of memory and body. Generally, medieval thinkers emphasized that the disembodied soul no longer requires images, or phantasms, derived from sense-experience in order to make experience or knowledge present to the mind; that is, to remember it. The soul in heaven is capable of knowing/remembering even physical things without reference to the thing's physicality. This is in part due to the transcendence of the body, but also due to the total presence of perfect memory in heaven—that is, God. Nevertheless, at the last judgment, we are to be rejoined to our bodies, at which time we will be perfected and live the true life of glory. Thus, the sublation of the body is finally essential to transcending it, and the end product is a vastly modified phys-

icality, sublated according to the mode of the transcendent truth to which it is assimilated. This analysis proceeds primarily by way of Dante, with reference to Bernard of Clairvaux, Duns Scotus, and the anonymous fourteenth-century *Cloud of Unknowing*.

The second part of this chapter develops an analysis of the fantasy referred to by Hayles in terms of the archivalistic/antimimnetic tendency noted by Kroker. Hypermemory enables and is enabled by forgetting; the virtual transcendence of memory empowers the virtual transcendence of the body and of history. In the end, the body seems headed toward the same kind of sublation we saw detailed in the medieval theories of salvation—first left behind completely in a kind of Hegelian antithesis, then synthesized into terminal bodies which have become extensions of cyberspace. This section of the chapter grounds itself generally in terms of available online material.

Finally, I attempt to establish the will to virtuality as an essentially religious will to transcendence, and similarly subject to deconstruction. Cyberspace is the postmodern paradise, where we forget the ills of our past lives in the total presence of absolute recall made possible by the relentless virtualization of reality. The discourse which furthers this virtual ideology is finally technosophical, a synthesis of theological and technological grammars. Analysis proceeds primarily in terms of cyberpunk authors Rudy Rucker and William Gibson, as well as French professor of hypermedia Pierre Lévy, who engages unabashedly in a true technosophy of cyberspace with the help of medieval neoplatonic theosophies of divine emanation.

*Memory and Transcendence in the Middle Ages*

In 1321, Dante Alighieri completed the *Paradiso*, the third and final part of his epic poem chronicling his journey through the realms of the afterlife. Narrated in the first person, the poem is the story of a character who is more than theoretically distinguishable from Dante the poet. This distinction only further complicates the question of the extent to which Dante claims that there is truth in his poem, and the nature of the truth to which he lays claim. Among the difficulties that arise is the question of whether Dante's narrative is to be understood as a dream vision, a waking vision, or an actual journey. One of the many issues at stake in this discussion is the relation of Dante's body to his experience of an incorporeal or quasi-corporeal afterworld. Without attempting to resolve these questions here, we may note that they nevertheless point us toward an impor-

tant distinction between mystical and beatific visions. Put somewhat crassly, mystical experience may be characterized by its bodily nature, such that a vision or experience is either bodily or, if ecstatic, is followed by a return to the body in history. The beatific vision, on the other hand, is the disembodied soul's perpetual contemplation of God in paradise. We should also notice, however, the essential continuity between beatitude and the mystical experience which mimics or prefigures it. That is, mystical vision is the temporal/historical antetype of beatitude, differing primarily in terms of its limitations—in part, its bodiliness. We should not mistake this for simple anti-corporeality: the body is frequently a crucial, positive element in mystical experience. The consumption of the Eucharistic host, for example, can bring on mystical ecstasy, while Julian of Norwich's visions of Christ's blood flowing over her body dramatize the raw corporeality of sight.[5]

The imaginary and therefore corporeal nature of such a vision brings us to the epistemological fact that, while in the body, a human being knows things physically. When Dante wonders why the souls in heaven appear to him in the celestial spheres, his guide, Beatrice, points to his corporeal limitations:

> They showed themselves to you here [in the Moon, the lowest sphere] not because/ this is their sphere, but as a sign for you/ that in the Empyrean their place is lowest./ Such signs are suited to your mind, since from/ the senses only can it apprehend/ what then becomes fit for the intellect./ And this is why the Bible condescends/ to human powers, assigning feet and hands/ to God, but meaning something else instead.[6]

Dante here follows Aristotle in holding that all thinking takes place with images in the mind—phantasmata. When the intellect thinks, it manipulates these phantasmata, which are fundamentally sensible, that is, corporeal. Memory, consequently, works much the same way.[7] Dante's vision is essentially a corporeal one in this sense, and therefore one which can be remembered—and recorded in a poem.

Dante also receives a glimpse of the transcendent beatific vision. But this final vision surpasses the ability of his memory to recall it:

> my sight, becoming pure, was able/ to penetrate the ray of Light [from God] more deeply—/ that Light, sublime, which in Itself is true./ From that

point on, what I could see was greater/ than speech can show: at such a sight it fails—/ and memory fails when faced with such excess./ . . . my vision almost fades/ completely.[8]

The beatific vision transcends memory in its excess—it is too much for frail human powers. Consequently, it is only when we have been disembodied that we may truly experience beatitude. Memory and body have been left behind in the face-to-face vision of God, transcended in oblivion, an excess of memory. The importance of amnesia to the mystical/beatific movement—connected with disembodiment—is strikingly apparent in the anonymous fourteenth-century English mystical treatise known as *The Cloud of Unknowing*. According to this popular work, the proximate objective of mystical activity is to enter the dark cloud beyond all human knowledge in which, from our human perspective, the eternal transcendent light that is God dwells. However, the author also points out that before we may attain to this mystical height, we must first forget all things here below:

> . . . you must put beneath you a cloud of forget-
> ting, between you and all the creatures that have
> ever been made. . . . Whenever I say "all the crea-
> tures that have ever been made," I mean not only
> the creatures themselves, but also all their work
> and circumstances.[9]

Body, history, poverty, charity—memory itself—are negated in an amnetic movement into the transcendent beyond body and beyond memory.

Dante also engages the dialectical power of amnesia in *Purgatory*. Bathing in the river Lethe, the river of oblivion, "obliterate[s]" his "sad memories."[10] He is then prepared to drink of the waters of Eunoe—a memory rejuvenated and restored—a memory purified of the "sad memories" of sin that weigh it down. Dante is transformed, transfigured, in a dialec-tic of amnesia and anamnesis. His bodily and spiritual weak-nesses are left behind. These final purifications at the summit of the mountain of Purgatory ready Dante for the final leg of his spectacular journey through the afterlife—Paradise. This forgetting and transfiguring hypermemory parallels the beatif-ic vision, in which history is left behind in the eternal now. As Dante himself puts it, he has been—and continues to become—"transhumanized."[11]

Memory, and by extension, body and history, is not a fac-

tor in the beatific vision. Just as the mimnetic function cannot process or retain the "excess" of the beatific vision, memory is obviated by the total presence of absolute memory—God. All that the blessed in heaven know they know in God, that is, in the perfect form in which all things exist in and are known by God himself.[12] Thus the disembodied souls enjoying the beatific vision not only can know without body, without images, without memory, they can even know the bodily or historical without reference to its body or historicity.[13] The early-fourteenth-century philosopher John Duns Scotus distinguished between what he called intuitive and abstractive cognition. Intuitive cognition is the knowledge of a thing as present and existing, abstractive cognition is indifferent to existence or non-existence. Thus, as I write this, I have intuitive knowledge of my pen and abstractive knowledge of Scotus. Scotus argued, then, that while the blessed in heaven have knowledge of him sitting and writing as he sits and writes, because they know all things in God, and their knowledge of God is itself intuitive, their knowledge of him (Scotus) is in fact abstractive, because he is not himself present in heaven. Memory, body, and history are all transcended in this abstractive, beatific vision, which even before the end of time knows even the historical transhistorically.

This problem points us back to the problem of the body itself in paradise. It is fitting, in this respect, that Dante makes Bernard of Clairvaux his intellectual and spiritual advisor at the moment of his attainment of the *visio dei*. Bernard, a twelfth-century Cistercian monk, held strong, and in certain respects unorthodox, views regarding beatitude and the resurrection of the body: in his opinion—and in this he followed Augustine—the separated soul was limited in its vision by its lack of a body, this lack resulting in its yearning to be rejoined to the body:

> It is not in dispute that they want their bodies back. . . . Until death is swallowed up in victory (I Cor. 15:54). . . so that heavenly glory gleams even in bodies, these souls cannot wholly remove themselves and transport themselves to God. . . [But] when our bodies are resurrected, we are intoxicated by immortal life, abounding in wonderful plenty.[14]

Dante's own view is that the blessed in heaven prior to the resurrection do enjoy the beatific vision, but long, nevertheless, for their bodies.

> When, glorified and sanctified, the flesh/ is once
> again our dress, our persons shall,/ in being all
> complete, please all the more;/. . . Nor will we tire
> when faced with such bright light,/ for then the
> body's organs will have force/ enough for all in
> which we can delight.[15]

It is only in this completed state, in other words, that the soul's final beatitude can be achieved.

The movement of medieval transcendence, then, is a dialectic of forgetting and remembering, of absence and presence. The body is left behind, but the memory of it may indeed persist until the last judgment, when the resurrection and glorification of the body completes the dialectic in a synthesis sublating the body into the glorious presence of God. Here, in this paradise, memory is wiped away in the double movement of the glorified body reunited to the soul, on the one hand, and the excess of the total presence of absolute memory on the other. In these hypermimnetic transformations, the history of body, of pain, of injustice is consigned to oblivion.

### Cyberspace and Transcendence

A good deal of critical ink has been spilled over the question of disembodiment in cyberspace and particularly in cyberpunk literature, fictional and otherwise.[16] The "desire to leave the body behind" is manifest in every aspect of virtual experience, from *Mondo 2000*'s description of virtual reality as "like having had your everything amputated" to Bobby Newmark's escape into virtual immortality in William Gibson's *Mona Lisa Overdrive*.[17] How does memory, and in particular the electronic archive, figure into these postmodern dreams of disembodiment?

To begin, we must consider in more detail the constitution of the archive. What, in fact, is archived? In a word, an archive stores data, information decontextualized, virtualized and placed in infinite sets of relations with other data—the relational database. Broadly speaking, this data could be anything from a pesto recipe to a C++ program to my brainwave patterns. In any case, data is dead—dead information, the stuff of Kroker's "recombinant history."[18] *Wired* magazine, certainly the hippest of all technoculture magazines, ran a blurb a few months ago called "Canned Juice," which described the O.J. Simpson forum on CompuServe. The forum contains a series of discussion threads on everything from the DNA testing to the jury, as well as an exhaustive archive of documents related to the case. Like all data, the information in this database is

dead. It differs from, say, an archive of Latin manuscripts in a library, in that it purports to represent living human beings and specific things they might have done. The alienation of this data from itself, and hence from O.J. or Nicole Simpson or Kato Kalen, is complete in its recombinatory possibilities: "imagine how jealous your friends will be when you show them O.J.'s mug shot GIF turned screen saver or those blueprints for a new Pez dispenser as modeled on the coroner's drawings of Nicole Simpson."[19] O.J. Simpson as click-art.

The O.J. forum opens up for us the archive insofar as it is the human that is archived, although always as data. We can actually participate in archiving ourselves in several ways. At perhaps the lowest level, simply owning an online account archives you. Your name, email address, and, depending on the system, perhaps even your login times, last mail read/received, and ".plan" and ".project" files that provide for anyone who "fingers" your account anything from a joke to an actual project you might be working on. Taken to an extreme, the human archive can reach remarkable proportions. At a digital industry conference several years ago, an executive from a major American computer firm described a hermetic, telematic paradise, in which the online would be able not only to order video-on-demand and a pizza to arrive just before the movie starts, but also the ability to hook up virtually in real-time with friends at their own homes and go shopping at the virtual mall. Presumably one could just as easily go to the virtual racetrack or watch a virtual movie together, although one would likely never take oneself to a virtual ghetto. One aspect of this virtual world was that the tastes of each individual/family could be catered to infinitely by archiving their interests, from the kinds of movies they like to, one would imagine, their favorite pizza, which would determine both services offered and advertised. Paradise thus takes the form of a human database.

Far more interesting and colorful places in which to archive oneself are multi-user domains (MUDs or MOOs for short), online virtual environments in which any number of people can participate at one time. When a user enters a MUD, the first thing he or she does is start a little file in the archive for him or her self. In a MUD, no one knows anything about anybody else except what they tell each other. Clearly not everyone is to be trusted (whatever that means in a total fantasy world) as should be patently obvious from the archival availability of a neuter sex. The MUD is not about trust, however. It is about recreating oneself and archiving one's re-creation, thereby

transforming oneself into data and moving into relation with all the other archived bits of data out there on the info super-highway. Joshua Quittner, on a visit to LambdaMOO, the original MOO, narrates the details of this process:

> I want to put down virtual roots here. To do that, first I need to create myself. . . I create [a character] named Johnny Manhattan. . . .Then I carefully type the following words: "@describe me as tall and thin, pale as string cheese, wearing a neighborhood hat." Now when anyone types "look at Johnny Manhattan," that description—tall and thin, pale as string cheese, wearing a neighborhood hat—will be returned.[20]

The archiving of the self is the transformation of oneself into data, into dead information. The online self can be anything—any gender (why be binary about sex?), any age, height, weight, race, or even species. There's no reason why one should not be able to be a tree or a Martian, either, because, in the end, the data one archives bears very little resemblance to its source. That is not to say that the cybernaut does not put something of him or her self into whatever identity is taken on in cyberspace. On the contrary, clearly whatever one chooses to be in the matrix expresses something of one's own desires or fantasies. But the move into cyberspace metamorphoses this desire into data and places it online.

The archival movement is thus a negative movement. The archive, self remembered as data, negates the body, history, memory itself. Baudrillard's conception of the simulacrum aptly characterizes the online self.[21] Archives are databases of simulacra. Transferred like a file into cyberspace, we can know more things, do more things, be more things. But cyberspace is full of data. The self online is data, a mere simulacrum of oneself. Thus, by extension, the online simulacrum interacts with other simulacra—data interacting with data, recombining in an infinite variety of ways but ultimately still only an infinite variety of simulacra.

The options available in a MUD are the negation of earthly, bodily limitation. This negativity is not, however, simply nihilism. Rather, it is the first stage in a dialectical movement of transcendence. Cybernauts negate corporeality for the incorporeality of cyberspace, but the body returns in a hyper-corporeal synthesis in which, like the resurrection in glory at the last judgment, it has lost all of its historical attributes: it has

become incorruptible (because it is data) and ultimately inde-structible. The characters in Quittner's Dantesque journey through the afterlife of the LambdaMOO sometimes kick people's heads off; this is possible because they're not really kicking anybody's head off.[22] The indestructible simulacrum can go everywhere and see everything in the total presence of the online database. No longer restricted to what it could see with its bodily eyes or do with its bodily arms, the hypercorporeal simulacrum finds itself capable of amazing feats of knowledge and endurance.

The dialectic of archivalism is thus a Hegelian dialectic in which, similar to the medieval mystical/beatific experience, the body is negated in favor of a discorporated self, but then sub-lated according to the logic of cyberspace—the relational data-base. Hypercorporeal identity re-incorporates the self as recombinant history (like O.J.'s mug shot), a virtual incorpora-tion. Transcendental dialectic is in operation in every facet of the online experience. Two-dimensional terminals negate the three-dimensional historical world, which is then synthesized into the hyperdimensionality of cyberspace. Historical time is negated in the static permanence of the archive, and then sub-lated into the eternal now of simulated presence in the matrix. The common thread, however, remains the hypermimnetic; amnesia synthesized with memory into the hypermemory of the archive forms the basis of the transcendental dialectic of cyberspace. Transcendent memory requires forgetting.

Before considering, in the final section of this chapter, the will to virtuality that drives the mass migration into cyber-space, we must finally take stock of the two modes of hyper-mimnetic transcendence implied by the above analysis. In the first, the self transcends memory in the Hegelian dialectical sense we have just been discussing, and thus parallels the mys-tical movement of dis- and re-embodiment we saw in medieval spirituality. Contrasting with the dynamism of the dialectical schema, the second mode of cyberspatial transcendence is the stasis of the archive. Cyberspace is actually full of similarly archived simulacra of other historical, bodily human beings and similarly sublated identities. In the archive, the cybernaut encounters that excess at which memory recedes, in fact, the total presence of absolute memory. Memory is eclipsed in the totality of infinite data, and, once again, the "bodily" can be known in a sublated way, without reference to its physicality, and still that presence is precisely the presence of data—dead information, simulacra. As Philip K. Dick put it, in a story at

bottom about the human become simulacrum, "We can remember it for you wholesale."

On the basis of the above, I contend that the postmodern will to virtuality parallels the medieval religious will to transcendence.[23] The individual leaves behind history with the body because transcendence in cyberspace is essentially the transcendence of memory. In this sense, the will to virtuality, and the will to immortality or incorruptibility or ahistoricity, is fundamentally a will to oblivion. Cyberspace is socially constructed as the postmodern paradise, and all our hopes for virtuality express our desire to escape the limitations of our bodies and the ills of our society. The difference, as Hayles notes, is that where this transcendence was once considered theologically possible we now conceive of it as technologically feasible. The continuity of this desire from the medieval to the postmodern world manifests itself in the synthesis of theological and techno-logical discourses into a technosophy of cyberspace.

The deployment of a technosophical hermeneutic in cyberpunk literature (whether fiction or non-fiction) spurs the will to virtuality. The glorified virtual body takes one of two forms. Neal Stephenson's *Snow Crash* offers a version in which the body very much as in the MUD is complete and complete-ly in cyberspace.[24] Cyberspatial physicality is hermetically sealed into cyberspace itself, rather like the glorified body in paradise. The other option is to quasi-rehistoricize the body, as in Rudy Rucker's Minskyan/Moravecian fantasies *Software* and *Wetware*, in which the main character is uploaded for storage in a central archive, from which he may be downloaded indefi-nitely into new and superior android bodies.[25] William Gibson's *Mona Lisa Overdrive* contains interesting versions of both of these modes of telematic/archival transcendence. The plot of the novel revolves around two figures. Angie has the ability to jack into the matrix without a deck, the portable computer console cyberspace cowboys normally use to access cyberspace. The result is that she is frequently possessed by artificial intelligences lurking in cyberspace and having taken on the identities of voodoo deities. Bobby Newmark, on the other hand, is present throughout the novel as a body hooked up to a portable mini-version of the matrix. By the end of the book, he has achieved virtual immortality in his own little chunk of cyberspace.

While the desire for transcendence is explicit in *Snow*

*Crash* and Bobby Newmark, the Rucker novels and Angie present subtly different visions. Rucker's Boppers, the rebellious self-aware robots who constitute the major plot-movers of the two novels, synthesize presence and absence, history and archive in a way which may be understood to rehistoricize the transcendent, insofar as they are always returning to bodies, however superhuman these bodies might be. In this sense, it is a vision of immortality and incorruptibility, but one which perpetually re-members its data—revivifies and rehistoricizes it. Leaving aside a possibly superficial (if nonetheless accurate) criticism of the utopianism of Rucker's world, we may observe that even in this case, insofar as the bodily/historical/memorial remains, it is subjected to the transcendent logic of the archived self. The body is expendable in a world in which "I" can always be downloaded into a new body. Cobb, one of the protagonists, explains his resentment at being re-embodied:

> When you're alive, you think you can't stand the idea of death. You don't want it to stop, the space and the time, the mass and the energy. You don't want it to stop...but suppose that it does. It's different then, it's nothing, it's everything, you could call it heaven. Once you're used to the Void, it's really not so great to have to startup in spacetime again.[26]

The characters periodically "save" their memories in an effort to retain some sense of continuity from one body to the next. The archive simulates history; history is merely its extension. Memory comes to serve data.

This privileging of the virtual is in some ways even more the case with Gibson's Angie. Angie's body is poised to become a telematic extension of the matrix. Where virtual collective consciousness does not really become an issue for Rucker, Angie could conceivably exist with her self as an interlocutor with the other entities in cyberspace—a kind of celestial communion with angels—even as her body continues to exist. Dante mentions in the *Inferno* that there are souls so evil that they are carried off to hell even before they die, their bodies inhabited rather by demons.[27] Angie's telematicism reverses the Dantean translation of the soul, providing her the opportunity even during bodily life to participate in the total presence of the eternal now of cyberspace. The physical, historical, political becomes a subset of the virtual.

Lest it be thought that these are merely literary fictions, or even the dreams of a few MUD addicts, I would point to the

THE POSTMODERN PARADISO

work of Marvin Minsky and Hans Moravec, both of whom espouse the objective of digitizing the self for computer "embodiment," as well as to a recently published book by Pierre Lévy entitled *Collective Intelligence*.[28] Lévy lays out an avowedly utopian program for a virtual society in which we would all take part in a democratic online collective intellect, in some respects a technologization of Rousseau's general will or even in some respects of a Hobbesian leviathan, by taking on virtual "angelic bodies."[29] A mish-mash of modernist and postmodernist philosophies and technologized medieval theological psychology, Lévy's work is technosophy *par excellence*. After outlining in some detail medieval neoplatonic views of emanation and the separate agent intellect (by being united with which all human beings understand all that they understand), he proceeds to secularize this vision à la cyberspace, and in doing so submits history, memory, body, and the sign to the dialectical march of negativity. The achievement of total and yet democratic presence in cyberspace of hypercorporeal angelic bodies, archived online, "puts a reassuring end to the movement of the sign" in the total context of a hypermimnetic eternal present. Insofar as anyone is likely to return from their angelic bodies, it is to act upon understanding and decisions reached by the truly cybernetic (in the Wienerian sense) collective intelligence.[30] Again, the body, here envisioned as the absence of the technosophical agent intellect, is subordinated to the agency of that intellect. The telematicism of Gibson's Angie or Rucker's Boppers is a very small step indeed.

Kroker and Weinstein worry in *Data Trash* that virtualization portends just such a telematic culture, in which bodies serve simply as externalizations of the online data archive. This is where the force of Kroker's concern for vampirism makes itself felt. The Internet archivally discorporates memory, and reincorporates it as telematic culture. The Internet does not further itself, however. It is the chosen project of many a virtual entrepreneur. As Rucker himself point out:

> None of us hackers or writers or rappers or samplers or mappers or singers or users of the tech are in it solely for the Great Work—no, us users be here for our own good. We work for the great work because the work is fun. The hours are easy and the pay is good. And the product we make is viable. It travels and it gets over.[31]

It is not necessary to demonize the last capitalists of the virtual

frontier in order to see what Kroker means when he talks about vampirism and vivisectionism. Notably, or perhaps simply ironically, a major subplot in *Software* involves a group of human cannibals organized and led by a Bopper as a way of accessing human brains in order to upload their biocybernetic patterns into archives.

Ultimately, the religiosity of the will to virtuality enforces a Dantesque amnesia on those who would be virtual. As the mystic places him or her self in the cloud of forgetting and Dante bathes in the river of oblivion in order to make possible transhumanization, so in the archive the cybernaut cleanses him or her self of the memory of worldly woes. Kroker and Weinstein describe the marks burnt onto the electronic flesh of the cybernaut, the first of which is "the mark of forgetfulness, as cybernauts systematically expunge from their world-view any account of the human cost of the coming to be of the technological dynamo."[32] While listening to a conference presentation about the virtual shopping mall, I could not help remembering *Blade Runner*, Ridley Scott's fantastic visualization of Phil Dick's *Do Androids Dream of Electric Sheep?* Most of the people with money in this near-future earth have moved off-world. The socioeconomic inequality among those who remain manifests itself in the stark contrasts between the ziggurats inhabited by people like Tyrell, owner of the major firm manufacturing androids, and the streets crowded with "little people." Tyrell can live out his entire life without setting foot in the streets, but the visual allusion to pyramids, built by and for pharaohs on the labor of slaves, suggests the moral bankruptcy of his hermetic isolation from society.

Technosophy encourages us to forget about social problems, specifically insofar as collective intelligence seems to require collective amnesia. Technosophy constructs cyberspace as a postmodern version of a medieval paradise, a space of transcendence in which evil and responsibility are left behind in a blissful conjunction with the really real. Cyberspace has genuine transformative possibilities, but technosophy, however diverting, will not realize them.

1 See for instance Walter Truett Anderson's *Reality Isn't What It Used to Be* (San Francisco: Harper & Row, 1990), 113.

2 Jean Baudrillard, *The Illusion of the End*, trans. Chris Turner (Cambridge: Polity Press, 1990), 89.

3 N. Katherine Hayles, "The Seduction of Cyberspace," in *Rethinking Technologies*, ed. Verena Andermatt Conley (Minneapolis: University of Minnesota Press, 1993), 173.

4 Arthur Kroker and Michael Weinstein, *Data Trash* (New York: St. Martin's Press, 1994), 134.

5 With respect to the body and later medieval mysticism, see especially the work of Caroline Walker Bynum, most notably *Holy Feast, Holy Fast* (Berkeley: University of California Press, 1988). See also *The Resurrection of the Body* (New York: Columbia University Press, 1995), especially the chapter on the beatific vision. For Julian's visions, see Julian of Norwich, *Revelations of Divine Love*, trans. Clifton Wolters (New York: Penguin, 1966).

6 *Paradiso* Canto IV, lines 37-45. Translation Allen Mandelbaum (New York: Bantam, 1986). All subsequent quotations from this version.

7 See Aristotle, *On Memory and Reminiscence*, as well as *On the Soul*, especially Book III, Ch. 7, in Jonathan Barnes, ed., *The Complete Works of Aristotle* (Princeton: Princeton University Press, 1984).

8 *Paradiso* XXXIII, 52–57.

9 *The Cloud of Unknowing*, ed. James J. Walsh (New York: Paulist Press, 1981), 128.

10 *Purgatorio* XXXI, 11–12.

11 *Paradiso* I, 75.

12 For this and the following discussion, see John Duns Scotus, *Oxford Commentary on the Book of Sentences (Opus Oxoniense)* (Paris, 1891–1895) IV, 14.3–6.

13  It should be noted that scholastic theologians like Scotus and
    Aquinas did hold that the intellect in heaven was capable of cer-
    tain immaterial forms of memory. The soul without body had to
    be capable of certain activities of remembering, knowing, and
    loving to enjoy to beatific vision, and of memory to ensure
    retention of individual identity distinct from the body.
    See below.

14  Bernard of Clairvaux, "On Loving God," XI. par. 30, trans. Robert
    Walton, in *Bernard of Clairvaux: Treatises II* (Kalamazoo:
    Cistercian Publications, 1980), 122.

15  *Paradiso* XI, 37–66.

16  Much good work has been done in this regard by feminist critics:
    see Donna Haraway, "A Cyborg Manifesto," in *Simians, Cyborgs
    and Women: The Reinvention of Nature* (New York: Routledge,
    1991). See also several essays in *Flame Wars*, ed. Mark Dery,
    *South Atlantic Quarterly* (92:4) Fall 1993. Finally, note Michael
    Heim's "The Erotic Ontology of Cyberspace," in *Cyberspace: First
    Steps* (Boston: MIT Press, 1991), and Katherine Hayles's essay
    cited above.

17  *Mondo 2000* cit. Vivian Sobchak, "Reading Mondo 2000," in *Flame
    Wars*, 577; William Gibson, *Mona Lisa Overdrive* (New York:
    Bantam, 1988).

18  See Kroker and Weinstein, *Data Trash*. On data as dead informa-
    tion and ways to make it live, see also Phil Agre, "Living Data,"
    *Wired*, Nov. 1994, 94–96.

19  *Wired*, January 1995, 148.

20  Josh Quittner, "Johnny Manhattan Meets the FurryMuckers,"
    *Wired*, March 1994, 92.

21  See Jean Baudrillard, *Simulations*, trans. Paul Foss et al. (New
    York: Semiotext(e), 1983). Scott Bukatman, borrowing a phrase
    from William Burroughs, describes a similar transformation as
    constituting "terminal identity" in *Terminal Identity: The Virtual
    Subject in Postmodern Science Fiction* (Durham: Duke University
    Press, 1993).

22  Quittner, 97. See also Erik Davis, "Techgnosis, Magic and

Memory," in *Flame Wars*, 593, on the similarity of the old computer dungeon game to Dante's poem in terms of definitions of space and movement.

23  See Kroker and Weinstein, *Data Trash*, op. cit., on the priests of the virtual class. When they discuss the "religiosity" of the drive into cyberspace, it is meant largely in the non-technical sense of zeal, but the double-entendre is also understood.

24  Neal Stephenson, *Snow Crash* (New York: Bantam, 1992).

25  These novels were recently reprinted in a single volume as *Live Robots* (New York: Avon Books, 1994).

26  Rucker, 240.

27  *Inferno* XXXIII, 130–132. Note also Kroker and Weinstein, *Data Trash*, 6: "The virtual class . . . is already the after-shock of the living dead: body vivisectionists and early (mind) abandoners surfing the Net on a road trip to the virtual Inferno."

28  See Minsky's *Society of Mind* (New York: Simon and Schuster, 1986), Moravec's *Mind Children* (Cambridge: Harvard University Press, 1988), and Pierre Lévy, *L'Intelligence Collective: Pour une anthropologie du cyberspace* (Paris: Editions Découverte, 1994).

29  "[C]orps angélique." See especially 95ff.

30  See Norbert Wiener, *The Human Use of Human Beings: Cybernetics and Society* (New York: Doubleday, 1954). Wiener used the term "cybernetics" to refer to the study of systems of communication and control.

31  Rucker, "On the Edge of the Pacific," in Rucker et al. eds., *User's Guide*, 13; cit. Sobchak, 581.

32  Kroker and Weinstein, *Data Trash*, 109.

# THREE

# LANGUAGE, WRITING, RHETORIC

# SPAM

## HETEROGLOSSIA AND HARASSMENT IN CYBERSPACE

### Charles J. Stivale

The syllable "spam" usually evokes a canned meat product that is an acquired taste and, by extension, the humorous, yet ultimately tedious, repetition of this syllable on the restaurant menu and by the male chorus in the Monty Python skit of the same title. These very qualities of humor and tedium, often bordering on irritation, account for the term "spam" being adopted in the parlance of cyberspace chat and role-playing sites, where it refers to that unnecessary data transmission that one participant deliberately produces often simply to fill lines on the recipients' screens, but sometimes to communicate aggressive messages as well. "To spam," then, means precisely to inflict such verbiage on other "Net" comrades, alone or en masse, and is generally taken to be a distinct form of online harassment.[1] Although spam is not unlike the network practice of flaming, the latter usually is content oriented. A flame sender seeks to communicate aggressively a specific message,[2] whereas spamming covers a spectrum of intentions tending to

emphasize its form, or what Jakobson calls the "phatic" linguistic function.[3]

By defining and examining three levels of aggressivity that correspond implicitly to participants' intentions in spamming one another, I will explore how these various forms of practice that permeate the increasingly popular medium of Internet discussion sites constitute what Bakhtin called "dialogized heteroglossia" both as social interaction and as resistance to authority.[4] We can understand this dense expression by referring to Bakhtin's examination of the parodic, oppositional and polemical tension created by "low" literary genres (e.g. fables, folksayings, anecdotes) directed against "official literary language." Bakhtin describes the dynamics inherent to "dialogic" and resistant exchanges, dynamics that are quite pertinent for comprehending the Internet environment.

> ...[T]he word, directed toward its object, enters a dialogically agitated and tension-filled environment of alien words, value judgements and accents, weaves in and out of complex interrelationships, merges with some, recoils from others, intersects with yet a third group: and all this may crucially shape discourse, may leave a trace in all its semantic layers, may complicate its expression and influence its entire stylistic profile.[5]

Thus, the term "heteroglossia" refers to the different kinds and uses of speech that struggle within a speech community, while the particular "dialogics" suggest how the computer-mediated environment offers opportunities for employing this speech, at times for creative play, at times for resistance, and even for the destructive infliction of verbiage that may occasionally replicate reprehensible actions of harassment found "in real life" (or "irl," in Internet speak).

I will examine this spectrum of practices with reference to a specific chat and role-playing site on the Internet, one of the numerous MUDs (multi-user dungeons or dimensions) known as LambdaMOO (MOO referring to MUD-Object-Oriented programming language), located at Xerox PARC (Palo Alto Research Center) and installed and run there since 1990 by Pavel Curtis.[6] This site is structured like a large house with nearby grounds and community. It forms a paradigm within which participants can log on via telnet from different locations around the globe, adopt character names ranging from "real" to, more commonly, some form of fantasy, and con-

verse directly with one another in real time.[7] In this house, one may move from room to room by indicating directions to "walk" or by "teleporting" directly, create one's own personalized abode, and entertain discussion with the vast population—over 8000—of inhabitants. The basic communication commands are available even to transient "guests," and permit one either to "say" (i.e. talk directly), "emote" (i.e. express a feeling or action indirectly) or "whisper" privately to recipients within in the same room.

However, once a participant has registered and chosen a character name, a gender, and a personal description, interactions within the LambdaMOO commons, the Living Room, acclimate one quickly to a complex array of social interactions, and make one increasingly aware of the uses, and often abuses, to which the programming language on the MOO can be put. Although the "help manners" screen to which every participant is directed indicates that the acceptable level of spam is zero, in practice various levels of unsolicited verbiage are not only tolerated, but even structured into the site. Indeed, different forms of what I describe below as "playful spam" constitute the very fabric of social exchange on the MOO, and manipulation of these forms indicates the extent to which a participant actually learns to speak the language of the virtual community.[8]

At the same time, however, we can understand this play as what Allon White describes, in referring to Pynchon's fiction, as "a dialogic confrontation whereby power and authority are probed and ritually contested by debunking these vernaculars." Just as the distinctions in Bakhtin's work between monoglossia and polyglossia are "tendencies rather than strictly separable stages in the life of a speech community,"[9] the three levels of spam that I delineate can and do spill into one another from moment to moment, often overlapping within the same room or between rooms, depending on which participants interact there. I believe, however, that these categories function to designate means through which the continual "dialogue" between MOO participants emerges beyond mere conversation as ongoing resistance to, as well as creative use of, the authoritative speech through which such site exists, i.e. their programming language.

These levels suggest, I argue, a form of liminal play, as described by Turner, interactions that occur on the border between margins and center.[10] Specifically, one may comprehend "center" as the formal, technical skills necessary for the programming and message generation that constitute daily

conversations in realtime with other participants. In relation to this center, then, occur the different forms of spam exchange on the margins, still requiring some programming skill and conversational abilities, but nonetheless employing the former to challenge the more day-to-day (real-life) forms of the latter. This play on all of its levels has produced impassioned discussion and high drama that bears out Brenda Laurel's insights about "computers as theater" energized by the "players" relative anonymity, and has resulted in concerted modes of self-governance that suggest different conceptions of virtual community.

*Playful Spam*

The first level, which I call "playful spam," in many ways is an integral part of the LambdaMOO environment, despite the official policy that no spam is tolerated in the site. For example, when a player spends any time in the Living Room commons, at least two effects programmed into that room become manifest: at regular intervals, the chiming of a clock, and at irregular intervals, the irritating squawking of the pet cockatoo that dwells there. However, in contrast to what we might consider "playful spam" inherent to the environment, this level of spam is most readily associated with different command functions, known as "bonks," developed deliberately and creatively by LambdaMOO programmers. These active, transitive verbs allow one to "aggress" another participant, usually in a comic way, by "bonking" him/her/it over the head and causing the "bonkee" to emit some involuntary exclamation. For example, in the course of a conversation on any topic, some playful participant (let's call him Jay) may decide, quite without provocation, to type the command "bonk Jan." The result is that everyone within the virtual room with Jan reads the following spam: "Jay bonks Jan. Jan says, 'OIF!'"

A creative programmer, who would no doubt tire rapidly of such a pedestrian response, might decide to vary the range of possible exclamations evoked by the "bonk" command. Bonks typically tend towards some thematic orientation, such as causing the victim to repeat the selected lyrics of rock groups or to quote lines from various television and film characters. The bonk command "@annoy," for example, compels the bonkee to imitate *Saturday Night Live*'s "Richmeister," while "@dylan" fills the room with strains from one of the singer's ballads. Other bonks enact a more general "physical" humor— a poke from the Pillsbury doughboy, a flying tackle, and various forms of

hugs, from simple one-liners to lengthy versions that may fill several computer screens.

In the terms of a model of dialogized heteroglossia, these bonks are examples of the "living word" caught simultaneously within centripetal and centrifugal dynamics: on one hand, despite, and perhaps because of, the silliness of most bonks, experienced participants usually treat them as harmless means by which to attract each other's attention, not unlike locker room cavorting. In this way, participants can also express quite easily a centripetal dynamic that emphasizes the shared sense of community through the "living word." On the other hand, when directed at the guests who often congregate in the Living Room commons, this centripetal bonding between established (i.e. self-identified, described) participants functions centrifugally in response to anonymous "others" perceived both as still remaining outside the community and sometimes as irritating nuisances for their naive and/or impertinent questions.

*Ambiguous Spam*

A second level, which I call "ambiguous spam," functions in a more centrifugal manner as an extension of the first level. Once one has commenced an exchange of bonks and other verbiage with a participant in the Living Room, that participant may choose to take more aggressive measures in response. Once one has been bonked, one might retaliate by causing one's aggressor to fart loudly in front of the other players or to become violently ill on the floor, both through pre-programmed feature verbs included expressly for this purpose. Furthermore, some programmers have developed various "weapons," from mere knives or swords (from the role-playing fantasy games) to "Spamblasters" and even nuclear devices. By "wielding" or "aiming" upon a victim, most often an unwary guest, the owner produces variously violent effects on the screen, e.g. "Biff blasts Jay through the wall onto the Deck," all usually having the same effect, to "move" the victim from one room to another.

Occasionally, such spam can have more pernicious consequences: when the move is to one of several rooms named "Hell" or "Prison," the victim may escape only by logging off and remaining off the MOO long enough to be "moved" automatically back to his/her/its preset "home." Indeed, the fine line between play and less welcome intrusion is evident in one character's apparently playful creation, a room entitled grandly, "Doctor_Mike's World Peace Spam Pavillion and Hall of Fun." Described as "dedicated to the Doctor_Mike Method of World

Peace through Spam and Fun," the room contains a number of pre-programmed "objects" designed to divert the entrant with voluminous data transmission, but within the diversion, peace and fun generally cease with the discovery that one cannot leave this room except by logging off the system. While more sophisticated participants can take measures to prevent such unwanted "moves," the unwelcome and invasive nature and implicit aggression of such activity communicate an explicit breach of the etiquette prescribed by "help manners" and, in terms of dialogized heteroglossia, establishes a distinctly centrifugal dynamic in relation to the virtual community.

Another manifestation of this "ambiguous spam" occurs when a participant produces a series of transmissions that clearly irritate one or several players. One such example was the subject of a formal dispute that arose on the MUD in December of 1993. In this case, the offending participant within the Living Room commons had deliberately typed over ninety times the same two keystrokes ("s <carriage return>") indicating multiple attempts to move to the south and causing the message "K attempts to walk through the plate-glass windows! Fortunately they're tougher than that" to appear repeatedly on all the other players' screens. A humorous story upon re-telling, this event was a major annoyance for those actually present, and one participant chose to lodge an official complaint, a course of action which led to some interesting results from the perspective of dialogized heteroglossia. The arbitrator in the case discovered that the offending participant had not, in fact, been logged on at the time, but rather that a dormitory roommate had borrowed his password and, in the guise of the registered player, had spammed the Living Room. The penitent participant received a minimum sanction (72-hour loss of login rights) for not having adequately protected his password. The arbitrator, however, decided to admonish as well the participant who lodged the complaint for having insisted on pursuing the dispute process to its end even when the arbitrator's interviews revealed the cause of the spam to have been the offending participant's carelessness.

This dispute and others like it raise two larger questions that bear directly on social interaction within Internet sites: on the one hand, when one should evoke the dispute process at all, and on the other, what a participant's responsibility is to the community in protecting it from deliberately aggressive actions by fellow participants. Contestatory and even polemical exchanges between the interested parties in any dispute are to

be expected as the participants employ the "living word" in ever more dynamic ways. However, this dynamic impulse often results in exchanges that conflict sharply with accepted standards of etiquette, standards that themselves are constantly shifting as new interpretations of the rules arise from the dynamic processes in which the participants are engaged.

This concern about standards comes to the fore most evidently in a third example of ambiguous spam: namely, the recourse that participants have to the "boot" command to discipline a fellow player for a perceived behavioral breach by blocking that player's connection to the MOOsite for a specific time period (usually an hour). In the course of a lively public conversation, it is not unusual for one participant to offend another in some way, for example, through vulgarity, verbal aggression, forceful argumentation that affronts another's opinions on some topic, or through some kind of gratuitously irritating behavior, as in the above examples of ambiguous spam. It is evident, however, that recourse to the "boot" option has become a form of spam in its own right, since measures have been taken on LambdaMOO to curtail its abuse: first, a ballot decision is required for participants with less than three months registration on LambdaMOO, and a second participant must concur in the use of the @boot command; and second, the institution of a public "boot log" to show daily use of the boot against guests, with records of witnesses and reasons.

When one consults this log, however, one discovers some highly questionable reasoning (e.g. a guest booted merely for being "clueless") that again reveals the inherent tensions of dialogized heteroglossia. Such reasoning often relies solely on an individual participant's difficult relation to the dynamics of the "living word," with the result being that the boot command is often exercised to enforce censorious attitudes toward entirely appropriate behavior. In turn, given that all "behavior" on these sites is mediated through text-based communication of some sort, the ambiguity of what is appropriate or not suggests once again the ongoing struggle between centripetal and centrifugal dialogic forces, i.e. forces that seek some unified, central "command" versus those seeking to contest such unification from the margins.

*Pernicious Spam*

A third level, which I call "pernicious spam," is considerably less ambiguous in its effects. In its most prevalent form, it consists in virtual imitations of "real life" practices of harassment, usu-

ally sexual, and hence constitutes dialogized heteroglossia in its most tension-filled expression. While a number of chat and role-playing sites have been noted for explicitly sexual activity between consenting participants, so-called VSex, Netsex, or "compu-sex,"[11] some participants employ their programming skills, particularly through "move" commands and aggressive and sexually explicit verbiage, to spam unwitting participants in ways that might well be legally actionable in real life. In the most notable case on LambdaMOO of such abuse, a clever programmer with the player-name "Mr.Bungle" devised certain commands that allowed him to isolate and "capture" female participants in order to spam them abusively. With no system of arbitration in place at that time, the community found itself ill equipped to levy sanctions against the player, despite the fact that the community generally deplored the character's behavior. Julian Dibbell's account of this incident reveals not only the consequences of the pernicious form of spam inflicted by one player on others, but also how the community was forced to address the question of standards and to create some form of mediation, i.e. the current dispute process, in order to deal effectively with further breaches of online manners.[12]

Furthermore, the publication of this account in *The Village Voice* corresponded to and, as some claim, even incited another attack by the player-identity with which Mr.Bungle re-registered following his exclusion for the earlier incident. The various "spams" by Dr_Jest were both homophobic and sexually violent, and one direct victim aggressively pursued a formal complaint to a relatively successful conclusion. This "Dr_Jest affair" raised a number of issues: in contrast to the earlier Mr.Bungle affair, when no formal dispute process existed, the phases of adjudication related to the later dispute brought forth conflicting visions of what behavior might be accepted and, especially, rejected by the community members, particularly regarding the need for mutual respect and the right to a harassment-free environment. The debate that unfolded in the discussion list dedicated to this dispute not only addressed and further refined these "community standards," but also revealed the absence of any means of effectively enforcing such standards.

These online conflicts have been very much informed by current debates on the potentially violent power of words, particularly as they relate to pornography and sexual harassment.[13] Are these transmissions within the virtual environment "only words" without power to cause harm, or do they contain the force of "acts" perpetrated by one (or even sev-

eral) participant(s) against others? In response to the disciplinary dismissal from the University of Michigan campus of a male student, Jake Baker, accused of using a woman student's real name in a sexual torture fantasy posted to a Usenet group, Catharine MacKinnon has stated unequivocally that such fantasy "is not a free speech issue" since, as "a threat to [the named] woman's life, safety, human dignity and equality," the fantasy would fall outside any protection by the First Amendment.[14] That is, following MacKinnon's argument, words are never "only words," but constitute *acts* in response to which authorities have an obligation to exercise sanctions against "offenders" despite the civil protections usually accorded citizens "in real life." Taking the other side, Ann Arbor attorney—and local ACLU chairwoman—Lore Rogers argues, in the same article, that fantasy is protected by the First Amendment and even, "that just because someone is named does not meant it's a threat." Rogers admits, however, that "a lot of women *would* feel raped by this story [i.e. the fantasy]" (my emphasis), and concludes by posing the key question for the discussion of pernicious spam as well: "Does the First Amendment take precedence over this woman's right to privacy and her right not to have her name used to further this man's right of free speech?"[15] As far as Jake Baker is concerned, the answer is "yes," since Judge Avern Cohn, on June 22, 1995, dismissed federal charges of transmitting a threat to kidnap or injure by electronic mail.[16]

These questions were the subject of a passionate debate around a legislative ballot initiative on LambdaMOO in the spring of 1994. Under the title "Virtual Rape Consequences," the ballot sought to define online actions that consitute sexual harassment. It proposed a definition of "MOOrape" or "virtual rape" as "any act which explicitly references the non-consensual, involuntary exposure, manipulation, or touching of sexual organs of or by a character." Such "acts" were specified as "a use of 'emote' (locally or remotely), a spoof [an unattributed transmission], or use of another verb performing the equivalent presentation, whether by a character or by an object controlled by the character." However, any "functionality creating an equivalent sense of quotation" (e.g. "say," "page," "whisper," and even "think") were not considered "acts" but "speech," and were not considered virtual rape "unless they explicitly and provokingly reference a character performing the actions associated with rape."[17]

The referendum finally failed, but the discussion that it

provoked revealed the tension between the centripetal and centrifugal forces of dialogized heteroglossia resulting from this level of spam as a segment of the virtual community banded together in an attempt to impose an official verdict against one mode of online expression that saw itself in explicit opposition to the expressive standards and practices of the online medium. What has emerged is a heightened awareness of the difficulties in enforcing sanctions effectively given both the persistence of participants who can subsequently reappear in different identities and the evolving procedures of online governance that attempt to respond to the needs of expanding virtual communities.

This glimpse at the seemingly mundane and innocuous practices of technical verb functions within a particular computer programming environment reveals how these practices raise important questions about future social interaction within cyberspace sites. For not only are "community standards" at issue, but they are contested both outside and within text-based virtual spaces, both in questions of censorship and access to the Internet and in questions of self-governance and acceptable behavior among site participants. At a time when discussions of committing billions of dollars in resources determine the future of our access to data and high-speed communications in the next century, the issue of spam provides insight in to the potential for creative linguistic play on the Internet and to the risks that such freedom of access may ultimately entail for a heteroglossia that, by its very nature, tends towards the disruption of a smooth flow of words along the dialogic highways of cyberspace.

NOTES

An earlier version of this essay appeared in the journal *Readerly/Writerly Texts* 302 (1996) and is reprinted here with permission.

1  The concept of "spam" took on national prominence in 1994 with the mass advertising campaign by the lawyers Laurence Canter and Martha Siegel on the Internet. See Laurie Flynn, "'Spamming' on the Internet Brings Fame and Fortune," *The New York Times*, 16 Oct. 1994: Business 9; and Mike Godwin, "Canning Spam," *Internet World* 5.7 (1994): 97–99.

2  See Mark Dery, ed., *Flame Wars: The Discourse of Cyberculture* (Durham: Duke University Press, 1994) and Kristina Harris, "Dousing Flames," *Internet World* 5.8 (1994): 42–44.

3  Roman Jakobson, "Linguistics in Poetics," in Thomas Sebeok, ed., *Style in Language*, (Cambridge: MIT Press, 1960), 356–357.

4  Mikhail Bakhtin, *The Dialogic Imagination*, ed. Michael Holquist (Austin: University of Texas Press, 1981), 272.

5  Bakhtin, 276.

6  Curtis defines a MUD succinctly as "a network-accessible, multi-participant, user-extensible virtual reality whose user interface is entirely textual. Participants (usually called players) have the appearance of being situated in an artificially constructed place that also contains those other players who are connected at the same time." See Pavel Curtis, "Mudding: Social Phenomena in Text-Based Virtual Realities," *Proc. of DIAC-92* (1992) (ftp://ftp.parc.xerox.com:/pub/MOO /papers/DIAC92.txt).

7  For more on MUD life, see David Bennahum, "Fly Me to the MOO: Adventures in Textual Reality," *Lingua Franca* 4.4 (1994): 1, 22–36; Pavel Curtis and David Nichols, "MUDs Grow Up: Social Virtual Reality in the Real World" (1993) (ftp://ftp.parc.xerox.com:/pub/MOO/papers/MUDsGrowUp.txt); and Elizabeth Reid, "Virtual Worlds: Culture and Imagination," in Steven Jones, ed., *Cybersociety: Computer-Mediated Communication and Community* (Thousand Oaks, CA: Sage, 1993), 164–183.

8  See Howard Rheingold, *The Virtual Community* (Reading, MA: Addison-Wesley, 1993).

9  Allon White, "Bakhtin, Sociolinguistics and Deconstruction" in *Carnival, Hysteria and Writing* (Oxford: Oxford University Press, 1993), 149–150.

10  Victor Turner, "Frame, Flow and Reflections: Ritual and Drama as Public Liminality," in Michel Benamou and Charles Caramello, eds., *Performance in Postmodern Culture* (Madison, WI: Coda Press, 1977), 33–55.

11  See, for example, Gareth Branwyn, "Compu-Sex: Erotica for

Cybernauts," in Dery, *Flame Wars*, 223–235 and Susie Bright, *Susie Bright's Sexual Reality: The Virtual Sex World Reader* (Pittsburgh and San Francisco: Cleis Press, 1992).

12  Julian Dibbell, "A Rape in Cyberspace," *The Village Voice*, 21 Dec. 1993: 36-42. Reprinted in Dery, *Flame Wars*, 237–261.

13  See Catharine MacKinnon, *Only Words* (Cambridge: Harvard University Press, 1993).

14  Maryanne George, "U-M Ousts Student Over Rape Fantasy," *Detroit News and Free Press*, 4 Feb. 1995: 1A, 6A.

15  George, 6A.

16  Amy Yuhn, "Judge Dismisses Charges in Internet Fantasy Case" Associated Press Wire Report, 22 June 1995. On issues of campus censorship of Net activities, see Godwin, Mike, "alt.sex.academic.freedom," *Wired* 3.02 (1995): 72 and Godwin, "Artist or Criminal?" *Internet World* 6.9 (1995): 96–100.

17  LambdaMOO, *ballot: Antirape (http://vesta.physics.ucla.edu/~smolin/lambda/laws_and_history/failed/anitrape.html).

# *I Flamed Freud*

## *A CASE STUDY IN TELETEXTUAL INCENDIARISM*

### William B. Millard

*The Evolution of Homo incinerans: An Overview*

In most of the Internet's discussion lists, flaming—which I define as a form of personal verbal violence arising largely from the peculiar conditions of online writing—is widely practiced and equally widely abominated. Why this is problematic or interesting is not immediately apparent. For centuries, rhetoricians have considered the *ad hominem* attack a transgression of the norms of debate, a form of cheating; this meta-contumely or "contempt for contempt" is a ground rule of civil discourse in discursive communities that prize civility. Many of the newly developing communities on the Internet arguably do not share such a standard. Their members may vigorously castigate the uncivil, but this castigation itself is liable to cross the *ad hominem* line, sometimes helping extinguish a flamewar but more often extending it, and seldom diminishing the frequency of flamewars in general.

Some commentators view an emerging routine of incivili-

ty as a simple decline into barbarism, an indication that the sense of depersonalization that accompanies online writing is bad for the soul. However, it is also possible that these transgressions, repeated so relentlessly that their transgressivity mutates into a strange new norm, constitute a productive new problem for rhetorical analysis by foregrounding the instability of self-representation in a realm where the visibility of a self through the ostensible transparencies of instrumental language is by no means certain.[1] Flaming may be cheating in a sense; on the other hand, cheating in any game may be seen as an indication that the game has become serious, or as a way of reframing the rules.[2] Merely bringing some of the implicit rules of communication (particularly academic communication) into explicit view may be cheating and may be more than cheating.

That communication in practically any field may involve vigorous disputation seems beyond question. That disputation vigorous enough to include wrath and invective is an integral, possibly even inseparable part of scholarly discourse may be more debatable. A connection between personal verbal abuse and the life of the mind is by no means intuitive, and there are many who would gladly—if it were possible—conduct their entire intellectual lives in the absence of any form of rhetorical excess. Yet in historical terms, it appears that prototypes of the flame have been a constant presence. The growth of literate cultures after the invention of Gutenbergian movable type was particularly conducive to exuberant displays of invective (the broadside, the pamphlet, even theses nailed to a door). Print culture has generally been accompanied by a kind of shadow-culture that adapts the clean, logical art of written language to playfully scurrilous purposes; the efflorescence of humanistic scholarship in the Italian Renaissance, for example, included the formation of a community whose sense of intellectual fellowship was counterbalanced by a willingness to insult one's fellows scabrously in private correspondence (such as the famously caustic letters of Pietro Aretino, one of which resulted in a swordfight). The letters of Samuel Johnson and Mark Twain extend this tradition. Rhetorical performances (abusive and otherwise), in short, are shaped by both social and technological circumstances; the history of rhetoric has a prominent material component. As the characteristic medium of the latest phase of that history, online writing combines certain features of previous media that have allowed *Homo incinerans*, the habitual (or, on occasion, expert) flamer, to thrive.

On discussion lists devoted to scholarly topics, flaming

and the often heated self-referential discourse about it—which I have elsewhere termed metaflaming—are distinctly contentious topics.[3] Perhaps this phenomenon is common on academic LISTSERVs because of the high concentration of reflexive, reflective, anxious, and/or contentious personalities in academic communities. However, preferring to describe phenomena in the language of socially constructed process rather than that of individual personality, I find it more plausible that the transfer of academic rhetorical practices into cyberspace amplifies the aspects of those practices that problematize self-construction, self-representation, and self-control. Textual cyberspace filters away all qualities of a personal self save the highly mediated, acutely self-conscious elements that appear in written language. Phatic or metacommunicative cues, the linguistic and paralinguistic signs that maintain cognizance of the social relation between the sender and receiver of a message, are drastically reduced in this medium.[4]

This metacommunicative minimalism, in combination with other distinct features of Internet writing—the customary economic constraints on connection time (and thus on personal patience), the delayed response of the audience, or the uncertainties ensuing from the consciousness that Internet communities are new enough to lack clear social protocols—as well as the general underlying tension between conceptions of language as a transparent medium for serious work or a dense material for ludic performance—implies that online academic writing as a genre is conducive to anxiety, wrath, and vendetta. Flaming, in short, is exuberantly overdetermined.

Print culture, as its historians Walter J. Ong and Eric Havelock attest, dissociates language from the oral world, with its immediate social contexts, implicit hierarchical decorum, and constant phatic reinforcement. By abstracting the sender and receiver of a message in space and time, print media allow the transmission of messages that would be, if not exactly unthinkable, at least nearly unperformable in an oral situation. The medium of electronic text further facilitates such performances while eventually allowing receivers the opportunity to respond and escalate a debate. Similar processes occur in print media such as academic journals, daily newspapers, or periodicals oriented toward intellectual debate such as *The New York Review of Books*. Online culture, however, if only through its temporal accelerations and chrono-economic stresses,[5] compounds the dissociation of sender from listener. The immediacy of response typical of online exchanges does not lend itself

to dispassionate, considered scholarship, nor does the alphanumeric ephemerality of an online persona. In addition, the very accessibility and inclusiveness of the Internet's virtual communities—which are hardly representative of the populace as a whole, given the unequal distribution of hardware, but are still far more open than the cautiously edited pages of most academic publications—may add to the combativeness of many participants, since a co-mingling of ranks (the amateur and the professional, the undergraduate and the tenured) inevitably produces status anxiety. Whether or not one accepts the McLuhanesque argument that electronic media have reintroduced oral rhetorical characteristics that print culture suppressed, online writing's unique balance between bodiless abstraction and dynamic public drama creates a rhythm of attacks and responses that is all but guaranteed to amplify disagreement into dissonance, disturbance, and finally the full-fledged dissing that links written academic debate with the oral insult-dramas that African-Americans know as "the dozens."

Involvement in such a drama can be both painful and entertaining. The entertainment can alleviate the personal pain of insult, particularly if a participant can maintain a conceptual disjuncture between his or her biological/psychological self and the verbal self-construction that appears online. Indeed, a postmodern fragmentation of the self into multiple entities— some private and some public, some requiring emotional cathexis and some, like the *eiron* of Socratic mock-ignorance, held at a distance—may be the precondition for what Richard Lanham calls "the *irenic*, the peacemaking, force of much postmodern formal experimentation."[6] However, online culture makes it fatally easy to conflate the ludic cyber-rhetorical self-fragment and its serious bio-emotional counterpart; all that the LISTSERV public sees of the latter is its reflection, or refraction, in the former. Affront is the characteristic symptom of the centralized, unified, reified self under conditions that reinforce self-fragmentation. Hence the ironic, distinctly anti-irenic postmodern phenomenon of the flamewar.

*Incendiary Hominids in the Wild: A Case Report*
My own experience with extended flaming and metaflaming includes a conversation on the list H-AMSTDY, an H-Net (History Net) list devoted to American studies. A frequent topic among the H-AMSTDY participants is the related discipline of cultural studies (abbreviated CS in many online posts)—its origins, its methods, its appropriate subjects, its

organizing ideologies, its distinctions from and relations with American studies. In November 1993 a conversation developed about the Marxian roots of cultural studies. One participant, David Williams, objected to the Marxist orientation prevalent in cultural studies; another, whom I will identify as G.S., countered that cultural studies would probably outgrow what he viewed as the relatively simplistic versions of a Marxist historical narrative occurring in the writings of some of the young discipline's practitioners. In G.S.'s view, cultural studies would eventually acquire greater sophistication in the same ways he found various psychoanalytically derived discourses moving beyond the outmoded Oedipal narrative. Transcending the reductionism of an originary narrative, G.S. held, was a characteristic of a maturing scholarly field; he implored Williams to give the new discipline more room to develop.

As circumstances would have it, I was working by day as a commercial medical journalist at the time I read the H-AMSTDY posts on cultural studies, Marxism, and psychoanalysis, and was engaged in research on the detection and treatment of depression based on interviews with a number of leading psychiatrists. I had long shared the Nabokovian conviction that advocates of psychoanalysis were, to say the least, uncomfortable with Occam's razor; my interviewees now indicated that the analytic profession routinely resisted the kind of reality testing that was rudimentary for competing therapeutic schools of thought. Animated by the patiently constructed but finely sharpened arguments of ex-Freudian Frederick Crews in a review published just a few weeks before,[7] I was primed for skeptical potshots at what I had come to regard as a personal intellectual *bête noir*.

At the point where G.S. attempted to defend cultural studies through a comparison to psychoanalysis, I decided to make the transition from lurker to participant in this thread. Believing as I do that Freud's modest rhetorical gifts generally obscure an alarming pseudointellectual dishonesty (a characteristic that recent revelations about his clinical techniques, results, and public representations bear out) and that psychoanalysis has proven to be the twentieth century's second-worst idea—as hermeneutically sterile as it is medically and therapeutically ineffective, and thoroughly complicit with the goals and structures of hegemonic capitalism—I shot back a long, forceful reply, maintaining that to compare cultural studies to the zombie-like psychoanalytic paradigm was to do cultural studies no favors.

In short, I flamed Freud. I will quote from my original inflammatory post:

> G.S.'s point about originating myths is intriguing, but I'd like to suggest that much is lost when originating "myths" with a verifiable basis in reality are conflated with those that merely represent the projections, delusions, or self-interested constructions of a field's founders. The initial story around which cultural studies was organized, the screwing of subordinated groups by hegemonic groups, does in fact happen. It's not all that happens, but its factual status is beyond serious dispute. The Oedipal myth, on the other hand, lacks the same historical status. Psychoanalysis is notoriously sloppy about huge, all-embracing truth claims that can't be referred to any other type of discourse, and many serious thinkers do in fact dismiss it entirely. . . .
>
> Whatever the limits of cultural studies' "hard domination" model may be, that model is still based on uncaricaturable historical events. CS is a living discipline precisely because it retains a sense of the correspondence between its discourses and that which lies outside its discourses. It needs no defense that relies on comparisons to the preposterous legacy of Freud. Psychoanalysis is its own caricature, and in its cult-like introversion it will perish. . . .Scholars who value complexity, open interchange among different discourses, and the ability to adapt to the dynamic variety of observable events will do a fine job in keeping CS from hardening into the caricature presented by David Williams. But *please* let's spare any comparisons to a deservedly dead paradigm like Freudianism. If CS has enough friends like G.S., enemies like Williams will be superfluous.
>
> Bill Millard,
> Skeptic-in-residence
> Hoboken Temporary Autonomous Zone

Predictably, this dismissal of Freudianism was interpreted in some quarters as a flame. It was certainly meant as such, written with at least as much glee as wrath and signed with a somewhat self-parodic identifying tag. Knowing the depth of

loyalty that psychoanalysis often inspires (irrespective, I cannot avoid adding, of observable results), I fully expected to be flamed in return. What I did not expect, however, was the overwhelming tendency of the debate to focus attention not so much on my arguments (or allusions to others' arguments) but on the twin targets of my rhetorical style and my persona. Distaste for what I consider the circularities, tautologies, and obfuscations of psychoanalysis as a hermeneutic, critical, or clinical method animated my original flame but soon ceased to be the issue under discussion. The initial reply by G.S., using a curious combination of concessions and refusal to debate specifics, managed to work up to a level of derogation that could reasonably be termed a counter-flame:

> I will make a brief aside to plead for intellectual tolerance. This thread began with David Williams's trumpeting that "Marxism is dead" and now has led to Millard announcing that "Psychoanalysis is dead." This trend of thought disturbs me greatly. Why do we feel the need to pronounce an epitaph over an entire body of thought? It seems ludicrous to me that one should say important, complex, and influential theories like Marxism or psychoanalysis are dead. This smacks of intellectual laziness. . . . It is possible to be highly critical of a body of work (and I share almost all Millard's concerns about psychoanalysis) and still find useful concepts within that body. . . .
>
> I think it's certainly valid to discuss the pros and cons of a body of work, to criticize its claims and rebut those claims. . . .But proclaiming the demise of a body of work, whether it's psychoanalysis or positivism (which many cultural studies scholars write off), is an anti-intellectual knee-jerk rhetorical move. It's one thing to say that one is critical of a field and doesn't find it useful in one's own work; it's another thing to have the chutzpah to write of an entire field as moribund.
>
> So, let us come to praise or criticize cultural studies/psychoanalysis/Marxism, not to bury them.

Battle lines are drawn early. I am guilty of many things, it appears, from laziness to chutzpah—some of which I would

readily concede (chutzpah more easily than laziness); others are no worse than my own descriptions of Freud—but the high point is "an anti-intellectual knee-jerk rhetorical move." "Rhetoric" in modern usage, of course, carries loaded meanings beyond the formal study of persuasive language; in many circles scholarly and vernacular alike, it is a term of abuse, an allegation that one is somehow cheating. The neo-Platonic distrust of performative language, theatrical display, and social drama lends vituperative force to "rhetorical" here: the term does not simply valuelessly indicate the category within which I make my anti-intellectual knee-jerk move, but provides the insulting climax toward which "anti-intellectual" and "knee-jerk" lend their momentum. Regardless of whether G.S. is right to claim that no text or body of work should be discarded, whatever its flaws, his own rhetoric accrues power precisely through his accusations against the accrual of power through rhetoric. This is Mark Antony's inverse meta-rhetorical maneuver, performed with no small skill. It would set the tone for much of the debate that followed, on both sides of the controversy.

In the course of the ensuing discussion, rhetorical performance itself came to the fore as the subject as well as the means of debate. My own comments focused on style and its discontents as explicitly as any of my opponents': I replied to G.S., and to another entrant to the debate on the pro-Freudian side, with acute self-consciousness, aware on some level that I had transgressed the list community's implicit anti-flaming codes through the mere vehemence of my attack, and closed one of my postings with a frank embrace of the *Homo incinerans* ethos:

> As for the excessive rhetoric: well, I'm guilty as charged. Three to five for second-degree flaming, not counting time already served. I appreciate the nudge in the direction of civility. I do enjoy a good rhetorical ride once in a while, and Freudianism is so full of irritations & provocations that it can evoke some real Flamethrower Behavior over here. What can I say? . . .Flames R Us. Hope the number of people who enjoy reading one is roughly equal to the number who take offense, or maybe even a bit higher.

> Please Read & Enjoy. Thanks for your comments.

Inviting list members to "read and enjoy" performances that I acknowledged as not entirely civil—in other words,

accepting the moral censure implicit in what I would later come to call metaflaming, and moving on to aestheticize the flame—may have been the crucial problematic step in extending this debate beyond its ostensible subject. List moderator Finlay immediately and presciently understood that this post might become a fissure point for the conversation: he prefaced it for the group with a framing comment of his own.

> Editor's Note: The message below is not a flame, although the poster claims it is. I have noticed on lists that when anyone uses the word "flame" in a post hitherto dormant netters gather for the kill from all parts of the known electronic universe. Don't overreact here to the poster's obvious act of indulgence. He addresses points, so far as I can see.

A different sense of what constitutes a flame animated Finlay to warn against metaflaming (ineffectively, as it would turn out). Implicit in his remarks is the idea that a true flame does not address points; I have thus erred semantically, in his view, by straddling the distinction between flaming and arguing about matters of substance. To wilfully assume the lowly ethos of the flamer is to forgo seriousness. The ensuing reactions, however, suggested that not all list members had as strong an interest in immobilizing the oscillation between the serious and the ludic.

This thread, after operating for a few days under the subject heading "In Defense of Psychoanalysis," soon evolved into numerous intertwined discussions. Finlay himself, reacting to an earlier Twain reference on my part, noticed that

> the grandiosity of 19th-century public writing (take the editorials of Bennett or Patrick Ford) seems to have parallels with the way people sometimes get rhetorically drunk (especially via flaming) on the Internet. I wonder if anyone else had noticed this "nothing exceeds like excess" attitude, or if any research had been done comparing nineteenth century modes of address with more recent electronic ones.

Finlay also repeatedly struck a fine (if precarious) balance between *ad hominem* derogation and admiration, both in posts to the list and in private mail.

> I guess Bill Millard gives me some things to think about in his self-styled attempts to desecrate different temples. What is interesting to me is that he

draws upon a stereotypical image of psychoanalysis and of patients (a TV image or a real one?) so as to make his point more forceful. . . . [O]ne could just as easily [say] that it is Millard whose concept of psychoanalysis is stuck in a time warp. He needs to deconstruct that image himself, but seems to me to be too much in love with profaning temples. And more power to him—being subversive for the sheer hell of it is a lot of fun!

Others, however, objected to the growing meta-rhetorical focus as a distraction. First Amendment historian Jesse Lemisch, in particular, castigated Finlay for crossing the line between etiquette and censorship:

I've stayed out of this quarrel until now. Here is what brings me in. As a person new to the Internet, I see a tyranny out there in cyberspace, bringing Millard to a kind of an apology and others to come along to analyze his rhetoric and to relate it to nineteenth-century "bombast." We should be talking not about rhetoric but about reality: looking at rhetoric misses the substance. This seems a clear case of somebody's conception of appropriate manners for Internet leading to a kind of suppression.

After Lemisch sounded the anti-censorship alarm, a voice of moderation was offered by social historian Frank Couvares. At times, opponents Couvares and Lemisch appear to share the premise that rhetorical exuberance is detrimental to debate, differing on the nature of the "reality" beyond language but never doubting its independence from language's constructing effects.

The issue is not manners, it's clarity; it's locating the issue under discussion, and separating it out from other matters. It's also determining levels of generalization useful to the discussion. We all can admire a hearty "flame" every now and then, but precisely because we want to speak to a "reality" and not simply our feelings about that reality, it's a good idea to avoid certain kinds of rhetoric. I think I agree with lots of what Millard thinks, but who knows? Nobody's suggesting "suppression" —quite the opposite; certain kinds of flaming make it hard for others to respond, make it seem that different opinions are benighted, off the meter, etc. You and I can talk any way we want on

Internet; the question is what kind of conversation are we looking for.

Some of the actual consequences of the debate destabilized this implicitly anti-rhetorical premise. Taking a position closer to Lanham's linguistic/dramatic social constructionism, Eliza J. Reilly acknowledged a result that deliberative rhetoric always intends yet almost never achieves in practice: actual persuasion to adopt a view.

> With apologies to Jesse Lemisch, rhetoric is exactly what Bill Millard's writing is about, brilliant, funny and very convincing rhetoric. I've heard the argument before, but never agreed with it till now. I suspect those carping about 19th-century bombast are just green with envy. . . .

Among all the reactions to the collective meta-inflammatory identification of rhetoric as a problematic subject for debate, a useful polarity appears between Reilly's encouragement for energetic rhetoric as an effective determinant of a personal ideological decision and Couvares's plea for toned-down rhetoric as an open pathway to democratic discussion. To map physically the relations among rough-and-tumble rhetorical play, serious transparent language that leaves feelings unruffled and positions undisturbed, and the practical effects of language in the social world, the alignment of these elements changed radically with Reilly's post. The neo-platonic privileging of the serious over the ludic assumes that the former is more likely than the latter to accomplish useful intellectual work; this assumption places transparent language in proximity to consequentiality, with ludicity off to one side, sometimes enjoyable but essentially irrelevant. Yet Reilly's experience of having "heard the argument before, but never agreed with it till now" implies that it is the ludic element in language that moves minds. Lanham's nonfoundationalist "Strong Defense" of the role of rhetoric[8]—that it is constitutive of, not ornamentally superfluous to, ethical principles and social virtue—has seldom been so unambiguously borne out in practice. Lemisch, though still unwilling to elevate flaming above dyslogistic status, soon pivoted into alignment with Reilly on this point, recalling that the fear of strong language had a history of concealing fear of change.

> In the sixties, we learned that terms like "strident" and "acerbic" were terms of abuse applied to radi-

cals and feminists by people who didn't like their arguments. We learned that those using these terms were often the true hysterics, but that their truly strident and acerbic arguments were not seen that way by other mainstream types who agreed with the substance of the arguments being made. Now we have "flaming." It's the same thing. Millard makes sensible and persuasive arguments, referring to a literature which offers strong empirical evidence for his contentions. Most of those arguing against him don't know the difference between argument and evidence. If you want to argue with him, deal with his evidence. Otherwise, you're just flaming, expressing a rage disguised as gentility. It's the conservatism of the times that allows you to think that your denunciations constitute reasonable argument.

Finlay, conversely, expressed surprise that anyone should even expect the debate to yield a result.

> I wasn't analyzing Bill Millard's rhetoric so much as drawing attention to his speculation about what would have happened if Twain had been around in the time of the 'Net. It is a fact that public writing in the nineteenth century at times resembled a maelstrom of—I know of no better word—bombast. I'm thinking of newspaper editors—Bennett, Greeley, Bryant, Ford, Donahoe. Fabulous stuff, mountainous waves of prose building up and thundering down on readers in the pursuit of some controversy. We've lost all that in every place I can think of except the Net, where people's tongues often seem miraculously untied.

While praising extravagant rhetoric as sheer performance, he nonetheless confined rhetoric to its epideictic or celebratory function, eliminating the deliberative element that allows it effects beyond the realm of aesthetics. This cordoning-off of consequentiality recurred in a later off-list reply to my own metaflaming suggestion that we "keep our respective phasors set on *stun* rather than *kill*."

> [I]f I were addressing you on the list, I would go for your points rather than your throat. . . . what it seems to me we are doing is parading our separate points of view in a courteous manner. . . .

But if debate amounts to a courteous parade of points of view, each of which awaits deconstruction, can a participant in a debate hope for anything beyond "parading" and self-display? Reilly's testimony suggests that the curious blend of sincerity and sport found in animated rhetoric, the vigorous conviction that one perspective can in fact outperform another (and ought to be allowed to, on the grounds of ongoing social and verbal drama, not merely arbitrary privilege), does occasionally yield results. Perhaps the salutary effects of flaming, apart from illuminating the fictionality of the sincere central self, can include a fusion of epideictic and deliberative rhetorics as well, a demonstration that performance does not occur in a vacuum.

Richard Rorty has usefully asserted that there is no such thing as relativism in actual practice:

> "Relativism" is the view that every belief on a certain topic, or perhaps any topic, is as good as every other. No one holds this view. Except for the occasional cooperative freshman, one cannot find anybody who says that two incompatible opinions on an important topic are equally good. The philosophers who get called "relativists" are those who say that the grounds for choosing between such opinions are less algorithmic than had been thought. . . . If there were any relativists, they would, of course, be easy to refute.[9]

Nonetheless, in a conversation where the defenses of contradictory opinions necessarily take a dramatic rather than algorithmic form, it is easy for relativistic claims (however internally inconsistent) to appear. The consensual ceasefire that occurred at the end of this debate involved agreement to disagree, once all parties had said their piece. This outcome should not, I believe, be interpreted as an indication that relativistic claims govern Internet discourse. Flamewars and debates can be open-ended in this medium, and no authority pronounces closure. Still, it can be argued that the overall narrative of a flamewar requires explicit recognition of the impossibility of relativism, on the grounds that the desire to achieve persuasion provides the initial and constant motivation for rhetoricians to perform. On occasion, evidence that such a desire is not ephemeral becomes publicly available, even irrefutable.

The mere existence of metaflaming implies that *Homo incinerans* remains cyberspace's equivalent of a folk devil, in Stan Cohen's terminology. Yet the participants in this discus-

I FLAMED FREUD

sion exhibited an enthusiasm, a willingness to return to the forum no matter how high the temperature, and an overall civility (paralleling the ferocity of argument, and continuing between some of the parties long after this debate ended) that indicate a positive value in something that was generally abominated at one stage. Only a small number of lurkers, perhaps puzzled by the vehemence—and somehow unconvinced that the evidentiary, logical, economic, and therapeutic status of an institution as established (if embattled) as psychoanalysis was indeed a valid subject for debate within the framework of American studies—called for an end to the debate.[10]

Perhaps the term "flaming" deserves to be recuperated and separated from personal opprobrium. Certainly, with the concept of a persona as thoroughly problematized as it is in online communication, opprobrium can never be simply personal. Provided that Internet writers can accept the fragmentation of their personae and the complexity of the rhetorics those personae generate, incendiary rhetoric can be not a cause for panic but a productive hermeneutic tool.

NOTES

1  See Richard Lanham, *The Electronic Word: Democracy, Technology, and the Arts* (Chicago: University of Chicago Press, 1994) and David Hawkes, "Regression to Barbarism?" post to Bad Subjects LISTSERV, November 19, 1994.

2  Gregory Bateson, *Steps to an Ecology of Mind: Collected Essays in Anthropology, Psychiatry, Evolution, and Epistemology* (Northvale, NJ: Jason Aronson, 1972), 14–20.

3  William B. Millard, "'A Great Flame Follows a Little Spark': Metaflaming and Functions of the 'Dis' in the Rhetoric of a Discussion List," in Charles Stivale, ed., *This Funny Chemistry: Pedagogy and Performance in the Discourse of Text-based Virtual Reality*, in *Works and Days* 25/26, 13.1–2 (1995), 137–149.

4  A related debate in cyberspace involves some online writers' reliance on emoticons or "smileys"—:) and its variants—to maintain the phatic element in their communications. Without taking sides in an often hilariously overheated debate about the functions and effects of cuteness, I would note from an information-theory perspective that the mere existence of emoticons,

which necessarily compress the varieties of social and emotional emotion that the nerves and muscles of the human facies can convey into a finite series of symbols, implies that the online medium lacks sufficient bandwidth to admit the redundant information that many communicators require.

5  "Chrono-economic stress," a term I have suggested elsewhere ("A Great Flame"), refers to the psycholinguistic effects of an online writer's awareness of the limits to the time, bandwidth, money, attention, and any other resources that he or she can devote to any given piece of discourse. If rhetoric is "the economics of attention, the allocation of a scarce resource," as Lanham has defined it (*The Electronic Word*, 64), then Internet rhetoric operates under conditions of extreme scarcity.

6  Lanham, *The Electronic Word*, 241.

7  Frederick Crews, "The Unknown Freud," *New York Review of Books*, November 18, 1993, 55–66.

8  Lanham, *The Electronic Word*, 156 ff.

9  Richard Rorty, *Consequences of Pragmatism: Essays, 1972–1980* (Minneapolis: University of Minnesota Press, 1982), 166–167.

10  The few posts that called for an end to the debate were vastly outweighed by expressions of interest or even fascination; the private comments I received from some participants, complaining about these complainers, constituted flames in the traditional unprintable sense.

# IMHO

## AUTHORITY AND EGALITARIAN RHETORIC IN THE VIRTUAL COFFEEHOUSE

Brian A. Connery

CyberMonk, a local squatter, frequents the Horse Shoe Coffeehouse in San Francisco, where for fifty cents he can access the SFNet (designed by Horse Shoe proprietor, Wayne Gregori) for twenty minutes. The combination of real and virtual space afforded by the coffeehouse allows CyberMonk to use it as living room, telephone, and mailbox.[1] In so doing, he emulates young men of meager means newly arrived in late seventeenth- and early eighteenth-century London who used coffeehouses for addresses to receive mail, social spaces in which to make a "good figure" (potentially belied by their actual shabby lodgings), and discursive spaces in which to discuss the "news" and so to launch themselves within commercial, political, or literary communities.[2] The early eighteenth-century coffeehouse is particularly important in Jürgen Habermas's explanation of the historical emergence of a "public sphere," a discursive space unregulated by established authority, in which all participants, regardless of their identity or station elsewhere,

are considered equally entitled to speak and be heard.[3] In Gregori's postmodern innovation, a virtual coffeehouse within an actual coffeehouse, he intuitively seeks to replicate in cyberspace a social phenomenon that had deep roots in the development of early modern Western culture but that was later eclipsed by modernity's concomitant emphasis upon privacy, competition, and individualism. Like the newly-arrived eighteenth-century Londoner, CyberMonk and other users of the Internet are afforded the opportunity to forge new identities for themselves in a public space that regards all participants as roughly equal until proven otherwise.

In our quest to understand both what cyberspace is and what it could or will become, analogies to everything from the American frontier to the Mall of America have proven applicable. The Horse Shoe Coffeehouse is particularly suggestive in its implicit analogy to the eighteenth-century coffeehouse. What we know about coffeehouse history is useful in understanding not only how cyberspace is currently being used but why it combines the particular functions that it does, why particular rhetorical difficulties and conventions have emerged, and, perhaps most tellingly, what internal forces threaten to close down the publicness of the Internet as a conversational space. This chapter rehearses the history of the coffeehouse, explains its relevance to the development of the "public sphere," examines the analogy to the Internet, and makes suggestions about the relevance of the eighteenth-century coffeehouse both to the current rhetorical styles found on newsgroups and discussion lists and to the future of such groups and lists.

• • •

Coffeehouses cannot be considered in isolation from the rest of seventeenth-century British culture or politics, but the politics of the period are far too complicated to review satisfactorily here. It will suffice to remind ourselves oversimplistically that at the middle of the century England suffered through a civil war as a coalition of Parliamentians and Puritans joined in a revolution against the absolutism of James I and then Charles I (the "Martyr King") and against the authority of the hierarchy of the Church of England, ultimately declaring England a republic under Oliver Cromwell. Though the monarchy was restored in 1660, eighteen years later, soon after the accession of James II, the Glorious Revolution deposed the King and introduced William and Mary to the throne, refuting the notion of the King as absolute ruler and establishing *de*

*facto* the constitutional principle argued subsequently by John Locke that the King rules at the behest of the people. While we know in retrospect that the constitutional settlement did indeed permanently settle matters, the people of the period did not enjoy the luxury of such hindsight and continued to see the newly emerged opposing parties, Whigs and Tories, as symptoms of a restless, and volatile politics. Throughout this period, the coffeehouse—as a place where the public gathered to discuss politics or, as many feared, to hatch plots and conspiracies—was both representative of, and instrumental in, the development of the new political and cultural climate, particularly what may be considered the emerging anti-authoritarian mood throughout the culture. Aside from politics, the new science, as represented by Bacon and Newton, was insistently suspicious of received truth and consequently of the authority of the past. So too in philosophy, Descartes, Hobbes, and Locke marked a radical departure from their predecessors, both classical and Christian.

The coffeehouse, then, was the real space where controversies between Cavaliers and Roundheads, Tories and Whigs, and Ancients and Moderns—simultaneously debated in print—were debated in realtime. As Habermas suggests, prior to this period, the Court had been the sponsor of all public discussion and information and thus the "official" and authoritative center of culture. In this period of revolution, however, suspicions arose that the interests of the Court and the interests of citizens were not identical, and consequently discussion moved out of the Court and into public spaces where the "unofficial" views of citizens might be heard. Coffeehouses were the most prominent of those spaces.

The first coffeehouse, Bowman's Pasqu Rosee, was established in 1652, during the Interregnum. Soon after his restoration to the throne, Charles II noted the subversive possibilities of coffeehouse culture and ordered that they be licensed in 1663. During the Plague of 1664, despite official warnings to avoid places of unregulated social contact, coffeehouses continued to thrive. A year later, Charles announced his intention to suppress the coffeehouses entirely because "many tradesman and others do herein misspend much of their time . . . but also for that in such houses divers false, malitious, and scandalous reports are devised to spread abroad to the defamation of his Majesty's government."[4] Shortly thereafter, recognizing the unpopularity of his intention (and, perhaps, heedful of the fate of his absolutist ancestors), Charles retracted his proclamation,

but enjoined coffeehouse proprietors not to allow scandalous papers on the premises.

Charles objected, clearly, not to the beverages served nor to the productivity lost, but to the circulation of news and opinions in a space unregulated by the Court. Indeed, the rise of coffeehouses was concomitant with the rise of newspapers. During the Interregnum, controversial periodicals had proliferated: 300 new periodicals appeared between 1641 and 1656. While many were ephemeral, publishing only once, the proliferation itself indicates a hunger for both information and informed opinion which persisted subsequent to the Restoration. In 1662, Charles ordered the Licensing Act, establishing Roger L'Estrange as the sole publisher of periodicals and thus reestablishing the Court as the source of information and opinion. A rival publisher, John Dunton, wrote in his autobiography that the Licensing Act indicated the King's opposition to the public's access to and discussion of information, a phenomenon that made "the *Coffee-Houses*, and all the *Popular Clubs*, Judges of Those *Councels* and *Deliberations*, which they have Nothing to do withal."[5] L'Estrange, notably, founded in 1665 the first genuine English newspaper (i.e., a newspaper as we know it), *The Oxford Gazette* (later, *The London Gazette*) in 1665, which, although it consistently represented the official position of the Court, became the model for later papers once the Licensing Act was enforced less actively. The Act lapsed in 1679, was revived by James II during his brief reign, was less stringently enforced under William and Mary, and expired in 1695. For several subsequent decades, publishing was regulated only *post facto* by prosecutions for libel and sedition.

"News" had become a profitable commodity and the link between the newspapers and coffeehouses solidified considerably throughout the last twelve years of the century as coffeehouses became the primary disseminators of news. Coffeehouses were the natural locations for mail delivery after the establishment of the penny post by William Dockwra and his associates in 1680, prior to which messages were carried by private porters throughout the city. Dockwra established seven sorting offices in London and Westminster along with numerous collection stations, and promised hourly deliveries to places of "quick negotiation."[6] Coffeehouses fit the bill—they were public, well-known, and easy to find. Much of the extant correspondence (between males) of the period names one or another coffeehouse as an address. Thus, coffeehouses became the destination of private correspondence that often included "news,"

which would then be made public among the addressee's companions. Many readers will be familiar with the story of the present-day Lloyd's of London, which started as a coffeehouse frequented by merchants and which was, consequently, the destination of mail and messengers with the latest and most accurate shipping news, making it the locus of important finance and insurance news. The reputation of Lloyd's as a locus of news made possible the publication of *Lloyd's List*, announcing arrivals, departures, safe voyages, and disasters.

As the example of Lloyd's indicates, newspapers took full advantage of coffeehouses as sources of news. Newsrunners for newspapers frequented coffeehouses, gathered what they could from the conversations they overheard, and published their information in the newspaper—which then returned to the coffeehouse. In announcing his method and function, for instance, Joseph Addison, in the first issue of *The Spectator*, describes the character of his persona, the Spectator, as follows:

> There is no place of general resort wherein I do not often make my appearance: sometimes I am seen thrusting my head into a round of politicians at Will's, and listening with great attention to the narratives that are made in those little circular audiences; sometimes I smoke a pipe at Child's [a popular coffeehouse with the clergy], and while I seem attentive to nothing but the potman, overhear the conversation of every table in the room. I appear on Sunday nights at St. James's coffeehouse, and sometime join a little committee of politics in the inner room, as one who comes to hear and improve. My face is likewise very well known at the Grecian and the Cocoa Tree. . . . I have been taken for a merchant upon the Exchange for above these ten Years. . . .[7]

Notable here, relative to newsgroups and discussion lists, is the apparent openness of each of these coffeehouses, their publicness, as well as Addison's ability to park his real identity at the door of each and to adopt a new identity within each.

Given the use made of coffeehouses by writers like Addison, one needs little imagination to envision the opportunities for fraud and manipulation within the freewheeling and unregulated communications loop between coffeehouses and newspapers. Those with political, financial, or other interests were not above planting stories in the coffeehouse which, overheard by newsrunners, would then be printed and re-dissemi-

nated via the newspaper. Coffeehouses were, in fact, the primary subscribers to newspapers, and because they offered the opportunity for greater dissemination of the newspapers' contents they were of great interest to advertisers as well. In the coffeehouse, the newspaper was usually read aloud by one member of the clientele. We can assume that he offered commentary, and that his audience did so as well.

No one coffeehouse or newspaper monopolized the "news." Instead, as Addison's self-description indicates, different coffeehouses served different clienteles: Garraways in Exchange Alley offered news on auctions, nearby Jonathan's had news on stocks and investments. The Grecian was frequented by scientists and would-be scientists, while Will's and Button's hosted the literary coterie, and so on. Newspapers, similarly, offered both partial and partisan news. Addison remarks that the newspapers "receive the same advices from abroad, and very often in the same words; but their way of cooking it is so different, that there is no citizen, who has an eye to the public good, that can leave the coffeehouse with peace of mind, before he has given every one of them a reading."[8] Consequently, each coffeehouse had to subscribe to many newspapers in order to offer the news in its entirety, and each newspaper had to frequent many coffeehouses in order to get the whole news.

Coffeehouses, then, were reincarnations of classical "marketplaces of ideas" like the *agora* and the forum, and served as laboratories for experimentation in some of the various freedoms articulated in the American Bill of Rights later in the eighteenth century: freedom of the press, freedom of association and assembly, freedom of speech. Indeed, in the egalitarian discourse of the coffeehouse we can see a rehearsal of the social relations that would eventually be practiced throughout much of society at large. But freedom always comes with a price—and the price is evident throughout the writings of this period: with the displacement of authority from Crown and Miter into the public sphere, authority itself becomes unstable. Within the discursive milieu of the coffeehouse, where the Church, the State, and other precedent authorities are under suspicion and newspapers are equally suspect, one's authority—i.e. one's right to speak, be heard, and possibly be believed—rests primarily upon one's own self-authorization and by the authority granted by the coffeehouse community or the reading public. As a classically liberal or anti-authoritarian discursive space, the coffeehouse resists the closure of

any discussion—since that closure would re-institute or reestablish authority.

Paradoxically, anti-authoritarianism becomes authoritative. Indeed, both the proliferation of newspapers and the public reading of them within coffeehouses assured that few statements either of fact or of opinion would go unchallenged. The increased frequency of newspaper publication allowed newspapers and authors to respond to one another within days—not quite the time frame of cyberspace, but a significant step in that direction. The combination of a discursive space in which all citizens are permitted to speak and a radical decrease in the delay between composition and dissemination of writing produced an explosion of "answers" and "answerers" that we might now term "flames" and "flamers." Even the usually dignified Addison in *Tatler* No. 229 refered to his opponents as "Vermin." Newspapers and pamphlets, in light of the rapidity with which they were disseminated, began to imitate the conversational style of the coffeehouses in which they were consumed. Writing, which ordinarily assumes a silent reader, began to be directed at readers who were expected to respond. Writing, at this point, lost authority as it began to imitate conversational speech. Writing, in and of itself, is normally considered authoritative, but when writing assumes that it will be answered, it authorizes the reader, just as when we speak in conversation we assume our companions' prerogatives to interrupt, contradict, or change the subject.

Indeed, it was not uncommon for newspapers to appear in pairs—one to offer its particular point of view and another to refute it. In many cases, we can characterize the opposing publications as authoritarian and anti-authoritarian, the one attempting to re-impose authority and thus to end the discussion, and the other nit-picking at the broad and frequently pompous assertions of the first. One pair of publications from the 1670s focuses upon coffeehouses themselves. The first, *The Character of a Coffee-House* (1673) sneers at the mixing of classes (both explicitly in its comments on Levelling and implicitly in the metaphors of sexuality and sexually transmitted diseases) and the dissemination of commodified misinformation characteristic of the coffeehouse:

> A Coffee-House is a Phanatique Theatre, a Hot-House to flux in for a clapt understanding, a *Sympathetical* Cure for the *Gonorrhea* of the Tongue, or a refin'd Baudy-House, where *Illegitimate* Reports are got in close *Adultery*

between Lying Lips and Itching Ears. . . [It is] an Exchange where *Haberdashers* of Political *small-wares* meet and mutually abuse each other and the Publique, with bottomless stories and head-less notions; the rendezvous of idle Pamphlets and persons more idly employed to read them; a *High Court of Justice*, where every little Fellow in a Chamlet Cloak takes upon him to transpose Affairs both in Church and State, to shew reasons against *Acts of Parliament*, and condemn the Decrees of *General* Counsels.

Aside from the misinformation generated by coffeehouses, the anonymous author here seems most impassioned by the self-authorized presumption of the coffeehouse denizens in having discussions and opinions on the Church, the State, the Parliament, and so on. He recognizes that coffeehouses are public spaces where citizens, the consumers of the news, deter-mine the meaning of the news by means of discussion unmedi-ated by official authority. Society appears to be imploding, as classes, ranks, and occupations mix:

As you have a hodge-podge of Drinks, such too is your Company, for each man seems a Leveller, and ranks and files himself as he lists, without regard to degrees or order; so that oft you may see a silly *Fop*, and a worshipful *Justice*, a griping *Rook*, and a grave *Citizen*, a worthy *Lawyer*, and an errant *Pickpocket*, a Religious *Nonconformist* and a Canting *Mountebank*; all blended together to compose an Olio of Impertinence.[9]

For this polemicist, the coffeehouse commits a variety of trans-gressions, indicated in the metaphors of disease and unnatural mixing. The coffeehouse breeds monsters, and the rhetoric of the coffeehouse is monstrous as well, combining writing and speaking into an ungovernable discourse. The solution for our writer, of course, is the suppression of coffeehouses—i.e., the suppression of discussion and the return to established and official authority.

History tells us emphatically that our polemicist lost his battle—and it's hard to see how he could possibly have won: by entering into the discussion himself, he has entered into a non-authoritative arena. A telling discursive moment comes at the end of Jonathan Swift's tenure as the chief publicist for the policies of Robert Harley and St. John Bolingbroke, the minis-

ters of Queen Anne. For a period of almost two years, Swift was the primary author of a newspaper entitled *The Examiner*, and after each issue he found much that he had said answered and criticized in other papers, chiefly by George Mainwaring's *The Medley*. In the final paragraph of his final issue, Swift claims a triumph and attempts to dismiss his answerers:

> For my own Particular, those little barking Pens which have so constantly pursu'd me, I take to be of no further Consequence to what I have writ, than the scoffing Slaves of old, placed behind the Chariot, to put the General in mind of his Mortality; which was but a Thing of Form, and made no Stop or Disturbance in the Shew. However, if those perpetual Snarlers against me, had the same Design, I must own they have effectually compass'd it; since nothing can well be more mortifying, than to reflect that I am of the Same Species with Creatures capable of uttering so much Scurrility, Dulness, Falshood and Impertinence, to the Scandal and Disgrace of Human Nature.[10]

Like the anti-coffeehouse polemicist, Swift establishes a rhetorical position that seems lofty, looking down upon his opponents—but this stance is compromised by his presence among them within the discussion, and he is brought to recognize that "I am of the Same Species." Swift discovers the impossibility of arguing for authority in a rhetorical space which is by definition anti-authoritarian. Unlike Addison, who willingly checks his own identity at the coffeehouse door, Swift discovers that he is unwillingly stripped of official authority upon entering the public sphere and reduced to equality with those who would answer him.

Our anti-coffeehouse polemicist was answered within days by another anonymous writer in *Coffee Houses Vindicated*, and as far as my research can tell, the answerer has the last word. He clearly recognizes and cherishes the egalitarian ethos and the self-authorization of the coffeehouse where he finds "a free and communicative company, where every Man may modestly begin his *story*, and propose to, or *Answer* another as he thinks fit." Moreover, he lauds the influence of such "Intelligent Society, the frequenting whose Converse and observing their *Discourses* and *Deportment* cannot but *civilize* our manners, Inlarge our Understandings, refine our *language*, teach us a generous confidence, and handsome Mode of Address."[11]

What is striking in this "vindication" is the emphasis upon civil manners, especially in conversation. Within the coffeehouse, where authority does not vie with anti-authoritarian voices, our author claims that a new form of discourse has emerged. We cannot recover the oral rhetoric of the coffeehouse, and tell-tale changes in written work do not appear until well later. But evidence such as the vindicator's description of coffee-house decorum suggests that because the discussion took place in realtime and because the anti-authoritarian ethos pervaded the coffeehouse, rhetoric was adjusted to offer respect to all while denying *a priori* authority to any. While rhetorical tone prior to the eighteenth century may be characterized as pater-nal (i.e., the speaker or writer plays the role of the father to the listener or reader's son), a gradual shift occurs into what may be regarded as a fraternal rhetorical stance, in which the speak-er or writer plays the role of brother and thereby gives up the paternalistic claim to authority. Indeed, within an anti-author-itarian discursive space, only by adopting this stance of equali-ty rather than by adopting a stance of authority can the speaker or writer authorize himself to participate. In a seeming para-dox that may be familiar to devotees of Rogerian rhetoric, signs of self-de-authorization lead to authorization within an anti-authoritarian rhetorical space, while claims of authority lead to de-authorization. Authority is no longer prior to discussion; it is granted by the audience in the course of discussion.

· · ·

Coffeehouse history has important implications for the rhetoric of discussion lists and newsgroups. Like the coffeehouse, the Internet is a repository of information with a potential for unprecedentedly fast dissemination of this information that sug-gests an analogy with eighteenth-century newspapers and penny post mail. It lacks regulation, so that much of its information is unofficial and potentially unauthoritative. And it provides a social space in which discussion of the "news" takes place both in virtual time, as in newspapers, and in realtime, as in coffeehouse conversations. This last feature seems most striking to me, for one of the most notable aspects of the Internet, especially of the dis-cussion lists and newsgroups, is the return of what can be called social reading—something that has not been common in our cul-ture outside the classroom for almost a century. The term sug-gests large groups of people reading and commenting upon supposedly stable but actually questionable texts. This hybrid nature, combining writing with the conventions of oral conversa-tion, is the source of many rhetorical difficulties on the Internet.

Like the eighteenth-century coffeehouse, the Internet has provided users with access to information and opinion beyond that provided by the "official" disseminators of news. While today many people enjoy the fruits of a "free" press or even an oppositional one, mainstream media may still be likened to the Court of Charles II as the regulators of information and opinion within our culture. Moreover, like the Court, media sponsors and owners—private and public—must be suspected of being interested in controlling the dissemination of information and opinion. Users of the Internet, like the denizens of coffeehouses, frequently have access to information (eyewitness accounts of crosstown fistfights or invading forces halfway across the world; manuscripts rejected by the official literary or scholarly presses) not disseminated by the "official" media. To this extent, at least, the Internet itself—currently regulated only minimally by local computer administrators—may be considered an inherently anti-authoritarian institution. As in the coffeehouse, neither the population nor the content of the discussion is regulated. All participants check their actual selves at the door and enter the virtual space as equals simply because they are unknown to one another. No one has *a priori* authority. The result, as the detractors of coffeehouse culture once also observed, is both a genuinely public space and a very messy one. As one discussion-list participant recently cautioned a new list-member objecting to the roughness of the give-and-take: "This is hoi-polloi out here, not Oxford High Table. It is an inherently uncouth environment."[12]

While many users have embraced the Internet's lack of regulation, others have not. And debates continue—at the national level regarding the Internet itself, at the local level regarding the dissemination of materials at specific sites, and within the cyberspace of newsgroups and discussion lists— about the degree, if any, to which authority should be re-imposed upon cyberspace. As with coffeehouses two hundred years ago, the future of the Internet depends upon the consequences of the tension between advocates of authority and an anti-authoritarian space.

Both consciously and unconsciously, many lists and newsgroups have, in fact, established authority. Lists devoted to a specific author or text have, for instance, constructed themselves as authoritarian to the extent that discussion is always regulated by the controlling author or text. One thinks, of course, of Bible groups, but I've lurked on lists devoted to anarchist philosophers that maintain a similar dogmatism with

reference to the texts at hand. On these lists, everybody agrees on what the book literally says, although discussion about what it means may be free-wheeling and boisterous, and the introduction of other published commentary on the authoritative text opens up the possibility again for a free-for-all.

Other lists use moderators who, like Roger L'Estrange of old, authorize the publication of posts by monitoring all incoming articles and refusing to pass along to the group messages deemed irrelevant, unseemly, or inflammatory. As in the later stages of the evolution of the coffeehouse, some discussion lists are closed and exclusive, maintained in a backroom of cyberspace. Potential members must apply by identifying their legitimate interests in the group and their qualifications for participating.

Lists and newsgroups which remain open and which are not organized around an *a priori* authority remain the most interesting in terms of their rhetorical dynamics. They typically attempt to relieve the tension between authority and anti-authority. These lists remain nominally free while minimizing the consequent conversational chaos by allowing participants to constitute the authority of the group. Many such groups establish FAQs (Frequently Asked Questions) to which newcomers are directed. FAQs often explicitly identify the group's purpose—and consequently establish what sorts of messages are pertinent and which are impertinent. Posters of impertinent messages receive multiple responses and sometimes flames, all directing them back to the FAQ, and thus impertinent threads are aborted. Many FAQs also contain information about the topic upon which the group is focused; and posters who send questions to the group are often referred to the FAQ for answers. While such a procedure creates efficiency, it also short-circuits discussion through reference to a now already authorized compendium of established information which is, consequently, beyond dispute. In a discussion of the unruliness of the Internet, a correspondent—who participates in a wide range of groups—observes:

> The net works best when one is looking for facts. We can, all around the planet, regardless of political, sexual, national, racial, etc. natures agree that certain facts are objective: the length of a meter, etc. To deny these facts is to display oneself as ignorant of the subject. The net is excellent for bibliographies, faq's, downloads, etc.

> It works at its worst when one is looking for a dif-

ference of opinion. When I first joined the net, I subscribed to discussion groups for arabic society, hoping to discuss the Koran with educated Arabs. Wrong move. It's mostly a lot of screaming between poorly educated, unintelligent people on both sides.[13]

As this correspondent suggests, turning to the Internet for authority on matters of debate is the "wrong move."

Many of the more professionally oriented lists in which I participate have established a seemingly tacit consensus that their rhetorical space is to be limited to the transfer of information in the form of queries and replies. Posters engaged in research turn to these groups for help in tracing allusions, quotations, historical minutiae, and list members helpfully respond with bibliographies, identifications, or leads on where the answers might be found. Having established such a norm, whenever participants begin a discussion it is easily short-circuited by one or two demands (sometimes in private email messages) that participants continue the discussion off-list. Similarly, many newsgroups use alt.flame as a back-alley where members can flame each other to their hearts' contents without disturbing the group. Other groups—usually small and long established ones—handle the felt threat of flame wars by responding with silence to posts that challenge already established consensus. Though these groups are theoretically open and public, they are carefully—though to an extent unconsciously—monitoring who will be included in the conversation. Their silence in response to a flame silences the writer and thereby establishes an authoritative norm. This may be necessary to the survival of the group, particularly in light of the very real existence of "invaders," like members of alt.syntax.tactical whose declared purpose in 1994 was to attempt the destruction of groups through the creation of irreparable dissension (and who declared a victory in the now-famous debacle in alt.rec.cats). Still, the tactic of silence can have the effect of closing down discussion of a variety of topics that, while legitimate for discussion, are perceived by the group as too hot to handle without an eruption of flames. That is, a reasonable post on gender roles may be ignored by group members for fear that the discussion will become inflammatory.

While efficiency and goodwill are probably invoked most often as the rationale for such procedures, such claims mask a more profound tension within such groups, that between authoritarian and anti-authoritarian impulses, which, in

rhetorical terms, might be categorized as the tension in a public sphere between those who seek group authority (and thus stability) through consensus and those who are satisfied with the freedom of dissensus. While the imposition of authority protects the cohesiveness of the group it does so by shutting down discussion.

Again, the hybrid nature of the discourse within these groups may be the source of tension. Combining the conventions of conversation with the semi-stability of writing, they embody a contradiction. In discussion outside of institutional parameters or established purposive conversation (business meetings and the like), conversation exists for its own sake and it proceeds freely, unregulated by either a success orientation or instrumental or rational efficiency. Participants interrupt, contradict, and digress. At the coffeehouse (or at the corner saloon), unlike a discussion list or a business meeting, one would not ordinarily turn to others and attempt to establish rules for discourse or to demand closure or consensus.[14] To the extent that discussion groups constructed without a purpose beyond the creation of a space for communication are structured along conversational lines—possible because of the rapidity of transmission and dissemination of messages—the imposition of such restrictions seems similarly out of place. However, writing—even when evanescent on a computer screen—has contrary conventions and implications. First, as readers we tend to perceive writing as the consequence of long consideration and thus an end-point rather than a jumping-off point. To this extent, writing embodies authority (as indicated by the fact that "author" is the root of "authority"). Yet only a relatively small percentage of posts to lists and groups are the product of such reflection. When we speak in conversation, the tacit assumption is that we can change our minds about what we've said. When we write, the very act of writing seems to imply that our minds are made up.[15] Unless we signal otherwise, our writing speaks to readers in authoritative tones.

The phenomenon of flaming—the attempt to silence another contributor through the violence of one's response to their post—is, I think, a direct consequence of these tensions. One typically finds authoritarians flaming anti-authoritarians, or vice-versa. Those angered by the lack of consensus and the consequent inefficiency of a group or those who privilege writing and de-privilege conversation attempt to short-circuit discussion by flaming. On the other hand, those who seek dissensus rather than consensus, those who privilege conversa-

tion over writing, attempt to short-circuit the imposition of authority by flaming. Those content with dissensus within anti-authoritarian groups flame those who seek to impose authority. Respect for dissensus and diversity is frequently signalled to readers through the rhetoric of the poster. Two common abbreviations on the Internet, "IMHO" ("In my humble opinion") and "my $.02" ("my two cents worth") actively de-authorize the writer, signalling that the accompanying opinion is meant to further—not to stop—the conversation. Readers of successful and long-running lists are no doubt familiar with a wide range of similar, though less formalized or conventionalized gestures that often either precede or conclude a post. Ironically, because of the innately authoritative nature of writing, within such anti-authoritarian conversations, the absence of such cues may trigger flames because of the suspicion that the author is claiming to put forward the definitive response which will end the discussion.[16]

This tension will either be resolved by the imposition of authority upon the Net or will continue as long as the Net is able to maintain or enhance itself as a truly public space. As long as it's unregulated, it will be a space of confrontation between authority and anti-authority. Groups will be in a continual process of negotiation and re-negotiation, opening up and closing down. One list member, recording his uneasiness with this tension, speaks for many: "I do not think that a 'can't we all just get along' appeal is desirable or realistic, but it seems to me that an 'anything goes' attitude toward argumentative method and personal address will soon leave whatever conversation exists in tatters."[17] Indeed, some groups may dissolve because of the chaos of unregulated discussion. But it is exactly its function as a large-scale, potentially universally accessible space for unregulated discussion that makes the Internet unique in contemporary culture. And it is this function, which allows us to rehearse non-authoritative social relations through a potentially never-ending conversation, that may be the Internet's greatest contribution to our future.

• • •

Beyond the rhetorical implications, the history of the coffee-house in London holds a potential warning for those who dream that the Internet will create utopian discursive communities similar to that extolled by the author of *Coffee Houses Vindicated*. Coffeehouse culture, as described thus far, was short-lived (otherwise, of course, Wayne Gregori's patrons at the Horse Shoe Coffeehouse would not need computer termi-

nals at their tables). A number of factors led to their demise.

Of marginal importance was the previously mentioned Stamp Act which raised the price of newspapers and consequently the expense of maintaining a coffeehouse. Commercial online services, like Compuserve, Prodigy, and America OnLine might learn a bit from the cautionary tale of the coffeehouse proprietors. Dismayed by rising expenses, in 1728 the coffeemen issued a pamphlet entitled *The Case of the Coffee-Men of London and Westminster* in which they vigorously criticized the newspapers for inaccuracy and "scurrilousness." This was the public rationale (designed, no doubt, to disguise their more pecuniary interest) for their starting two newspapers of their own in January 1729.[18] We must infer that customers did not receive favorably either *The Coffee-House Morning Post* or *The Coffee-House Evening Post,* for there are no extant copies of these papers today. Those who would attempt to make the Internet more efficient, more profitable, and more centralized should be forewarned.

More important in the demise of the coffeehouse, however, were two trends: the reestablishment of authority and the institution of exclusivity. Regular denizens of particular coffeehouses, presumably becoming self-satisfied and uninterested in the views and news of less-regular participants in discussion, began to withdraw into backrooms. As early as 1715, according to William Thomas Laprade, "the bluff democracy of the public rooms in earlier coffeehouses [was gone as] men of note withdrew and did not court the common crowd. Select assemblies gathered in the private rooms."[19] Such "select" assemblies led to the rise of the private club.

The public rooms, instead, tended to be dominated by a few men or even one man. In 1719, Lord Molesworth writes that "each of the great Coffee Houses . . . has one or more Men of Authority" who "hold the Chair in Disputes" and fix "the Value of Opinions just as Stock-Jobbers did those of Stocks in Exchange Alley," as "Inferiour Auditors" submit with "great Alacrity" to the "Force of these Gentlemen's Reason and Eloquence."[20] This, of course, was encouraged by coffeehouse proprietors, who could use the celebrity of their prize client as a draw for other patrons—much as online services tout the participation of stars from Hollywood or the music industry.

Such a development may be inevitable within discussion lists and newsgroups. While authority is not fixed and is not claimable by any one individual, it is granted by the group. On

one list to which I subscribe a mild skirmish broke out after a relative newcomer to the list responded to a somewhat open-ended one-line question from another poster by proposing that the moderator screen out such messages, on the grounds that they contributed nothing to serious discussion. The moderator replied that no such screening would be undertaken, and jocularly noted that the original one-line poster had achieved tenure due to his long-term participation on the list. Thus, while certainly not guilty of double-speak, the moderator made clear that while all on the list are equal some are more equal than others, and that those who are in the group have more freedom and authority than those new to the group. But the freedom of the group as a public sphere can only be revitalized by unruly newcomers who flout the conventions and the authorities which inevitably evolve in long-lived groups. The flow of discourse in a group is always establishing norms which become authoritative; only abnormal discourse can re-institute the publicness and the freedom of lists and newsgroups by breaking emerging conventions. In order to maintain themselves as public spheres, discussion lists and newsgroups must not give in to the tension created between their anti-authoritarian constitutions and the desire for closure that can be achieved only by the re-inscription of authority upon a non-authoritarian and therefore free—but unruly—discursive space.

Newcomers must authorize themselves to stand up to the seeming authority of established groups in order to save those groups from their own ossification, as suggested in the following advice from a veteran Internet user to a newbie whose introduction of a volatile topic on a list elicited demands that the ensuing controversy be taken off the list:

> Don't let yourself be intimated by people who are trying to get others to take it [the discussion] off-list on the grounds that it doesn't interest them or isn't up to their high standards or is a waste of their valuable time or wastes bandwidth or any of that other stuff that really just serves the general purpose of announcing that their superiority is to be duly acknowledged and accommodated by the hundreds of other people in attendance here. (I don't think it occurs to them that they are putting others down because they are concerned rather with putting themselves up.) They talk as if they represent everybody, and because one is naturally self-conscious in addressing a gathering as large as this, they can seem to be the voice of the "silent

majority." They are not. Like all the rest of us they represent nothing but themselves.[21]

NOTES

As subsequent notes suggest, my thinking about the nature of the rhetoric of discussion lists and newsgroups has been greatly influenced by the subscribers to PHIL-LIT, the discussion list affiliated with the journal *Philosophy and Literature*, whose own attempts to negotiate the difficult tension between authority and anti-authority has produced an abundant and insightful meta-discourse from which I have learned. I am grateful to all of them, and especially to David Gershom Myers, the founding moderator of the group.

1 Katherine Bishop, "The Electronic Coffeehouse," *New York Times*, August 2, 1993, Section 3.

2 Throughout this essay, for information on coffeehouses, I rely primarily upon Bryant Lillywhite's *London Coffeehouses: A Reference Book of Coffee Houses of the Seventeenth, Eighteenth, and Nineteenth Centuries* (London: George Allen and Unwin, Ltd., 1963). A highly readable account of the coffeehouses is Aytoun Ellis's *The Penny Universities* (London, Secker & Warburg, 1956).

3 Jürgen Habermas, *The Structural Transformation of the Public Sphere: An Inquiry into a Category of Bourgeois Society*, tr. Thomas Burger (Cambridge: Massachusetts Institute of Technology Press, 1989).

4 James Sutherland, *The Restoration Newspaper and Its Development* (Cambridge: Cambridge University Press, 1986), 8.

5 John Dunton, *The Life and Errors of John Dunton* (London: J. Nichols, 1818), 266.

6 Sutherland, 48–49.

7 Joseph Addison, *The Spectator* (London: J. & R. Tonson and S. Draper, 1711), No. 1.

8 *Spectator* No. 452.

9  Anonymous, *The Character of a Coffee-house, with the Symptomes of a Town Wit* (London: Jonathan Edwin, 1675).

10  Frank Ellis, ed., *Swift vs. Mainwaring: "The Examiner" and "The Medley"* (Oxford: Clarendon Press, 1985), 470.

11  Anonymous, *Coffee-Houses Vindicated, in Answer to the late Published Character of a Coffee-House* (London: J. Lock, 1675).

12  Joseph Ransdell, "Discourse on the Net," PHIL-LIT: An Electronic Symposium of *Philosophy and Literature*, October 17, 1994.

13  Andreas Ramos, "E-Mail and Flames," PHIL-LIT: An Electronic Symposium of *Philosophy and Literature*, September 26, 1994.

14  Joseph Ransdell, "Discourse on the Net," PHIL-LIT: An Electronic Symposium of *Philosophy and Literature*, October 16, 1994.

15  The hybrid nature of discourse on the Internet has been explored by Marie-Michelle Strah, "Flaming Questions," PHIL-LIT: An Electronic Symposium of *Philosophy and Literature*, September 27, 1994.

16  My notion of the authority of anti-authoritarianism parallels arguments made by Stanley Fish in *There's No Such Thing As Free Speech* (New York: Oxford University Press, 1994). Similarly, my notion of the newsgroup or discussion list as a community of readers which authorizes its participants is based on Fish's *Is There a Text in This Class: The Authority of Interpretive Communities* (Cambridge: Harvard University Press, 1980).

17  Jeffrey Hippolito, "Re: Gentlemanly Debate," PHIL-LIT: An Electronic Symposium of *Philosophy and Literature*, November 30, 1994.

18  Sutherland, 222.

19  William Thomas Laprade, *Public Opinion and Politics in Eighteenth-Century England* (Westport: Greenwood Press, 1936), 280.

20  Laprade, 219.

21  Joseph Ransdell, "Re: Blake & More," PHIL-LIT: An Electronic Symposium of *Philosophy and Literature*, October 18, 1994.

# ESSAYISTIC MESSAGES

## INTERNET NEWSGROUPS AS
## AN ELECTRONIC PUBLIC SPHERE

James A. Knapp

The concept of the "public sphere" has gained considerable
attention from cultural critics since the translation of Jürgen
Habermas' *The Structural Transformation of the Public Sphere*
into English in 1989.[1] Although Habermas' description of the
public sphere as a short-lived historical reality in eighteenth-
century bourgeois civil society has been met with significant
reservations, the concept persists in a wide range of discourses
on political and cultural theory. As a result of critiques from
Michael Warner, Nancy Fraser and others that point to the
problems of conceptualizing a single, homogeneous public
space, attempts to locate and define a contemporary public
sphere have concentrated on the ways in which a heteroge-
neous public represents itself in the late twentieth century. To
locate representations of the public, critics have turned to the
mass media and the very entity Habermas blames for the
destruction of the bourgeois public sphere. Yet, while
Habermas bases his formulation of the public sphere (as the

space enabling reasoned public debate by private individuals) on a rhetorical form of abstraction that Michael Warner describes as "white, male, literate, and propertied,"[2] critics wanting to hold on to the concept have seen that this formulation must be abandoned in order to accommodate a multiplicity of voices. The shift from thinking of a unified public space in which public opinion is derived from a consensus view to the theorizing of a public space that is made up of heterogeneous and contestatory subject positions marks a shift in the definition of the public/private dichotomy. The identification of the traditional conception of public as male and private as female is one of the many ways that traditional publicness has been shown to deny those outside of the public discourse a political voice. Thus, reconciling some concept of a consensus-forming public to the actual experience of a heterogeneous society without falling back on Habermas' formulation has become the challenge for those of us who still hold on to the belief that social democracy is possible.

As the mass media has become more diversified and interactive, popular culture has appeared as one place where the public could be represented and public opinion formed. One reason that popular culture has only recently begun to attract attention is its traditional relegation to the realm of unidirectional (monologic) entertainment and thus to the private and apolitical sphere. Though describing purchasing power and television viewing habits as political power may grant too much to the consumer and too little to the advertising industry, it is true that the choices we make as consumers and the way we present ourselves in public indicate our desire to represent ourselves as a part of a community. Warner does well to point out this often-overlooked commonplace of social interaction: "Even the most refined or the most perverse among us could point to his or her desires or identifications and see that in most cases they were public desires, even mass public desires."[3] Anyone travelling to attend the annual conference of the Modern Language Association has experienced the increasing homogeneity of the crowd's fashions (reducible to about three or four academic types) and can attest to the fact that, on some level, private decisions concerning personal appearance and presentation have public consequences ultimately pointing to political choices. Placing emphasis on this, now familiar, social phenomenon is roughly the project of identity politics. The idea that bringing the formerly private (read: marginalized) realm into the public sphere is an effective way of opening up a

new public space in which all voices may be heard represents a real response to the problems of a public sphere that restricts participation to the dominant rhetoric. It remains true, however, that the invocation "the personal is the political" is abstract and ultimately ineffectual in the realm of the institutional politics that constitute the state. The task for those who would like to bring the personal into the political is to identify a public space in which the personal is legitimately represented as political, where it is difficult to explain away personal representation as just another economic effect.

One such space where the division between the public-political and the private-personal seems to be breaking down is in the public discussion groups and bulletin boards of the Internet computer network.[4] In groups whose topics range from Victorian Literature to Star Trek to welfare reform, participants engage in something like public debate. Yet unlike other public forums dominated by the conventional formal rhetoric of political debate, the specific views presented in the messages gain their authority from personal experience. Formally, the messages posted to discussion lists and bulletin boards can be described as essays; they can be seen to give personal experience a formal representation which, despite its specificity, is ultimately intended for public presentation. The characteristics of the essay genre, as with any genre, place certain demands on both readers and writers which inevitably point back to political, economic and cultural determinants, but the dynamic relation of personal reflection and public representation displays a potential model for liberated opinion formation in the public sphere. Still, if the kind of public space offered by the Internet and in the "electronic essay" can be seen to remove some of the problems facing the political representation of the "public," the form also raises several new questions. Is it possible to reach a consensus when the personal is the major reference point of the debates? What role do computer mediation and network structure play in opinion formation? Where, other than in the overlap of personal experiences, can "public opinion" be located? And finally, how, if at all, can public opinion based on personal testimony be brought to bear on the political establishment? Some of these questions are specific to the Internet while others accompany any theory of identity politics; I do not pretend to have definitive answers to the latter. Before turning to these questions, however, I will consider why and how it might be helpful to view electronic messages as essays and why this online adaptation of a relatively formal

genre might be better able to accommodate difference than the rational rhetoric of the bourgeois public sphere.

<div align="right">*I*</div>

Less than three decades after Montaigne first applied the term "essay" to his personal writings in the sixteenth century, Francis Bacon re-appropriated the new form for a very different use: namely, the description of "certain and demonstrable knowledge."[5] As a result of these conflicted origins, the term "essay" has often been used to designate anything that could not be identified with another genre. As studies by literary scholars have increasingly focused on the highly wrought rhetoric of Bacon's supposedly "objective" essays, writers wishing to present their work as objective have increasingly shied away from describing it as essayistic. Thus, according to Réda Bensmaïa, the description of the essay that has prevailed for some time has been: "any prose text of medium length wherein an informal tone prevails and the author does not attempt an exhaustive treatment." But as Bensmaïa points out, the limitations of this description have often given way to an even more general description of the essay as "a wide variety of works that have nothing in common but the absence of system and a relative 'brevity.'"[6]

As a result of the difficulty of discussing what Bensmaïa calls an "impossible genre" and John Snyder calls a "nongenre" in formal generic terms, critics have begun to approach the essay from a different angle. Ruth-Ellen Boetcher Joeres and Elizabeth Mittman as well as Snyder and Bensmaïa have each introduced a theory of the essay that focuses on the relationship between the form and the author. Rather than search for consistencies in the historical manifestations of the genre, theorists have begun to view the essay as a "reflective text" (Bensmaïa) that is open to "appropriation" (Joeres and Mittman), a form that "possesses voice" (Snyder). Each of the practitioners of this new approach to the essay are careful to remind us that it remains a completely historical genre, though they go on to point out that its history is not in its style or its subjects *per se* (as both cannot be subsumed under a single rubric). In this new formulation, the choice of the essay form offers the author an escape from the formal constraints of other genres: to choose the essay is "to assert ourselves."[7] This emphasis on choice marks the essay as a form that consistently points to specific subject positions that implicate the author as a textual arranger without hypostatizing the author as subject. The author here is not, then, a creative force able to forge a

completely new textual artifact out of nothing, as Theodor Adorno has commented: "The essay, which is always directed toward something already created, does not present itself as creation, nor does it covet something all-encompassing whose totality would resemble that of creation."[8] Rather, the essayist chooses to bring various forms together, which often appear eclectic, according to their associative affects/effects rather than their formal authority.

Bensmaïa describes the eclectic juxtapositions of the essay as both "a tactics without a strategy" and "a consideration of effects."[9] In his description, strategy is roughly analogous to more stable generic forms, which imply a unified position for the author, and where the choice to write in a specific genre limits the text to a single strategy: sonnet writing, for example, binds the author to the formal constraints of the sonnet genre. Conversely, in the essay, all genres are accessible and all subject positions are available, but none dominate. Bensmaïa describes the makeup of the essay:

> [A]t the origin of the work… is no longer Subject, identified and identical to itself, but the formal structure of the work which at each of its levels produces subjects: like passive Selves correlative to these resonances, these folds, these fires of language, these miraculous encounters among words, making it seem that the subject is snatched up by the text.[10]

Adorno described this function in "The Essay as Form": "It [the essay] gets involved with particular cultural artifacts only to the extent to which they can be used to exemplify universal categories, or to the extent to which the particular becomes transparent when seen in terms of them." Because essayists have access to all textual strategies, but are not confined by any single form, they have often been rejected by established institutions: "In Germany the essay arouses resistance because it evokes intellectual freedom."[11] This resistance has given an outright pejorative valence to the essay; it has been devalued in part because its formal "tactics" cannot be justified according to a unified, public and objective discourse. To valorize the form, then, is to demystify the objectivity of the hegemonic rhetoric. To politicize the form is thus to level the field of discursive strategies by legitimating specific personal positions—the particular cultural, historical, and economic sources of an essay's form—that do not attempt to offer the illusion of universality:

> If science and scholarship, falsifying as is their custom, reduce what is difficult and complex in a reality that is antagonistic and split into monads to simplified models and then differentiate the models in terms of their ostensible material, the essay, in contrast, shakes off the illusion of a simple and fundamentally logical world, an illusion well suited to the defense of the *status quo*.[12]

Renouncing the illusion of a "fundamentally logical world," is, however, also to give up the ideal of consensus for a more provisional idea of sympathetic understanding as the basis for public opinion. Public opinion constituted through the exchange of essays would look something like an essay itself, where collectivity would be constituted by the juxtaposition of diverse subjectivities. The essay as vehicle for public opinion formation would thus depend on the recognition of relational associations between the multiplicity of subject positions offered, rather than on a consensus view derived from persuasion through rational rhetoric. But this essayistic model of public opinion looks notoriously utopian, as the recognition of associations would require that all positions be equally available. Nancy Fraser comes to a similar conclusion in her attempt to conceive of a "post-bourgeois" public sphere: "an adequate conception of the public sphere requires not merely the bracketing, but rather the elimination, of social inequality."[13] Though few would argue that eliminating social inequality would not do wonders for the public sphere, a more immediate and less daunting goal might be to work towards creating spaces in which differences in social status become largely irrelevant.

*II*

If the essay genre can be viewed as part of a history of texts which derive their form from a "unique source" (the author as organizer of artifacts)[14] that reflects the author's awareness of the variety of subject positions constructed by formal strategies, it is easier to see how it might encompass public messages posted on the Internet. Certainly, these messages fulfill all of the general requirements of the essay form—they are short, informal (they rarely include documented textual citations) and they do not attempt an exhaustive treatment of their subject. But, as such definitions have been shown to account for an unmanageably wide range of texts, it is perhaps more helpful to consider whether and how Internet "essays" display an affinity with the essay as a personal, voiced, and reflective text. This kind of analy-

sis demands that both style and content be seen as commodities, included or excluded for their ability to evoke associative meanings that in combination serve to place the discourse.

The essayistic juxtaposition of rhetorical forms, tropes and structures, severed from their constitutive function in static generic forms, exploits references to forms without being restricted by them. Without the ability to validate their positions according to the formal conventions of a larger discourse, Internet message writers often turn to explicit pronouncements of the positions with which they choose to be associated. Interestingly, these pronouncements tend not to align the writers with an authority position, but instead impute authority to them on the basis of their positions as members of a public. One Internet essayist legitimates his thoughts on postmodernism and deconstruction with this comment: "I'm a *working* software engineer, not a student nor an academic nor a person with any real background in the humanities."[15] By specifying his status as a productive and constitutive member of public society, the writer validates his essay as accessible to everyone. Another writer's attempt to remove the personal from the debate (in the name of objectivity) is met with this comment: "You are what you say and what you think, Mr. _____ If you want us to separate Mr. _____ from his postings, it won't happen, it should NOT happen. Go knock on another door."[16] The claim that the essayist is inseparable from his or her essays recalls Montaigne's famous statement in defining his project, "I am myself the matter of my book."[17] Associating the writer with the message further collapses the division between public and private while identifying the essay as a vehicle for self-presentation in the public forum. Not surprisingly, objectivity and technical expertise often take a back seat to personal representation in such messages.

This foregrounding of personal experience on the Net seems akin to the commonly observed rejection of expert opinions on television talk shows. In "Chatter in the Age of Electronic Reproduction: Talk Television and the 'Public Mind,'" Paolo Carpignano and his collaborators attribute hostility toward specialists to a public affirmation of "common sense": "No longer can experts shut down discourse with scientific studies and endlessly boring statistics and legalisms." However, the rejection of experts and the re-introduction of common sense does not exclude the experts from the discussion, it only brings them down to the level of the discourse of common sense: ". . . it is in the nature of the show to discourage

the use of data or theories that are not immediately explicable and plausible."[18] Although these critics are describing "shows" in which spectacle is a major factor, Internet essays share some of the same characteristics. When citations of experts occur in these messages, they tend to locate the author in relation to the cited authorities more than to strengthen the writer's argument. Thus a citation to Derrida serves to identify the author's attitude toward the discourse of literary theory without validating either the "wisdom" cited or the argument of the message writer. In the world of the electronic essay, citations act like rhetorical tropes which reflect the position of the writer. The references are often to "my reading" of this or that text rather than to the actual text cited, statements are qualified by the author's experience, and the qualifications serve to set the limits which frame the debate. This process is evident in such typical disclaimers as the following: "from my knowledge (admittedly not very big). . . "; "I am not saying I am smarter, I am not saying I can do better"; "Paleontologists *do not have* a monopoly on truth."[19]

Although a great deal of information is included in the messages, it is all—nominally, anyway—of more or less the same status. The report of a Clinton-sanctioned secret task force that is killing Americans who "had been doing too much talking" is given in the same format as a critique of *The Bell Curve* or a discussion of Armenian history.[20] In the world of the electronic essay, no one—not even a paleontologist—has a monopoly on truth, and the essay form is the genre most able to accommodate this provisional discourse. As one of its key characteristics is that it does not (and cannot) treat its material in an exhaustive fashion, the information offered in the messages is made explicitly specific and provisional. Yet, despite the specificity of the arguments, the essays are posted to the Net in the spirit of collective discussion. In order to examine the product of this collective process, and determine if it can be described as a form of public opinion in the Habermasian sense, it is helpful to look both at the material aspects of the messages and the structural organization of the Internet itself.

*III*

The very essence of the electronic essay lies in its ready reproducibility. Its difference from its printed predecessor can therefore perhaps best be understood in relation to Walter Benjamin's description of the role of mechanical reproduction in art. Benjamin's claim that mechanically reproduced art

marked the end of "aura," and thus the end of art's reliance on authenticity and ritual, depends on the status of mechanically reproduced art as "the work of art designed for reproducibility."[21] Each of the subsequent prints made from a photographic negative represents the same image, and as such there is no recourse to the original authentic print. For Benjamin the lack of an original in mechanically reproduced art gave it the potential to release art from ritual, and subsequently break down the hierarchy of economic and class barriers that had long kept art from the people.

Electronic reproduction goes a step further than Benjamin's mechanical reproduction, to the extent that it may accomplish what Benjamin could have only anticipated as a function of film. One of the obstacles that prevented mechanically reproduced art from accomplishing its emancipatory function was that the forms available to Benjamin still depended on a tangible material element—the textual proof, the photographic negative, the print, the film reel—and it was precisely in the material dimension of art that Benjamin located the cultural manifestation of an appeal to authority.

Following Robert McClintock, Eugene F. Provenzo Jr. has examined the significance of the recent shift from analog to digital technologies of artifact reproduction. When Benjamin was writing, of course, the only technologies available for mechanical reproduction were analog. McClintock's description is useful here:

> Analog technologies use changes in one medium, say electromagnetic waves, to represent changes in another medium, say sound waves or changes of illumination along a path back and forth, filling a phosphorent screen. The system is inexpensive and efficient, but inherently prone to error, which we experience as noise, static, interference.[22]

The important characteristic of reproductions created using analog technologies is that, due to the "interference" caused by translation from one medium to another, it is ultimately possible to distinguish between the master (or original) and the subsequent copies. Provenzo contrasts this with the new digital technology:

> Analog systems have a much greater tendency toward entropy than digital systems. Digital systems 're-create' an object or thing from a binary

code. As long as the binary code is preserved and not allowed to degenerate, an *exact* copy of the original phenomenon is reproduced. With a laser audio disk, there should be *no difference* between the master disk and the digital copy made.[23]

The implications of this technological shift for texts and images produced in the digital medium is profound. Here what Benjamin saw as the effect of a virtual lack of an original (virtual as a result of the existence of the master), is actualized as a real lack of origin (the master and the copy are identical); where analog reproductions can be traced back to an original point at which a material translation occurred, digital reproductions lack this intermediary step.[24]

The most obvious implication of the shift to digital technologies is the complete loss of material authority: for all of their reproducibility, analog reproductions retained their material status allowing, through careful analysis, for the detection of alterations. As the very concept of alteration is dependent on an original, digital texts and images, because they only become material after-the-fact, never have an original and subsequently never reveal alterations. To change the binary code is to change the thing itself, forever and without a trace. It is true that the conventional photographic negative could be altered, but this alteration had to be of the material negative, a material alteration which could be detected.

Like Benjamin's film, messages on the Internet are designed for reproducibility, but unlike analog reproductions which can be arranged, according to the amount of detectable interference, in the order in which they were produced, these digital reproductions are completely detached from any narrative of progression and at the same time completely dependant on the moments of transmission and reception. As no trace of alterations to the master or the original can be detected, the material history of the texts is replaced by the process of production and consumption.

As a result of their digital format, electronic essays have no authority as documents and are inadmissible as evidence in the debates of which they are a part. This strange quality detaches the essays completely from the language of facts and truth, a point made clear in the following electronic exchange

> SY: It was I who said that your age was mentioned in the email message you sent to me 6–8 weeks ago. If your age was a lie too, then I give up!

> DD:  Look, I have a copy of my email messages to
> you and I didn't say I was 42 years old! In any case,
> it makes no difference![25]

Although DD wants to argue that age should not effect the argument at hand, the point is already moot for there is no way of ever finding out what the "original" messages contained. The fact that DD has copies does not strengthen his case because it would be impossible to verify their authenticity: such copies could be made at any time from altered or "original" code. The argument must ultimately rely on one person's word against another's: the only way to resolve such conflicts is to rely on personal testimony and the plausibility of the case presented by each side. The question of DD's age gives way to the question of what each party could gain or lose by "misrepresenting" their experience. In a peculiar way the nature of digital reproductions serves to enhance the essayistic quality of the messages. Even the very messages that constitute the debate become the "cultural artifacts" which in Adorno's description are used only to "exemplify universal categories" or to make the particular transparent (understandable). In this manner statements made in the messages are released from their material status as textual documents, and consequently take on the status of linguistic devices. Moreover, the code by which these devices are ordered is not abstract Reason, but plausibility and common sense—a plausibility that is conditioned by the contextual location of the electronic essay in a specific discussion list or newsgroup.

*IV*

Though the space occupied by these essay-messages seems to be free from some of the constraints of traditional public discourse, the larger structure of the Internet problematizes a characterization of the network as a liberated space. For all of the leveling of authority positions that seems to occur in the messages themselves, the Internet remains a highly structured environment. On the one hand, this structure provides a freedom unavailable in earlier media: network "newsgroups" enable participants to respond immediately to each other's messages without the intervention of an editor or host, as well as to print, reproduce, and forward them on to other readers, with or without alterations and commentary.

The editorial mediation of earlier forms, on the other hand, is replaced by an intricate organizational structure of information routing, storage and retrieval that ultimately

confines information to narrowly specific categories and sub-categories. A typical newsgroup location, for example, is indicated by the label "alt.current-events.clinton.whitewater," where each qualifier limits the scope of the messages to be posted to that location. Though some labels are self-evident, others take some work to decipher, and the map of locations is so complex that specialized network-searching software is required to find specific information. The need to rely on this software reduces the autonomy of the users while simultaneously limiting the accessibility of information: as computer searches are based on specific keywords and rigid definitions, they typically miss information that might be located along more nuanced associative paths.[26]

The specificity of newsgroups tends, as well, to segregate users according to interests and affiliations, as the lines between groups viewed as incompatible are typically very rigid. In a message posted to alt.atheism and soc.history, one contributor accuses a fellow group member of "just the sort of thing a fundie [fundamentalist Christian] does as the opening barrage for an assault on Evolution over on talk.origins."[27] Clearly, the writer is implying that the rhetorical strategies employed on talk.origins are not acceptable on alt.atheism or soc.history. Though the lack of an editor or host leaves the direction of the group in the hands of its participants and thus encourages moderating comments like this one, such segregation by topic and rhetorical strategy calls the publicness of these debates into question. The guidelines aimed at helping new users determine where to post are equally inflexible:

> Although abortion might appear to be an appropriate topic for soc.women, more heat than light is generated when it is brought up. All abortion-related discussion should take place in the newsgroup talk.abortion. If your site administrators have chosen not to receive this group, you should respect this and not post articles about abortion at all. . . . Zionism discussions should be kept to talk.politics.mideast and not in soc.culture.jewish. . . . Usenet newsgroups are named for mostly historical reasons, and are not intended to be fully general discussion groups.[28]

While these guidelines serve a practical purpose—abortion discussion on soc.women could overwhelm other discussions pertinent to that group—the specificity of topics also allows administrators to exclude groups that could be controversial,

and consequently deny whole populations a voice on the network. The relegation of certain "hot" topics to specific groups and the consequent power of administrators to pick and choose among the existing groups effectively limits the scope of discussions on the Internet.

A similar dynamic is at work in discussion groups to which members must "subscribe" (at no charge) in order to receive the messages. The postings on a list as specific as E-Grad, a discussion group for graduate students in the modern languages, become homogeneous to the point that contestatory views from outside the forum are met with vicious attacks. The essay critique of deconstruction by the "working software engineer" referred to above provoked hundreds of outraged replies when it was posted on E-Grad. Most of these replies were couched in an English-grad-student rhetoric which relied heavily on the assumptions of literary study. In this exchange little common ground was created, though everyone may have gotten a little personal satisfaction from unloading on an enemy all too easily objectified by the discussants.

*V*

What can be gained from simply voicing particularities if these voices must necessarily be kept separate? Though the essay form as it is manifested on the Internet has the potential to open up a space for diverse discourses, the effect of its location in a complex of specific categories is to compartmentalize differences, thereby dramatically limiting their public status. While an analysis of the structural effects of categorization on the Internet is beyond the scope of this paper, it remains an important place to begin if the potential of the electronic essay is to be realized. Still, the space opened up by the Internet does seem to represent an example of a public sphere that is not confined to a single voice. One issue on which its users seem to be in agreement is the desire to preserve the network's adaptability and openness to new subjects and discourses. And although the specificity of discussion sites may tend to isolate the various discourses, vastly divergent subjectivities coexist in the larger community that is the network as a whole. Compared to the popular media, certainly, and to the political establishment, a much more diverse field of identities is represented on the net. Lesbian discussion groups exist alongside those designated for Christian fundamentalists; discussions aimed at determining obscenity guidelines go on only a few menu headings away from sites containing pornographic pic-

tures; and, all of these sites are accessible to all users with relatively minor restrictions.

Minimizing the future expansion of these restrictions and ensuring that all of the users have access to the development process will be a major challenge to the Internet's status as a public space. As it now stands, those using the various newsgroups are expected to be aware of "netiquette," a code aimed at the creation of a civil community: users are expected to include their name, use publicly acceptable language, and refrain from sending chain letters. But these voluntary standards, which arose originally out of a shared hope of creating a civil community, have already begun to strain under the pressure of commercialization, legal challenges, and sensationalist journalism. These pressures will not disappear, and network administrators will increasingly have to provide justifications for newsgroups they make available while restricting access to those which create unmanageable liabilities. Despite their efforts to stress the apolitical aspect of most newsgroups ("Don't sweat it—it's not real life. It's only ones and zeroes"[29]), the debate over censorship on the Net is reaching the proportions of a major controversy. Avoiding what appears to be the inevitable homogenization of the Internet will be the one true test of the power of the personal to translate into a public opinion that can be brought to bear on the political establishment. If, in the name of diversity, the users of the Internet can justify their essayistic forum as one that serves the public interest in concrete and demonstrable ways, it would represent a step in the direction of an egalitarian public sphere; if not, the heterogeneity of identity politics will have displayed a telling weakness in the face of the rhetoric of unity and univocality.

NOTES

1 Habermas originally published the book as *Strukturwandel der Öffentlichkeit* (Berlin: Luchterhand, 1962). It was translated into English by Thomas Burger and Frederick Lawrence as *The Structural Transformation of the Public Sphere: An Inquiry into a Category of Bourgeois Society* (Cambridge: Massachusetts Institute of Technology Press, 1989). The most notable initial reaction to the concept came from German theorists including Oskar Negt and Alexander Kluge.

2 Michael Warner, "The Mass Public and the Mass Subject," in *The*

*Phantom Public Sphere*, ed. Bruce Robbins (Minneapolis: University of Minnesota Press, 1993), 239.

3  Warner, 242.

4  Though my basic argument would apply to other aspects of the Internet (including the World Wide Web), the focus of this study is on the debates that take place in "LISTSERV" discussion groups and "Usenet newsgroups," and it is from these discussions that I have gathered my examples.

5  *The Works of Francis Bacon*, ed. and trans. James Spedding, Robert Leslie Ellis, and Douglas Denon Heath, vol. 8 (Boston: Brown, 1861), 64.

6  Réda Bensmaïa, *The Barthes Effect*, trans. Pat Fedkiew (Minneapolis: University of Minnesota Press, 1987), 95.

7  Ruth-Ellen Boetcher Joeres and Elizabeth Mittman, "An Introductory Essay," in *The Politics of the Essay: Feminist Perspectives*, ed. Joeres and Mittman (Indianapolis: University of Indiana Press, 1993), 20.

8  Theodor Adorno, "The Essay as Form," in *Notes on Literature*, ed. Rolf Tiedemann, trans. Sherry Weber Nicholsen (New York: Columbia University Press, 1991), 17.

9  Bensmaïa, 51,57.

10  Bensmaïa, 52.

11  Adorno, 3.

12  Adorno, 15.

13  Nancy Fraser, "Rethinking the Public Sphere: A Contribution to the Critique of Existing Democracy," in *The Phantom Public Sphere*, ed. Bruce Robbins (Minneapolis: University of Minnesota Press, 1993), 27.

14  Bensmaïa, 98.

15  Chip Morningstar, "How to Deconstruct Almost Anything: My Postmodern Adventure," in E-Grad [Electronic Mailing list,

cited 2 October 1994]. Available from listserv@RUTVM1. BITNET; my emphasis.

16  David Davidian, "RE: Wrong Assumptions," in soc.culture. turkish [Usenet newsgroup, cited 28 November 1994].

17  *Montaigne's Essays and Selected Writings*, ed. and trans. Donald Frame (New York: St. Martin's Press, 1963), 3.

18  Paolo Carpignano, Robin Andersen, Stanley Aronowitz, and William DiFazio, "Chatter in the Age of Electronic Reproduction: Talk Television and the 'Public Mind,'" in *The Phantom Public Sphere*, ed. Bruce Robbins (Minneapolis: University of Minnesota Press, 1993), 117.

19  The first quotation is Oliver Moldenhauer, "RE: Thorsten Hauptfleisch and German Nazis," in soc.culture.jewish [Usenet newsgroup, cited 28 November 1994]; the second two quotations are Gene Ward Smith, "RE: History vs Paleontology," in alt.atheism [Usenet newsgroup, cited 2 December 1994].

20  Art A. Swanson, "Clinton's New Police in Action," in alt.current-events.clinton.whitewater [Usenet newsgroup, cited 1 December 1994]; Gordon Fitch, "Why Then, Is 'The Bell Curve' a Best-Seller?" in talk.politics.theory [Usenet newsgroup, cited 27 November 1994]; Davidian, "RE: Wrong Assumptions."

21  Walter Benjamin, "The Work of Art in the Age of Mechanical Reproduction," in *Illuminations*, ed. Hannah Arendt, trans. Harry Zohn (New York: Shocken Books, 1969), 224.

22  Robert McClintock, "Marking the Second Frontier," *Teachers College Record* 89 (1988): 347, quoted in Eugene F. Provenzo, "The Electronic Panopticon: Censorship, Control, and Indoctrination in a Post-Typographic Culture," in *Literacy Online: The Promise (and Peril) of Reading and Writing with Computers*, ed. Myron C. Tuman (Pittsburgh: University of Pittsburgh Press, 1992), 172.

23  Eugene F. Provenzo, "The Electronic Panopticon: Censorship, Control, and Indoctrination in a Post-Typographic Culture," in *Literacy Online: The Promise (and Peril) of Reading and Writing with Computers*, ed. Myron C. Tuman (Pittsburgh: University of Pittsburgh Press, 1992), 172; my emphasis.

24 In digital photography (and other forms of digital reproduction) there is an initial transformation, of natural phenomenon (light rays, sounds, etc.) into binary code, and it is, of course, possible to tell the difference between the image derived from the code and the "original" natural phenomena. My point here is that there is not the same slippage between copies generated from the code as can be observed in the various prints that can be made from a single negative.

25 Davidian, "RE: Wrong Assumptions."

26 In *Computer-Mediated Communication: Human Relationships in a Computerized World* (Tuscaloosa and London: University of Alabama Press, 1989), James W. Chesebro and Donald G. Bonsall discuss the inherent slippage between computer and human based information processing: "Far more critical in this context is the difference between the associational or relational processing of the human brain and the computer's need to hold its charges as discrete in order for them to be meaningful during computation" (45).

27 Smith, "RE: History vs Paleontology."

28 Mark Moraes, "Answers to Frequently Asked Questions about Usenet," in news.announce.newusers [Usenet newsgroup, cited 12 December 1994].

29 Gene Spafford, "That's All Folks," in news.announce.newusers [Usenet newsgroup, cited 29 April 1993].

*FOUR*

# POLITICS AND THE
## PUBLIC SPHERE

# CYBERDEMOCRACY

## INTERNET AND THE PUBLIC SPHERE

Mark Poster

*I am an advertisement for a version of myself.*
—*David Byrne*

*The Stakes of the Question*

The discussion of the political impact of the Internet has focused on a number of issues: access, technological determinism, encryption, commodification, intellectual property, the public sphere, decentralization, anarchy, gender and ethnicity. While these issues may be addressed from a number of standpoints, only some them are able to assess the full extent of what is at stake in the new communications technology at the cultural level of identity formation. If questions are framed in relation to prevailing political structures, forces and ideologies, for example, blinders are being imposed which exclude the question of the subject or identity construction from the domain of discussion. Instances of such apparently urgent but actually limiting questions are those of encryption and

commodification. In the case of encryption, the United States government seeks to secure its borders from "terrorists" who might use the Internet and thereby threaten it. But the dangers to the population are and have always been far greater from this state apparatus itself than from so-called terrorists. If the prospects of democracy on the Internet are viewed in terms of encryption, then the security of the existing national government becomes the limit of the matter: what is secure for the nation-state is taken to mean true security for everyone, a highly dubious proposition.[1] The question of the potential for new forms of social space to empower individuals in new ways is foreclosed in favor of preserving existing relations of force as they are embodied in the state.

The issue of commodification also affords a narrow focus, often restricting the discussion of the politics of the Internet to the question of which corporation will be able to obtain what amount of income from which configuration of the Internet. Will the telephone companies, the cable companies or some amalgam of both be able to secure adequate markets and profits from providing the general public with railroad timetables, five hundred channels of television, the movie of one's choice on demand and so forth? From this vantage point the questions raised are as follows: Shall the Internet be used to deliver entertainment products, like some gigantic, virtual theme park? Or shall it be used to sell commodities, functioning as an electronic retail store or mall? These questions consume corporate managers around the country and their Marxist critics alike, though here again, as with the encryption issue, the Internet is being understood as an extension of or substitution for existing institutions.

While there is no doubt that the Internet folds into existing social functions and extends them in new ways, translating the act of shopping, for example, into an electronic form, what are far more cogent as possible long-term political effects of the Internet are the ways in which it institutes new social functions, ones that do not fit easily within those of characteristically modern organizations. The problem is that these new functions can only become intelligible if a framework is adopted that does not limit the discussion from the outset to modern patterns of interpretation. For example, if one understands politics as the restriction or expansion of the existing executive, legislative and judicial branches of government, one will not be able even to broach the question of new types of participation in government. To ask, then, about the relation of the Internet

to democracy is to challenge or to risk challenging our existing theoretical approaches to these questions.

If one brackets political theories that address modern governmental institutions in order to assess the "postmodern" possibilities suggested by the Internet, two difficulties immediately emerge: 1. there is no adequate "postmodern" theory of politics and 2. the issue of democracy, the dominant political norm and ideal, is itself a "modern" category associated with the project of the Enlightenment. Let me address these issues in turn.

Recently theorists such as Philippe Lacoue Labarthe and Jean-Luc Nancy have pointed to the limitations of a "left/right" spectrum of ideologies for addressing contemporary political issues.[2] Deriving from seating arrangements of legislators during the French Revolution of 1789, the modern ideological spectrum inscribes a grand narrative of liberation which contains several problematic aspects. The most important of these for our purposes is that this Enlightenment narrative establishes a process of liberation at the heart of history which requires at its base a pre-social, foundational, individual identity. The individual is posited as outside of and prior to history, only later becoming ensnared in externally imposed chains. Politics from this modern perspective is then the arduous extraction of an autonomous agent from the contingent obstacles imposed by the past. In its rush to ontologize freedom, the modern view of the subject hides the process of its historical construction. A postmodern orientation would have to allow for the constitution of identity within the social and within language, displacing the question of freedom from a presupposition of and a conclusion to theory to become instead a pre-theoretical or non-foundational discursive preference.

Postmodern theorists have discovered that modern theory's insistence on the freedom of the subject, its compulsive, repetitive inscription into discourse of the sign of the resisting agent, functions to restrict the shape of identity to its modern form, rather than contributing towards emancipation. Postmodern theory, then, must resist ontologizing any form of the subject, while simultaneously insisting on the constructedness of identity. In the effort to avoid the pitfalls of modern political theory, then, postmodern theory sharply restricts the scope of its ability to define a new political direction.

But there are further difficulties in establishing a position from which to recognize and analyze the cultural aspect of the Internet. Postmodern theory still invokes the modern term democracy, even when this is modified by the adjective "radi-

cal" as in the work of Ernesto Laclau.[3] One may characterize postmodern or post-Marxist democracy in Laclau's terms as one that opens new positions of speech, empowering previously excluded groups and enabling new aspects of social life to become part of the political process. While the Internet is often accused of elitism (a mere thirty million users), there does exist a growing and vibrant grass-roots participation in it organized in part by local public libraries.[4] But are not these initiatives, the modern skeptic may persist, simply extensions of existing political institutions rather than being "post-," and representing a break of some kind? In response I can assert only that the "postmodern" position need not be taken as a metaphysical assertion of a new age. Theorists are trapped within existing frameworks as much as they may be critical of them and wish not to be. In the absence of a coherent alternative political program the best one can do is to examine phenomena such as the Internet in relation to new forms of the old democracy, while holding open the possibility that what emerges might be something other than democracy in any shape that we can conceive given our embeddedness in the present. Democracy, the rule by all, is surely preferable to its historic alternatives. And the term may yet contain critical potentials since existing forms of democracy surely do not fulfill the promise of freedom and equality. The colonization of the term by existing institutions encourages one to look elsewhere for the means to name the new patterns of force relations emerging in certain parts of the Internet.

### Decentralized Technology

My plea for indulgence with the limitations of the postmodern position on politics quickly gains credibility when the old question of technological determinism is posed in relation to the Internet. When the question of technology is posed we see immediately how the Internet disrupts the basic assumptions of the older positions. The Internet is above all a decentralized communication system. As with the telephone network, anyone hooked up to the Internet may initiate a call, send a message that he or she has composed to one or multiple recipients, and receive messages in return. The Internet is also decentralized at a basic level of organization since, as a network of networks, new networks may be added so long as they conform to certain communications protocols. As an historian I find it fascinating that this unique structure should emerge from a confluence of cultural communities which appear to have so

little in common: the Cold War Defense Department, which sought to insure survival against nuclear attack by promoting decentralization; the counter-cultural ethos of computer programming engineers, which showed a deep distaste for any form of censorship or active restraint of communications, and the world of university research, which I am at a loss to characterize. Added to this is a technological substratum of digital electronics which unifies all symbolic forms in a single system of codes, rendering transmission instantaneous and duplication effortless. If the technological structure of the Internet institutes costless reproduction, instantaneous dissemination and radical decentralization, what might be its effects upon the society, the culture and the political institutions?

There can be only one answer to this question, and that is that it is the wrong question. Technologically determined effects derive from a broad set of assumptions in which what is technological is a configuration of materials that effect other materials, and the relation between the technology and human beings is external, that is, where human beings are understood to manipulate the materials for ends that they impose upon the technology from a preconstituted position of subjectivity. But what the Internet technology imposes is a dematerialization of communication and in many of its aspects a transformation of the subject position of the individual who engages within it. The Internet resists the basic conditions for asking the question of the effects of technology. It installs a new regime of relations between humans and matter and between matter and non-matter, reconfiguring the relation of technology to culture and thereby undermining the standpoint from within which, in the past, a discourse developed—one which appeared to be natural—about the effects of technology. The only way to define the technological effects of the Internet is to build the Internet, to set in place a series of relations which constitute an electronic geography. Put differently, the Internet is more like a social space than a thing; its effects are more like those of Germany than those of hammers. The effect of Germany upon the people within it is to make them Germans (at least for the most part); the effect of hammers is not to make people hammers, though Heideggerians and some others might disagree, but to force metal spikes into wood. As long as we understand the Internet as a hammer we will fail to discern the way it is like Germany. The problem is that modern perspectives tend to reduce the Internet to a hammer. In the grand narrative of modernity, the Internet is an efficient tool of communication,

CYBERDEMOCRACY

advancing the goals of its users who are understood as precon-stituted instrumental identities.

The Internet is complex enough that it may with some profit be viewed in part as a hammer. If I search the database functions of the Internet or if I send email purely as a substi-tute for paper mail, then its effects may reasonably be seen to be those of a mere tool. But the aspects of the Internet that I would like to underscore are those which instantiate new forms of interaction and which pose the question of new kinds of relations of power between participants. The question that needs to be asked about the relation of the Internet to democ-racy is this: are there new kinds of relations occurring within it which suggest new forms of power configurations between communicating individuals? In other words, is there a new politics on the Internet?

One way to approach this question is to make a detour from the issue of technology and raise again the question of a public sphere, gauging the extent to which Internet democracy may become intelligible in relation to it. To frame the issue of the political nature of the Internet in relation to the concept of the public sphere is particularly appropriate because of the spatial metaphor associated with the term. Instead of an imme-diate reference to the structure of an institution, which is often a formalist argument over procedures, or to the claims of a given social group, which assumes a certain figure of agency that I would like to keep in suspense, the notion of a public sphere suggests an arena of exchange, like the ancient Greek agora or the colonial New England town hall. If there is a public sphere on the Internet, who populates it and how? In particular one must ask what kinds of beings exchange infor-mation in this public sphere? Since there occurs no face-to-face interaction, only electronic flickers[5] on a screen, what kind of community can there be in this space? What kind of disembod-ied politics are inscribed so evanescently in cyberspace? Modernist curmudgeons may object vehemently against attributing to information flows on the Internet the dignified term "community." Are they correct, and if so, what sort of phenomenon is this cyberdemocracy?

### The Internet as a Public Sphere?

The issue of the public sphere is at the heart of any reconceptu-alization of democracy. Contemporary social relations seem to be devoid of a basic level of interactive practice which, in the past, was the matrix of democratizing politics: loci such as the

agora, the New England town hall, the village Church, the coffee house, the tavern, the public square, a convenient barn, a union hall, a park, a factory lunchroom, and even a street corner. Many of these places remain but no longer serve as organizing centers for political discussion and action. It appears that the media, and especially television, have become the animating source of political information and action. An example from the Clinton heath-care reform campaign will suffice: the Clinton forces at one point (mid-July 1994) felt that Congress was less favorable to their proposal than the general population. To convince recalcitrant legislators of the wisdom of health-care reform, the administration purchased television advertising which depicted ordinary citizens speaking in favor of the President's plan. The ads were shown only in Washington D.C. because they were directed not at the general population of viewers but at congressmen and congresswomen alone. Such are politics in the era of the mode of information. In a context like this, one may ask, where is the public sphere, where is the place citizens interact to form opinions in relation to which public policy must be attuned? John Hartley makes the bold and convincing argument that the media are the public sphere: "Television, popular newspapers, magazines and photography, the popular media of the modern period, *are* the public domain, the place where and the means by which the public is created and has its being."[6]

Sensing a collapse of the public sphere and therefore a crisis of democratic politics, Jürgen Habermas published *The Structural Transformation of the Public Sphere* in 1962.[7] In this highly influential work he traced the development of a democratic public sphere in the seventeenth and eighteenth centuries and charted its course to its decline in the twentieth century. In that work and arguably since then as well, Habermas' political intent was to further "the project of Enlightenment" by the reconstruction of a public sphere in which reason might prevail, not the instrumental reason of much modern practice but the critical reason that represents the best of the democratic tradition. Habermas defined the public sphere as a domain of uncoerced conversation oriented toward a pragmatic accord. His position came under attack by poststructuralists like Lyotard who questioned the emancipatory potential of its model of consensus through rational debate.[8] More recently, Rita Felski has synthesized Marxist, feminist, and poststructuralist critiques of Habermas' enlightenment ideal of the autonomous rational subject as a universal foundation for

CYBERDEMOCRACY

democracy.[9] For Felski the concept of the public sphere must build on the "experience" of political protest (in the sense of Negt and Kluge), must acknowledge and amplify the multiplicity of the subject (in the sense of poststructuralism) and must account for gender differences (in the sense of feminism). She writes:

> Unlike the bourgeois public sphere, then, the feminist public sphere does not claim a representative universality but rather offers a critique of cultural values from the standpoint of women as a marginalized group within society. In this sense it constitutes a *partial* or counter-public sphere.... Yet insofar as it is a *public* sphere, its arguments are also directed outward, toward a dissemination of feminist ideas and values throughout society as a whole.[10]

Felski seriously revises the Habermasian notion of the public sphere, separating it from its patriarchal, bourgeois and logocentric attachments perhaps, but nonetheless still invoking the notion of a public sphere and more or less reducing politics to it. This becomes clear in the conclusion of her argument:

> Some form of appeal to collective identity and solidarity is a necessary precondition for the emergence and effectiveness of an oppositional movement; feminist theorists who reject any notion of a unifying identity as a repressive fiction in favor of a stress on absolute difference fail to show how such diversity and fragmentation can be reconciled with goal-oriented political struggles based upon common interests. An appeal to a shared experience of oppression provides the starting point from which women as a group can open upon the problematic of gender, at the same time as this notion of gendered community contains a strongly utopian dimension.... [11]

In the end, Felski sees the public sphere as central to feminist politics. But then we must ask how this public sphere is to be distinguished from any political discussion? From the heights of Habermas' impossible (counter-factual) ideal of rational communication, the public sphere here multiplies, opens and extends to political discussion by all oppressed individuals.

The problem we face is that of defining the term "public." Liberal theory generally resorted to the ancient Greek distinction between the family or household and the polis, the former

being "private" and the latter "public." When the term crossed boundaries from political to economic theory, with Ricardo and Marx, a complication set in: the term "political economy" combined the Greek sense of public and the Greek sense of private since economy referred for them to the governance of the (private) household. The older usage preserved a space for the public in the agora, to be sure, but referred to discussions about the general good, not market transactions. In the newer usage the economic realm is termed "political economy" but is considered "private." To make matters worse, common parlance nowadays has the term "private" designating speeches and actions that are isolated, unobserved by anyone and not recorded or monitored by any machine.[12] Privacy now becomes restricted to the space of the home, in a sense returning to the ancient Greek usage even though family structure has altered dramatically in the interim. In Fraser's argument, for example, the "public" sphere is the opposite of the "private" sphere in the sense that it is a locus of "talk," "a space in which citizens deliberate about their common affairs . . ." and is essential to democracy.[13] There are serious problems, then, in using the term "public" in relation to a politics of emancipation.

This difficulty is amplified considerably once newer electronically mediated communications are taken into account, in particular the Internet. Now the question of "talk," of meeting face-to-face, of "public" discourse is confused and complicated by the electronic form of exchange of symbols. If "public" discourse exists as pixels on screens generated at remote locations by individuals one has never and probably will never meet, as it is in the case of the Internet with its "virtual communities" and "electronic cafés," then how is it to be distinguished from "private" letters, printface and so forth? The age of the public sphere as face-to-face talk is clearly over: the question of democracy must henceforth take into account new forms of electronically mediated discourse. What are the conditions of democratic speech in the mode of information? What kind of "subject" speaks or writes or communicates in these conditions? What is its relation to machines? What complexes of subjects, bodies and machines are required for democratic exchange and emancipatory action? For Habermas, the public sphere is a homogeneous space of embodied subjects in symmetrical relations, pursuing consensus through the critique of arguments and the presentation of validity claims. This model, I contend, is systematically denied in the arenas of electronic politics. We are advised then to abandon Habermas' concept of

the public sphere in assessing the Internet as a political domain.

Now that the thick culture of information machines provides the interface for much if not most discourse on political issues, the fiction of the democratic community of full human presence serves only to obscure critical reflection and divert the development of a political theory of this decidedly postmodern condition. For too long, critical theory has insisted on a public sphere, bemoaning the fact of media "interference," the static of first radio's and then television's role in politics. But the fact is that political discourse has long been mediated by electronic machines: the issue now is that the machines enable new forms of decentralized dialogue and create new combinations of human-machine assemblages, new individual and collective "voices," "specters," "interactivities" which are the new building blocks of political formations and groupings. As Paul Virilio writes, "What remains of the notion of things 'public' when public *images* (in real time) are more important than public space?"[14] If the technological basis of the media has habitually been viewed as a threat to democracy, how can theory account for the turn toward a construction of technology (the Internet) which appears to promote a decentralization of discourse if not democracy itself and appears to threaten the state (unmonitorable conversations), mock at private property (the infinite reproducibility of information) and flaunt moral propriety (the dissemination of images of unclothed people often in awkward positions)?

*A Postmodern Technology?*

Many areas of the Internet extend preexisting identities and institutions. Usenet newsgroups elicit obnoxious pranks from teenage boys; databases enable researchers and corporations to retrieve information at lower costs; electronic mail affords speedy, reliable communication of messages; the digitization of images allows a wider distribution of erotic materials, and so it goes. The Internet, then, is modern in the sense of continuing the tradition of tools as efficient means and in the sense that prevailing modern cultures transfer their characteristics to the new domain. Other areas of the Internet, however, are less easy to contain within modern points of view. The examination of these cyberspaces raises the issue of a new understanding of technology and finally leads to a reassessment of the political aspects of the Internet. I refer to the bulletin board services that have come to be known as "virtual communities," to the MOO phenomenon and to the synthesis of virtual reality technology with the Internet.

In these cases, what is at stake is the direct solicitation to construct identities in the course of communication practices. Individuals invent themselves and do so repeatedly and differentially in the course of conversing or messaging electronically. Now there is surely nothing new in discursive practices that are so characterized: reading a novel,[15] speaking on CB radio, indeed watching a television advertisement, I contend, all in varying degrees and in different ways encourage the individual to shape an identity in the course of engaging in communication. On a MOO, communication requires linguistic acts of self-positioning that are much more explicit than in the cases of reading a novel or watching a television advertisement. On the Internet, individuals read and interpret communications to themselves and to others and also respond by shaping sentences and transmitting them. Novels and television ads are interpreted by individuals who are interpellated by them, but these readers and viewers are not addressed directly, only as a generalized audience and, of course, they do not respond in fully articulated linguistic acts.

I avoid framing the distinction I am making here in the binary active/passive because that couplet is so associated with the modern autonomous agent that it would appear that I am depicting the Internet as the realization of the modern dream universal, "active" speech. I refuse this resort because it rests upon the notion of identity as a fixed essence, pre-social and pre-linguistic, whereas I want to argue that Internet discourse constitutes the subject as the subject fashions him or herself.

On the Internet, individuals construct their identities in relation to ongoing dialogues, not as acts of pure consciousness. But such activity does not count as freedom in the liberal-Marxist sense because it does not refer back to a foundational subject. Yet it does connote a "democratization" of subject constitution because the acts of discourse are not limited to one-way address and are not constrained by the gender and ethnic traces inscribed in face-to-face communications. The "magic" of the Internet is that it is a technology that puts cultural acts, symbolizations in all forms, in the hands of all participants; it radically decentralizes the positions of speech, publishing, film-making, radio and television broadcasting, in short the apparatuses of cultural production.

*Gender and Virtual Communities*

Let us examine the case of gender in Internet communication as a way to clarify what is at stake and to remove some likely

confusions about what I am arguing. Studies have pointed out that the absence of gender cues in bulletin board discussion groups does not eliminate sexism or even the hierarchies of gender that pervade society generally.[16] The disadvantages suffered by women in society carry over into the "virtual communities" on the Internet: women are under-represented in these electronic places and are subjected to various forms of harassment and sexual abuse. The fact that sexual identities are self-designated does not in itself eliminate the annoyances and the hurts of patriarchy. The case of "Joan" is instructive in this regard. A man named Alex presented himself on a bulletin board as a disabled woman, "Joan," in order to experience the "intimacy" he admired in women's conversations. Van Gelder reports that when his "ruse" was unveiled, many of the women "Joan" interacted with were deeply hurt. But Van Gelder also reports that their greatest disappointment was that "Joan" did not exist.[17] The construction of gender in this example indicates a level of complexity not accounted for by the supposition that cultural and social forms are or are not transferrable to the Internet. Alex turned to the Internet virtual community to make up for a perceived lack of feminine traits in his masculine sexual identity. The women who suffered his ploy regretted the "death" of the virtual friend "Joan." These are unique uses of virtual communities not easily found in "reality." Still, in the "worst" cases, one must admit that the mere fact of communicating under the conditions of the new technology does not cancel the marks of power relations constituted under the conditions of face-to-face, print and electronic broadcasting modes of intercourse.

Nonetheless, the structural conditions of communicating in Internet communities does introduce resistances to and breaks with these gender determinations. The fact of having to decide on one's gender itself raises the issue of individual identity in a novel and compelling manner. If one is to be masculine, one must choose to be so. Further, one must enact one's gender choice in language and in language alone, without any marks and gestures of the body, without clothing or intonations of voice. Presenting one's gender is accomplished solely through textual means, although this does include various iconic markings invented in electronic communities such as the smiley [ :-) ] and its variants. Also, one may experience directly the opposite gender by assuming it and enacting it in conversations. Finally, the particular configuration of conversation through computers and modems produces a new relation to one's body as it

communicates, a cyborg in cyberspace who is different from all the embodied genders of earlier modes of information. These cyborg genders test and transgress the boundaries of the modern gender system without any necessary inclination in that direction on the part of the participant.[18]

While ordinary email between previous acquaintances clearly introduces no strong disruption of the gender system, socially oriented MUDs and MOOs typically do enact the most advanced possibilities of postmodern identity construction. Here identities are invented and changeable; elaborate self-descriptions are enacted; domiciles are depicted in textual form and individuals interact purely for the sake of doing so. MOO inhabitants, however, do not enjoy a democratic utopia. There exist hierarchies specific to this form of cyberspace: the programmers who construct and maintain the MOO have abilities to change rules and procedures that are not available to the players. After these "Gods" come the wizards, those who have accumulated certain privileges through past participation. Another but far more trivial criterion of political differentiation is typing skill, since this determines in part who speaks most often, especially as conversations move along with considerable speed. Even in cyberspace, asymmetries emerge which could be termed "political inequalities." Yet the salient characteristic of Internet community is the diminution of prevailing hierarchies of race, class and especially gender. What appears in the embodied world as irreducible hierarchy plays a lesser role in the cyberspace of MOOs. And, as a result, the relation of cyberspace to material human geography is decidedly one of rupture and challenge. Internet communities function as places of difference from and resistance to modern society. In a sense, they serve the function of a Habermasian public sphere without intentionally being one. They are places not of the presence of validity claims or the actuality of critical reason, but of the inscription of new assemblages of self-constitution. When audio and video enhance the current textual mode of conversation the claims of these virtual realities may even be more exigent.[19] The complaint that these electronic villages are no more than the escapism of white, male undergraduates may then become less convincing.

## Cyborg Politics

The example of the deconstruction of gender in Internet MOO communities underlines the importance of theorizing politics in the mode of information. Because the Internet inscribes the new

social figure of the cyborg and institutes a communicative practice of self-constitution, the political as we have known it is reconfigured. The wrapping of language on the Internet, its digitized, machine-mediated signifiers in a space without bodies introduces an unprecedented novelty for political theory.[20] How will electronic beings be governed? How will their experience of self-constitution rebound in the existing political arena? How will power relations on the Internet combine with or influence power relations that emerge from face-to-face relations, print relations and broadcast relations? Assuming the United States government and the corporations do not shape the Internet entirely in their own image and that places of cyberdemocracy remain and spread to larger and larger segments of the population, what will emerge as a postmodern politics?

One possibility is that the nature of authority as we have known it will change drastically. Political authority has evolved from embodiment in lineages in the Middle Ages to instrumentally rational mandates from voters in the modern era. At each stage, a certain aura has become fetishistically attached to the bearers of authority. In Internet communities, such an aura is more difficult to sustain, as the Internet seems to discourage the endowment of individuals with inflated status. The example of scholarly research illustrates the point. The formation of canons and authorities is seriously undermined by the electronic nature of texts. Texts become "hypertexts" that are reconstructed in the act of reading, rendering the reader an author and disrupting the stability of experts or "authorities."[21] If scholarly authority is challenged and reformed by the location and dissemination of texts on the Internet, it is possible that political authorities will be subject to a similar fate. If the term democracy refers to the sovereignty of embodied individuals and the system of determining office-holders by them, a new term will be required to indicate a relation of leaders and followers that is mediated by cyberspace and constituted in relation to the mobile identities found therein.

## NOTES

A version of this essay first appeared in the journal *Lusitania*, and is reprinted here with permission.

1 For an intelligent review of the battle over encryption see Steven Levy, "The Battle of the Clipper Chip," *The New York Times*

*Magazine* (June 12, 1994), 44–51, 60, 70.

2  Philippe Lacoue-Labarthe, *Heidegger, Art and Politics*, trans. Chris
   Turner (New York: Blackwell, 1990) and Jean-Luc Nancy, *The
   Inoperative Community*, trans. Peter Conor et al. (Minneapolis:
   University of Minnesota Press, 1991).

3  Ernesto Laclau, *New Reflections on the Revolution of Our Time*
   (New York: Verso, 1990).

4  See Jean Armour Polly and Steve Cisler, "Community Networks on
   the Internet," *Library Journal* (June 15, 1994), 22–23.

5  See N. Katherine Hayles, "Virtual Bodies and Flickering Signifiers,"
   *October* 66 (Fall 1993), 69–91.

6  For a study of the role of the media in the formation of a public
   sphere see John Hartley, *The Politics of Pictures: The Creation of
   the Public in the Age of Popular Media* (New York: Routledge,
   1992), 1. Hartley examines in particular the role of graphic
   images in newspapers.

7  Jürgen Habermas, *The Structural Transformation of the Public
   Sphere*, trans. Thomas Burger (Cambridge: MIT Press, 1989).

8  Jean-François Lyotard, *The Postmodern Condition*, trans. Brian
   Massumi et al. (Minneapolis: University of Minnesota Press, 1984).

9  See, for example, Oskar Negt and Alexander Kluge, *Public Sphere
   and Experience: Toward an Analysis of the Bourgeois and
   Proletarian Public Sphere,* trans. Peter Labanyi et al.
   (Minneapolis: University of Minnesota Press, 1993); and Nancy
   Fraser, "Rethinking the Public Sphere," *Social Text* 25/26 (1990),
   56-80 and *Unruly Practices* (Minneapolis: University of
   Minnesota Press, 1989), especially chapter 6, "What's Critical
   about Critical Theory? The Case of Habermas and Gender." For
   a critique of Habermas' historical analysis see Joan Landes,
   *Women and the Public Sphere in the Age of the French Revolution*
   (Ithaca: Cornell University Press, 1988).

10  Rita Felski, *Beyond Feminist Aesthetics: Feminist Literature and
    Social Change* (Cambridge: Harvard University Press, 1989), 167.

11  Felski, 168–169.

12  See the discussion of privacy in relation to electronic surveillance
in David Lyon, *The Electronic Eye: The Rise of Surveillance Society*
(Minneapolis: University of Minnesota Press, 1994), 14–17.

13  Nancy Fraser, "Rethinking the Public Sphere," 57, 55.

14  Paul Virilio, "The Third Interval: A Critical Transition," in Verena
Conley, ed. *Rethinking Technologies* (Minneapolis: University of
Minnesota Press, 1993), 9.

15  Marie-Laure Ryan, "Immersion vs. Interactivity: Virtual Reality
and Literary Theory," *Postmodern Culture*, 5:1 (September, 1994)
presents a subtle, complex comparison of reading a novel and
virtual reality, though the author does not deal directly with
MOOs and Internet virtual communities.

16  Lynn Cherny, "Gender Differences in Text-Based Virtual Reality,"
*Proceedings of the Berkeley Conference on Women and Language*,
April 1994 (forthcoming) concludes that men and women have
gender specific communications on MOOs. For an analysis of
bulletin board conversations that reaches the same pessimistic
conclusions see Susan C. Herring, "Gender and Democracy in
Computer-Mediated Communication," *Electronic Journal of
Communications* 3:2 (1993) (can be found at
info.curtin.edu.au in the directory Journals/curtin/arteduc/
ejcrec/Volume_03/Number_02/herring.txt).

17  Lindsy Van Gelder, "The Strange Case of the Electronic Lover," in
Charles Dunlop and Rob Kling, eds., *Computerization and
Controversy* (New York: Academic Press, 1991), 373.

18  For an excellent study of the cultural implications of virtual com-
munities see Elizabeth Reid, "Cultural Formations in Text-Based
Virtual Realities," an electronic essay at ftp.parc.xerox.com in
/pub/Moo/Papers; also appearing as "Virtual Worlds: Culture
and Imagination," in Steve Jones, ed., *Cybersociety* (New York:
Sage, 1994), 164–183.

19  For a discussion of these new developments see "MUDs Grow Up:
Social Virtual Reality in the Real World," by Pavel Curtis and
David A. Nichols ( ftp://ftp.parc.xerox.com:/
pub.Moo.Papers/MUDsGrowUp.txt).

20  On this issue see the important essay by Hans Ulrich Gumbrecht,

"A Farewell to Interpretation," in Hans Ulrich Gumbrecht and K. Ludwig Pfeiffer, eds., *Materialities of Communication*, trans. William Whobrey (Stanford: Stanford University Press, 1994), 389–402.

21  "The Scholar's Rhizome: Networked Communication Issues" by Kathleen Burnett (kburnett@gandalf.rutgers.edu) explores this issue with convincing logic.

# PROGRESSIVE POLITICS, ELECTRONIC INDIVIDUALISM AND THE MYTH OF VIRTUAL COMMUNITY

*Joseph Lockard*

*Yes, the railroad had prevailed. The ranches had been seized in the tentacles of the octopus; the iniquitous burden of extortionate freight rates had been imposed like a yoke of iron. . . .*
—*The Octopus*, Frank Norris

Ponzi schemes abound in cyberspace, and the nicest people are selling them. Let's take Howard Jonas, the founder of the Digital Freedom Network, who was responding to criticism that his new human rights cybernet was no help to computerless Bangladeshis, or to those in countries where economic and human rights are least available. According to Jonas, however, "It's the business leaders and intellectual groups in universities, where opinion is made, where people in those countries will have access to the Internet."[1] Politically speaking, Jonas shouldn't be let out of the house without a seeing-eye dog. And he represents many, far too many, who believe that elite access to cyberspace means democratic enlightenment.

Because the obvious so clearly needs restatement: cyberspace is expensive space. True believers who tout the Internet as democracy actualized, as an electronic town hall meeting, live with class blinders in a muddle of self-delusion. One might as well call suburban country clubs models of classless social integration. Access to cyberspace is effectively divided between self-financed, institutionally-financed, and unprotected non-access. Private access requires significant disposable income to cover computer capitalization and the continuing outlays of phone bills, repair of maintenance-intensive equipment, and periodic recapitalization. For those whose employers pick up the tab, the cost arrives in the form of hierarchical workplaces and limited personal autonomy on the networks. Others—university students, for example—receive access as a temporary, institutionally-sponsored privilege that comes with a "keep-up-with-the-cutting-edge" education. A few excepted classes exist, but a middle-class income is the basic password to Internet access. Nonetheless cyberspace has arrived virtually unchallenged as a democratic myth, a fresh field for participatory citizenship. Standard celebratory phrases include "a new Jeffersonian democracy" and "an electronic Athenian agora." Aside from the historical ignorance incorporated in these comments, they all leave unspoken the hard fact that access capital is the poll tax for would-be virtual citizens.

As I traipse merrily through Internet gopherspace exploring interesting bulletin boards, I remind myself of the invisible price tags draped all over the electronic scenery. For all its pretense of global culture, cyberspace functions within the context of a characteristically American pseudo-classlessness. The system's very diffuseness deters a simplistic class versus capital analysis of the old school. As a means of production that does not specifically belong to any identifiable owner (yet), cyberspace eludes those nineteenth-century political formulations that trailed in the wake of the Industrial Revolution. The locus of class/power relations has slipped into a more diffuse, individuated mode, yet one that certainly is not class-neutral. This new diffuseness does not exempt cyberspace structure from class structure. Sartre observed in *Search for a Method* that "(W)orks of the mind are complex objects, difficult to classify. . . . one can rarely 'situate' them in relation to a single class ideology [rather]. . . . they reproduce in their profound structure the contradictions and struggles of contemporary ideologies."[2] These ideologies—and especially their contradictions—manifest themselves most clearly at the gateways of cyberspace.

When thought is given to the implicit ideology of the Internet, it tends to focus on the question of system privatization. Will ITT, AT&T, Time-Warner and others be allowed to take over parts of the Internet system developed at taxpayer expense? By this point the basic questions of Internet control and function have already been decided. Sartrean ideological 'complexity' begins outside the system rather than inside it. The gateway decision—who gets access to an online VDT terminal—is the mediating point between external (social) and internal (techno-social) complexities.

There's still another ideology involved, an ideology of computing cheapness. Techology enthusiasts straightway point to the plummeting price of hardware and the massive expansion of the user base as evidence of future possibilities. "The price of computing power drops by half every two years," goes the mantra. Prices do fall, but the overall economic logic is about as valid as that old Attic brainteaser about how a race can never be completed since runners complete half the distance, then half of half, *ad infinitum*. As prices fall, production is discontinued on low-end and less-profitable hardware, and the industry sets a more advanced, high-priced and profitable standard. This species of argument, along with its suggestion that a fully accessible and democratic cyber-culture is achievable in the not-too-distant future, is simply another social Ponzi scheme. It promises that Ms./Mr. User can purchase ever-more sophisticated hardware and communication links while costs will inevitably decline towards near-zero. And they can buy the Brooklyn Bridge as a peripheral, too. . .

Cyberspace may be ethereal, but it will never be as cheap as air. Trickle-down technology ideologues assert that cheap-as-rice chips and computer assemblies will eventually ensure universal cyberspace availability, they choose to ignore the gateway stratification and maldistribution of access incorporated in the current regime. As economic theory, it differs not a wit from the Friedmanian "free markets solve all" panacea that have been deployed to rationalize social greed. The market forces evidenced in the computer industry, the fundament of cyberspace, have privileged leading-edge technologies in the search for profitability. It would be self-deceiving naivete to trust Silicon Valley market forces to provide affordable autonomous communications for those with less than American middle-class status. Further, corporate interests have increasingly regarded cyberspace as a discrete market in its own right, one where cybermalls will be accessed by remote shoppers. The

THE MYTH OF VIRTUAL COMMUNITY

market's size has already reached several hundred million dollars, and an estimated half of Internet users are commercial businesses. Marketplace access (i.e. computer purchase), credit access, and possible Internet privatization will act as successive barriers to "down-market" buyers. Profit from the mid- and upscale-market, not downwardly spiraling cheapness, is already contouring public access.

*Access and Anti-Cooperatism*

To rephrase the question, why should we rely on a corporate-shaped market for cyberspace distribution, when education and vital public services will be increasingly contingent upon online access?

In the mid-1980s an acquaintance of mine managed to obtain an hour-long interview with the general director of France Telecom, the government-operated telecommunications company, to present her visionary idea: free unlimited universal telephone service as a social right. She couched part of her visionary argument in quasi-adventist terms—everybody talks to everybody, and an Age of Peace ensues. Leaving aside notions of Absolute Interconnectivity and mystical techno-theology, maybe it's time I apologized for the scorn I poured at that time on the core idea. Why shouldn't we consider access to cyberspace an extension of the already publicly-regulated broadcast media, as mass interactive broadcasting? How can we shift paradigms from private-pay access to public cyberspace access on demand? Since free speech depends on an available platform, free speech in cyberspace can only be achieved through universal, democratic access to the medium.

I'm afraid that won't happen while I'm above ground, Social cooperatism in access to cyberspace contradicts the dominant ethos of privatized access, even while cyberspace represents the creation of an implicitly cooperatist social enterprise. Cyberspace functions under the fictive individualism of an "electronic frontier" ethos.[3] Its terminology preserves these individualistic distinctions even while describing a mass phenomenon. A user may access cyberspace, as though a single material door were being opened to allow entry. A user can access an electronic "bulletin board," as though standing alone in a town square gazing at the hoardings. The curious web-surfer peers through immaterial http entryways where anonymous visitors are greeted by a "home page" constructed for mass virtual inhabitation. An illusory ontogeny prevails; the netsurfer rides alone, solitary even amid electronic crowds.

More comprehensive and realistic terminology might incorporate the mass simultaneity of these electronic acts and loci, but we continue to operate under more easily understood canons of contemporary individualism. This same sense of individualism and fragmented interests can only act as an impediment to social cooperation in cyberspace, and to the valuation of personal class privilege over an inclusive community.

Electronic Frontier Foundation pundit John Perry Barlow captured the essence of this cyber-bravura when he posed for the glossy photocover of his Wesleyan University alumni magazine standing heavily dressed in a twilight snowscape alongside a barbed wire fence, with a ranch cabin invitingly aglow in the background. An Apple computer stands atop a fencepost and Barlow packs a double-barrelled shotgun under his arm. Barlow's clumsy and unthinkingly malevolent symbolic exercise exemplifies themes of anti-social monadism and implicit violence that Richard Slotkin has traced so well through the history of American narrative. The ideal client for this old-new ideology is the one who writes a letter to the editors of *Wired* damning the Clipper Chip because "Secure encryption, like firearms, represents an insurance policy for all citizens against future tyrants."[4] Mounting guard over private electronic property, not embracing social needs and human interdependency, defines this ethos of isolation and self-privileging. The essential solitude of a "Don't tread on me" attitude and laissez-faire electronic frontier politics contain walloping measures of anti-communitarianism.

Newt Gingrich and his right-wing cohorts clearly prefer the term "cyberspace" and envisage new Sooners rushing to claim their stake in the bandwidth. Cyberspace lends the air of open country available to pioneers, and later for subdivision into suburban tracts and malls. Bill Clinton's "information highway," on the other hand, smacks of a New Deal public works project. A deeply conservative strain of American political life needs and cherishes a living frontier, and has never brought itself to accept Frederick Jackson Turner's nearly century-old pronouncement of the American frontier's closure. It seizes on technology to reinvent an imagined apotheosis of the American national spirit, a phenomenon that Walter McDougall has examined in the Space Age rhetoric of the early 1960s. These periodic bouts with techno-frontierism, as we are now witnessing in cyberspace, are an exercise in avoiding history's ugliness. The frontier destroyed as much as it created, and the frontier metaphor in cyberspace is at least appropriate in its legitimations of rugged individualism, social greed, and monoculturalism.

Alongside the individualistic privatization of cyberspace we encounter its plural, the "virtual community" theorized by Howard Rheingold and others. A "virtual community" is a confused oxymoron, a dependent derivative of material communities, and not an autonomous existential rubric. The phrase transforms mechanical mediations into a convivial entity and canonizes phone calls as Community Incarnate. Or as my wise eleven-year-old daughter phrased it, "A discussion list uses telephone calls by computer. So why couldn't we call telephone calls between people themselves 'community'?" Communications are contingent on community and are one of its constituents, not its entire body. James Gleick, for example, similarly mistakes an agent for the whole when he prophecies that cyberspace will not remake society but rather will *be* society.[5] In the Gleickian nightmare of totalized communications, distinctions between online and offline will disappear and an all-embracing "virtual community" will replace outmoded offline reality.

That cyberspace can even be mistaken for "community" testifies to the attenuated sense of community that prevails in too many quarters of American society. Where "community" means driving to a mall miles distant for a loaf of bread instead of walking to a corner store, ersatz substitutes hold sway. Instead of real communities, cyber-consumers sit in front of the Apple World opening screen that pictures a cluster of cartoon buildings which represent community functions (click on post office for email, a store for online shopping, a pillared library for electronic encyclopedias, etc.). Cyberspace software commonly imitates "community" in order to further a nonexistent verisimilitude. What the software addresses is desire for community rather than the difficult-to-achieve, sweated-over reality of community. Cybercommunity thus can be understood as an element in the ideological superstructure over the material base of cyberspace (computers, software, labor costs), an element that facilitates technological acceptance, integration, familiarity , and consumption. America Online's marketing strategy, for example, focuses expressly on creating online communities. This strategy of fostering mutually supportive participatory consumption has resulted in 60 percent of the company's online hours being generated by AOL subscribers communicating with each other.[6] An AOL cybercommunity might be conceived as a nineteenth-century company town in late-cap-

italistic full reverse, where labor pays management to create a community to fulfill its desires.

Pseudo-communities like these inspire and privilege commodified desires, otherwise known as "lifestyle choices." To park at home in front of a glowing VDT terminal for online chats or to keep up with the latest postings at alt.sex.beastiality certainly qualify as lifestyle choices, but in content are essentially ephemeral interactions or distractions. What Rheingold et al. really offer is the vision of cyberspace immateriality as a lifestyle choice. Yet materiality has been the historic bedrock of individual/community relations, and it is difficult to accept the notion that advanced communications represent an evolutionary flying leap into immaterial communities, a domain hitherto reserved for promises of divine reward. Possibly a "virtual community" can been seen as an assertion of faith in an immaterial existence, an extension of an older human tradition of affirming a spiritual community-that-cannot-be-seen. Tellingly, when Rheingold relates his experiences of community at the WELL in *The Virtual Community*, he returns again and again to comparisons of an electronic persona with the physicality he encounters at WELL get-togethers. The gravity of the material world pulls him back repeatedly to address an on-the-ground community.

Rheingold's desire for "virtual communities" speaks of a basic human need. In the midst of desire we sometimes function under the conceit that if we name an object after our desire, the object is what we name it. Hard-up men buy large blow-up figures of women and hump desperately, admiring the femininity of their "girlfriends" and groaning women's names over them. But whatever their imagination makes of them, the reality is rubberized plastic, not a woman. Likewise, cyberspace is to community as Rubber Rita is to human companionship.

Virtual communites do not replicate material communities in a parallel world where we can reformulate communality. To accept only communication in place of a community's manifold functions is to sell our common faith in community vastly short. Despite this intellectual faith, my forever sentimental side very much responds to the lure of online "community." Then, grabbing hold of my wits, I recognize that it is precisely this human need for community that is being projected onto cyberspace and exploited, sometimes even with the best of intentions. In hyper-consumption societies characterized by individual alienation and loneliness, there is an enormous appeal to buying some fine new equipment and joining the

online world in search of community. Once television narrow-casting was supposed to accomplish the same function: stay at home, watch community meetings, vote on-screen, form a brave new community. This sort of communications rhetoric died in the '70s: today the consumption-devoted Home Shopping Channel doesn't even make the pretense of community-building.

In cyberspace rhetoric we're watching the same hopes and deflations that characterized this once-rampant belief in communications as community. Twentieth-century American technology, from those early 1920s family gathering ads for Zenith cabinet radios forward, has found familiality and communality exceedingly useful as feel-good advertising and sales themes. Saving permutations of globality and speed, cyberspace technologies are little different from their technological predecessors in this regard. Thus to posit cyberspace "communities" as the contemporary equivalent of a barn-raising, clam bake, or a town fair is to validate such electronic exchanges as the ideological inheritors of an American community spirit. It's precisely this "homegrown-ness" in which Mitch Kapor, Howard Rheingold, the Electronic Frontier Foundation, and their crew are trading, a libertarian mythic vision of how it once was and can be again in virtual communities.

One of my favorite literary scenes takes place in the nineteenth-century Parisian public neighborhood laundry in Emile Zola's novel, *Assommoir*. That washingroom scene weaves together themes of human emotion and work life so masterfully because it elicits a sense of community. Although the university computer facility "bullpen" is a rather more sedate environment, its ranks of students at terminals have reminded me of the serried rows of washerwomen Zola described. My strange imagination, perhaps. A friend reports that the same computer-room scene, with its printer queues and occasional rudeness, has few positive qualities. Still, I feel fortunate to sit surrounded by a physically present community, one where I can wave to a passing friend or ask for technical assistance while exploring the nets. Community in its full materiality is visibly realized here; it is not an invisible hypothesis. If cyberspace becomes a substitute for the material reality of coexisting and cooperating with neighbors, whether in a work or residential environment, then it will become an off-the-streets political retreat and trap.

*White Space, Global Space*
It's simplistic futurism to believe that electronic individualism

leads ineluctably towards a monad's "electronic cottage" and the neo-romantic pioneer spirit of telecommuting. The ideology being advanced is that of implicit entrepreneurship, of Emersonian self-reliance in the electromagnetic spectra. Although a nominally liberal ideology of autonomous labor, this consciousness bases itself on some deeply conservative assumptions about our capacity for self-capitalization and social predisposition to technological dependence. The same individualized ideological complex erases not only class, but differential access based on gender, race, communal origin, and geographic location. The resultant field of putatively null, anti-signified cyberspace is unmistakably signed with Euro-American whiteness. Race and ethnicity are simply not up for discussion in cyberspace social theory, and their very absence identifies unsubstantiated presumptions of community. The featurelessness of a presumptive non-raciality/ethnicity in cyberspace fails to correspond with the real and diverse communities around us. Even as ethnic/racial user groups establish themselves on Internet, they disappear from public view, accessed only by those interested. Non-physicality elides their presence and alterity. While Internet's intercontinental breadth ensures its multi-racial character, its character as a totalizing medium denies the diversity of its users. This lack of correspondence between racial/ethnic presence and felt presence points, if not to the extinguishing of alterity, to its extreme marginalization. Such internalized online monoculturalism reiterates the external racisms prevalent in American social structures. Middle-class suburban America, confronted with its diversity on urban streets, has retreated to cyberspace to avoid the otherwise inescapable realities of diversity. For example, a pending FCC complaint by a civil rights coalition charges four Baby Bells with "electronic redlining" in their planning of advanced interactive video networks that will avoid (black/ethnic) inner cities and serve (mainly affluent white) suburbs.[7] Access, community, and race are inextricably interlinked issues.

Our concept of community returns here as the keystone in a broader argument. Capital has a long history of defining community in reference to profitable or dying technologies—logging towns, boom towns, Dust Bowl ghost towns, Rust Belt mill towns—and now "virtual communities" have joined the list as the computer industry's contribution. There has been an equally long oppositional movement that defines community in terms of common human conditions: gender, race, ethnicity and class. The former is paternalistic at best and exploitative as

THE MYTH OF VIRTUAL COMMUNITY

a rule; the latter has been an embrace of community for group survival. While American racial and ethnic communities have been under sustained and racist assault, cyber-communities are being tendered as the New World Order's pallid substitutes. If the offline/black streets have turned mean, go plug into online/white optic fiber. Simply, the local geography of cyberspace follows the lines and contours of American racism, sexism and classism. An entire world lives outside those lines, and they've been electronically redlined out of cyberspace.

The Internet may be in the process of internationalization, but it remains blatantly American in its social rhetoric and values. And as found more generally in American politics, class simply does not exist as an extended cyberspace discourse. The Internet's globality itself becomes another objection to class analysis of its systems because the Internet links an impossibly diverse set of social circumstances (e.g. how does the same class analysis encompass both Calcutta and Scarsdale?). In the chaos of globality, an American identity imprints itself on the Internet by default of any other seriously contending identity. As an Americanist, I find myself very much at home sorting through the Internet's narrative threads. The electronic cabin evokes Hector St. John de Crevecoeur at the frontier and virtual communities seem like dreamy Hudson Valley villages sketched by Washington Irving. Examining these threads helps identify that distinctly American mix of self-referentiality, near-sightedness, and insularity that frames the Net as universal, classless, and of solely technical articulation.

The political geography of cyberspace effectively mirrors the prevailing patterns of global resource distribution. Vast swaths of the world remain entirely unserved by Internet. On one hand this is simply a reiteration of the existing asymmetrical information orders; on the other, it's an exacerbation and new order of magnitude in international disparity. In the developing world, problems of access to cyberspace are cast first in national terms before arriving at questions of private/public appropriation. For example, the USIA encountered its own national presumptions recently during a teleconference on assembling online archeological data bases between Egypt, Israel, and Jordan. The Jordanians thought it was a fine idea, only the Internet didn't exist in Jordan. Even with the Net's enormous international growth, it doesn't even approach serving one percent of the adult global population. It remains unknown and irrelevant to daily life in the world-at-large.

Confusing improved communications with international

community is another easy mistake of technological enthusiasm. Educated Victorian opinion made the same error when hailing the Eastern Cable Company's Suez-Aden-Bombay submarine cable for reinforcing and consolidating the British Empire as a unified community. The sense of closeness engendered when governmental instructions could be wired from London to India within hours was a measure of improved capacities for control of the imperial periphery. In some measure, cyberspace seems to serve as a contemporary equivalent to the early "All Red Route," the British-sponsored trans-global cable system that served its commercial and administrative interests. This example underlines how communications globalism and near-simultaneity, two characteristics attributed to "virtual communities," have been present for quite awhile. The Internet simply sets a new standard for the technical expression of these characteristics. The comparison suggests that ideologies of metropole/periphery relations and international order inform the extension of Internet just as thoroughly and more complexly than its technological predecessor of a century ago, the colonial cable system.

In the skeptical view, global cyberspace lends itself to an elite political voyeurism more readily than to effective activism. Distant lives translate into a gopherspace file organized into a collectivity of deprived subjects and absent even the materiality of yesterday's newspaper. Lebanese novelist Elias Khoury observes that Third World lives and texts tend to be treated like its natural resources and become grist for First World critical mills. For all its honorable intentions, a project such as the Digital Freedom Network is just an advanced mission civilitrice operating from a safe distance, one that dispenses (negligible) human rights information instead of religious tracts. Perhaps the relevant criterion for assessing subject-description relations here should be the proximity between a class/gender/racial/national experience and access to cyberspace. In other words, a documentation team from the Palestine Human Rights Data Bank attains a doubled subjectivity; theirs are both the experiences and on-the-scene reports. A community reports on itself, rather than is reported on by others. Where cyberspace can marry collective narrative with collective access, whether near or far, its effectiveness and credibility can only gain.

"Virtual communities," in short, have become a new governing myth. The opening of new communications paradigms coincides with a yawning and unfulfilled need for community, and communications consumerism persuades us that this

dream is available in an electronic affinity group. In its most expansive form, this notion becomes a comprehensive myth of global community. However, as Jonathan Sterne points out, universalism too has been a staple of communications industry rhetoric to encourage infrastructure investment.[8] Communications capital has simultaneous and related mythographic needs for "community" to facilitate micro-marketing and universalism to ensure market expansion. The challenge for progressive politics will be to separate the technological benefits of cyberspace from its marketing myths.

We are in the midst of a rapidly evolving Cybermachine Age that, like the Machine Age of the post-Civil War period in America, is engaged in creating a new quasi-invisible public architecture and social master narrative. Too often in our vision of this cyber-world we are rewriting Edward Bellamy's *Looking Backward* and its quaint nineteenth-century belief in neat technological utopias. By rushing to subscribe to the avant-gardism of an electronic society, even in some alternative and anti-capitalistic formation, we simultaneously subscribe to that faith in expanding productive forces that has done so much to shape American society, for good or ill. Now as then, emergent cyberspace ideologies commonly promote credence in machine-mediated social relations and their benefits, together with mystifications of individual, community, and global relations. Progressive politics should seek to analyze, clarify, and demystify these relations. Otherwise there will be little to separate the celebration of cybermachines from the then-progressive nineteenth-century infatuation with machines as the realization of human liberation. If we embrace cyberspace uncritically without a political consciousness of its structured dreams, then we are certain to awake "in the tentacles of the octopus."

NOTES

1 Howard Jonas, "On the Internet, Dissidents' Shots Heard 'Round the World," *New York Times*, June 5, 1994, E 18.

2 Jean-Paul Sartre, *Search for a Method*, trans. Hazel Barnes (New York: Knopf, 1963), 116.

3 These individualistic origins are captured in the name of the "Electronic Frontier Foundation," proposed by co-founder John

Perry Barlow, who likens netsurfers to American pioneers who "were able to tolerate harsh conditions, like fur traders." *Wired*, June 1994, 129.

4  "Rants and Raves," *Wired*, September 1994, 23.

5  "James Gleick's Pipe Dream," *Netguide* 2.1 (January, 1995), 38.

6  "Steve Case at a Crossroad," *New York Times*, August 14, 1995, D4.

7  "Gerrymandering the Electronic Future?" *MacWorld*, October 1994, 104–105.

8  Jonathan Sterne, "Alienation in Cyberspace," paper delivered at the Speech Communication Association annual conference, San Antonio, Texas, November 1995.

# READING, WRITING, HYPERTEXT
## DEMOCRATIC POLITICS IN THE VIRTUAL CLASSROOM

Joseph Tabbi

This chapter was initially written for the yearly cultural studies symposium at my university, an event whose title got reported in the campus paper as "Western Humanities, Pedagogy, and the Public's Fear."[1] Evidently the reporter had gotten her information over the phone, and that was how she heard "The Public Sphere," the Habermasian third term in our title. Appearing mid-way into the conference, the paper's unwitting pun brought a lot into focus; we wondered why we hadn't thought of it ourselves. Instead, a felicitous mistranslation between media was needed to set the keynote for the rest of the conference.

It is worth reflecting on a communications system that would have avoided both the embarrassment and the uncanny rightness of the *Collegian* misquote, which in itself marks the disparity between a high academic jargon and what a reporter is likely to hear in it. Had the conference title been read off the posters, or, better yet, had it been sent directly from the English Department to the Journalism building via email, no confusion

could have occurred, for no translation would have been needed between print and oral media. Take the logic a step further: once any and all media that are now separate are connected to each other through fiber optic cables, the possibility of inaccurate transmissions (outside of a total system collapse) will be reduced to zero. As Friedrich Kittler has observed, in the not-too-distant future, "When films, music, phone calls, and texts are able to reach the individual household via optical fiber cables. . . the previously separate media of television, radio, telephone, and mail will become a single medium, standardized according to transmission frequency and bit format."[2]

Kittler presents this scenario as a triumph of technical positivity, the enforced preservation of information over background noise which would do away with ambiguity, puns, and other indirections of a natural language. The source of our collective fear, however, may be more than linguistic:

> Above all, the opto-electronic channel will be immunized against disturbances that might randomize the beautiful patterns of bits behind the images and sounds. Immunized, that is, against the bomb. For it is well known that nuclear explosions may send a high intensity electromagnetic pulse through traditional copper cables and cripple the connected computer network.[3]

The origins of the Internet in systems of university education and military defense are, as Kittler says, well known. The NSFnet and the ARPAnet, configured in a widely distributed, flexible, and purposely uncentered global network, may stand as the quintessential postmodern structure, a living monument to cold war dreams of nuclear apocalypse. Today it is no less indicative of the post-cold war culture that funding for the Internet infrastructure is increasingly being redirected from the government to the private sector. As of April 30, 1995, the National Science Foundation ceased to operate the Internet backbone. All educational traffic is henceforth to be carried by commercial enterprises.[4]

With privatization and the redirection of public funding, the nation's collective fear has been redirected—to the enemy within. Senator Exon's Communications Decency Act, which went into law in Feburary 1996, would allow the U.S. Government to impose fines of up to $100,000 on anyone found posting, or running a list that posts, "obscene, lewd, lascivious, filthy, or indecent" messages, or the kind of sex

narratives that, in the words of one journalist, have turned the Net into "an electronic sink of depravity."[5] The Clinton Administration's Counter-Terrorism Bill of February 10, 1995 has already been invoked to "sabotage" lawful electronic activism and circulation of information on behalf of the Zapatista rebellion in Chiapas, Mexico.[6] Objections to the anti-democratic bias in such State actions have been loud but not decisive. If the Decency Bill goes unenforced and international lines are kept open, it will probably have to do less with the First Amendment than with the "laissez-faire utopianism" of the 104th U. S. Congress.[7]

The Internet has clearly become a cultural laboratory— that is, a field for conducting utopian experiments in cummu-nicative action as well as cultivating new fears about the too-free circulation of information. A potentially liberating medium emerges at an especially inopportune political moment, so that many of the educators who were initially upbeat about the democratic potential of the Internet now downplay it.[8] I myself doubt that the Internet can ever approach the ideal of a public sphere as set forth by Habermas; indeed, the rearguard skirmishes in Congress lend new cre-dence to postmodernist arguments that the very ideal of a sin-gle and universally accessible public sphere is fundamentally at odds with a corporate technological democracy, or what Gregory Ulmer has termed an "electracy."[9] The very notion of the nation state, and the creation of widespread (print) literacy through a system of universal education, is challenged by the trans-national nature of the World Wide Web. Thus, if one is to continue to speak meaningfully about an online democratic culture, the notion of a public sphere needs to be re-examined at every point.

Against such political ill winds and fundamental infra-structure change, the question becomes not one of merely lamenting fading hopes and performing a critical post-mortem, but of determining how best to use the new system in a manner that will facilitate democratic exchange. To this end, it is advisable not to think of the Internet as a single medium, but (carrying Kittler's image into the political sphere) to argue for a diversity of media in relation, including our bodies and our natural languages, to keep open the possiblities of reform and dissent within the newly aggregated digital media.

Because materially distinct media belong to different con-ceptual orders, they can critique one another and correct each others' excesses—creating an intermedial balance of powers, so

to speak, which may be taken as an aesthetic and pedagogical corollary to the democratic principal recently stated by the Supreme Court in *Turner Broadcasting v. FCC*: "Assuring that the public has access to a multiplicity of information sources is a governmental purpose of the highest order, for it promotes values central to the First Amendment." The Internet, so long as it is able to sustain a multiplicity of media, has an extraordinary potential to be a democratic space for internal dissent—a prospect that has created a marked nervousness in legislators whose main interest is in ensuring the smooth functioning of a uniform and potentially profitable machine.

• • •

To begin with the Habermasian theme of the humanities symposium I referred to earlier: there are many possible intersections between the Internet and the concept of a public sphere. For the moment, at least, the Internet hosts a swarm of informal conversations carried on more or less openly, and often in public. The Communications Decency Act notwithstanding, the Internet is as yet without the Federal restrictions and commercial requirements that cripple more established media such as radio and television (including the requirement that a mass medium must consistently entertain—i.e., engage people without demanding anything back from them). The Internet also allows, by virtue of its many direct-mail electronic links to lobbying groups, a "specific," and even a nagging, "means for transmitting information and influencing those who receive it."[10] Admittedly, access to the Internet is by no means universal and it can hardly be expected ever to acheive greater currency than the telephone, which is unavailable to 75 percent of humanity, including a significant percentage of households in industrialized countries. Still, popular faith in progress (crucial to most democratic ideologies) is fueled by the sensible expansion of material possibilities, however incomplete and inequitably shared. Internet access, in its own academic and professional spheres, is undeniably exploding, and its much feared commercialization will no doubt depend on the corresponding expansion of markets beyong the "elite" group of professionals, educators, hackers, students, journalists, shoppers, avant-pop writers, and cyberspace "terrorists" who currently enjoy access.

Access in itself, however, is no guarantee that the new electronic and digital environments will be democratic. The technology's touted capacity to support open, free-ranging conversations in real time with an equality of participation is

not intrinsically democratic, even if this capacity turns out to be realizable on a mass scale. In the political public sphere defined by Habermas, the expression of public opinion presupposes the capacity for "criticism and control" on the part of the polity; more than ever, control now means the ability to exert power over and through the technological means of communication themselves. The great number and variety of groups who have identified themselves and located each other on the Internet—what would seem the very embodiment of a healthy pluralist democracy—could easily turn into fragmented and powerless constituencies. Unless they can themselves influence the development of the new media of communicative action, these groups are likely to be made subject to the same processes that have produced, according to Habermas, a "refeudalization" of the contemporary public sphere, a degradation of rational "public discourse" into "a publicity stunt working to advance the cause of special interests."[11]

The fate of the Internet—public sphere or refeudalized marketplace—thus depends largely on the ability of its numerous constituencies to use it critically, and with some awareness of each other's existence. And here is where the strongest claims have been made for the digital classroom; namely, that it is an ideal environment in which to train students in habits of mind which would make it possible for them to engage in democratic decision making. This democracy claim is consistent with the position, most often associated with Henry Giroux, that pedagogy in general "is about the creation of a healthy public sphere, one that brings people together in a variety of sites to talk, exchange information, listen, feel their desires, and expand their capacities for joy, love, solidarity, and struggle."[12]

In general, classroom uses have emphasized the instrumental conveniences of the Internet as a place for students to "exchange information" and "feel their desires." That Giroux defines such activity as taking place in a "variety of sites" seems an even more crucial stipulation, however, since that is the one criterion that can ensure the articulation of differences and the consequent "struggle" that is needed to give significance to the information and to keep desire from becoming self-validating. The Internet and hypermedia certainly could become a heterogeneous forum, facilitating the articulation of differences among participants in print and various electronic and digital sites, but (for reasons I will explore) media multiplicity has yet to be produced and fully exploited in most classroom environments. From a pedagogical standpoint, the challenge has been

to use digital media as means for widening classroom conversations, expanding university access to remote locations, fostering equality of participation and interaction, and thus cohesion, among students, and allowing the convenience of group writing during class time. Hypertext and the Interchange Network (a platform for simultaneous online conversations) may well facilitate all of these classroom innovations. But the democratizing impulse behind the innovations will be of small import if writing teachers do not have students think critically about processes of mediation, and the ways that different technologies impact on their reading and writing.

There is reason to hope that the humanities, for a change, will be participants in innovation—that our critical disposition will actually play a role in shaping the new technologies, and not simply in critiquing their effects after the fact. "After the technologists come the theoreticians," says Friedrich Kittler.[13] Too often, the luxury of critical distance is purchased at the cost of powerlessness to influence the development of the very media that constrain and condition cultural work. In the emerging field of cultural studies, (perhaps the last refuge of what Peter Uwe Hohendahl terms the "literary public sphere"), analysts on the left are in danger of being reduced to "color commentators" on "the formation of hegemonies that are actually *being* formed on the right."[14] And it is the right, mainly, that stands to benefit from the transfer of Internet technology from the universities to the "private" (read: multinational corporate) sphere.

There is a branch of literary theory, however, whose participants have been quick to recognize the practical relevance of theory, and who have even tried to carry theory into the realm of media policy. Forward-looking accounts of the new electronic and digital environments, and of hypertext in particular, have come from literary critics, such as Kittler in Germany and Ulmer in the United States, who have drawn on postmodernist and post-structuralist theory for more than interpretive or descriptive power. An unexpected benefit of the rapid turnover in academic fashions may be that, with its fading novelty, post-structuralist criticism will be freed from its near exclusive employment (in the United States, at least) as a method of interpreting literary texts. For it is a major recognition of Kittler's media theory and of Ulmer's "teletheory" that post-structuralism, which has always been about relations between systems rather than "emotional dispositions," has its natural application in the study of technical means of transmission,

reproduction, and storage.[15] Human agency and subjective interiority are not denied in post-structuralist media theory, but they need to be located within "discourse networks," the institutions that connect books and other media with people. To write about the self in such a context is necessarily to go *outside* the self, to ask (with Ulmer and Jacques Derrida) "how a unique, individual subject discovers, invents, or otherwise gives rise to a system of knowledge."[16]

Serious problems remain, however, in the ongoing technology transfer of post-structuralist theory: answers to problems in the literary sphere do not translate directly to the technological sphere, and superficial resemblances that hold out promise can backfire on humanists when the computer scientists get the ear of legislators. *A priori* assumptions about the liberating potential of the new media are especially suspect. The majority of theoretical writers on hypertext, according to Charles Ess, have written as if electronic and digital writing environments were inherently democratic—as if the more equitable relations between students and a professor in a computer-supported classroom could lead, in time, to the cultivation of democratic habits and a greater democratization in the society as a whole. The medium is, to be sure, anti-hierarchical in its organization: it was designed so that readers could have as much agency as writers; so that they could build active links among blocks of electronic texts, or "lexias," and move from one text to another without regard for an author's controlling structures, in an environment—the World Wide Web—that changes from moment to moment. (The word "lexia," of course, comes from Roland Barthes, whose essay, "The Death of the Author," informs much of the anti-authoritarian rhetoric of hypertext theory). So, too, have networked classrooms shifted attention away from the central authority of the teacher, whose responsibility it has been, traditionally, to recognize valid input and encourage a consensus. The digital medium (when it's not trivialized and used to project a canned lesson) instead encourages a branching written discussion in which students link up to a network. The pedagogical dynamic is more provisional, not question-answer but comment-elaborate, with cues coming from a number of centers besides that of the teacher.

One might present the post-structuralist transformation, even in this caricatured sketch, as largely a translation between geometries: instead of the smooth and continuous space of a public *sphere* gravitationally centered on a tacitly recognized

authority that keeps things moving in a consensual orbit, we now have a flattened surface, projected into multicultural contact zones and local dissipative networks. According to most theoretical accounts, reading itself has been altered to fit such geometries. No longer is the act of reading a sequential and continuous progress from the beginning to the end of a text that remains fixed and unalterable; readers are now free to determine their own paths through multiple texts, and (given the fluidity of the medium) they can alter these texts as they go along, becoming, in effect, not interpreters but collaborators in the creation of meaning.

The new geometry is seductive and participatory, but not *necessarily* democratic, and not nearly as revolutionary as many theorists suppose. Martin Rosenberg, the first critic systematically to study the geometrical tropes that underlie both "hypertext systems *and* their rhetorics," demonstrates that the vaunted "nonlinearity" of hypertextual media is more precisely a *multilinearity*, an environment that is (in the absence of nodes, links, and directions that an author very consciously constructs) indifferent to the path taken by the reader/writer. After all, "words must be read one after another, and cannot be read backwards," so what really occurs in hypertext reading is a continuing shift of attention between different local geometries.[17] To be sure, readers of hypertext may be liberated from the necessity of following someone else's logic, but no print author of any interest is likely to be so directive. And much can be lost when freedom is conceived as boundlessness, a license to wander endlessly in an infinitely expandable, infinitely connectible and episodic hypertext. One of the least desirable prospects for hypertext reading is that it could free us from the more flexible, moment-by-moment testing of readerly expectations against authorial devices, the continual give-and-take that makes for the dialogic pleasure of print narrative. Even if one is not disoriented by the endlessly branching "docuverse" (tracking aids and on-screen visual maps are being devised), boredom takes its toll. Without *some* authorial resistance, readerly desires can be too easily satisfied, and are unlikely to end until the "riter" tires of "wreading."

Ess, for his part, finds little that is *inherently* radical or democratic in hypertext and online platforms that decenter classrooms and conversations by opening them to other classrooms and sites on the Internet. He cites a study of the Intermedia system at Brown University, the longest running program of its sort in the country, whose authors found even it

to be indifferent, at heart, to democratic values. Whether a decentered and interactive classroom experience can in fact produce a democratic impact must depend, not on the hypermedia system itself, but on the "larger social contexts in which the system is used."[18] In the absence of this context, Ess argues, the democratic ideal tends to be utopian and ideological, and thus easily dismissable by skeptics "who see," or wish to see, "no essential connection between hypertext and democratization at all." Giving agency to systems of information exchange rather than to individual subjects who communicate primarily through natural language, the ideal remains far "removed from the particularities and constraints of everyday praxis," that proving ground near to the hearts of Habermas's Frankfurt School predecessors.[19]

Composition theory, which is often put at the "service" of non-literary disciplines, is a field that has involved itself from the start in real-world requirements, and one whose pedagogy has responded to demographic changes that have opened the university to students of various ethnic and linguistic backgrounds. Writers in the field of composition studies tend to be duly sensitive to discrepancies and asymmetries in access, power, and authority that constrain any technological utopia, even the "achieved utopia of the networked classroom," to cite the title of one especially detailed report from the field. With Giroux, writers on electronic classrooms have stressed the need for a radical pedagogy, one that would recognize and alter systematic oppression, and that would break down borders whose very visibility is obscured by ideology. Generally, radical composition theory would bring the concept of the public sphere into a postmodern, multicultural milieu. Cynthia Selfe and Richard Selfe, for example, appropriate the concept of a linguistic "contact zone" from Mary Louise Pratt, and apply the concept to computer interfaces. They argue that computers, like other systems of cultural power, create "social spaces where cultures meet, clash, and grapple with each other, often in contexts of highly asymmetrical relations of power, such as colonialism, slavery, or their aftermaths as they are lived out in many parts of the world today."[20]

What is laudable about the application of the concept of a contact zone to the field of composition studies is that it prevents both teachers and students from taking for granted the democratic basis of any power relation, including their own relations with each other in the classroom. Unlike many of their more strictly literary colleagues in the field of hypertext

theory, Cynthia and Richard Selfe foreground the concept of struggle in the working out of any democratic program.[21] Remaining aware of the "overly positive rhetoric of technology" that characterizes the field of education, they do not promote an apolitical technocracy; neither do they mistake a contact zone for a "linguistic utopia," in which conflicts are glossed over, and "cues of gender, race, and socioeconomic status are minimized."[22] Their pedagogy rather seeks to intensify differences, even if that means making students uncomfortable, less confident in the rightness of their own intellectual and demographic backgrounds.

What the Selfes and Pratt advocate, then, is at one level nothing more (or more difficult, in practice) than a response to demographic realities, a way of facing up to social pressures and new intellectual demands when a significant percentage, often a majority, of university students are non-white. The Selfes, however, manage to avoid both the traditionalist and "politically correct" versions of multiculturalism by extending their critique beyond the particular backgrounds, ideologies, and identities of their students, to the one culture based on mass media that all university students are being asked to share, and against which they must struggle to maintain or create any local identity. The most striking passages in the Selfes's article, "The Politics of the Interface," are indeed those that lay bare the class-bound values and general corporate orientation of computer interfaces that composition programs currently employ. Such interfaces include: documentation in which there is "a preponderance of white people and icons of middle- and upper-class white culture"; software applications that represent the "virtual world as a desktop;" passwords, copyright protections, and levels of privileged access that sustain notions of ownership and class hierarchy; generic computer classrooms (often borrowed from engineering or computer science departments) that in their very layout reinforce the centralized authority of the teacher.[23] Moreover, by virtue of their often killing ugliness and basement clastrophobia, such enviroments reinforce mind/body oppositions and a professionalist valuation of mental over physical work. Too many computer enviroments are conducive to an adolescent Platonism, expressed in cyberpunk fiction's memorable references to the body itself as a mere "meat thing" destined to move in wasted suburban spaces (to which the cyberspace cowboy reluctantly returns after an all-nighter in the realms of sheer data).

The typically corporate environment again raises the pos-

sibility that, to appropriate Rosenberg's Deleuzean language, the "combatants" in a computerized contact zone may be "already inscribed before they even design the field and begin the struggle." Such "designs" go deep, beyond human interchanges to software interfaces: "The savvy programmers may inscript the hypertext; the naive consumers may be inscribed by the hypertext." Kittler goes even further, and further back in computer history: the last act of writing, he surmises, may have occurred in the early seventies, when the Intel designers of the first integrated microprocessor "laid out some dozen square meters of blueprint paper."[24] It's an open secret, for Kittler as for Barthes and Foucault, that nobody writes anymore: human writing passes through channels already laid out in computer hardware and communication channels, the miniaturized writing in the sand that links thousands of transistors on a silicon chip.

Signs of human resistance are beginning to appear, however. With Rosenberg and Moulthrop, the Selfes want to bring the war back home and keep the student writer's agency alive.[25] I hope that the recommendations in their article get a hearing outside the circle of composition and rhetoric teachers, lest popular resistance degenerates into a full-fledged backlash against a technology whose revolutionary potential was overstated from the start. The Selfes suggest, for example, that composition teachers and students become "technology *critics* as well as technology users," that we get involved in the design of software, and turn the generic computing environment into a *writing* environment.[26] The ideal milieu for electronic writing would be neither an office nor even an "integrated" classroom, but a multi-media performance studio. Such an environment would also bring out what is attractive about collaborative computer work; namely, the opportunity to see other people (preferably over a screen that can be recessed into the desktop), to share information, and to move around in a studio space that includes visual and audio elements as well as text.

The redesign of compositional space—and of the digital page itself—could help return the act of writing to its materiality and non-verbal contexts, introducing a tactile quality that from the time of illuminated manuscripts has surfaced only sporadically in literary history, notably in the typographical innovations of William Morris and his modernist successors. A greater attention to the embodied text *and* its physical context could serve to promote a self-consciousness about media that is necessary if one is to have a chance—or even the *desire*— to change them; such media self-consciousness could also help

READING, WRITING, HYPERTEXT

educators to counter popular dismissals of electronic writing, which, unlike printed books, can't be read in bed or in the bath or in a comfortable chair by the fire. Instead of passive comfort, the new electronic writing environments promise to bring more media (including our bodies) into the creative process. Along with a certain physical reorientation, such a program also would willingly create and urge the expression of mental *dis*comfort in students, not in order to correct their thought and clean up their speech, and not simply to encourage the self-reflection and its public scrutiny that has been the traditional goal of composition studies. Rather, students and teachers alike need to reflect on, and thus alter, the media through which most of their work, in and out of class, is going to be processed.

Self-consciousness in the use of media, the disruption of expectations, even a certain *alienation* can have a place in electronic pedagogy. It's a mistake, I think, to try to make the medium too comfortable. Alienation in a learning enviroment is better than the transparency of an inchoate ideology: conflicts need to be exposed. This is why, despite talk of the networked classroom as an "acheived utopia," studies generally emphasize disturbance and discomfort in the pedagogical experiences that go with the new media. Lester Faigley, for example, celebrates the democratizing impulse behind Interchange discussions, and their potential for bringing students of widely diverse backgrounds together. Students, especially women, who according to Faigley often felt inhibited talking in a traditional classroom, entered willingly into the realtime, optionally anonymous electronic discussion. But Faigley also notes an "uneasiness," even a tendency toward "aggression" in many participants, suggesting that all is not well in his utopia: dissensus emerges more naturally from diversity than consensus, the open communal sphere of discourse excites self-assertion before dialogue, and a classroom that respects difference in its subjects has trouble moving beyond the expression of conflicting points of view.[27]

To his credit, Faigley himself goes beyond the tried method of dealing with internecine aggression, which is simply to teach the conflicts. He relates the uneasy atmosphere of the electronic classroom, rightly I think, to the disorienting qualities of Jean Baudrillard's culture of simulation and, more generally, to Jean-François Lyotard's "postmodern condition," a disorientation that occurs in the absence of any authority grounded in consensually determined (let alone universal) truths. The postmodern perspective predicates another, less

positive, fate for the Internet; its communicative landscape is not a democratic public sphere but a playing field for pure language games—and a denatured language at that, shorn of the material, physical, and other non-verbal contexts that constitute much of what we experience as natural language.

The *disembodiment* of electronic discussions may be what most limits the Internet's capacity to sustain real democratic exchange. Students exchanging ideas on a LISTSERVer or real-time interchange network experience the postmodern condition as a shock at being given total freedom to say anything, in an environment where, for the duration of a writing session, at least, they do not have to face their interlocutors or answer to a teacher's authority. And not only the teacher's authority is diminished: among students, the subtly empowering and socially hierarchizing cues of bearing, attractiveness, accent, and locution are missing, not to mention such physical markers as skin color. Yet the disposition of precisely such qualities, the contingency of selfhood, are a large part of what it means to speak as a particular, human subject. Their absence can be liberating momentarily, or even permanently, as in the case of commercial authors who, even now, take on pen-names of an indeterminate gender. Yet the desire for such invisibility evades, rather than solves, differences of race, social status, and class. Ultimately, any conversational equality that traduces the physicality of the participants is bound to be idealist and utopian in the worst sense, for by collapsing real exchanges into disembodied communications, language itself is turned into a system.[28]

Is it any wonder that so ethereal an equality turns to flames in the practice of composition classrooms? "This equality of participation," Faigley notes, does not lead to the community building that "some teachers have theorized, following Kenneth Bruffee's model of collaborative learning, where conversation leads to cooperation." Indeed, the aggressiveness that can erupt in the digital environments tends to support Lyotard's contention that "conversation is inherently agonistic and to speak is to fight."[29] Faigley does all he can, however, to downplay the inflammatory potential of Internet talk, lest the digital contact zone degenerate into a war zone. He is quick to say that no "flaming" ever came about in his discussions, despite the protection of pseudonyms; and he goes out of his way to anticipate and contradict the usual complaints about class talk groups— e.g., that students are unable to participate in electronic discussions without wandering off the topic and using profanity. Years before the proposal of the Decency Act, composition the-

ory is already on the defensive, anticipating the corporate displeasure of the profanity police.

Faigley perceives that, in the absence of any personal authority, the authority or "logic" of the marketplace soon takes over, even in "electronic discussions" where "topics are introduced and consumed according to what students like at the moment and what they don't like."[30] The very habits of reading and writing on email and interchange discussions, where posts are "most often quickly produced, quickly consumed, and quickly discarded," discourages reflection. Such discussions are certainly a welcome alternative to the tedium of conventional "process" writing. With Ronald Sukenick, I prefer the transitional character of electronic writing, the mental rhythms of "improve-elaborate" over the process system of "draft-revise." And where the field of composition has typically favored writing about the self, the digital medium is appealing in its potential for taking us outside ourselves. This it can do, however, only if it is used critically and self-consciously, interrupting the "natural" fluidity of electronic writing.[31]

To indicate how the critical potential of the medium might begin to be realized in practice, I would stress an aspect of hypertext that, while sometimes noted, is rarely given the centrality it deserves. I refer to its potential as a technology of quotation. That hypertext is a medium in which elements of text, video, and sound are all readily citable (or will be when digital images are available on the same platform as text and can be downloaded as readily) is a feature that crucially distinguishes it from, say, television. The citability of Internet discourse need not preclude its fluid, conversational, qualities, but it might well transform conversation from a self-validating activity into material for further composition. As Faigley himself points out, the electronic discussion is savable, and thus available for use beyond the conversational moment that produced it.

Any pedagogical practice that hopes to employ the new media as a form of quotation-technology must acknowledge the effects of its enabling technological substrate and avoid the pretense that electronic talk is as free as any other good conversation of undue interruptions and constraints. Writing practices have never been independent of their materiality, and classroom assignments need to emphasize, not downplay, the electronic medium of instruction. One of the techniques that I have developed in my own email-course talklists involves citing fragments of student writing that may have been composed quickly, and returning these fragments, with or without com-

mentary, but in a wholly different context. I find myself assigning frequent pastiches, which get students used to writing in voices not their own; and I often send fragments of one student's essay-in-progress to another student, for the second student to complete. I will on occasion assign a "plagiarism," in which students are asked to locate a fragment of classic literature—a minimum of fifteen words from anywhere in Proust, for example—and work that fragment into their own narrative. (The paper gets an automatic "A" if I am unable to distinguish between the plagiarized passage and the student's words.)

Each of these techniques—even the last, which need not depend on the new media at all—tends to reinforce the positive possibilities for self-dislocation in dispersed and digitalized writing spaces. The practice of out-of-context citation begins to put the alienating qualities of media to use, as a way of breaking down "natural" habits of thought. (Whatever a student may have been thinking when she originally contributed a post, it is often not what I am thinking when I cite her sentences back at her.)

As Derrida defines it, the activity of quotation is an act of *violence*, a wresting of a passage from its context, that alters the entire textual field. The cited passage, in Derrida's visual and embodied metaphor, is chewed in the teeth of "quotation marks, brackets, parentheses: when language is cited (put between quotation marks), the effect is that of releasing the grasp or hold of a controlling context." The hypertext, though "absolutely illimitable," need not be regarded as an expanding research base to which the academic writer must forever add new knowledge.[32] Digital technology is defined not as an entity, but as an activity—and this activity, conveniently, is one in which literary people can claim expertise. Citation of knowledge is indeed one of the few areas of humanist work that *both* the bureaucratic culture and a radical pedagogy can endorse. At the same time, the radical emphasis on dislocation and decontextualization can avoid the aridity and pedanticism of institutional citation practices—as embodied, most familiarly, in the footnoted academic reference.

This conception of hypertext as a technology of citation also avoids the delusory quality of most virtual spaces, including the conversational space of the totally electronic classroom. The virtual classroom is delusory only when one cannot go back to it and thus test it against ongoing experience in any context outside the virtual writing world. The success of a virtual environment, whether it be a classroom or the more

common headset display, depends on the erasure of differences between self and world. This erasure renders the medium itself invisible so that the user can sustain the illusion that he or she is immediately realizing his or her desires. "'Take your desires for reality!' is the slogan of power," writes Baudrillard.[33] So long as a system is invisible, it will remain in the service of the reigning ideology—and all the more so in a consumer culture, whose primary goal is the free, uninhibited circulation of machinic desire (which the most interactive learning environment cannot, by itself, resist).

The fluidity of hypertext has been celebrated for just these qualities of freely circulating desire, where users follow their own choices in responding to posts and following a given conversational or textual thread. But more is lost in this consumption economy than the book or written document as durable product. Aside from its economics, the book since Plato has offered a medium that readers can go back to, that they can cite and recite in new contexts. And it is this modestly flexible durability, not the waste culture of consumerism, that hypertext and other electronic writing environments should be made to emulate and encourage. The conception of hypertext as a multilinear, multimedia technology of citation avoids the false opposition between canonically durable and immediately consumable goods. The strength of the book has been, traditionally, not in its monumental status as a cultural icon, but as a point of reference that is citable, and thus shareable among many people. The (only apparent) immateriality of electronic media need not dissolve textuality, reducing the book to bits. The digital culture may turn out to be the one context that preserves the book's essential difference.

NOTES

1  Amy Ziegler, "Scholars Discuss Culture, Education," *The Collegian* (Kansas State University, March 9, 1995): 10.

2  Friedrich A. Kittler, "Gramophone, Film, Typewriter," trans. Dorothea von Mücke and Philipe L. Similon, *October* 41 (1987): 101–118.

3  Kittler, 101.

4  Glenn Fleishman, "The Experiment is Over," *TidBITS* (ftp://ftp.tidbits.com/pub/tidbits/issues).

5  Simon Winchester, "An Electronic Sink of Depravity," *The Spectator* (4 February 1995): 9–11.

6  The National Commission for Democracy in Mexico finds U. S. and Mexican state interference in network operations to be in violation of the individual's freedom to circulate information. David Cole, a professor at the Georgetown University Law Center, notes further violations of civil liberties in the bill's immigration provisions. By denying due process and imposing criminal penalties in cases "where a non-citizen has done nothing more than support lawful activities of an organization that the government labels "terrorist," the bill would "reintroduce to federal law the very principle of guilt by association that defined the McCarthy era." See David Cole, "Terrorizing the Constitution," *The Nation*, March 25, 1996: 11–15; and "Analysis of Immigration and Fund-Raising Provisions in Omnibus Counterterrorism Act of 1995," forwarded by "The Pakistan News Service," pakistan@asuacad.bitnet.

7  Andrew L. Shapiro, "Street Corners in Cyberspace," *The Nation* (July 3, 1995): 10–14.

8  This is the impression of my colleague James Sosnoski, who has been following the discussions of electronic pedagogy in recent years at the 4Cs conference, the national forum for teachers of composition and rhetoric.

9  "A Project for a New Consultancy," Gregory Ulmer and Joseph Tabbi, *The Electronic Book Review* 2 (Spring 1996) (http://www.altx.com/ebr).

10  Jürgen Habermas, "The Public Sphere: An Encyclopedia Article (1964)," trans. Sara Lennox and Frank Lennox, in *New German Critique* 3 (1974): 49–55. Originally in *Staat und Politik*, new edition (Frankfurt am Main: Fischer Lexicon, 1964), 220–226.

11  Habermas, 49; Linda Brigham and Gregory Eiselein, "Transforming Pedagogy and Communicative Action: Habermas, Adorno, and the Democratic Classroom" (paper presented at the Fourth Annual Cultural Studies Symposium, Kansas State University, March 9–11, 1995), 2.

12  Henry Giroux, *Disturbing Pleasures: Learning Popular Culture* (New York: Routledge, 1994), x.

13  Friedrich A. Kittler, *Discourse Networks, 1800/1900*, trans. Michael Metteer, with Chris Cullens (Stanford: Stanford University Press, 1990).

14  Michael Bérubé, "Cultural Criticism and the Politics of Selling Out," *The Electronic Book Review* 2 (1996) (http://www.altx.com/ebr); Peter Uwe Hohendahl, *The Institution of Criticism* (Ithaca: Cornell University Press, 1982).

15  Kittler, *Discourse Networks*, 370. See also Gregory Ulmer, *Applied Grammatology: Post(e)-Pedagogy from Jacques Derrida to Joseph Bueys* (Baltimore: Johns Hopkins University Press, 1985) and "Teletheory: A *Mystory*," in *The Current in Criticism: Essays on the Present and Future of Literary Theory*, ed. Clayton Koelb and Virgil Lokke (West Lafayette, Indiana: Purdue University Press, 1987).

16  Ulmer, "Teletheory," 342.

17  Martin Rosenberg, "Physics and Hypertext: Liberation and Complicity in Art and Pedagogy," in *Hyper/Text/Theory*, ed. George Landow (Baltimore: Johns Hopkins University Press, 1994), 274–275.

18  Charles Ess, "The Political Computer," in *Hyper/Text/Theory*, ed. George Landow (Baltimore: Johns Hopkins University Press, 1994), 228.

19  Ess, 229.

20  Cynthia L. Selfe and Richard J. Selfe, Jr., "The Politics of the Interface: Power and Its Exercise in Electronic Contact Zones," *CCC* 45.4 (December 1994): 482. See also Mary Louise Pratt, "Humanities for the Future: Reflections on the Western Culture Debate at Stanford," *The South Atlantic Quarterly* 89 (Winter 1990): 7–26.

21  Here one must mention important attempts to do so by Martin Rosenberg and Stuart Moulthrop, who have followed Robert Coover in characterizing "the future of interactive media in terms of "struggle." Struggle in these instances has been conceived, however, as primarily an *aesthetic* process, a creation of "structures which we will then deconstruct or deterritorialize and which we will replace with new structures." Nothing in such an aesthetic fundamentally challenges a commercial culture's

own dependence on continued innovation, instability, and technological transformation. See Stuart Moulthrop, "Rhizome and Resistance: Hypertext and the Dreams of a New Culture," in *Hyper/Text/Theory*, ed. George Landow (Baltimore: Johns Hopkins University Press, 1994), 316.

22  Selfe and Selfe, 483.

23  Selfe and Selfe, 486–487.

24  Rosenberg, 285; Friedrich A. Kittler, "There Is No Software," *Stanford Literary Review* 9 (Spring 1992), 81.

25  Stuart Moulthrop, "No War Machine," in pre-print on the World Wide Web, http://www.ubalt.edu/www/ygcla/sam/essays/war_machine.html.

26  Selfe and Selfe, 484.

27  Lester Faigley, "The Achieved Utopia of the Networked Classroom," in *Fragments of Rationality: Postmodernity and the Subject of Composition* (Pittsburgh: University of Pittsburgh Press, 1992).

28  An increasingly widespread use of written symbols—smileys—in electronic discussions, reveals a level of discomfort with, or at least a desire to compensate for, the medium's disembodiment. For those unfamiliar with smileys, a colon followed by a right parenthesis indicates a smile, thus: :). Variations might include the frown, :(, the wink, ;), etc. In unimaginative writers and teachers, the impulse toward unambiguous utterances and the use of directive (and often merely self-defensive) gestures will remain strong. And this is no less true of spoken discourse, as one of Faigley's examples shows. In the standard question-and-answer format, "teachers often slow the cadence of their speech and lower their voices in evaluations, then speak more rapidly and [give] nonverbal cues when they introduce a new topic" (180).

29  Faigley, 185.

30  Faigley, 190.

31  Ronald Sukenick, "Down & In" (http://altx.com).

32 Jacques Derrida, "Signature Event Context," *Glyph 1: Johns Hopkins Textual Studies* (Baltimore: Johns Hopkins University Press, 1977), 185. There is a helpful summary in Ulmer, *Applied Grammatology*, 58.

33 Jean Baudrillard, "Simulacra and Simulations," *Selected Writings*, ed. Mark Poster (Stanford: Stanford University Press, 1988), 179.

# Cyberspace and the Globalization of Culture

Jon Stratton

In his 1984 novel *Neuromancer*, William Gibson introduces the idea of "cyberspace" to describe a fundamental transformation in human-machine relations mediated by a massive interlinking web of computer networks. As Robert Adrian puts it:

> In Gibson's *Neuromancer* the protagonist "jacks in" to the net. He is not a user, he is not at the wheel of his datamobile speeding down the Infobahn—he simply disappears into the net and becomes a part of the data-flow.[1]

Gibson's imagery is saturated through with an anxiety over gender relations and the loss of the body as a site of the construction of identity. The cowboys and jockeys who jack into the network, or "matrix," as Gibson calls it, are male. As its name suggests, the matrix itself is female. It is simultaneously mother and lover. In the image, womb and vagina are conflated and the male who disappears into the matrix, leaving his body behind, succeeds in fulfilling the desire that, Freud argues,

makes the woman's genitals uncanny: he returns "home." The price of this fulfillment is the loss of the body. As we shall see, repressed in this image is the recognition of the pleasures and anxieties that are associated with the (relatively) new bodiless virtual identity of Internet users.

There is, however, another theme suppressed in this image of cyberspace as a mother/lover. The matrix is a site of reproduction, but of what? The short answer is capitalism, but it is more complicated than this. In the *Grundrisse*, Marx explains that "Circulation time ... appears as a barrier to the productivity of labour" and goes on:

> [capital] strives ... to annihilate this space [of circulation] with time, i.e. to reduce to a minimum the time spent in motion from one place to another. The more developed the capital, therefore, the more extensive the market over which it circulates, which forms the spatial orbit of its circulation, the more does it strive simultaneously for an even greater extension of the market and for the greater annihilation of space by time.[2]

The alternative to decreasing circulation time is what Harvey has succinctly called "the spatial fix;" in short, the expansion of the capitalist economic order to new geographical spaces in order to find raw materials, new, cheap sources of labour and new markets.[3] Cyberspace, I want to suggest, did not simply appear fully formed at a point in the second half of the 1980s. Rather, it has its origins in nineteenth-century attempts to speed up circulation time, and has taken on a new importance with the globalization of consumption-oriented capitalism and the ending of the possibility of the spatial fix.

The most fruitful place to look for a beginning to cyberspace is with the invention of the telegraph in the first half of the nineteenth century. In what has become a celebrated insight, James Carey has noted that, "The simplest and most important point about the telegraph is that it marked the decisive separation of 'transportation' and 'communication.'"[4] It is, I would argue, not the introduction of computers that marks the beginning of the production of cyberspace, but the increase in the speed of communication over distance to a point where the time taken for a message to traverse that distance reduces to a period experienced by the receiver, and sender, as negligible. In metaphorical terms, we could say that as the time taken to cross the geographical space decreases, that space is decontex-

tualized and replaced by a distinctly non-geographical hyper-space. In such a space, as Carey explains, "symbols move independently of geography and independently of and faster than transport"[5]—precisely the precondition, in other words, for the reification of information we have come to take for granted in the computer age.

There is one more aspect of the introduction of the telegraph which we need to explore here. Carey argues that:

> The effect of the telegraph is a simple one: it evens out markets in space. The telegraph puts everyone in the same place for purposes of trade; it makes geography irrelevant. The telegraph brings the conditions of supply and demand in all markets to bear on the determination of a price. Except for the marginal exception here and there, it elimi-nates opportunities for arbitrage by realizing the classical assumption of perfect information.[6]

Here Carey is thinking of the telegraph in the service of capital-ist exchange. If, as Marx argues, money is a universal solvent, because it enables the exchange value of all commodities to be compared when they have been priced, so the telegraph begins the process of dissolving all markets into one hypermarket, because information in all local markets can be communicated to all other local markets. Where arbitrage is an effect of the inability to transfer information across geographical space, the instantaneous media of communication produce a homoge-nized hypermarket in hyperspace.

This hyperspatial market is ideal for dealing in money itself—as money, too, has become reified into a commodity during the second half of the twentieth century, especially since the early 1970s. This process is materially associated with the global movement away from the gold standard, but it is most clearly expressed in the increasing importance of finance capi-tal. This money is not tied directly to production and is used to make more money by playing the (world) stock exchanges, gambling on exchange rate shifts or seeking-out high interest rates. Harvey describes the new situation like this:

> What does seem special about the period since 1972 is the extraordinary efflorescence and trans-formation in finance markets. There have been phases of capitalist history—from 1890 to 1929 for example—when finance capital (however defined) seemed to occupy a position of para-

mount importance within capitalism, only to lose that position in the speculative crashes that followed. In the present phase, however, it is not so much the concentration of power in financial institutions that matters, as the explosion in new financial instruments and markets, coupled with the rise of highly sophisticated systems of financial co-ordination on a global scale.[7]

What has enabled these highly sophisticated global systems to flourish has been the development of increasingly complex computers and their coupling with an automated and digitalized telecommunications system linking points not only nationally but internationally. The reification of money, like that of information, leads us back to the reconstitution of communication media as transport systems. These new commodities are being transported through a hyperspace in which distance does not exist, and place and extension are replaced by pure movement.

Where geographical space was colonized and transformed into a site of production (and consumption) within the capitalist exchange system, hyperspace is, itself, a product of communication technologies developed in the context of capitalism. The terrain of cyberspace is fundamentally deterritorialized. In *Anti-Oedipus*, Gilles Deleuze and Felix Guattari have constructed a history of place that describes how capitalism deterritorializes and reterritorializes. Robert Young has usefully summed up this part of their argument:

> The reduction of everything, including production and labour, to the abstract value of money enables [capitalism] to decode flows and "deterritorialize" the socius. Having achieved a universal form of exchange, it then reterritorializes—"institutes or restores all sorts of residual and artificial, imaginary, or symbolic territorialities" such as states, nations or families.[8]

Young goes on to quote from *Anti-Oedipus*:

> There is a two-fold movement of decoding or deterritorializing flows on the one hand, and their violent and artificial reterritorialization on the other. The more the capitalist machine deterritorializes, decoding and axiomatizing flows in order to extract surplus values from them, the more its ancillary apparatuses, such as government

bureaucracies and the forces of law and order, do
their utmost to reterritorialize, absorbing in the
process a larger and larger share of surplus value.[9]

Young points out that this description not only fits the "west-
ern" history of industrialization, but also the "western" process
of colonization. Capitalist exchange produces a new organiza-
tion of space, one bound together by exchange and organized
according to a perspectival and panoptic understanding. As
Jean Baudrillard has noted, "We are witnessing the end of
perspective and panoptic space (which remains a moral
hypothesis bound up with every classical analysis of the 'objec-
tive' essence of power), and hence the *very abolition of the spec-
tacular*."[10] Although announcing the end of the world of
spectacle is hyperbole, nevertheless, as we shall see, the attempt
to reconceptualize cyberspace as an information superhighway
evidences a nostalgia for linkages between capital, communica-
tion media and the nation-state. The equivalence between a
democracy of citizen voters and a "passive" mass audience
which operates in modern democratic nation-states as a conse-
quence of the rise of traditional mass media is broken down in
the proliferating interactivity of the Internet.

The opening up of cyberspace begins a new movement of
hyper-deterritorialization, this time within the exchange sys-
tem of capitalism. From this point of view the Internet, the
day-to-day expression of cyberspace, might best be understood
as a vector in McKenzie Wark's sense of the term:

> Both capital and the military command space with
> vectors—technologies that traverse and thereby
> abstract space and time from the specificities of
> locality, culture, terrain and tradition. It is no acci-
> dent that accelerated development of the vector is
> synonymous with modernity, and has been jointly
> sponsored by military and corporate interests.[11]

Within the post-World War II history of economic inter-
nationalization, this new form of electronic hyper-deterritori-
alization can be read as a further spatial fix to capitalism's
globalization. As Arjun Appadurai argues, "The new global
cultural economy has to be understood as a complex, disjunc-
tive order, which cannot any longer be understood in terms of
existing center-periphery models (even those that might
account for multiple centers and peripheries)."[12] Appadurai's
point is that global capitalism needs to be thought of in terms

of flows rather than binary positionalities. He proposes a framework which identifies five dimensions of the "global cultural flow"—ethnoscapes, mediascapes, technoscapes, finanscapes and ideoscapes. He argues, using the same term as Deleuze and Guattari but in a different way, that these flows drive an increasing deterritorialization of people, images, commodities, money and ideas, or what I have been calling hyper-deterritorialization. While recognizing the crucial limits on connection to the Internet—out of an estimated 30 million users in 1994, roughly 25 million are American, and all require access to a computer, a phone line and a provider—it is, nevertheless, a significant vector in the reinforcement of the global flows which Appadurai describes.

Appadurai's center-periphery metaphor expresses well the global order which developed from the seventeenth-century spread of colonialism. It opposes a Euro-American core made up, ultimately, of "developed" modern nation-states with a periphery of the rest of the world whose relation to the "west" is primarily as a source of surplus value. The concept of the nation-state has been one of the most successful of the exports of "western" modernity. Important to center-periphery models is the idea of emplaced relations, relations which were, in fact, focused in and through the nation-state. Appadurai has signalled how these relations have been transformed:

> The globalization of culture is not the same as its homogenization, but globalization involves the use of a variety of instruments of homogenization (armaments, advertising techniques, language hegemonies, clothing styles and the like), which are absorbed into local political and cultural economies, only to be repatriated as heterogeneous dialogues of national sovereignty, free enterprise, fundamentalism, etc. in which the state plays an increasingly delicate role: too much openness to global flows and the nation-state is threatened by revolt—the China syndrome; too little, and the state exits the national stage, as Burma, Albania and North Korea, in various ways have done.[13]

The reorganization of global capitalism, which is expressed through the change in metaphor, has altered the experience of the nation-state. The world which was organized along center-periphery lines was dominated by space, in particular a geographical space organized into nation-states and their colonial adjuncts.

Global flows are a consequence of the capitalist dynamics of nation-states but, at the same time, place the old spatial verities of the nation-state under pressure. Nowhere is this more obvious than in the Internet. The instantaneity of communication with the telegraph and the telephone helped to bind the nation-state together for two reasons. First, they were used within the context of the homogenizing ideology of the nation-state. This process was reinforced by the use the state made of these technologies in its bureaucratic and administrative systems, both in direct relation to the citizenry and in the increased centralization of power they allowed over the forces of control—the armed forces and the police. Second, they were used primarily within the nation-state. However, by the 1970s the new telecommunications technologies—including, for example, the use of satellites—made international telephone calls easier to make, cheaper and, above all for the citizen user, clearer. Reworking Carey's point, Wark comments that, "Together with the railroad, the vectors of the telegraph and telephone largely created the possibility of extensive interstate communications."[14] Carey notes that, "In a sense the railroad and the canal regionalized markets; the telegraph nationalized them."[15] In this way these technologies pursued one of the main themes of the modern nation-state, the movement towards internal homogenization. The user's perception of hyperspace as a static, emplaced space is a function of the instantaneity of communication. In the vectorial space of the Internet the special quality of both information and money—that unlike other commodities they have no use value in their own right but only as items of exchange—is naturalized. More and more it became the case that talking to someone "on the other side of the world," most importantly for this argument in another nation-state, sounded just as if they were "just down the road."

Nation-states seek to homogenize and define themselves as different from other nation-states. In the last instance this difference is defined spatially, expressed in the material and cultural environment within the nation-state's borders and delimited by those borders. The separation of communication from transport meant that, when the new communication media were used internationally, people's sense of the nation-state as expressed in a distinctive geographical spatiality diminished. From this perspective, the hyperspace of the Internet elides the geographical spatial formations of nation-states which underpin their claims to a national culture. It is for this

general reason that many nation-states, such as Japan and Singapore, have been hesitant about enabling their citizens to connect to the Internet at all.[16] While most nation-states were prepared to tolerate the lack of control over the one-to-one interaction of international telephone calls—except, maybe, in times of internal revolt—the Internet offers a qualitative increase in communicative possibilities. It is therefore logical that those nation-states whose citizens at present dominate the Internet will tend to feel less threatened by the technology, while conversely, those which sense that such dominance threatens their own cultural integrity will show a more hostile reaction. This would be a consequence not only of the prevalence of English and the use of the Roman alphabet, but also of the kinds of information available and the culturally specific modes of interaction which predominate in cyberspace: the very rhetoric, for example, of freedom, censorship, and human rights which are central to discussion of these issues.

American dominance in the direction of the global flow in the Internet, however, need not necessarily continue. Here, indeed, lies an irony—or what Marx would have described as a contradiction in capitalism. At present the United States is taking the lead in the construction of a "global information infrastructure" (GII), a project which has taken on the aura of a humanitarian mission. In a 1994 address in Kyoto, Japan, American Vice President Al Gore said:

> The effort to build the GII provides us with an opportunity to reach beyond ideology to forge a common goal of providing an infrastructure that will benefit all the citizens of our nations. We will use this infrastructure to help our respective economies and to promote health, education, environmental protection and democracy.[17]

Sandwiching health, education and the environment is, significantly, the dual emphasis on economic and political goals. Gore no doubt intends that the "freedom" of information access offered by the Internet will correlate with a movement within authoritarian nation-states towards democracy. The United States, in other words, is promoting and underwriting the GII for its own economic—and ideological—advantage, but as more non-Americans and non-English speakers come on line the American hegemony over the use of the Internet will become harder to sustain.

The connection between the economic order and the

Internet is reinforced in the five principles that the International Telecommunication Union has adopted for a GII: "Private investment. Market-driven competition. Flexible regulatory systems. Non-discriminatory access. And universal service."[18] The first three of these principles emphasize a capitalist form for the building, ownership and running of the GII, including what it is used for. The last two are about audience. The idea—or, given its Utopian quality, the ideal—is to constitute the entire global population as an audience. In order to understand fully what is being promoted here we need to remember Gore's rhetorical shift from talking about the Internet to the Information Superhighway. Making this connection, we can see that the building of the GII provides the basis for a global interactive commodity-delivery system for vastly expanded media companies.

How, precisely, is this marketer's dream to be achieved? Wark describes how, in military and corporate terms, "ever faster, cheaper, more flexible and higher bandwidth vectors arm those who have access to them with strategic advantages."[19] Adrian, noting the limited prospects for the growth of value-added services for the telephone, also sees the answer in increased bandwidth:

> Increased bandwidth allows telephone space to be appropriated for commercial propaganda; occupied by infotainment commodities; turned into a shopping mall. . . .What these corporations really want is interactive cable TV—with the interactivity restricted to on-line shopping, video games and pay-to-view movies with the telephone thrown in as a give-away because it requires almost no space on the cable. The Infobahn in this definition is little more than a catalogue of products, services, information and entertainment that can be ordered or purchased and consumed on line.[20]

The point here is in the recognition that the corporations would like, ideally, to limit interactivity. The extraordinary thing about the telephone, as compared to radio and television, is that it did not develop as a mass communication medium. It is non-centralized and interactive. Based on the same telecommunications technology, the Internet offers the one-to-one interaction of email or "talk" as well as a wide variety of one-to-many interactions from Usenet to LISTSERV lists and the

instantaneous multiple interaction of IRC. All this in contrast to the functional complicity in the way radio and television technologies developed with the organization of the modern nation-state.

In a now justly celebrated image, Benedict Anderson has described the nation as an imagined community.[21] His idea is that a sense of nationhood is produced out of the sharing of a range of myths and knowledge. He argues that the newspaper started as one means through which such sharing could take place. Writing about South America, Anderson describes the gazette, which he views as the antecedent to the newspaper, as containing:

> aside from news about the metropole—commercial news (when ships would arrive and depart, what prices were current for what commodities in what ports), as well as colonial political appointments, marriages of the wealthy and so forth. In other words, what brought together, on the same page, *this* marriage with *that* ship, *this* price with *that* bishop, was the very structure of the colonial administration and market system itself. In this way, the newspaper of Caracas quite naturally, and even apolitically, created an imagined community among a specific assemblage of fellow-readers, to whom these ships, brides, bishops, and prices belonged.

As the "news" aspect of the newspaper developed, Anderson points out how "the very conception of the newspaper implies the refraction of even 'world events' into a specific imagined world of vernacular readers."[22] In this connection between the "invention" of the newspaper and the rise of the nation-state we find two other developments: the formation of a modern public sphere, and the formation of the mass audience.

In his influential discussion of the rise of the modern public sphere, Jürgen Habermas argues that it evolved as a bourgeois development that took place in the context of the spread of the capitalist market. He views it as a key component in the functioning of democracy, suggesting that "the public sphere as a functional element in the political realm was given the normative status of an organ for the self-articulation of civil society with a state authority corresponding to its needs."[23] Based in print culture and especially that of newspapers, the public sphere, for Habermas, is the site of the political

debate central to democratic society. Newspapers, in this view, serve primarily to stimulate and aid informed debate. There is another side, however, to their role. As we have seen, Anderson argues that newspapers help to produce the imagined community of the nation-state by imparting information to an audience. The point here is that, like the later mass media of radio and television, newspapers are not interactive. Their production of a national imagined community takes place through the construction of a silenced mass audience. John Hartley, taking this approach a step further, emphasizes this somewhat more cynical view of the mass media's role in the construction of the public sphere. Comparing the modern situation with that of ancient Greece and Rome, Hartley writes,

> nowadays there is no physical public domain, and politics is not "of the populace." Contemporary politics are *representative* in both senses of the term; citizens are represented by a chosen few, and politics is represented to the public via the various media of communication. Representative political space is literally made of pictures—they *constitute* the public domain.[24]

There is no need to limit the constitution of the public sphere to pictures. It includes both print (as in newspapers) and voice (as in radio). In order to understand how this has come about, Hartley goes back to the first attempt to theorize a modern political state, that of Thomas Hobbes in *Leviathan* (1651), and shows how, when

> Leviathan is given life by completely taking over the powers of those represented, leaving nothing behind. . . . [a]ny henceforth exercised by civil subjects (private individuals) are those that Leviathan "authorizes" or devolves back onto them. In short, the public transfers its sovereign powers to Leviathan, and Leviathan is thence *author* of the public.

Now, "the strong state, Leviathan, which has often been equated with *absolute monarchy*, becomes the polity under which *democracy* is possible. This is because political *participation* has transformed into *representation* on the abolition of the public."[25] The public, in other words, has been transformed into an audience.

Ien Ang, in discussing the discursive construction of the

mass television audience, distinguishes between two basic audience constructs reflecting the division of television into commercial and public service forms, namely, audience-as-market and audience-as-public. Though they differ in substantial ways, "both kinds of institution," she notes, "inevitably foster an instrumental view of the audience as an object to be conquered. . . in both cases the audience is structurally placed at the receiving end of a linear, one-way process."[26] This overarching discursive construct of the audience forms it as attentive, massified and passive. While Ang is writing about television in particular, the understanding of the audience that she elaborates is a general characteristic of the public sphere in the modern nation-state.

Anderson describes how the creation of a nation depends, in large part, on the construction of its members as an audience who can be transformed into an imagined community. Hartley shows a similar process in operation with the democratic state. Whereas for Habermas there is a discontinuity between the roles of newspapers and of the new audio and visual mass media, the latter corresponding to a degradation of the public sphere, Hartley sees these media as continuing the same process of which the newspaper has always been a part. Following Hartley's argument, we are now in a position to understand why radio and television developed as centralized communication delivery systems. In short, the nation-state's imagined community, its public sphere and its audience are, ideally, co-terminous. In this context, the generalized interactivity of the Internet, along with the ability of anyone with access to put forward their own views in any of a range of forums, poses a threat to the distinction between public information—epitomized in the notion of journalistic objectivity—and personal opinion, a distinction central to the formation of the imagined community of the democratic nation-state.

Over the last few years, however, there have been two tendencies in media development that have begun to restructure the mass media/audience formation. The first is the move to multiple channels made possible by the spread of cable television. This has led to narrow-casting and to a general problematization of the category of the "mass media." The second is the move towards greater interactivity. This ranges from the use of VCRs to pay-per-view and, eventually, the ability to order the programs one wants to watch. In terms of both these developments the Internet marks a qualitative shift. In the case of the Internet the passive media audience described by Ang becomes

(inter)active, participating fully in the production of the media product. It is the attempt to "reform" the Internet into yet another mass media delivery system which is at the heart of the rhetorical shift towards the notion of an "Information Superhighway." Where the traditional mass media audience consumes images, the scarcely veiled aim of the Information Superhighway is to transform the passive, receiving audience of the mass media into an active, consuming audience, now consuming, however, not just images but also—for a fee—the entire range of commercial goods and services which are becoming available online.

In *The Practice of Everyday Life*, his radical account of the active role citizen populations play in the production of an everyday life apparently determined by the material and disciplinary expressions of the nation-state, Michel de Certeau claims, "Marginality is today no longer limited to minority groups, but is rather massive and pervasive." He goes on to assert that, "Marginality is becoming universal. A marginal group has now become a silent majority."[27] What he is describing is the very success of the processes described by Anderson, Hartley and Ang, a success threatened by the demassification and interactivity, here to be understood as the "public" speaking out by those previously silenced by the mass media, that is central to the access structure of the Internet in its current form. When minority, silenced groups, such as the Chiapas Amerindians in Mexico can speak out on the Internet and when anybody can voice their opinions on a newsgroup, not only the organization of the media and the construct of the audience, but also the formation of a unified and distinct imagined community—a disciplined and disciplinary public sphere—and the very understanding of the nation-state itself are transformed. The Internet is one more vector in the global flows that have shifted nation-state rhetoric from homogeneity to multiculturalism, and nation-state politics from a class basis to an interest basis. We can now appreciate that there is a second reason, of necessity deeply imbricated with the first, for Gore's concern to shift the rhetoric—and the material form—of the Internet towards the Information Superhighway. In addition to economic considerations, the latter would reconstitute the Internet as something much more approaching the modern mass media, and as such would be less threatening to the established form of the nation-state.

We must distinguish carefully between the idea of a radically new public sphere in which the old "audience" can be

active in the presentation of their views and the idea of community. Particularly in American discussions of the Internet there is a tendency for these two concepts to merge. At its most basic the modern idea of a public sphere depends on a distinction between private and public life. The public sphere, the realm of public life, has been, in the modern world, the space of shared knowledge and of politics. Anderson and Hartley would agree that the traditional mix of information in newspapers expresses well the form of the modern public sphere that has been developing since the eighteenth century.[28]

Previously I have suggested that the citizen-audience is silenced in the modern public sphere. The situation is actually a little more complicated. From the eighteenth-century coffee houses of London to today's discussions during office tea-breaks there is consideration of issues. However, this consideration is limited to the information presented by the mass media, and the structure of the media-audience relation allows almost no response or other opportunity for expression within the organization of the media beyond letters to the editor and talk radio. As we have seen, the suggestion is that the Internet provides a new forum where the audience can express itself. In his article "Old Freedoms and New Technologies: The Evolution of Community Networking," Jay Weston is very clear about this potential:

> The Internet is mostly about people finding their voice, speaking for themselves in a public way, and the content that carries this relationship is of separate, even secondary, importance.... Mass media do not confirm [personal] existence, and cannot. The market audience exists, but the reader, listener or viewer does not.[29]

As the title of this article indicates, Weston believes that the citizen's ability to speak out in the public sphere is an "old freedom" which has been limited by the development of the mass media. My point has been that this is not an old freedom at all, but that, in fact, democracy as it exists in the modern state is built on the illusion that freedom exists.

The discourse of community appears to coincide with that of the modern public sphere in the notion of interactive communication—people talking to one another. But in the modern west, "community" carries an additional nostalgic connotation. It refers to a mythic understanding of the essential "sharedness" of a way of life before the fragmentation of interpersonal

interaction and the loss of a taken-for-granted moral order brought about by the founding modern changes—secularization, urbanization, capitalism, industrialization and, of course, the emergence of the nation-state.

In the United States this nostalgic myth of a pre-modern community has been situated in the ideology of the "small town." Ruth Rosen has explained how:

> As early as 1835, de Tocqueville noted that Americans were busy creating a vast network of associations that would provide a surrogate communal life. Still, as the cities expanded, Americans mourned the passing of the small towns they had left behind. The more they were forced to confront the anonymity or urban life, the more they mythologized the stability, face-to-face recognition, shared values, and moral accountability of the village. By the early decades of the twentieth century, the myth had grown to such proportions that it inspired Progressive reformers to attempt to make over the American city into a small town.[30]

Rosen's argument is that one reason for the American love affair with soap operas is that they provide a surrogate community. The Internet is very often discussed in exactly these terms.

Probably the most widely read—and intellectually sophisticated—introduction to the Internet is Howard Rheingold's *The Virtual Community: Finding Connection in a Computerized World* (1994). The title signals Rheingold's governing premise about the Internet. In the Introduction he writes about the WELL, a "medium-size computer conferencing communit[y]" of which he is a member and which is now connected to the Internet:

> The WELL is a small town, but now there is a doorway in that town that opens onto the blooming, buzzing confusion of the Net, an entity with properties altogether different from the virtual villages of a few years ago.

Here the WELL is not described as being like a small town—but actually being one! The Internet, by comparison, seems to be more like a city. Nevertheless, within this "city" Rheingold is able to become a part of virtual communities made up of people with similar interests. Interestingly, given Rosen's argument, Rheingold makes the connection with soap opera:

> Watching a particular virtual community change over a period of time has something of the thrill of do-it-yourself anthropology, and some of the garden-variety voyeurism of eavesdropping on an endless amateur soap opera where there is no boundary separating the audience from the cast.[31]

The importance of the image of community to the American experience of the Internet can be demonstrated through personal reminiscences. On 19 November 1994, Peter F. McDermott posted a lengthy response on the CPSR-GLOBAL LISTSERV to a query: "Someone was asking why the Internet has become so popular in the United States versus other countries and if there is anything special about the U.S. that would keep it from being developed on the same level elsewhere." After a description of his personal pleasure on finding the Internet and musing about the "sense of community" he feels the Internet provides, he goes on to muse on the reasons for it:

> I wonder how much American culture has to do with it (yes, we do have our own culture over here :) ). Thinking about the destruction that communities have gone through in the last 20 or 30 years over here in the States makes me wonder. When my parents were growing up, their families knew everyone in the neighborhood; I can't count the number of times I've heard my friends mention that they now barely know their next door neighbors and don't really know any of the other families on their street. Could this loss of community (assuming I'm not just imagining things) and the corresponding groping to fit into one be one reason for how popular the internet is here?[32]

In this thoughtful account McDermott places the destruction of "community" between his parents' generation and his own. For him the Internet has become the virtual substitute for the real community of which his parents were members. Correlatively he perceives a decline in the quality of life in the United States which the virtual community he finds on the Internet helps to balance.

An analogous point was made in a posting by Bernd Frohmann, also on CPSR-GLOBAL. Putting a European perspective, Frohman asks rhetorically: "does the attractiveness of the concept of a community of cyber-buddies gain force in direct proportion to the degradation of public space in

America, and its replacement with privatized spaces, like malls, and large corporate centers, like Detroit's Renaissance Center?" He goes on to compare the American city's built environment with that of many European cities:

> Talking to colleagues at a recent conference in Graz, I learned that many of them are simply bemused by what they take as the typically American conceit of cyber-communities. And their reaction is understandable when you live in a city that has ample public space, with real opportunities and places for people to meet [and publicly-supported] spaces, you are likely to think that celebrations of the "information highway" as a place for meaningful contact between people is more than a little ridiculous.[33]

Frohmann is wrong to equate so literally a virtual community with a real community, if only because the former, existing in hyperspace, can include people who live at great geographic distance from each other. His point about the comparative material form of European and American cities is suggestive, however, and this may well complement what would seem to be a particularly enhanced yearning in American culture for the mythical community. After all, while European cities often have pre-modern centers comprised of squares and piazzas, American cities are all modern—and formed according to the needs of capitalist exchange, privileging business, and now shopping malls. In reality the American small town seems to have had more of an institutional focus, the church, the town hall or even the post office.

The American image of community as being a small town may well be the reason that community networks, or freenets as they are also called, have come to be laid out using that same image. Ray Archee argues that

> The underlying philosophy of the free-net, and its fundamental promise, is empowerment. . . community computer networks, whether they be free or even fee-paying, permit ordinary people access to the most significant commodity in the world today, information.[34]

Jay Weston, describing the idea which underlay the Canadian National Capital FreeNet, stresses the communal nature of this empowerment.

CYBERSPACE AND THE GLOBALIZATION OF CULTURE

The National Capital FreeNet was an imagined public space, a dumb platform where all individuals, groups and organizations could represent themselves, where conflict and controversy could occur as the manifestations of conflict and controversy already occurring within the community. . . . Such a space could be constructed only by the community as a community, and not by any public or private organization acting on behalf of the community.[35]

Here we can see how the ideas of community and a new broad-based, interactive public sphere get blurred together. While the Internet is often thought of as (re)-creating communities on the model of a small town, here we have a claim that rather than providing the conditions for new community, the Canadian National FreeNet arises out of a pre-existing community and provides a virtual public sphere in which the previously silenced can speak. As Weston puts it:

While expressions like "public involvement," and "participative democracy," are imbedded in our rhetorical traditions, their unquestionable acceptability has always been conditional upon their equally unquestionable non-attainability. The technologies of mass communication always ensured that involvement and participation would not be outdone.[36]

Weston, in other words, would concur with Hartley that the ideology of representative democracy has, at least in the domain of public media, typically been at odds with its practice.

There is one last point to be made here. If the Internet—or a freenet—is indeed thought of as a small town, then who inhabits it? I don't mean this question in the sense of who actually at present has access to the Internet. Rather, if the Internet offers—especially for Americans—the realization of the myth of community, and if that myth is expressed in the nostalgic American mythic image of a small town, then who are the mythic inhabitants of that small town?

Embodied identity today is most often triangulated through what Kobena Mercer has described as "the all-too-familiar 'race-class-gender' mantra,"[37] which increasingly reflects the three markers by which inhabitants of the west read off the identity of the people they meet. In this sense, it has become central to the semiotic experience of modern urban

life. But this semiosis requires bodies and clothes. On the Internet—in the mythical virtual small town community—these are pointedly lacking. One consequence of the disembodiment of Internet inhabitants is the potential construction of virtual identities: names, profiles, and voices that might suggest a different gender, class background, or personal history than those they occupy in "real" life.

And yet, just how much real difference can actually be accommodated in the prototypical small-town after which online worlds so often seem to model themselves? From an American perspective, racial diversity, anyway, seems to be as much a euphemism for urban decline and the breakdown of community as a widely shared ideal. In particular, as Ien Ang and myself have explained elsewhere, the racialized difference of African-Americans has always been the always already present fracture in the attempt to construct a homogeneous American identity.[38] Certainly the mythical American small town that Rosen describes, with its shared moral order, did not contain African-Americans—or Asians—just European-originated (probably mostly second-generation) white settlers. These hard-working semi-rural folk would have been upwardly mobile into the middle-class, demonstrating the American incarnation of the bourgeois work ethic—success through individual self-help—while transforming their small town into a city. And those occupying all the town's key public positions would have been male. We can begin to see that, far from being innocent, the American mythologization of the Internet as a community represents a nostalgic dream for a mythical early modern community which reasserts the dominance of the white, middle-class male and his cultural assumptions. Far from the present-day attempts to construct heterogeneous nation-states founded on an acceptance of difference, the image of the small-town community is located in the melting-pot politics of homogenization into a new, unitary American national identity.

As I have remarked before, there are, as yet, no American complaints about the Internet's threat to American culture; the naive perception, and one hidden in Gore's pronouncements about the GII, is that American ideology, founded on European Enlightenment values, will form the homogenizing basis for the Internet community. These values, such as human rights, individualism and democracy, go hand-in-hand with Gore's other concern, the spread of capitalism. The determination to transform the Internet into the Information Superhighway

would counter the "problems" of minority access, by returning to the modern mass media relation, metamorphosing the current access to public speaking into a limited, interactive choice among different purchasable commodities and, in the process, slowing down the reconstitution of the nation-state. In the end, however, it will remain to be seen whether the American capitalist dominance of hyperspace will continue, or whether more space can be produced in which other languages, other cultures, and non-economic concerns can all have a space.

NOTES

1 Robert Adrian, "Infobahn Blues," *CTHEORY*, article 21 (1995). Available by contacting ctheory@concordia.ca; William Gibson, *Neuromancer* (New York: Ace Books, 1984).

2 Karl Marx, *Grundrisse* (London: New Left Review, 1973), 539.

3 David Harvey, *The Limits to Capital* (Oxford: Basil Blackwell, 1982).

4 James Carey, *Communication as Culture: Essays on Media and Society* (Boston: Unwin Hyman, 1988), 213.

5 Carey, 213.

6 Carey, 217.

7 David Harvey, *The Condition of Postmodernity: An Enquiry into the Origins of Cultural Change* (Oxford: Basil Blackwell, 1989), 192–194.

8 Robert Young, *Colonial Desire: Hybridity in Theory, Culture and Race* (London: Routledge, 1995), 169.

9 Gilles Deleuze and Felix Guattari, *Anti-Oedipus: Capitalism and Schizophrenia* (London: Athlone, 1984), 34–35.

10 Jean Baudrillard, *Simulations* (New York: Semiotexte, 1983), 54.

11 McKenzie Wark, "What does Capital Want? Corporate Desire and the Infobahn Fantasy," *Media Information Australia* 74 (Nov. 1994), 18. In *The Virtual Community: Homesteading on the*

*Electronic Frontier* (Reading, Mass.: Addison-Wesley, 1993).
Howard Rheingold provides a technological history of the
Internet locating it as an outgrowth of the U.S. Department of
Defence Advanced Research Project Agency during the 1960s
and 1970s (67).

12  Arjun Appadurai, "Difference in the Global Cultural Economy," in
Mike Featherstone, ed. *Global Culture: Nationalism,
Globalization and Modernity* (London: Sage, 1990), 296.

13  Appadurai, 307.

14  Wark, 19.

15  Carey, 217.

16  In Japan the concern seems to have been that the Internet would
increase foreign influences on Japanese culture. In "Wiring
Japan," *Wired* 2.2 (February 1994), 38–42, Bob Johnstone
describes Japan's tardiness in connecting to the Internet as the
effect of a "head-on collision of two cultures: the freewheeling,
democratic style of the Internet has run smack into traditional
Japan at its most authoritarian." In Singapore, after much initial
official hesitation, the population is now being encouraged to
access the Internet as a part of Singapore's modernization drive.
At the same time, there remains some concern over the effects
on "Asian" morality of "western" depravity.

17  Remarks (as delivered) by Vice President Al Gore via satellite to
the International Telecommunication Union Plenipotentiary
Conference Kyoto, Japan; September 22nd, 1994. Taken, here,
from the LISTSERV CPSR-GLOBAL.

18  Gore, "Remarks."

19  Wark, 18.

20  Adrian, "Infobahn Blues."

21  Benedict Anderson, *Imagined Communities: Reflections on the
Origin and Spread of Nationalism* (London: Verso, 1983).

22  Anderson, 62–63.

23  Jürgen Habermas, *The Structural Transformation of the Public Sphere: An Inquiry into a Category of Bourgeois Society* (Cambridge, Mass.: MIT Press, 1989), 74.

24  John Hartley, *The Politics of Pictures: The Creation of the Public in the Age of Popular Media* (London: Routledge, 1992), 35.

25  Hartley, 124–125.

26  Ien Ang, *Desperately Seeking the Audience* (London: Routledge, 1990), 31–32.

27  Michel de Certeau, *The Practice of Everyday Life* (Berkeley: University of California Press, 1984), xvii.

28  See, for example, Richard Sennett, *The Fall of Public Man* (Cambridge: Cambridge University Press, 1977).

29  Jay Weston, "Old Freedoms and New Technologies: The Evolution of Community Networking," electronically published in cyber-journal@Sunnyside.Com, Dec. 22, 1994.

30  Ruth Rosen, "Soap Operas: The Search for Yesterday," in Todd Gitlin, ed. *Watching Television: A Pantheon Guide to Popular Culture* (New York: Pantheon, 1986), 47–48.

31  Rheingold, *The Virtual Community*, 10–11. (The subtitle of Rheingold's book varies in different editions.)

32  Peter F. McDermott, "US NII for GII," CPSR-GLOBAL LISTSERV, Nov. 19, 1994.

33  Bernd Frohmann, "Electronic Communities," CPSR-GLOBAL, Nov. 23, 1994.

34  Ray Archee, "The NII and Community Computer Networks: Highway, Tollway or Backroad," *Media Information Australia* 74 (1994), 51.

35  Weston, "Old Freedoms."

36  Weston, "Old Freedoms."

37  Kobena Mercer, "'1968': Periodizing Politics and Identity,"

*Welcome to the Jungle: New Positions in Black Cultural Studies*
(London: Routledge, 1994), 288.

8  Jon Stratton and Ien Ang, "Multicultural Imagined Communities:
Cultural Difference and National Identity in Australia and the
USA," *Continuum* 8.4 (1994), 124–158.

## CONTRIBUTORS

**Brian A. Connery** is Associate Professor of English at Oakland University, the founding editor of *Writing on the Edge* and co-editor of *Theorizing Satire: Essays in Literary Criticism* (1995). He is currently completing a study of anonymity and authority in the work of Jonathan Swift.

**Jeffrey Fisher** recently completed his Ph.D. in Medieval Studies at Yale University, where he wrote his dissertation on medieval mystical theology. He is currently at work on a book on the discourse of virtual transcendence.

**Derek Foster** received his M.A. in political science from Wilfred Laurier University and is pursuing further graduate studies in Carleton University's program in Mass Communication.

**Dave Healy** directs the Reading and Writing Center at the University of Minnesota's General College, where he also teaches composition. Healy manages an email discussion list for writing center tutors and edits *The Writing Center Journal.*

**Mizuko Ito** is an advanced doctoral student at the Stanford

School of Education and Department of Anthropology. Her work focuses on the use of multi-user dungeons, the development of related networking systems, and educational applications.

**James A. Knapp** received an M.A. from Temple University in English literature and is currently a doctoral student at the University of Rochester. His work focuses on the transformative effects of new media on the emergence of modernity from the early modern period to the late twentieth century.

**Joseph Lockard** is a doctoral candidate in English literature at the University of California, Berkeley. He has taught on the faculty of Seminar Hakibbutzim, Tel Aviv, and A.B. Gordon Teachers College, Haifa. He is a member of the Bad Subjects Collective (http://english-www.hss.smu.edu/bs), a progressive forum on the politics of everyday life.

**Shannon McRae** is a Ph.D. candidate in English at the University of Washington. She runs a virtual world, Dahlgren MOO, with a small group of friends.

**William B. Millard** is a doctoral candidate in English at Rutgers University. He is writing a dissertation on the later works of Mark Twain, and has published widely in the areas of postmodern fiction, popular culture, and literary satire.

**David Porter** is Assistant Professor of English at the University of Michigan. He has taught courses on the social impact of computing and is currently completing a book on European interpretations of Chinese culture in the eighteenth century. He has edited another Routledge anthology, *Between Men and Feminism* (1992).

**Mark Poster** teaches History and Critical Theory at the University of California, Irvine. His recent books include *The Second Media Age* (1995) and *The Mode of Information* (1990).

**Charles J. Stivale** is Associate Professor of French in the Department of Romance Languages and Literatures at Wayne State University in Detroit. He is currently developing a special issue of the journal *Works and Days* entitled "CyberSpaces: Pedagogy and Performance on the Electronic Frontier."

**Jon Stratton** is Senior Lecturer in Cultural Studies at the School of Communication and Cultural Studies at Curtin University of Technology. His most recent books are *Writing Sites: A Genealogy of the Postmodern World* (1992) and *The Desirable Body: Cultural Fetishism and the Erotics of Consumption* (1996).

**Joseph Tabbi** is Assistant Professor of English at the University of Illinois-Chicago and editor of the online journal *Electronic Book Review*. He is the author of *Postmodern Sublime: Technology and American Writing from Mailer to Cyberpunk* (1995).

**Michele Tepper** is a graduate student in the Department of English Language and Literature at the University of Michigan, Ann Arbor. She is currently writing a dissertation on modernist literature.

**Shawn P. Wilbur** is a Graduate Fellow in American Culture Studies at Bowling Green State University. He edits the electronic magazine *Voices From the Net* and serves as a host and site mantainer for the online "virtual community" Postmodern Culture MOO.